MAN

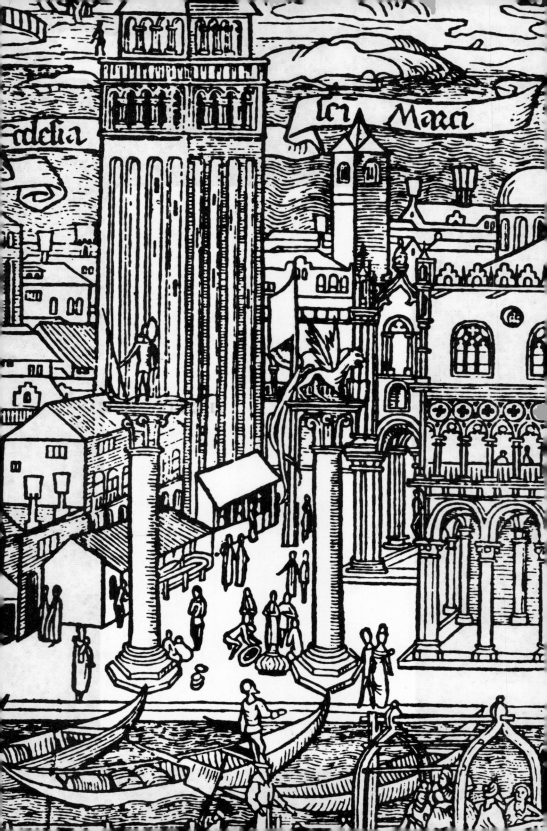

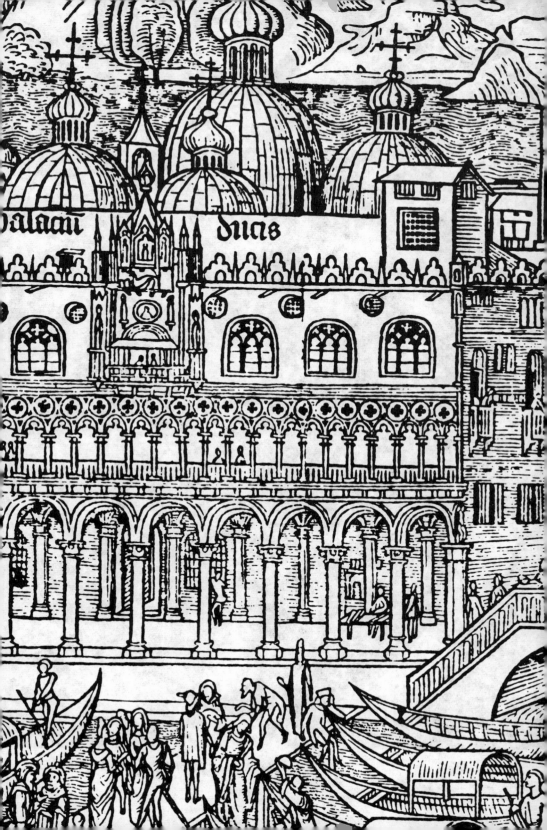

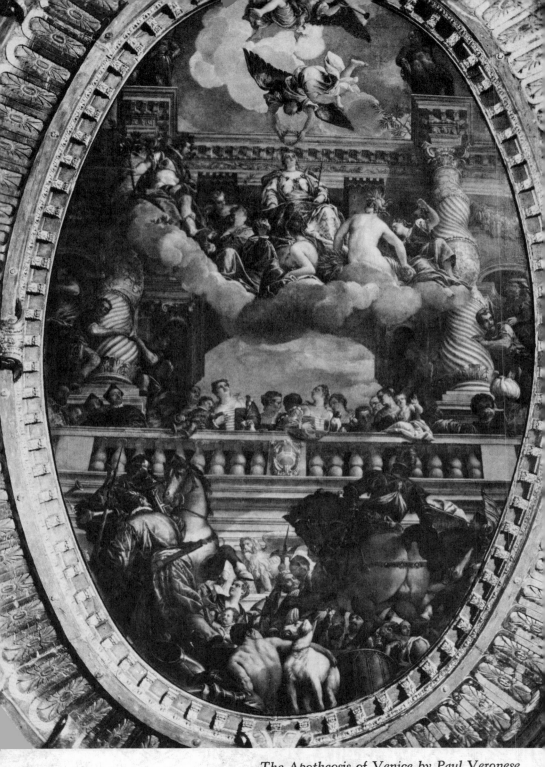

The Apotheosis of Venice by Paul Veronese

THE CITY OF MAN

SECOND EDITION

BY CHRISTOPHER TUNNARD

CHARLES SCRIBNER'S SONS, NEW YORK

To M, L, and C.R.T.

ACKNOWLEDGMENTS

The author wishes to thank Wayne Andrews, Archives of American Art Professor at Wayne State University, for his introduction to little-known aspects of the American scene. The author is especially indebted to Henry Hope Reed, Jr., Curator of Parks, New York City, for his generous help in preparing the text and illustrations. Others who have afforded assistance of a specific nature are mentioned in the notes.

Some of the material in the book was first developed in the form of lectures at the Columbus Gallery of Fine Arts, the Massachusetts Institute of Technology, North Carolina State College, the Rhode Island School of Design, the University of Arkansas, the University of Houston, and the University of Illinois; portions of chapters have been published in the *Magazine of Art*, the *Architectural Review*, the *Town Planning Review*, the *Journal* of the Society of Architectural Historians and the *Journal* of the American Institute of Planners. Thanks are due these institutions and publications for opportunities afforded and cooperation received.

The author wishes to express his appreciation of the award of a Guggenheim Fellowship, which enabled him to visit many of the places discussed in the book.

ix

TABLE OF CONTENTS

LIST OF ILLUSTRATIONS

I PLATES

Plates 1 to 26 will be found following page 232.

Plates 27 to 57 will be found following page 360.

II WITHIN TEXT

LIST OF ILLUSTRATIONS

INTRODUCTION

In a world struggling to make peace within itself among a growing number of conflicting ideologies, the voice of humanism speaks as clearly as ever. "Build nobly," it calls to architects and planners, "and build as if you were building forever."

Classical humanism has great power, although we may not be taking advantage of its strength at the moment. We lose this heritage and forget. Worse, we destroy it. Pennsylvania Station in New York City has gone, and so has the Euston Arch in London. When new opportunities to build arise, as in Boston's Government Center, we succumb to the easy superficialities of a Secessionist complex,* or settle for a series of unrelated structures, as on almost any post-war American college campus. Boston, Baltimore, Montreal, Chicago—the end result is all the same, while in the announced plans for Lower Manhattan, project is piled upon project in a false gigantism undreamed of even by the architects of the Temple of Jupiter at Baalbek, where the classical idiom was stretched to its ultimate limits.

Europe fares no better. The center of Padua is ruined by random skyscrapers in imitation of the Milanese; the rebuilt area of London around St. Paul's destroys the view of the Cathedral; in Nuremberg the scale is lost. Only a few cities like Munich, Copenhagen, Rome, and Stockholm have honored their debt to the past; in some places the world of memory remains in

* Secessionism was an artistic movement emergent in Vienna in the late 1890's. In architecture, the word has since been used to indicate a composition which is abstract, rationalist in concept, and picturesque or assymetrical in design. Hence: Picturesque Secessionism, a term descriptive of much modern architecture.

active force, but it is constantly threatened by demolitions or intrusions.

An entirely false notion of progress has produced the modern city, which is rapidly taking the form of a series of "self-contained" projects built on clean and cleared sites interspersed with arterial highways and freeways. It is all done to improve values and keep out undesirable uses—the effect is antiseptic, uninteresting, and therefore deadening to the spirit. The new city is also antisocial in the literal sense of the term. The poor have no place there. If the French can accuse Haussmann of creating a Paris without soul, what can be said of the soulless boards of directors, the managers of corporate capitalism, who have financed and allowed the present city to happen?

While the cultural revolution predicted in this book has not yet taken place, fortunately, in very recent years, a new interest in architecture and planning has been developing in many parts of the world. This is a forecast of things to come. Society is learning to be critical of badly-placed and wretchedly-designed buildings, although those in the latter category are still accepted complacently by far too many people. When citizens' groups in Agrigento in the mid-1960's succeeded in having removed a nearly completed 16-story skyscraper, looming over the Valley of the Temples, this was merely a dramatic forerunner of hundreds of similar protests—some successes, some failures— in cities all over the globe. Home-owners of Paddington, a historic district of Sydney, Australia, successfully protested the intrusion of new highways through their ornate terrace houses, while citizens of Shaker Heights, Ohio, fought the threat of freeways intruding on their local parks. Funds have been raised and support given for preservation by governments and private individuals alike, the former being the more active agents in Europe and the latter in the United States. Newly-independent nations like Jamaica have allocated precious funds to their Na-

tional Trusts, while richer, older countries like France have devised ways of linking renewal programs to historic preservation so that old buildings could be assured of a new life through careful restoration and adaptive use. In the Marais district of Paris, as in the Colonial seaport town of Newport, Rhode Island, groups of young people have band together to save and restore with their own labor old houses threatened by decay or "urban removal".

There is irony in the knowledge that it has taken this new interest in planning and historic preservation to alert the public to the nature of good design, yet nostalgia has been the basis of every important movement in architecture and urbanism since the Renaissance discovered Vitruvius, when artists turned to the ancients for inspiration and new ideals. It is too early to say what the current interest in protest and protection will bring, but current scrutiny of the barren idiom and way of doing things in the city can only result in a healthy and uninhibited criticism by "consumers" of their surroundings. The recent constructive participation of thousands of Parisians in the controversy over the proposed plan for Les Halles is a case in point.

With today's infinitely greater resources and expertise, the aim of putting man back at the center should be less difficult than in the cultural revolution of 1450. It is heartening to see society in all countries responding to the threatened destruction of the natural environment. But that is only part of the task ahead. The response to the challenge of the city should be equally loud and clear.

<div style="text-align: right">

Christopher Tunnard
Director of Planning Studies
Yale University

</div>

PART 1 IN SEARCH OF A CITY

THIS IS THE CITY

"All things to all men." Of course. You may work in a factory and I in a Gothic tower; our paths may never cross; we each have our own city, and yet we live in the same place. Even people who do the same kind of work have their private cities: Somerset Maugham was often to be found in the Palm Court at the tea hour, while Jean Paul Sartre expressed his preference for the Third Avenue bar. Rome, Paris, London ("a roost for every bird"), New York, Naples, Marseilles, Edinburgh, and Chicago: the meaning of these names to different people would be an endless recitation.

And yet: "I am a citizen, not of Athens or Greece, but of the world," Socrates is supposed to have said. And "This is the city, and I am one of the citizens," wrote Whitman. "What-

1

ever interests the rest interests me: politics, wars, markets, newspapers, schools, the mayor and councils, banks, tariffs, steamships, factories, stocks, stores, real estate and personal estate . . ." Here is no private place, but the universal city, an archetype. Can it be described?

Perhaps the city can only be experienced, but a few things may be said. First, the city is here to stay. It is, as will be pointed out, constantly changing—cities of men are like the endless succession of pebbles on the shore, Emerson observed—but it is first of all an economic fact. We live today in an *urbanized* economy, not an agricultural one. In the foreseeable future there will be more urbanization, not less. Urbanization has become such an influence that the word we use to describe our highest aims is *citizenship*. The process is advancing at such a pace that before long there will scarcely be any countryside untouched by urban influence. This is happening all over the world, but nowhere has it happened so drastically, so speedily, or with so little reckoning of the consequences as in the United States.

This was not true in our early days, when the American economy was rural; but even then there were certain strains which forecast our present day community patterns. Jefferson's friend, Count Volney, observed them in 1795–97, when he recorded this quaint picture of life on the frontier:

"The slow and taciturn American colonist does not get up very early in the morning but once up he passes the whole day in an uninterrupted chain of useful jobs. Even at breakfast time he coldly gives orders to his wife, who accepts them timidly and unresponsively, carrying them out automatically. If the weather is good he goes out and ploughs, chops down trees, or encloses land; and if the weather is bad he takes stock of the house, the barn, fixes the doors, the

windows and the locks, downs his tools and then builds tables or chairs and gives himself to making his house safe, comfortable, and clean. Once having everything as he desires it, he will sell the farm to go ten or twenty miles from the frontier to start a new one. He will pass years at chopping down trees, at first building a hut, then a stable and then a barn and then he will clear the land for sowing. His ever patient and serious wife will help him. They will sometimes go for six months without seeing another's face, but at the end of four or five years they will have conquered a piece of land which will guarantee the family's existence."

But the frontier was composed of many types:

"The French colonist, on the other hand," Volney goes on to say, "gets up early in the morning, if only to boast of it. He discusses the day with his wife and takes her advice. It would be a miracle if they always agreed. His wife comments, checks and dis-

1. A "Clearing" (Columbus, Ga.) c. 1828.

agrees, and the husband insists or gives in, becoming angry or discouraged. Sometimes the household becomes too much of a burden, so he takes his gun and goes off on a hunting trip or goes visiting with his neighbors. Sometimes he stays at home, and passes the time talking cheerfully, or quarreling and complaining. To visit and to talk are such a pressing need with the French that all along the frontier of Canada and Louisiana not one colonist of this nation can be named who lives out of range and sight of another. In a number of places when I asked the whereabouts of the furthest settler I was told: 'He's in the desert with the bears— a mile from anywhere *without a soul to talk to!* ' " [1]

The need for community was always strong, in spite of this picture of the American pioneer, and it is probable that the first American woman's club met during his absence one day in the fields. In fact, Americans much earlier than this had banded together in cities, and the land ten or twenty miles beyond our slow and taciturn farmer was in all probability already owned by a Boston banker. When Jefferson wrote his famous dictum on the virtues of an agrarian democracy, it was already too late. The industrial revolution had begun. "It revolutionized the history of the United States and its locus here was in the eastern cities. It is in these cities, then, and not only on the frontier that we must seek the new forces in America and the source of change in American life." [2]

The city has been with us ever since, growing in importance with the second railroad age after the Civil War and dominating our lives with the twentieth century. It is therefore to the urban areas where over 70 per cent of our population now lives that we must turn for our evidences of American culture and for our understanding of modern man. [3]

Here we run into a confusion between the concept of the city and what the city really is. Our modern picture of the city-dweller is over-romanticized, untypical. We think of the city and Broadway comes to mind, with its crowds of strangely-assorted wanderers desperately seeking entertainment, or we think of Elmtown at the corner of 4th and Main, inhabited by lounging corner-boys or teen-agers at the soda-fountain. It is true that Broadway offers a fascinating picture of New York life, but it is a picture so unique as to be quite useless in any attempt to define the modern city-dweller. The columnist, the divorcée with her toy Pomeranian, the patrons of the bar, the actresses, the servicemen, the visitor from Topeka who has come to stare . . . all these add flavor to the view, but it is a musical comedy scene that appears before us. Neither are our towns exclusively the haunts of youth, delinquent or otherwise, in spite of youth's predominance in the movies and in the magazines.

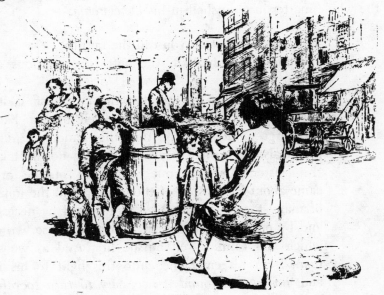

2. "On a Side Street in New York."

In reality, the city consists, as with certain exceptions[4] it always has, of hundreds or thousands of a unit which we may call the *family group*. Not the statistical American family, perhaps, of father, mother and one and a half children, but a looser, changeable confederacy of dependents, grandparents, in-laws, cousins, boarders, and visitors, who live under one roof or in one dwelling unit at a given time, and add the spice of reality to family living. It is this unit and its relationships to other units by kin, acquaintanceship or mores, which gives life to the city; it is this unit which, in spite of dire predictions as to its break-up by sociologists and clergymen alike, still "resists the dissolving forces brought to bear on it by the ever increasing separation of the processes of production and consumption,"[5] and to which our institutions, social and economic, owe their continuing forms.

Leon Battista Alberti, that admirable humanist whose social theories deserve as much attention as his esthetics, puts the whole matter in a nutshell in his *Deiciarchia:*

> "*Giovanni:* What do you call the family?
>
> *Antonio:* The children, the wife, the relations and servants . . .
>
> *Battista:* It seems to me that the city, just as it is made up of many *families*, is itself almost like a very large *family*. And on the other hand, the *family* might also be a small *city*. And if I am not mistaken, the existence of the one with that of the other came about for reasons of the coming and the joining of many together, assembled and bound by necessity and by profit. The necessary things are those without which you cannot well pursue life. And as we see, man, from his emergence into this light to his last end, *has always found it necessary to turn to others*

for help. But then cities were created for no other reason than for men to live together in comfort and contentment." [6]

It is important that we speak of the family here, because the whole physical structure of the modern city is based on it.[7] The shape of the city is not conditioned by voting districts, department stores, amusement centers or traffic arteries, but by the homes of American families. The movement to the outskirts, the whole decentralizing tendency of the contemporary city is not a movement of individuals, bankers or factory-workers, it is a movement of *families*. When they move far enough out, the churches, shops and even the industries which are not tied to the center, follow them. When the growing number of families was denied accommodation in the center of our cities by frozen land values or in the older residential districts because of obsolescence, they moved out to cheaper land, fresher air and healthier conditions (*pro tem.*). Before the turn of the present century, the New England philanthropist Robert Treat Paine thought he had solved the housing question by advising the families of workingmen to take advantage of the trolley car and move out to the suburbs. They did so if they could. The old run-down central areas are still kept filled by in-migration, but they are evacuated by people who have scraped enough together to be able to move. In the 1930's, to follow in the footsteps of Theodore Roosevelt and Jacob Riis in their earlier walks through New York's East Side, would be to find, not as they did—dead horses and teeming humanity in the streets—but row after row of boarded-up tenements, empty and silent, among the centers of heavier population. An acute housing shortage has since filled up these insalubrious holes, but tomorrow their occupants may move to what is now a potato patch far out on Long Island or a cow pasture in New Jersey.

7

If anyone should doubt that the family is the determining factor in the city pattern, let him examine the figures of the United States Department of Commerce which show that at the mid-century the non-farm mortgage debt almost equaled the long-term corporate debt of the United States and has actually since surpassed it.[8] This indicates urban home-buying and building on a scale never before seen. It shows that the urban family is thriving, despite rising prices and extraordinary inadequacies in the city's facilities and conveniences. It shows that we are more than ever a nation of families, not of glamorous guys and dolls. Let us at once get rid of the idea that the city is a non-family society of misfits who have left home, of hall-bedrooms and flop-houses, by citing the late-lamented American humorist Robert Benchley who asked his readers to imagine what he did on his first night as a young man in wicked and glamorous Gotham. "I went to a church social," said he.

The city is then, regardless of type or configuration, a changeable but continuing society, which is largely made up of households or family groups, its geographical area being restricted by comparison with the population it contains. As contrasted with rural areas it grows continually in importance—on farm and in hamlets it is the city's television that is watched, the city's newspaper that is read. In spite of the continuing authority of state governments we are tending toward the creation of a new type of city-state, with some rare open country in between. The mechanization of farming is pushing people faster and faster off the land, according to Warren Thompson, who points out that nowadays only 15 to 18 per cent of the population need be engaged directly in agricultural work.[9]

This does not mean that towns and villages will disappear; far from it. Their physical structure will remain, but their functions are changing rapidly. "The pattern of village

life had its woof severely pulled about by the agricultural and industrial revolutions; but the coming of the internal combustion engine has ripped the warp right out of it." Evidence of change are numerous, but the change in educational locus from the village to the regional school or the fact that a large part of the population of the village may work elsewhere[10] are signs of the loss of social and economic autonomy. In fact, the town and village are being subjected to the same irresistible pressure as the cities, to a new form of economy which, because it is not clearly envisaged, leads to a futile resistance on the part of many who are loath to see the old things change.

It is significant that the word "economics" originally meant the science of managing a household. Perhaps there is still an important connection between the family and the work of the nation, as there was in Aristotle's time:

> "The primary partnership made up of several households . . . is the village . . . The partnership finally composed of several villages is the city state [polis]; it has at last achieved the limit of virtually complete self-sufficiency, and thus, while it comes into existence for the sake of life, it continues to exist for the good life. Hence every city state exists by nature . . ." [11]

Aristotle also tells us that:

> ". . . in point of self-sufficiency the individual is surpassed by the family and the family by the state [city state] and in principle a state is fully realized only when it comes to pass that the community of numbers is self-sufficing.[12]

He is explaining that human needs are to be satisfied better in the city state than elsewhere, and in spite of the fact that his city state is small and many of our communities are large, the

9

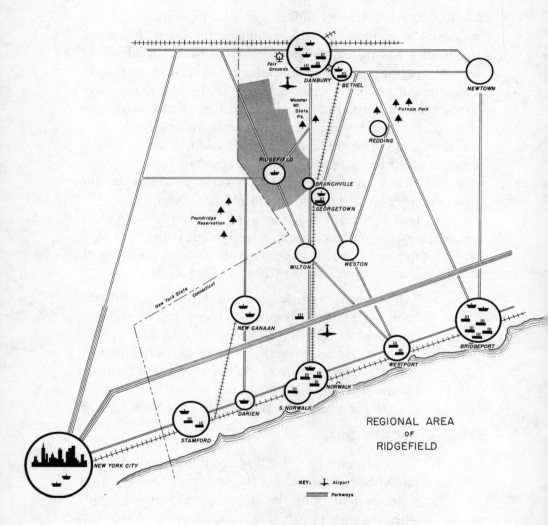

Diagrammatic map from the Yale-Ridgefield Case Study, showing other communities on which Ridgefield is dependent for some of its shopping, recreation and working facilities. In the case of employment, it was found that 58% of those asked still worked in Ridgefield, 17% in New York City, 4% in Danbury, 2% in Norwalk, 1% in Bridgeport and 10% elsewhere. 8% of those questioned did not answer.

basic needs have not altered greatly. There is a much greater degree of specialization today, but the social and working unit is still the household. For instance, the status of women has changed so completely that of the 102 million women over 14 years of age in the United States 29 million are gainfully employed[13]. This does not mean that they were all living as career girls in bachelor apartments. With certain professional exceptions they were living at home, with parents, husband, or other relations, and contributing to American family resources by their earned income and experience. People travel miles to work, live in unsatisfactory dwellings, injure their health and suffer worse penalties in order to keep their homes together; they are searching for a decent life in urban surroundings; seldom do they find it. The art of urbanism should be practiced to enlarge experiences like these, to make possible the community satisfactions that Aristotle thought a "coming-together" could provide. This is the aim; and it is not to be obscured by those who look on the city exclusively as a market place, a passageway or a sink of iniquity which must at all costs be destroyed.

We find then that the city is composed of families; we must now ask why they are there.

They are there today because the town or village is not enough, or because the town or village has become a city or come under the influence of a city. And because of this their lives are different. If, as the medieval encyclopaedist, Brunetto Latini, observed in the 13th century, a city is nothing other than the people assembled under one law and one government, there remains the fact that politics and law have undergone significant changes since the city became important.[14] Rural *custom* becomes *law* in the city—in fact our entire legal and moral code stems from man's coming together in cities. The *jus civile* of Rome as well as the law of the Greek states

present a combination of legal rules which depend on one dominant factor—the nature of the city commonwealth.[15] While the law of Rome gradually became the law of an empire, losing its municipal conception, the less familiar law of the Greek states existed on the plane of the city. English common law also took its final shape there.

Men have also come together in cities in order to worship, and in doing so have cemented the city more strongly. Religion has actually created cities. A temple was built in Jerusalem . . . "and, behold, I purpose to build a house unto the name of the Lord my God," pronounced Solomon before Hiram, King of Tyre; "Now therefore command thou that they hew me cedar trees out of Lebanon." Only when banded together in numbers could men build temples fitting for their gods—Jerusalem's temple, the Acropolis at Athens, the Roman Capitoline. There was the sacred hearth fire and the family hearth fire, the prytanea of the Greeks and the Vestal fire of the Romans. Only cities could support the caste of priests

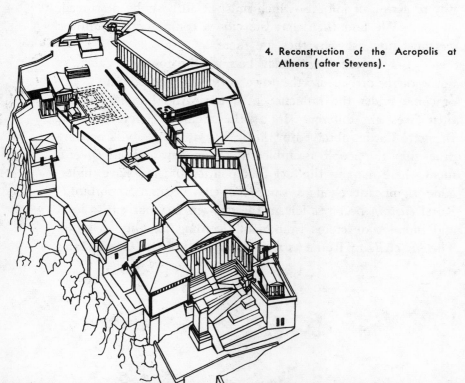

4. Reconstruction of the Acropolis at Athens (after Stevens).

necessary for the multitude of rites that evolved as religious ideas proliferated. Looking for important cities in the late Roman Empire, we turn to those which had bishops. Some of them, like Canterbury and York, are no longer important, but even today the Primate of All Gaul is the Archbishop of Lyons, not of Paris, because Lugdunum was once the greater city. One of the important dates in the early history of Venice is the year 774–775 when the island of Olivolo was raised to an episcopate.

The great American cathedrals and temples are all to be found in urban areas. It is hard to remind ourselves of the role of religion in creating American cities since the church steeple has been dwarfed by taller buildings. A visit to Charleston, where until quite recently the skyline was still punctured by religious towers alone, is salutary; and we have Cooper's description to remind us that every city was once dominated by the house of God. "New York is rich in churches, if number alone be considered. I saw more than a dozen in the process of construction, and there is scarce a street of any magnitude that does not possess one. There must be at least a hundred and there may be many more." [16] But in spite of the structure of

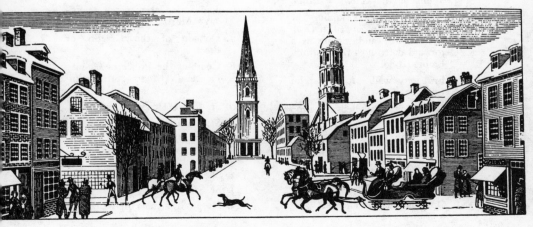

5. Wall Street, New York City, about 1800. The skyline of the pre-industrial American city dominated by the house of God.

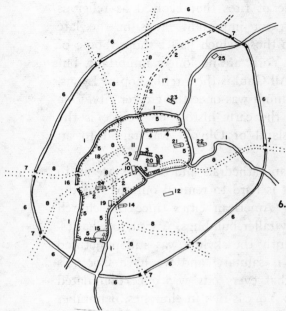

6. Analysis by Professor Ganshof of the plan of Bruges by Jacob van Deventer illustrated in Plate (2) showing the origin of the medieval city in the castrum and its development in the commercial suburb outside.

1. Natural waterways

2. Natural waterways which disappeared before the 14th century.

3. Walls of the county *castrum*.

4. Artificial waterway joining the Rije to the Vuldersreiken (Fullers' Brook) and serving as a forward defense to the *castrum*. Before 1089.

5. First city wall, probably prior to 1089.

6. Second city wall between 1297 and 1300.

7. Gate with bridge.

8. Streets.

9. Grand Place (market).

10. Covered markets.

11. Open landing and market.

12. Abbey.

13. Hôtel de Ville.

14. Notre Dame.

15. Convent.

16. The Sand, later known as Friday's Market.

17. Domain of the Knights of Praet.

18. Court of the Prince of County Palace (14th to 16th centuries).

19. St. John's Hospital.

20. St. Donatiaan.

21. St. Walburgis.

22. St. Ann.

23. St. Gillis.

24. St. Salvator.

25. Hospital of the Poterije.

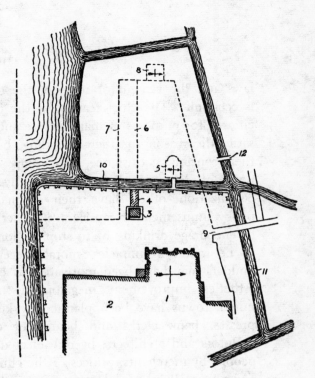

7. The Evolution of St. Mark's Square in Venice.

1. The Chapel of St. Mark, private chapel of the Doge. Placed on this site in 827 as a sepulchre for the body of St. Mark stolen in Alexandria by two Venetian merchants. It became a cathedral in 1807.
2. The Doge's Palace. The first building on the site was a fortress or keep built outside the city walls in last quarter of the 8th century.
3. The Campanile. C. 890.
4. Wall joining the Campanile to rampart which is presumed to have been extended beyond the city walls to enclose the first square.
5. SS. Geminiano e Meno. C. 810.
6. The Procuratia of Doge Sebastiano Ziani (1172–1178). Doge Ziani left a portion of his immense estate to the Chapel of St. Mark, allowing the Procurators (trustees or vestrymen) of the Chapel to extend the limits of the original square.
7. The New Procuratia. The building line was fixed by Jacopo Sansovino in 1537 when he designed the Library and placed the northern facade of the Library away from the Campanile. The New Procuratia, designed by Vincenzo Scamozzi, was begun in 1584 and finished, after his death, by Baldassare Longhena and others around the year 1640.
8. Second St. Geminiano. With the extension of the square in the 12th century, the old church was destroyed and a new one built on this site. Sansovino redesigned its facade in 1557. It was destroyed in 1810 to make way for the Fabbrica Nuova housing a ballroom for Eugène Beauharnais.
9. The Entrance under the Clocktower (1499) to the Merceria, main shopping street of medieval and renaissance Venice.
10. Rio Batario or del Badoer, filled in when the first square was enlarged in the 12th century.
11. Rio del Capello Nero, a portion of which still exists.

laws and the cement of religion, the overwhelming influence is economic. The chief reason for the coming together in the cities is for purposes of manufacture and trade. It is not necessarily the reason for their founding, but it is the reason for their continuing existence. Cities have been founded for purposes of defense, religion, politics, hygiene, cooperation and colonization; others have their origin in smuggling, slavery, piracy, amusement or caprice. Still others have been established to encourage drinking or to stop it. Sometimes beginnings are to be found in miracles, moral precepts and dreams. City-builders may have been motivated by exploitation, emulation, esthetics, improvement, megalomania or the wish to be admired; towns have been planned by kings, dictators and empresses, bank clerks and boards of directors; by painters, sculptors and architects; by duly-elected representatives of the people; by merchants, princes of the church and pilgrim bands, and above all by speculators and gamblers. Whatever the reason for their establishment, if they have succeeded it is because of economics. In the rise of the city which occurred with the Middle Ages, as a result of what historians are now calling the Commercial Revolution, it was the merchant's settlement that ensured success. "If we follow the growth of the built-up area of significant cities during this first era of urban development, we will see that the commercial centers, wherever they existed, were the germ of the city. There is of course no question that during this period, other elements, already existing, played a part—such as the pre-urban core, or the agglomerations about abbeys and collegiate churches, but this part was largely passive. The vitality sprang from the commercial center." [17] On the edge of the *civitas* (the fortified government and church center), this authority goes on to say, or of the *castrum* (the fort proper) there formed a suburb which constituted the real urban core. It is no accident that the word *forum* comes from the (earlier)

forus, meaning "outside" . . . merchants and artisans established them outside earlier settlements and formed a market quarter. Even the finally magnificent Roman forum was originally a market square on the edge of the town.[18] St. Mark's Square which has become the center of all that we consider beautiful was in all probability a market place outside the earlier community of Venice, then called Olivolo, where the former cathedral still stands.[19] Its character changed very soon after the body of St. Mark was brought from Alexandria (827 A.D.) but the commercial note was never lost. It continued in the fairs held during the periods of carnival and until the nineteenth century the fish market was just around the corner.

8. Robert Barret's Camp, thought to be a source for American colonial plans like that of Savannah, Georgia.

American cities of the seventeenth and eighteenth centuries were mercantile creations. Mercantile aspects were not swept away by the industrial revolution; on the contrary they grew with the rise of manufacturing. If manufacturing placed its distinctive mark on our newer cities from 1820 until just recently, it is commerce in the form of wholesale and retail areas which has always provided the life-blood of cities like New York.

There were, of course, exceptions to the rule of Fortuna over urban areas. There have always been and still are special city types: government cities (Washington, D. C., Springfield, Ill., Raleigh, N. C., Augusta, Me.); university communities (Williamstown and Northampton, Mass.); resort towns (Miami, a city which has grown entirely with the present century); defense cities (Oak Ridge, Tenn., Richland, Wash.). Religious towns are still to be found in Europe (Loretto and Assisi) or cities which are entirely supported by agriculture (Vicenza and Mantua) which the Italians call *città di silenzio* (cities of silence) because they have no noise-making plants. Even so, such cities can change their base of existence in very short order, as they have been forced to do in the past—from pleasure to manufacturing, from war to peace. When the triumphant port of Venice found itself deserted by foreign merchants following the Portuguese seizure of the spice trade after 1500, she turned to manufacturing and became a leading exporter of silks, velvets, glass and mirrors. Nowadays there is a tendency for the urban pattern to become the same everywhere, largely due to the spread of mechanization and the twentieth century concentration of economic power. Your community may start as a health resort or as a manufacturing center, and each may arrive at a city economically indistinguishable from the other.

Take Los Angeles and Detroit, two large cities with contrasting experiences. "As people and wealth flowed into this

area (Southern California), manufacturing and other wealth-producing activities have developed also. In this respect the growth of Los Angeles has been quite different from that of the Detroit area, which has grown directly as the result of the development of manufacturers. Population was attracted to Detroit by the comparatively high wages paid by the motor industry. In other words, industry grew and drew population into this region; whereas in the Los Angeles area population and wealth flowed into the region, and industry followed in response to the market opportunities." [20] This growing similarity in the end-product is a mark of our civilization; products are standardized, communications are standardized; cities are becoming standardized. It is only people who are not yet stamped in one mold, and therein lies our hope for the urbanism of the future.

The city today is in the throes of another change, and it is enormously important that we should recognize what this change implies, because it means the economic triumph of the city over all other forms of living. The main characteristics have been (1) *Protection* (2) *Religious or Political* (3) *Mercantile* (4) *Manufacturing*. The fifth state, which we are now experiencing is called *Servicing,* and it is a direct result of the accumulation of households that the earlier states encouraged. R. D. McKenzie[21] was among the first to comment on the new phase. Colin Clark, until recently economic adviser to the Queensland government, has since examined the phenomenon further, hinting at a theory of the modern city which can now be developed as a result of his findings.[22]

Clark divides economic activity under three heads:

1. *Direct exploitation of natural resources:* (agriculture, pasture, forestry, fishing, hunting and trapping, mining and quarrying, hydro-electric power).

2. *Manufacture:* which may be precisely defined as the organized labor of a number of workers using mechanical power for the purpose of continually producing transportable goods.

19

(This definition thus excludes, for instance, the workshop employing only one or two workers, the dressmaker who does not use mechanical power, the builder whose product is not transportable.)

3. *All other activities*, which may be described for convenience as *Service Industries*. The principal service industries are building and construction, commerce, transport, education, public administration and the like.

The first group of industries, Clark goes on to say, must, by their nature, be carried on where the natural resources are located.

The manufacturing industries, on the other hand, producing by definition goods and using materials that are transportable can be carried on at a point, if desired, distant both from consumers and supplies.

The service industries, however diverse though they may be in other respects, all share the fundamental characteristic that they can, on the whole, only be carried on in the city where the consuming population lives, or at least at some center that the consuming population can reach without much difficulty. A community at any given level of average income expects to consume services up to a certain standard; if there is no city within easy reach, the inhabitants must either do without such services altogether, or rely on distant cities for wholesale trade, insurance, banking, specialist medical services or higher education.

A city cannot be said nowadays to be of optimum size until it can provide its own inhabitants and the inhabitants of the surrounding region with all but the most specialized of such services. Clark estimates the population of this city to be between 100,000 and 200,000 persons. In newer communities, where the manufacturing population is lower, a city somewhere within the 200,000 to 500,000 population range is necessary for the full development of manufacture.[23]

20

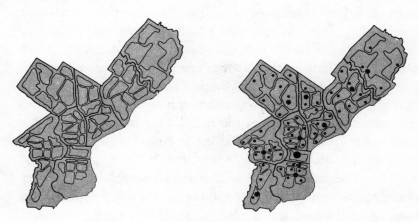

Proposed service areas and neighborhood centers from comprehensive plan of Philadelphia; at bottom left, service areas for each set of facilities; bottom right, neighborhood centers for each service area. Courtesy, Philadelphia City Planning Commission

We have already seen that cities discover new functions when their original economic purpose becomes obsolete. It is now apparent that the manufacturing city is, in its turn, giving place to one which includes manufacture but is also developing a servicing character; also, that this city must of necessity be of substantial size in order to function effectively.

Since service industry cities cannot be small in population, the territory that they cover, aided by present-day transportation facilities, is also not likely to be small. Fifty years ago, the service industry city could not have existed as a type; today it exists by virtue of accelerated migration to urban areas and the development of the automobile and trucking industry. The latter has made possible the growth of the metropolitan region—that sprawling agglomeration of cities, towns and villages which have lost their original identity to become part of a larger whole. Many of these areas are not served by railroads

21

which are indeed tending to disappear as servicing instruments; a witness to this fact is the number of commodities which are now carried by truck.[24] Most railroads continue to draw their chief income from carrying coal, which has been used in increasing amounts for steam-powered generation of electricity. However, in the middle of the twentieth century, far greater increases can be found in the use of two other fuels: petroleum and natural gas. Carried in large proportion by pipe-line, these latter two products do not depend on the railroad for transportation; it is thus not the railroad which has made possible our new type of city, but the internal combustion engine.[25]

The automobile has also made possible the peculiar shape of the service industry city by permitting the family to have its own home and garden on the periphery of the older centers. As we have seen, the service industries tend to follow this movement outward (decentralization) while new industries are also located away from the older centers. It is this movement which in our present initial stage of the service industry city accounts for the strange lack of personality or character in both the older centers and the newer suburbs—the one is losing life and the other shows a still uncoordinated form. "It might have struck you," observed Henry James many years ago, "that great cities, with the eyes of the world on them, as the phrase is, should be capable either of a proper form or failing this of a proper compunction; which tributes to propriety were (on the part of American cities) equally wanting." They have not achieved either form or compunction in the years between; at the same time the process of change which constantly alters their appearance while it has not improved their looks at least prevents their seeming static. The American community is not visually a standardized product like the American automobile. It may usually have its tallest buildings in the center and its smallest houses on the periphery—easily recognizable and re-

curring phenomena; it may use standardized building materials and motifs on banks and shopfronts, so that Main Street in an Ohio town becomes a model of Elm Street in Massachusetts; it may employ standardized fixtures supplied by the General Electric or the American Bridge Company. National advertising spells out Pepsi-Cola on billboards from coast to coast or in the sky; mobile America looks the same everywhere; dress is almost standardized. Neither can we look for many differences in plan, the gridiron having long ago triumphed over other forms.

The differences are by contrast subtle, and only sometimes spectacular. They are to be found oftenest in the setting, which sometimes dominates and frequently changes the whole character of cities. To realize this, one has only to see the north-western community of Portland, with Mount Hood commanding the urban view, separated from and yet a part of the city; or the mountain copper towns where man and his works are rendered insignificant by nature; or a city of the plains country, where one's apartment on the edge of town may look over miles of cornfields and the surroundings are known before they are seen; or a New England manufacturing town, so green with trees that from above it seems more forest than community; or a southern city, sweltering in the humidity of a languorous atmosphere where moss-draped oaks and water cypresses invest the scene with fantasy.

It can be argued here of course that such differences are not confined to the United States, and that they occur in other even narrower zones . . . the contrast between Berne's setting and that of Clermont-Ferrand, both regional capitals, is quite as strong as that between Denver and Tulsa; but in America this diversity of setting is important because it throws the search for comfort and the familiar into sharp contrast with the organic fact of unchanging nature.

23

9. The Coming of the Service-Industry City. The Evolution of New Haven.

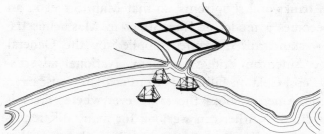

1. Established in 1638, and one of the earliest planned communities in the American colonies, New Haven consisted of nine squares, the central one a common square or green which has been preserved to the present day.

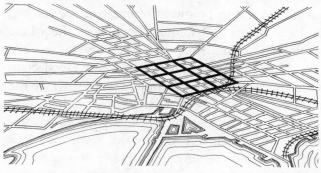

2. Early industrial development and the coming of the railroad create a spider-web pattern of streets, added to the original squares, which have been cut through with new streets to provide more frontage for expanding commerce.

Within the city the ground plan is immediately recognized. Nothing is accidental, few streets will run askew. Dissatisfied with familiarity we look up, and here the skyline, which Ruskin considered so important in any city, transforms the view. A broken line, blank side-walls . . . windowless in anticipation of a neighbor that never came, huge signs on steel frames, the pencil form of taller buildings, a wisp of black smoke or white steam, an over-all tone of grey if the structures rise to any height. Not the grey, blue and whitish-yellow of Paris, but darker anonymous grey with an occasional brick-

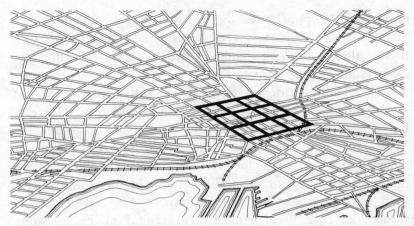

3. The automobile age and the expansion of suburbia, with its new centers of population and services, creates a pattern typical of American cities of about 200,000 population.

4. In anticipation of service-industry development, the city prepares a plan to provide easier circulation for trucking and automobile traffic. The over-all plan of the city, which began as a mercantile grid, thus becomes radio-concentric in character, insofar as the harbor and topographical features permit.

25

faced building, punctuated by the flash of glass in sunlight. At night, the tall buildings of the central city glitter with electricity, the rhythm changing as late workers leave and the cleaners move from floor to floor.

These accidental views are a source of pleasure, and all the more because the whole city is rarely seen in silhouette. Exceptions are places which can be seen across the water, like Miami, San Francisco, some of the Mississippi river towns and New York; or cities which can be seen across the plains. Sometimes a New England town will rear up in the distance, seen from a motorway, as for instance Hartford the state capital of Connecticut, or Bethlehem a steel capital of Pennsylvania, lying visible in a bowl. And sometimes . . . but it is a rare prospect . . . within the city's grid, a street may cut clear to the horizon, to stir the imagination strangely, or widen out to encompass the waters of a harbor or a lake.

To find other aspects of the picturesque in the American city one must be a student of human relations, or else . . . and this is the architect's task . . . journey rather widely in search of a few rare treasures, to some unguided spot where suddenly the city becomes something more than commerce and takes on special character. The situation is usually fortuitous but there is always some element of order present wherein the seeds of urban beauty seem to lie. It may be the "air-bridged harbor" of Manhattan seen through the pearly mists that soften every contour; or a street of brownstone fronts in Brooklyn, punctuated by a startling church of the 70's, whose terra-cotta facing and rose-purple glass strike uncompromising Calvinism into the rows of French detail. Or it may be one of the few entirely ordered complexes, now disappearing, such as Mount Vernon Place in Baltimore where the monument to Washington by Mills proudly avers the great period in American culture when all the arts were one. Or it may be a city's fringe, where the naive gardens and unarchitectural houses of those who

supply the central markets offer the stimulus of a loudly colored folk art, making the timid inner suburbs seem pale and sickly replicas of a monument called Taste.

These are all fragments . . . scenes that the painters have sometimes caught in their search for the picturesque, carefully selected visions from the broad mass of the urban landscape. For every significant view there are miles and miles of insignificant building, until the eye is arrested by a Brooklyn Bridge, a lively street market, or a strange collection of building materials and window details that can be put on canvas or caught by the camera. The painters have made us see more clearly what is in the city by piquing our curiosity; they have not yet shown us the city that could be. A collection of urban scenes by Hopper, Shahn, Stella and Guglielmi gives rise to melancholy feelings.[26] This is due to the painters' special preoccupations; the American city itself is seldom melancholy, in spite of slums, smoke and paper-blown urban wastes; next to the Italian or the Mexican city it is perhaps the most active and exciting theater of life to be found in the West.

These impressions may be obtained without knowing anything of the economic and social forces which are shaping the contemporary city. Meanwhile, and in spite of the common error of describing the modern city as an ever-extending octopus which has "just grown" without rhyme or reason, it is important to realize that the city is being shaped by a new economic force—that our seemingly-anarchistic residential, commercial, industrial and highway patterns are its direct result; that they are no accident;[27] and that any attempts at urbanism must acknowledge this trend, which is still in its initial stages, or fail miserably in the common aim of achieving the good life. There is in fact a golden opportunity for society in the changes that are taking place. A better understanding of the city and the forces that are now shaping it should enable us to foresee possible future development and channel it into a constructive pattern.

CHAPTER **2**

THE HYDRA

If the city were only a working-place, a machine or tool for earning a living and making money, it would be possible to stop here in the search and suggest means of making it more efficient, less wasteful and fully productive—in short, to apply the principles that are used in operating a factory or managing a business. We would then be avoiding the main issue: in his search for the city man has looked for other things and has thought of it very differently in his attempt to master the environment. He has in fact linked the city with his noblest aims and hopes for civilization. The search thus leads us far beyond economics into the realm of social ideas.

From earliest time, the city has had such an attraction and fascination for man that he has given it symbolic meaning,

has made it a god. "The ancient poets animated all sensible objects with Gods and Geniuses," wrote William Blake in *The Marriage of Heaven and Hell*, "and particularly they studied the genius of each city and country, placing it under its mental deity . . ." Such a goddess was Athena, protectress of Greek cities, whose image, the Palladium, guarded the holy places of the city. The identity of the guardian deity of Rome was a profound secret, lest the enemies of the republic lure him away by prayers and incantations, as the Roman priests had themselves induced the gods to desert, like rats, many a beleaguered city. The ancient Assyrians were forbidden to mention the mystic names of their cities and even today the Cheremiss of the Caucasus keep the names of their villages secret from motives of superstition.[1] There was St. Mark for Venice, the Black Virgin for Cracow, St. John the Baptist for Florence, St. Erkenwald for London. . . . Italian cities, in particular, were portrayed and glorified by painters such as Veronese and in pride and affection were given special names: Venice, la Serenissima (the most serene): Genoa, la Superba (the superb one): Bologna, la Dotta (the erudite one): Florence, la Fiorente (the flowering one).

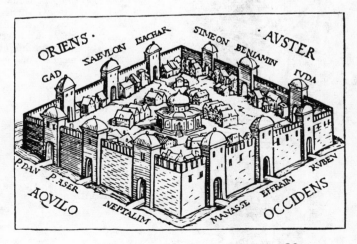

Jerusalem promised to the Jews by Ezekiel. A woodcut by Hans Holbein.

29

2. Gods and Symbols Connected with the City.

(a) The Palladium, ancient figure of Athena. The image was venerated by the Romans who were convinced that the life of the city depended on possessing it.

(b) Pallas Athene.

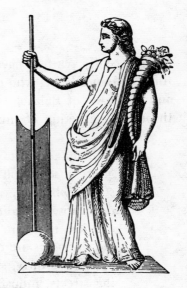

(c) Rhea, called the "Mater turita" because of her mural crown. In Asia Minor she was accepted as the protectress of cities.

(d) Fortuna.

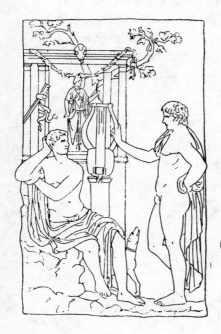

(e) Amphion and his brother, Zethus. The strains of Amphion's lute caused the stones of Thebes to fall into place without human labor.

More recently, writers have given special traits to cities. We think of James Joyce, who captured Dublin in its myriad facets, and especially of Balzac, who more than any other understood the urban gathering of humanity:

"There are certain streets as disgraceful as a man guilty of some foul action. Then there are noble streets, streets which are upright by nature, and young streets on whose morality the public has yet to form an opinion; there are murderous streets, streets older than old dowagers are old, respectable streets, streets which are always dirty, streets which are always clean, working streets, industrious streets, commercial streets. In a word, the streets of Paris have human qualities and by their aspect convey to us certain ideas before which we are helpless. There are streets of bad company where you would not want to live, and there are streets where you would gladly reside. Some streets, such as the Rue Montmartre, have a pretty head and then end in a fish's tail. The Rue de la Paix is a wide street, a big street, but it does not give rise to any of those thoughts, so graceful and noble, which surprise the sensitive person in the middle of the Rue Royale, and it certainly lacks the majesty that rules in the Place Vendôme . . .

". . . Paris is the most delightful of creatures: there a pretty woman, further on old and poor; here all new like the money of a new reign, and in that corner as

elegant as a woman of fashion. A complete monster besides! . . . What an active life this monster has! Hardly has the jingle of the last carriage returning from the ball ended in its heart than its arms begin to tremble at the outskirts, moving slowly. All the doors yawn, turn on their hinges, like the parts of a giant lobster, moved invisibly by thirty thousand men or women, each one of whom lives in a space of six square feet, has a kitchen, a workshop, a bed, children and a garden, who cannot see clearly and yet who should see all. Imperceptibly the joints creak, the movement spreads, the street speaks. At noon all is alive, the chimneys belch smoke, and the monster eats; then it roars, and its thousand feet move. Beautiful spectacle! But, ah, Paris! He who has not stopped in admiration in your dark passageways, before your glimpses of light, in your blind alleys deep and silent, he who has not heard you murmur between midnight and two in the morning, does not know your true poetry nor your strange and vast antitheses." [2]

Valéry Larbaud lingers affectionately over the cities—"J'ai des souvenirs de villes, comme on a des souvenirs d'amour;"—Kipling makes them sing their own proud songs. Henry James couples his fascination with faint evidences of alarm—New York is "a bold, bad beauty" and Boston has been ruined by its shopkeepers. Perhaps with James the border line is reached.

For there is another image in the frame, like Judas

darkly seen behind the figure of Christ. Cities, to some, have been strumpets, whores and monsters. Listen to Isaiah calling down a curse on Babylon and recall the images of Sodom and Gomorrah. American cities above all have not escaped the flagellation:

"I view great cities as pestilential to the *morals*, the *health* and the *liberties* of man," wrote Jefferson in 1800.[3] Why did the most understanding of American presidents adopt this point of view? It is important to find out, since hatred tends in our moderns to become denial of the city and denial effectively prevents all continuation of effort for improvement.

Taking Jefferson's grounds for condemnation in reverse order, let us examine the sources of dissatisfaction from which they spring. First, *liberties*. It was Aristotle who praised the small farmer and the herdsman as the guardian of democracy, just as Jefferson pinned his hopes on the agrarian democracy of his day; but why were the artisans, the market-people, and the wage-earners condemned? Aristotle condemned them because their occupations were mean and because they coveted their neighbors' goods—here the Greek aversion to foreign traders must be taken into account. Jefferson did not believe with La Rochefoucauld and Montaigne that 14 out of 15 men were rogues, but he had had ample opportunity to observe the city as an instrument of political power. Much earlier, a French feudal lord of the 13th century saw in the city an instrument of royal prerogative as did an English baron or a German knight. When the Valois and the Plantagenets warred, they obtained the aid of commoners by granting them privileges.[4] Royalty often found cause to grant liberties and privileges to the burghers, principally because the towns were sources of royal revenue. Henry IV, a convert to Catholicism, thought Paris "was worth a mass;" by winning it he ruled France.

Yet even to royalty the city had other faces. Louis XIV would never live in Paris because of childhood memories of the

3. An American Armory of the 1890's. The Armory of the 71st Regiment at 34th Street and Park Avenue, New York.

revolt against royal power in the Fronde. He knew what it was like to escape in the dark and sleep on a bed of straw. The screams of a Paris mob echoed forever in the ears of Madame de Pompadour after she had visited her little daughter in the Convent of the Capucines. The whole drama of the French Revolution took place in the heart of Paris. Even later, the straight streets planned by Baron Haussmann for defense by the soldiery of Napoleon III could not prevent the Commune. The Russian Revolutions of 1905 and of 1917 were pivoted on St. Petersburg. In America, it was the great strikes of 1877 that sprinkled her cities with armories and after the strike in his company town it was the fear of urban ghouls that caused George Pullman to make a will ensuring that his coffin be encased in steel and asphalt.[5] American cities have been noted for their radical movements; they have always been pointed at as sources of corruption by up-state senators and although the state machines have never been lacking in the taint themselves, the states enjoy far more "freedom" than the cities, especially in taxation and borrowing powers, by feeding the fears of urban corruption and radicalism in the rural areas.

Tied in with political hatred of the city is the economic. The city is the home of the capitalist, the banker, the money-lender, the middleman. Cities have often been located at breaks in transportation, from water to railroad, or from one railroad to another (Buffalo, Richmond, Chicago, St. Louis) and there the middleman exacts his commission. It is the banker who holds the mortgage on the farm and he is preeminently a city-dweller. Consider the symbol of Wall Street, LaSalle Street, State Street, of the Paris Bourse or the London stock exchange, of the Behrenstrasse in Berlin. Note the devilish pains taken by those who fan the flames of racial hatred to identify the Jew with cities. How many times have we heard the expression "a New York or a London Jew?"

36

Second, *health*. Did not Boccaccio's *Decameron* spring from the Scourge of God upon the cities, the plague of 1348 that forced its author to flee with a group of youths and maidens to a villa on the outskirts of Florence? The cities have always been centers of pestilence, urging some like the evangelical reformer Lord Shaftesbury to call for "a new fire of London to sweep away all these filthy regions that must be destroyed." Yet it must be remembered the greatest of our humanitarian institutions, the hospitals, are in the cities; from the day that Henry IV planned the Hôpital St. Louis they have often been

4. The Hôtel des Invalides in Paris, an early veterans' hospital.

the pride of our public service, and to them must journey everyone from rural parts needing special care. We have had our eyes fixed on the city slum, the home of crime, disease, poverty and death. Since Appalachia we have begun to realize the extent of the less spectacular rural slum; to read Rölvaag's *Giants in the Earth* or Willa Cather's *My Antonia* is to discover the rural slum which was the frontier of the 1880's. In both city and country the specter of crime and disease takes flight with better living conditions and proper housing; the slum is indigenous to neither region.

Lastly, *morals*. Among the reasons for the hatred of cities, it is the moral note which overshadows all, as man recoils from the evil he has caused. No single source has been more influential here than St. Augustine's *City of God*; the good Bishop of Hippo's poetic description of the two cities—the

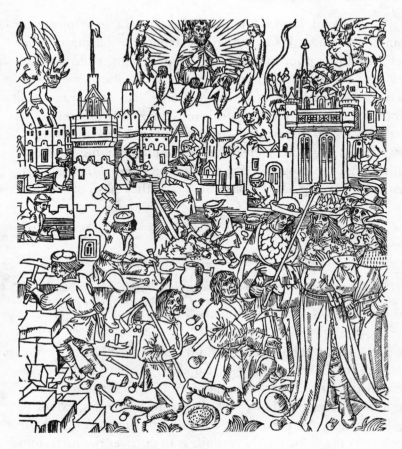

5. The City of Man being destroyed by Devils.

earthly city founded by Romulus who stained it with his
brother's blood (just as Cain, "the first founder of the earthly
city," had murdered Abel) and the city of heavenly hope where-
in all man's treasures must be stored up—were part of his mes-
sage for the building of the Church in Rome. Rome for St.
Augustine was the symbol of vanity in material things (had it
not fallen into the hands of an enemy in 410 A.D. for the first
time in a thousand years?), but it is curious to find that his

book, a prime instrument in building the Church, thereby created in the 16th century a new City of Man in Rome which is and remains the glory of the Western World. The East has Peiping as its mecca of architecture, South America has Cuzco, the West has Rome. The City of Man has its glories, yes, even its virtues, and we should not be so concerned about our environment if it were not also a symbol of our aspirations here on earth.

Again and again the note of immorality is struck. Rousseau was violent in his dislike of Paris—"I saw nothing but dirty and stinking little streets, ugly black houses, an atmosphere of filth and poverty, beggars, carters, menders, and hawkers of tea and old hats."—It was he who encouraged the romantics in their desire to escape from the city's clutches (see Chapter 8) and, earlier than they, Jefferson was one of his readers. Certainly the Romantic Age condemned the city; it was of course an arcadian nymph that possessed its imagination; but a late product, William Morris, hoped actually to destroy the city and rebuild it as a country village:

> "Forget six counties overhung with smoke,
> Forget the snorting steam and piston stroke,
> Forget the spreading of the hideous town;
> Think rather of the pack-horse on the down;
> And dream of London, small and white and clean,
> The clear Thames bordered by its gardens green;" [6]

Morris describes Trafalgar Square as "a great space surrounded by tall ugly houses, with an ugly church at the corner"—(this is Gibbs' masterpiece, St. Martin's in the Fields)—"and a good many singularly ugly bronze images, one on top of a tall column"—(the Nelson monument). He contrasts this rancid view with the same square in 1962, now planted with an orchard of apricot trees, in the middle a painted and gilded little refresh-

ment stall (ah, the merrie, merrie England of Chaucer's time)
and a long street planted with old pear trees leading down to
the dung market (the aging Socialist's proposed use for the
Houses of Parliament.) [7]

It is noteworthy that America's best known economist
Thorstein Veblen, a figure whose influence on American social
attitudes should never be underestimated, visited Europe espe-
cially to see William Morris. A son of the Wisconsin farmland
where the Norwegian language and an antipathy to the Ameri-
canizing influence of the city prevailed, Veblen saw the history
of civilization characterized by a conflict between the predatory
and the industrious. His later works suggest a system of pro-
duction and distribution controlled by engineers or technocrats,

6. The picturesque small market place proposed as a
model for early twentieth century city planning by fol-
lowers of the Garden City Movement.

7. The first Garden City, Letchworth, England, 1904. Designed by architects, its plan shows the influence of the Pan-Hellenic Beaux Arts Revival, then in its first wave of popularity.

but it is his idea of beauty, which did not admit of style or simple pleasure, which is significant to the urbanist. The useful and the unadorned were to him esthetically most pleasing, and his comment on the tenements and apartment houses of New York, a city of conspicuous waste, reveals his attitude: "Considered as objects of beauty, the dead walls of the sides and backs of these structures, left untouched by the hand of the artist, are commonly the best feature of the building." [8] How well does Veblen fit among the group of late-nineteenth century intellectuals who deny all innocent vanities or in fact any

pleasure in life unrelated to the useful; how often is he echoed to the present day in the denial of any taste which is "non-functional" or "wasteful"; and how violently contrasts his esthetic with that of that very practical architect, Claude-Nicolas Ledoux, "le luxe vivifiant, ami nourricier des arts," or with that of our own Cooper, who said: "Your lover of political economy should not affect to despise the labors of the chisel and the pencil."

The city and the machine were synonymous to reformers of the late nineteenth century. They had seen the human degradation caused by the factory system, and because manufacturing had created an urban population, the city was to be condemned. Thus, Ebenezer Howard in proposing his Garden City starts with the assumption that the city is evil, contemplating the destruction of London with feelings of pleasure. He assumed that the migration of Londoners to his new garden cities would bring about a catastrophic fall in land values, precipitating a crisis in municipal finance. Then London would be rebuilt, not as a series of villages (unlike Morris, Howard considered the machine a necessity) but as a group of garden cities—with a fifth of the population of his day.[9] A weakness of many other theories of ideal cities, hatred always breeds inadequacies such as Howard's and an inability to face the urban reality. Even those who are dedicated to reform of the city as it exists have not always escaped the poison, if the soulless unimaginative blocks which sometimes pass for housing projects can be counted as evidence of what government officials and reformers consider the city-dweller deserves.

The pointing finger of morality may advance from a guilty hand. We, too, shall not be blameless if aversion to the city and all its works leads us to deny it the possibility of existence. Where in the contemporary world does this attitude persist and in what form?

We are told that:

"In the close quarters of the city, perversities and evils spread more quickly; and in the stones of the city, these anti-social facts become imbedded."

"To look at the plan of a great City is to look at something like the cross-section of a fibrous tumor."

"In these tentacled cities life is madness. Men move seated about their cities, in trams and underground railways, in cars and suburban trains, living a disordered and demoralizing existence. It is a new slavery. The wars were but explosive crises of revolt."

"The city today is still profoundly menaced . . . by an evil shaping within itself. This is the evil of the machine."

"Left alone in the city desert without neighborly contact, people's minds are dulled and their growth stunted." [10]

All these statements show a unanimous dislike of the city, their authors exhibiting an unwillingness to find any compensating virtues, judging by all that they have written and practised. The attacks are becoming more violent, the reasoning vaguer. The city as an evil is accepted without criticism. Some unimpeachable authority had made it possible for this fact to be stated and agreed with by a generous number of readers.

It would be misleading to return to Rousseau or to William Morris for the philosophy which prophesies the doom of the great city and which exerts so strong a fascination for the intellectuals, educators, architects and city planners who have been quoted. The shadow of the twentieth century "synthesizer" looms much larger in their thinking. Some have buried him in their subconscious, for he is to them as sinister an in-

fluence as the city itself, but they could not but be drawn to his theory; nor could they escape it, for an extraordinary vogue in the 1920's disseminated his "biologizing" philosophy into popular thought.[11] To conjure up this strange figure—the necromancer of a Germany between two wars—is to reveal the source of the misdirection. . . . Oswald Spengler.

There is none of the charming poetical imagery of a Balzac in the prophet of doom. All the important characteristics of Spengler's approach to art and history have left their mark: 1. The "biological" approach to art: the birth, growth and death of architecture or cities; the ascendent period (culture); the period of decline (civilization); death. 2. The "wrenched" comparison (of a Doric column to Euclid's geometry, for instance) which comes from ascribing the same set of laws to all the arts and sciences, and 3. The notion of heroic destiny— a theory that enabled the Nazis to use Spengler as one of their chief apologists: his announcement to the young, "Do not waste time with poetry, philosophy or painting. The past is dead. Orient yourselves toward that which is living. Develop in yourselves the primeval force which makes for greatness, which great men have used . . ."[12]

The biological fallacy, that of ascribing to inorganic forms the biological sequence of growth, maturity and decay, or of describing the arts in the scientific terms of evolution, has often been attacked. Thus: "After Brunelleschi the herald and Bramante the achiever, must come Bernini and the fall."[13] It is a false simplification. The events of history, and the creations of man, are not subject to the laws of human growth; but Spengler's formula is seductive and dies hard. So that when he describes the stone colossus Cosmopolis standing at the end of the life-span of every culture, with man becoming the victim of his own creation—the death-symbol in stone,—those who have swallowed his philosophy can only but agree that the city

must die and "the primary values of the soil return anew to take its place." We are then subjected to schemes for "green" cities, "organic" cities or "garden" cities, instead of stone cities where the roots of Being, according to Spengler, are dried up.

If the *Decline of the West* is accepted as a work of historical synthesis,[14] if the decline of Europe is analogous to the decline of the Roman Empire as Spengler and Toynbee would have it, if the arts of every period can be assigned to predetermined categories of growth or decay, then the way is prepared for the forced historical comparisons which enable us to dismiss certain periods of art or reinforce our moral prejudices against them. Recent architectural histories exhibit this tendency; we are told that modern architecture began with Ledoux, in spite of the fact that Ledoux and a modern architect had no common purpose in their work, or that the plan of a city may be fashioned after the branch structure of a tree. We are informed that the gilding at Versailles is a symbol of sinfulness or that the Baroque city plan is "despotic". It is assumed that

8. "The Drayneflete of Tomorrow" by Osbert Lancaster, incorporating the clichés of today.

the city is an "organism"; that it can therefore "die", which would be beneficial to civilization in general, and that it can be reborn in a form more desirable to the citizens of a "bio-technic" society.

Finally, if you accept the interpretations of Burckhardt and Spengler that decadence is part of a ubiquitous process of cyclical fulfillment, you may dismiss any period which seems to be one of decline, and if this period is your own, turn to self-expression in the arts regardless of the aid of history.[15] This turning-inward has led to the creation of architectural forms which have significance only to a small circle of admirers.

The Spenglerian approach to the city is not only false and unrealistic: it is guilty. The evil of cities is the evil of man, not of stone or concrete. Denial of the city *as it is*, and a refusal to see its virtues as well as its faults has led to an unreasoning, cynical attitude to its problems; in solutions sought outside the economic pattern or in the insect world of cells, efficiency and minimum standards. The solution which denies the city is not born of the artist's vision of Utopia; it springs from ignorance,

9. A cross-section of a wasps' nest.

anti-intellectual prejudice, or contempt for human beings. To-day this prejudice is fed again by talk of dispersal of the city for reasons of defense against atomic bombing. Spenglerians welcome a fresh arrow in the quiver, but the city will not be dispersed for defense reasons. No matter how great the advances in technology, in pre-fabrication, in highway engineering, in speed of transportation, people will gather to enjoy the significant contributions of urban life or the experience of being together. *City life* has a reality, it is tangible; it cannot be replaced by a substitute life in the fields. It has its pride of belonging, its pride of tradition, its pride of ownership. The fact that the city is getting bigger should not frighten us. There will be more problems, but there will also be more institutions, private and public, that we can build and enjoy in common. We must cultivate an interest in the city, conquer our prejudices and fears, and learn to understand the patterns that man makes there—the color in the streets, the jostle of a market place, the proud old houses, the quiet villas, the pageants and processions. Shall we dare destroy all this, even though we could? Can we perhaps not *learn* something from "the evil mass of stone and concrete" rather than sweep it away (how?) in order to build anew? Are there not points of departure which may be found by searching—places, streets or institutions which "men have admired all the days of their lives?" Are there not genuine, friendly customs, habits or occasions to inspire us in the city: customs which can be made more freely enjoyable by an understanding urbanism rather than the inverted type of planning which aims no higher than introducing the continental café? Instead of pinning our faith on those who have turned their backs on the city it would be wiser to encourage those who consider the city a challenge and to listen to those who have loved it. The search can only successfully follow the path of understanding. It is an uphill task, as we know from Pliny the

Elder, to bring freshness to what is old, prestige to what is new, to re-illumine with its first brightness that which is now dim— in effect to restore to everything its first significance. In America there is much already destroyed, much that is not worth keeping, but much, also, that is fine. The challenge lies in a promise —American cities are not barren deserts; they are still warm and plastic; they are the focal points of a nation in which "the chaos of a mighty world is rounding into form."

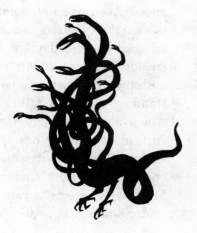

VISION AND REALITY

"And now come with me, for I have kept you too long from your gondola!

"Stroke by stroke, we count the plunges of the oar, each heaving up the side of the boat slightly as the silver beak shoots forward. We lose patience and extricate ourselves from the cushions; the sea air blows keenly by, as we stand leaning on the roof of the floating cell. In front, nothing can be seen but the long and level canal bank. . . .

"Now we can see nothing but what seems a low and monotonous dockyard wall, with flat arches to let the tide through it;—this is the railroad bridge, conspicuous above all things. But at the end of those dismal arches

there rises, out of the wide water, a straggling line of
low and confused brick buildings, which, but for the
many towers that are mingled among them, might be
the suburbs of an English manufacturing town. Four
or five domes, pale, and apparently at a greater distance,
rise over the center of the line; but the object which
first catches the eye is a sullen cloud of black smoke
brooding over the northern half of it, and which issues
from the belfry of a church.

"It is Venice."

Like the view of distant mountains, there is always
promise in a city seen from afar. A promise here amply ful-
filled; the Ethical Observer will not rest until he has shown us
Venice stone by stone, until we have learned the history of
each stone, until finally the stones themselves are telling their
own story. Wars, politics, trade, manners ancient and contem-
porary, the arts of architecture, painting and decoration are all
explained in terms of the town itself; the journey takes the
better part of a long life and many volumes; it occasions perhaps
the greatest passage in the literature of cities as the traveler
approaches the Cathedral of St. Mark. Where criticism appears—
and it is violent—the harsh words are tempered by the knowl-
edge of a love and understanding of the greater phenomenon—
the city risen from the waves, braced perilously on hardened
posts in clay and storing up through the centuries a treasury of
marvels for the future.

If today we see Venice, Amiens, Florence, Paris, Que-
bec or Ouro Preto more clearly, it is because they have been
seen. We are in debt to the observers of art and literature who
have made it possible for us to view with understanding the
phenomenon we call the city. The search thus is furthered by
observant eyes, but only when we have learned to use them
well. That which we see and record is our only basis for com-

parison; we cannot know how well we have done or where we have failed without the evidence of other hands.

There is another kind of vision which has aided in the journey: the vision of "a nameless city set in a distant sea;" sometimes called Utopia. This is the city dreamed of in the shadow of the dungeon, in the camps of revolution, in the sober statesman's library, in the monk's cell. It is a projection of the search for a better society. "We see men running and throwing themselves after happiness, towards a better life," the poet Schiller observed in 1797. "The world grows older without ceasing, and, without ceasing, grows younger, and man always hopes to see his condition bettered." In Schiller's time the most dramatic of the Utopians was Saint-Just, the associate of Robespierre, who at the age of 25 had made an impassioned speech which led Louis XVI to the guillotine. It was he who declared "happiness is an idea new to Europe" and his ideal state forbade the punishment of little children. (He was himself beheaded on the 9th Thermidor in 1794.) [1]

Utopias have been dreamed in all ages, but especially since the Renaissance with the dawn of modern philosophy and ideas of political and religious freedom. The notion of presenting political and philosophical principles in the form of an ideal state derives from Plato; as Sir Thomas More's does. His plea for tolerance in religious and political affairs gave it an immediate and lasting appeal. Also, there was no private property in Amaurot, as the Lord Chancellor of England described his ideal city, and "every man may freely enter into any house whatsoever." Common ownership of property and religious tolerance are distinguishing features of many Utopias, leading to the experiments actually carried out in the 19th century in Utopian socialist or sectarian communities in America.

The true Utopia must be distinguished from an Aldous Huxley's or a George Orwell's warning vision of what the world

may become because it is not guided by despair but the hope of man's progress. Yet in examining the long line of ideal states and cities a disappointment awaits the curious; excluding the purely architectural fantasies of a Thomas Cole, a Tony Garnier or a Bruno Taut, who dreamed of glass palaces set to crown the Alps, he will find that Utopia is not enlivened by the arts and that its cities are on the whole unimaginative if not extremely dull. The houses are solid, uniform and sheltered from the winds; the streets are wide enough to allow carriages to pass (twenty feet in the case of Christianopolis and Amaurot); the walls are impregnable to attack and all forms of construction are fireproof. We cannot turn to the Utopias for a vision of the beautiful city; as in reading the works of the planner Patrick Geddes, we may expect a long lesson in civics but not in art.

Educational theories, economic reforms and model laws have stemmed from Utopias; there have been many contributions equal to the Royal Society's origin in Sir Francis Bacon's interest in science, or in Andreae's suggestions for zoning, but it is rare in the literature to find the demand of Saint-Just: "The republic will do honor to the arts and to genius." More usual is the negation of art by over-emphasis of sobriety, utility or a favorite theory such as dress reform or smoke abatement.

A certain flavor is to be found in the sectarian Utopias of the Dominicans, Anabaptists, and in the Jesuit theocracies or certain Protestant religious sects like the Harmonists. With some exceptions religious societies have fostered the forms of art which agnostic or atheistic schemes have tended to ignore. Hence in Campanella's *Civitas Solis*, the dream of a Calabrian monk and man of action who in 1599 succeeded in organizing a conspiracy to drive the Spaniards from Southern Italy only to be betrayed,[2] we find the focal point a temple set on a hill

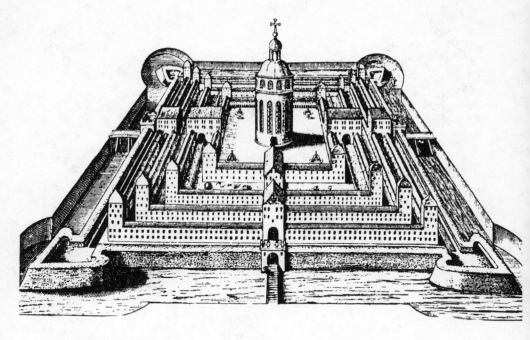

I. Christianopolis.

and decorated with spheres, with the heavenly bodies painted
thereon and other rich adornments. The pavement of the
temple is bright with precious stones; its seven golden lamps
are always burning, and these bear the names of the seven
planets.

About the temple are thrown seven great circles,
ringed with buildings on their convex sides, in which lives a
society distinguished mainly by its selective mating process and
a complete break-up of family life. Romantic love is unknown,
but the love of art is encouraged—the dwellings are picture-
galleries hung with paintings of an educational nature. By con-
trast, the Christianopolis of Andreae, which derives from Cal-
vin's theocratic city, is extremely plain; it contains "strong
towers" and all the buildings are of burnt stone, separated
by fireproof walls. "No one need be surprised at the rather
cramped quarters," explains this preacher of an enthusiastic
but undefined Christianity, "for there being only a very few
persons there is need for very little furniture." [3] More interest-

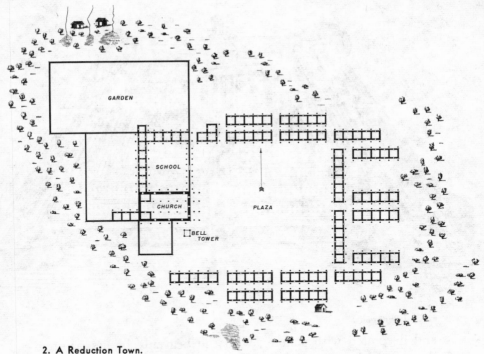

GARDEN

SCHOOL

CHURCH

PLAZA

BELL
TOWER

2. A Reduction Town.

ing are the "Reduction" towns of the Christian Indian State
in what is now the country of Paraguay. Often thought to be
modelled on the City of the Sun, they resemble it neither in
form nor government. The Reductions were established by a
Jesuit theocracy to abolish slavery among the Indians and offset
the bad example of the Spanish colonists. Here the famous
Yerba Maté tea was first domesticated by the fathers to end
drunkenness, on land owned by the Indians in common. The
Jesuits taught these peoples how to carve stone and wood and
how to build their porticoed houses so that one could walk
through the town without getting wet. The general plan was
like that of the Spanish *pueblos* (villages), with a large central
plaza giving ample scope for visual order. The churches, mostly
three-aisled, were built of great stone blocks, with an elaborately
ornamented facade, a main door, and several other wide en-
trances. The rich interior furnishings would have graced any

54

cathedral, and the impression, even in ruins is one of grandeur. Flowers and orange groves contributed to the scene in this remote interior commonwealth, which vanished with the 18th century attacks on the Jesuit Order.[4]

Evidences of art were sometimes to be found in 19th century sectarian communities, notably among the Harmonists of Economy (now Ambridge, Pa.) and in the Shaker communities. But in general and in the dreams of their designers, the non-sectarian Utopian communities were more valuable for their political innovations than for their urban image. Robert Owen, Fourier, John Humphrey Noyes, Bellamy, Howard and others of this diverse group of planners contribute little to the art of town building. If they had been more successful in educating society, perhaps their communities would have blossomed with the forms of art; or possibly if art had been a premise their Utopias would have won greater favor; as it is, they failed to win the world. Emerson's description of Brook Farm—"a perpetual picnic, a French Revolution in small, an age of reason in a patty-pan,"—is what society finally came to expect of Utopia, and the dreams of today must be inspired by a fiercer struggle with reality in order to produce the ideal commonwealth.

It is, therefore, interesting to turn to community forms that have been widely established in order to discover a direction in which the search may be pursued. And here we are rewarded by the breath of life, by the work of hands, as we walk among the cities of men.

Here is a city street, supporting an architectural frame. The street may be straight, regularly curved or winding, wide or narrow. It may be empty or teeming with life. The street enables the city to move, perhaps to breathe; it provides a view, a dead-end or, if curved, or sloping, a mystery. Further on, it joins with other streets, creating a pattern, or widens into a

3. A European street.

square or "circus." The web of streets becomes the base for the whole city, which feeds it, cleans its waste, by which we count the houses, find our way with ease or difficulty, and form an opinion of its size. Therefore the street plan is important, and must be understood as a pattern which in greater or lesser degree conditions the city's life.

There are few basic types of street pattern in two dimensions, and they are all with modern variations to be found in the cities "half as old as time." It is as though man experimented early, chose his types and left the rest to builders; or otherwise allowed the limitations of geometry to guide the path and left the rest to chance and the erratic roads of the cart,

the carriage or automobile. In any case, our progress in the planning of cities is simple to chart, if we ignore the complexity of architecture, ornament and of the exigencies of site.

The type which has occurred most frequently was used in the earliest cities of which there is record. This is the orthogonal, or quadrilateral plan. There is a reason for its persistence. The orthogonal plan is a generic urban solution,[5] of no critical significance. Unlike the wheel, which had to be invented, it existed as a basic design pattern in remote pre-urban times. As George Kubler[6] has pointed out it was independently achieved by many peoples; examples, for instance, are to be found in pre-conquest North America. It is mechanically simple and can be laid out by rudimentary surveying methods. It has been used for agricultural lands, for towns needing easy expansion, and for almost all situations demanding easy land sale and transfer.

In the light of these facts it seems less profitable to speculate, as Stanislawski does,[7] on the origins of the gridiron, than on its continuous use. Simplicity and ease may be one reason for its prevalence, but another hitherto unexplored characteristic of the gridiron may be equally important—that of system or order.

To the golden city of Pericles came Hippodamus, son of Euryphon, a Milesian, so Aristotle tells us. The half-legend goes that this first of the practical planners, who "invented the division of the city into blocks" and cut up Piraeus, was somewhat eccentric in his manners and dress, owing to a desire for recognition. Aristotle describes him as having a quantity of hair and expensive ornaments, and dressing too warmly in summer in cheap clothes. He wished to be a man of learning in the natural sciences and was "the first man not engaged in politics who attempted to speak on the subject of the best form of constitution." He suggested that property be of three types

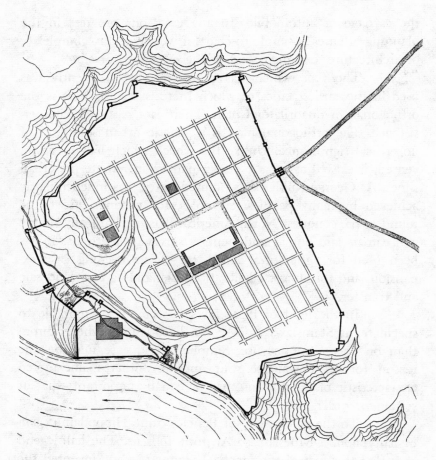

4. Reconstruction of the Hellenistic plan of Dura-Europos showing its orthogonal pattern.

(1) Sacred (for offerings), (2) Public (to support the warrior class), and (3) Private (land owned by farmers). Aristotle himself did not wholly approve of the laying out of straight streets "after the modern fashion;" he thought security demanded "the contrary plan, as cities used to be in ancient times," so that foreign troops would have difficulty in finding their way

about. Perhaps, he thought, the two plans could be combined in a *quincunx*, by siting the houses as farmers planted their vines in the field, in staggered rows, "for in this way it (the city) will combine security with beauty." [8] The quincunx has never found much favor—(in spite of its fascination for the curious in all ages—Sir Thomas Browne and Jefferson and Brigham Young employed it)—owing to the complicated street pattern it occasions, and "practical" planning has usually demanded something easier. "For the form of Babylon, the first city, was square, and so shall also be the last, according to the description of the Holy City in the Apocalypse," records Sir Thomas More. It was thus the Babylonian plan which Hippodamus brought to Piraeus in the golden age of Pericles, and from there to our modern western world. The agrarian-mystic society in Athens had its own plan—a crazy quilt of little rhyme or reason, if we except the Agora and the Acropolis. What Hippodamus, the first important and official city planner, introduced in the way of a plan was startling by comparison. It was a striking contrast, a palindrome which read backwards or forwards, of absolute regularity—the introduction of rationality in Grecian city planning.

How were the Greeks persuaded to adopt a system of

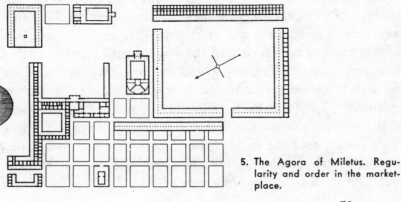

5. The Agora of Miletus. Regularity and order in the market-place.

59

planning from Ionia whose rationalist anti-superstitious philosopher Anaximander was banned from the streets of Athens? How to reconcile the broad straight streets of Miletus with the asymmetrical placing of the Parthenon, the Propylaea and the Odeon, completed during the rule of Pericles? The answer is clear enough. The Athenians allowed the gridiron to be used by the despised trading classes at Piraeus[9] and other commercial places, but not in the agrarian-aristocratic centers. The cleavage between agriculture and trade is noticeable for many centuries more, not only in ancient times but into the middle ages.

It is as though the quadrilateral plan was especially favored by traders. Instead of adopting the wheel, symbol of their goddess Fortuna, the gridiron became the plan of business cities. Hippodamus brought it to commercial Rhodes, the trading Etruscans borrowed it and later gave the Romans the block system of city planning, paved streets and sewers (for the trading classes have always been insistent on hygiene).

Alexandria was built in a rectilinear pattern, with an enormous main street. Ephesus and Palmyra, the caravan cities, had these main shopping streets; in the latter, the artery was two-thirds of a mile in length. All of these places were the homes of trades and contrast sharply with the agriculturally-based communities. Most of them were beautifully adorned. From the business city of Corinth came the luxuriously decorated columns which are still admired and erected by bankers.[10] Traders have always enjoyed ornament and the handicrafts as much as they have appreciated plumbing. Our historians have treated them as scurvily as did the Athenians and Romans; their flowers of culture are lost to us in the salty furrow of the Roman plough and the archaeologist has recently preferred to dig elsewhere. Yet nothing could be more useful than more exact information on these early planners, who may have been too fat to fight, but who were by no means crude or gross in their enjoyment

of the arts, or lacking in imagination when applying system to their surroundings. One does not need to draw invidious comparisons between Athens and Palmyra to decide which had the bolder plan. The Grand Colonnade at Palmyra with its magnificent columns on either side, each over ten yards high and punctuated by triumphal arches, may have been a shopping center, but of such a scale—3,500 feet long to the Temple of Neptune at its end—as to catch the breath of every traveller who saw it. The gems of Athenian architecture may be civilization's master stroke, but the plan of that city has seldom provoked discussion.

From this time on, among the welter of plans for cities, the traders' theme with variations is easily identifiable. It becomes especially prominent in times of business ascendancy, or when trade is being rigorously encouraged—as in the towns of Holland in the seventeenth century, or in Mexico or other parts of North America during the sixteenth and seventeenth centuries. In feudal times, it is less apparent, but as commerce became more important and local merchants banded into guilds, founding city-states like the Hansa towns, it is used extensively; at Lübeck, in spite of the picturesque chaos of overhanging gables and squeezed-in buildings caused by high land prices, the plan is essentially a gridiron.

While the rising merchants of Florence flourished in towns built by feudal lords, northern European businessmen laid out countless towns between 1000 and 1500 A.D., during the first rise of business-managed cities since the fall of Carthage. This rise in turn was cut short by the increasing power of European kings, who often had their own ideas about civic design. Even they, and the church too,—heavily in debt to the merchant class since the days of Rome—used the gridiron as an expediency in their haste, as in Southern France after devastating wars in the thirteenth century or in Mexican colonization

in the sixteenth. King and aristocrats must perforce be practical and use the practical plan, nevertheless it is they and the military, more often than the church and the trades, who used other forms during the Renaissance and made the history of street pattern less monotonous than it would otherwise have been.

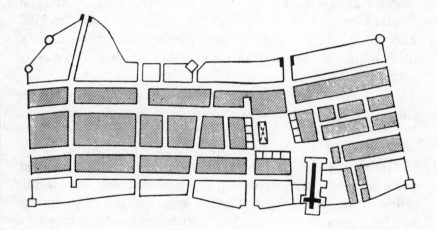

6. Plan of Beaumont-en-Périgord. The orthogonal plan adapted to the contours of the site. Built in 1272 at the command of Edward I of England.

Our theory of the appearance of planning types, then, can be made as follows: A sharp distinction may be made between the urban plans of agricultural-feudal and those of trading societies. The first is characterized by irregularity, stiffened only by the persistence of a Roman cross-roads or the widening of a confluence into a closed square. The second is characterized by the introduction of system, usually in the form of a grid of varying widths and proportions. This plan is dominant in all trading centers from Ionia to Massachussetts Bay. (There are exceptions to the rule in both classes.)

It is thus no accident that our American colonial

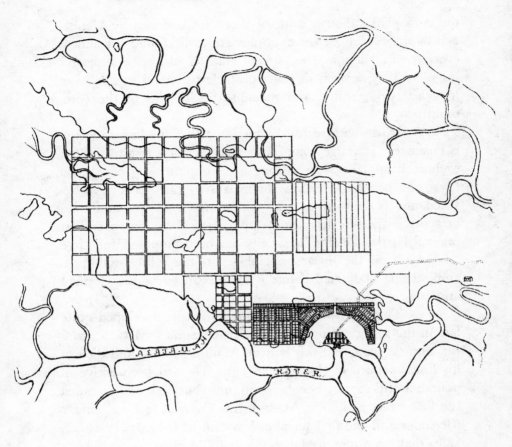

7. Frederika, Georgia, one of the fortified towns of the Ogle-
thorpe colony. "Its mission was accomplished when the
Spaniard no longer threatened."

towns—mercantile centers usually—employed the grid pattern,
or that it was continued in the period of industrial expansion.
There is a variation to be seen, in America as elsewhere, how-
ever, which is different enough to be a special type—this is the
linear plan. Usually found in villages and small towns, this plan
consists of a spinal thoroughfare to which the feeder secondary
streets are attached. Williamsburg and Litchfield are essentially

63

linear in plan although both of them are stiffened by a cross-axis at the center. Better examples are to be found—in almost every country—among the "street" villages, where, because of a ridge, a valley, a river, or other obstacle to lateral expansion, a long artery is created and remains the life-line of the community.

It can with reason be supposed that the linear scheme is unsuitable for large communities; in fact it is rare to find an exclusively spinal system existing in communities of over 5,000 to 10,000 people. Pressures for expansion can scarcely be resisted, and as the town grows it will often spread up a mountain or across a river in defiance of topographical limitation and its original layout. Yet the linear city has been proposed and large cities built on the linear principle exist—the most notable example being Stalingrad before it was destroyed by the German armies.

The principle of linear planning was developed quite late in the history of urbanism by Arturo Soria y Mata, a Spanish business man who was born in Madrid in 1844 and died in his linear suburb of that city in 1920. He had been active in politics until 1875, when he went into business and founded the first streetcar line in Madrid, the *Tranvia de Estaciones y Mercados* and the first telephone system in the city. It was in 1882 that he announced the *Ciudad Lineal* as a solution to urban problems and ten years later that he founded the *Campania Madrilena de Urbanizacion* which was to build a circular trolley line about Madrid and create the linear city.[11]

In announcing the linear city to the world Soria pointed out that the cost of transforming an old city would be far greater than creating a new one. The new one, he suggested, should expand "organically" from the old, by which he meant "in an organized fashion." [12] Geometry being the most "organic" science, "if the house can be considered the point of urban

geometry, the logical, indispensable and superior form is the Linear City, the single street prolonged indefinitely . . . the point giving birth to the line, and the line to the plane." The linear form was also, he thought, contemplating his streetcar and

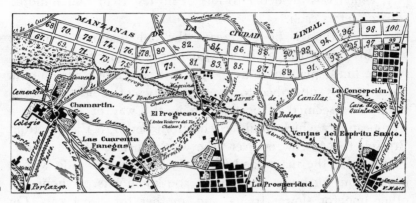

8. Arturo Soria's linear suburb in Madrid.

telephone lines which were then appearing in Madrid, the most characteristic of the age. "Where you see crooked lines, deadened streets, narrow streets, recognize that it is the picture of a poor old city resisting progress. The straight line is perfection . . . it is also, in most instances, the line of least resistance, and, as a result, the best according to the doctrines of Herbert Spencer." Soria also claimed that his proposal was a logical consequence of the theories of Darwin and Hegel, that linear cities were perfect and definite forms for the whole surface of the earth, whereas garden cities were provisional and imperfect forms for small and special tracts of land. "It is the plan of symmetry, sexuality and progress" he loudly averred "which declares the superiority of animal over vegetable forms." The linear city with its spine was the vertebrate or higher form of city, while the garden city was a lower or vegetable form,—a criticism which did not prevent the garden city from achieving far greater popularity than anticipated by the energetic Spaniard,

65

whose linear suburb of Madrid housed only 6,000 people by the time he died. The spine, or *cardo*, was of uniform width, connected by cross streets to narrower parallel streets on either side. These two parallel streets were to mark the limits of the city, which was divided into lots of no less than four hundred square meters each.

Although by no means the only planner before or since his time to be afflicted with megalomania, Soria's claims for the linear plan led him to regard it as a universal solution. Once having subscribed to the possibilities of rapid transportation, there seemed to be nothing in the way of proposing a European city which would extend from Berlin to Vienna, from Brussels to Moscow or over "the whole surface of the earth." In this case the main road would be 100 meters wide with a central line for trains traveling at 200 kilometers per hour, another line for slower trains, and another for street cars. On approaching irregularities of terrain caused by mountains or hills the linear city would narrow down to this basic artery of transport, spreading out again when the obstacle was passed. With the time-distance factor minimized, there would be increased intercommunication of all peoples, the countryside would be saved, and all irregular, ugly urban patterns abolished.[13]

Theories of this kind are proposed from time to time[14] and while often unworkable in their original form they are sometimes productive of ideas for the future. Soria would have approved of our modern express highways and perhaps have been content to see them cutting down communication time between urban points without wanting to convert them into linear cities. He would certainly have been horrified by our older, uncontrolled post roads like Route 1, which runs from Maine to Florida, where nightmare linear cities exist in ribbons along the way, with their mixtures of industry, housing and hot

dog stands. "The plan of symmetry, sexuality and progress is to be found in ships and all kinds of vehicles," he had observed, "which are nothing less than small mobile cities." In the case of ribbon development along the highways, a small mobile city

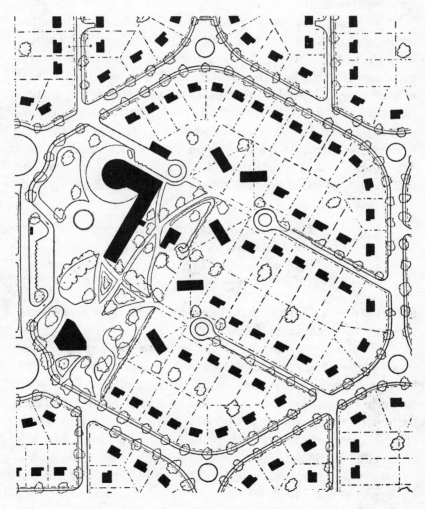

9. A contemporary hexagonal plan by Ricardo C. Humbert of Buenos Aires.

called the automobile has brought with it a static linear city which nobody had the foresight to prevent and which may well discourage planners in the future from building their developments in "the perfect and definite form—the line of least resistance."

The *curvilinear plan* is more seductive than the orthogonal or the linear types and engages our interest because it appears fortuitously until the nineteenth century and the appearance of the Romantic Suburb described in Chapter 8. It is to be found in crowded medieval towns, in eighteenth century suburban extensions, in nineteenth century American villages— always appearing more casual, less studied than its more geometrical relations. It does not lend itself conveniently to any theory until the late eighteenth century, when lovers of the picturesque invented the principle of studied irregularity in landscape gardening:

> "Discordant objects taught to join,
> Now form now break the varying line;
> With well-ranged lights one mass compose
> Till with full strength the landskip glows:" [15]

and Hogarth had invested the serpentine line with a new prestige in *The Analysis of Beauty*.

Curving or sinuous street patterns are popularly supposed to be characteristic of medieval planning. On the other hand as Lavedan has pointed out[16] all types of plan have been found in the middle ages; but it can be stated that the *building pattern* of the medieval period did create irregularities which affected the course of the streets themselves. As Justus Bier has observed: "With medieval towns everything is based on movement and untrammelled rhythm. Though juttings in the street-walls suggest one whole, yet they sub-divide too, just as they turn off and they unite. The houses are rarely of the same height—

Thais

Phedria

Parmeno

10. The changing direc-
tions of medieval
roofs. From the *Eu-
nuchus* of Terence
(Conrad Diuchmont,
Ulm, 1486).

they are adjusted to one another in a manner which defies any
rule. The gables . . . seem to be imbued with a permanent
spherical space-movement . . . they never appear symmetrically
to correspond to each other, but seem to change direction con-
tinuously." [17] Otherwise the curved street originated in the wind-
ing path, taken over for the city's use, or in the curve of the
fortifications, pulled down as the city expanded beyond its orig-
inal limits. Beyond this, in the newer parts of the city where
commerce ruled, the grid was often employed, a sign that some
enterprising merchant had discovered the speculative value of

69

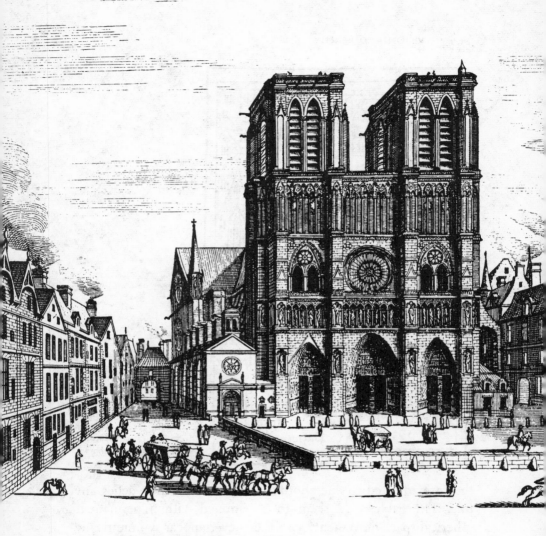

land. When new cities were created the grid was likely to be used exclusively, as at Aigues-Mortes in 1240 by Louis IX, or during the same century in the new town of Salisbury, when the large blocks created were called "chequers." Nothing could be less romantic, and it was a curiously romantic notion that impelled the eighteenth century followers of the Picturesque to claim the medieval garden as a precedent, that charming culti-

70

11. The Parvis of Notre Dame de Paris in its original form which forced the upward gaze by confining space and by its proximity to the Cathedral. View by Mathieu Merian in the early part of the seventeenth century.

vated plot that its creator always tried to make as regular as possible.

And so, although the curvilinear plan does appear in medieval times, we can conveniently wait until reaching nineteenth century America before describing its conscious use. Meanwhile, no mention of medieval planning should be allowed to pass without summarizing its main contributions, largely for-

gotten because of present-day avoidance of symbolism in design. The medieval search into the nature of things made use of stone to point up its discoveries, and the richly ornamented facades of the larger churches rose into the air like open books wherein all who saw might learn of the heavenly marvels. All this was surmounted by a tower or spire, "lifted above the purple crowd of humbler roofs" with which the age introduced the element of *accent*, unknown to the ancients except in the pharos of Alexandria and other rare vertical devices.

To reach this holy place, the traveler entered the city by a formal gateway, perhaps crowned by towers, affording a perspective of the main street, leading eventually to a gateway on the other side of the town. The main street might be straight or angled, and would pass by or through the market-place, which was almost always a *closed square* and sometimes arcaded. Now there would be a view of the main portal of the Church, seen down a dark narrow street, and after traversing this the pilgrim would suddenly find himself in a small square or parvis experiencing the element of *surprise* by being forced to look upward at the towering church with its torrent of sculptured figures, serene, benign, or wrathful; pointing, demonstrating, reading or waving a blessing at the space below. (The modern pilgrim can still experience the element of surprise at Strasbourg, Quimper, Clermont-Ferrand, and Lincoln.) The feeling of surprise would change to that of awful majesty as the pilgrim entered the darkened church, realizing that the line of progression from the outer gate had led him to that point of light above the far-away altar where the story that had been told in stone was now retold in blazing color—the element of *climax* unerringly employed.

Planning of this nature—planning with a theme or purpose—can scarcely fail to please, regardless of the two-dimensional plan on which it is based. When the devices of accent, surprise,

enclosure, grandeur or ornament are returned to planning once again, the civic designer will be assured of public interest and support for his efforts to remake the city as a fair and pleasant place.

CHAPTER **4**

THE GRAND DESIGN

The final type of plan, and by far the most interesting, if only because it is the basis of many of the urbanist's greatest triumphs, is the *Metonian* street pattern, sometimes called *radio-concentric*. This is the plan which of recent years has been slighted, largely because it is associated with the unpopular City Beautiful movement; the pathetic fallacy has been recklessly indulged to label it "aristocratic," "despotic," or "dictatorial." In actuality, the Metonian plan is no "better" and no "worse" than any other type—in a given situation it may function just as well, or better, than the grid, the spinal or the curvilinear plan. Its convenience is demonstrated by the post-war plans for London, Moscow and Washington which are radio-concentric in their main lines, with great arteries running out from the centers

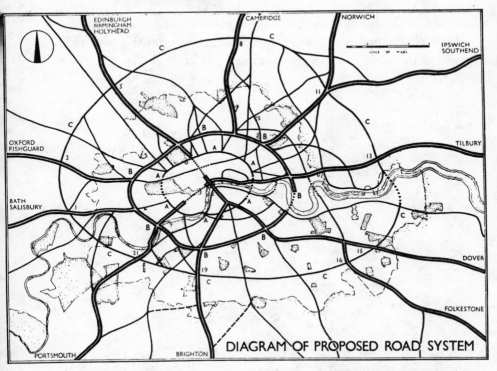

1. The Plan of London (1943) by J. H. Forshaw and Sir Patrick Abercrombie. The series of belt-roads and radial arteries create an over-all pattern which is radio-concentric in its main lines.

and a series of concentric traffic "belts" connecting them as they widen out from the core.

The Metonian plan produces entirely different city patterns from the grid, but like it is also expandable and therefore flexible enough to be retained as a basic pattern. Radials may or may not be present, but usually are, since expansion takes the form of an ever-widening circle and not the addition of a series of new circles. It has a more curious history than the grid. We find it being used by the Hittites at Zendjirli and Karkemisch,[1] circular towns with double defense walls and a citadel or acropolis in the middle. Lavedan's theory that these towns were influ-

75

ential in the development of the radio-concentric plan has since been challenged, but there are precedents in primitive societies, where the round village is common.

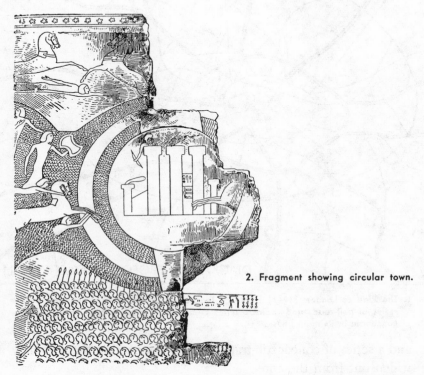

2. Fragment showing circular town.

While it has now been proved false, the classical idea that primitive man like his animal friends was unable to construct anything in straight or rectilinear patterns has a certain affinity with primitive philosophies of nature wherein man bowed to the natural forms he observed around him, and the appearance of the circular village with the main street or path oriented to the east and the rising sun seems to bear this out. Ancient societies had other gods, however, and by the time of the Egyptians it is the rectilinear plan which moves through Babylonia to Ionia and

76

finally assumes supreme importance in the seafaring world. Greece and ancient Rome eschewed the radio-concentric pattern, and although Aristophanes in *The Birds* makes Meton draw a radial plan for Nephelococcygia, the city in the clouds, there was nothing of this nature in the towns which the playwright saw around him. A more important link in the chain of circular planning is the description in Herodotus of the King of the Medes, who made his subjects abandon their homes and build a city on a hill of seven concentric walls, each painted different colors, with houses interspersed and a palace in the middle, the whole occupying an area the size of Athens. Lavedan compares this with the descriptions of the Camp of Attila and the Ring of Avars, both concentric patterns with the chieftain's palace in the middle, and infers that the existence of radio-concentric plan-

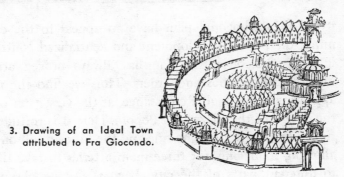

3. Drawing of an Ideal Town attributed to Fra Giocondo.

ning in the ancient middle east was transmitted through the barbarian invasions at the end of the Roman Empire to the heart of Europe, where it achieved its first wonderful flowering in the plans of the medieval city.[2] Later it is rediscovered by the makers of ideal plans in the early Renaissance, since when it has never been forgotten.

Whereas the orthogonal plan is identified with traders, the Metonian plan has been beloved by chieftains, emperors, priests and popes. While the interchangeable parts and anonym-

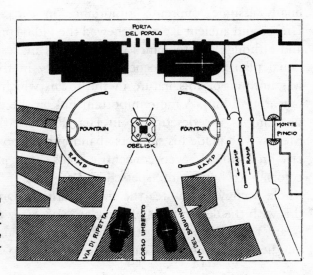

4. Plan of the Piazza del Popolo, Rome, an early fortuitous use of the goose-foot in modern times.

ity of the orthogonal plan have an appeal to the commercial mind, the perfect envelopment and centralized control implicit in the radio-concentric plan has always proved attractive to hierarchical societies and orders. Thus we find the radial plan appearing in the high Renaissance, at the very gates of Rome in the design of the Piazza del Popolo. Here it is fortuitous, conditioned by the river on one side and the Pincian hill on the other, allowing room only for three main arteries to take the traveller to different parts of the city. It may also be observed in the goose-foot plan of the Aldobrandini garden. But its first large-scale, calculated use in modern times was the laying-out of a new quarter of Rome at the very end of the 16th century.

Sixtus V's scheme for the new quarter was in one sense a democratic concession to the populace and to the thousands of pilgrims pouring into Rome who heretofore had pursued their tired way from church to church through tortuous and unsanitary side streets. For the first time we find a complete philosophy of urban planning, expressed in the engineering of a pure water

78

supply, the Aqua Felice, the establishment of a *system* of circulating streets and the creation of strong esthetic values. Aided by that most calculating of urbanists, Domenico Fontana, Sixtus V created a six-branched star radiating from S. Maria Maggiore to all the important churches and monuments on that side of the Tiber. But there were also connecting circular routes, making the transformation a true radio-concentric plan and thus enabling the prospective inhabitants to move freely about within the new quarter. Those who built houses or came to live in the region were accorded privileges and immunities under the Bull of 1587. The pure water supply and fine new streets rapidly attracted an increased population, so that the area became established at once as a very successful example of modern "improvement."

It is in France that the radio-concentric plan achieved its full expression. Marie de Medicis brought a wave of Italian inspiration to Paris after 1600, but it was a *French* artist who planned the castle and garden of her Luxembourg Palace, and it was a series of French architects, painters and gardeners who created a new tradition. There is nothing in Italy to match the refinements of the Metonian plan developed in France during the long period of the Baroque and Rococo. This new kind of improvement was a blending of the grand and the beautiful into the conception of magnificence always associated with the name of Louis XIV, who inherited a passion for architecture and gardening from his admired grandfather, Henry IV, and who was schooled by Mazarin in the "taste of angels," the art of collecting. With Louis must also be mentioned the remarkable figure of Jean Baptiste Colbert, the national planner of France, who developed the country while his sovereign embellished Paris and Versailles. Colbert supplanted the extortioner Fouquet who had excited the envy of the king by the grandeur of his estate at Vaux la Vicomte, an undertaking which covered

5. The Beginning of the World's Most Famous Urban Axis.

(a) The original gardens of the Tuileries designed by the Claude Mollets, father and son, and Jean Le Nôtre, father of the famous landscape architect.

acres and necessitated the destruction of three villages.[3] Planned by Le Nôtre, the grounds of Vaux exhibited a new principle—the mastery of the whole and its parts. To the former stiff axial symmetry of gardens, a variety of incident was introduced to provide unending and unexpected pleasure. Although the whole could be seen from the house, shrubberies, bosquets and private gardens abounded. It was a frame for costume parties and fireworks. It introduced a style which the newly-rich could copy on one level and the king could surpass on another.

80

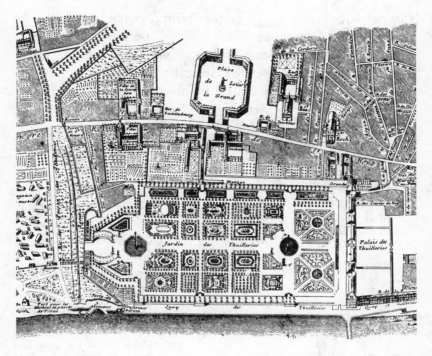

(b) Redesigned by André Le Nôtre, gardener to Louis XIV, in the new style, a central axis is created which becomes the nucleus for a later extension in the Champs Elysées.

When the audacious Fouquet was imprisoned, Colbert set about reorganizing the nation's finances and enriching it by commerce. New industries were established, state factories opened, inventors protected, workmen encouraged to come from foreign countries, the flow of goods facilitated by the improvement of roads and canals and the navy and the merchant marine firmly established. But Colbert was also superintendent of buildings. He embellished Paris with boulevards, quays and triumphal arches; he began the improvement of the

81

Louvre and brought "le grand Bernin" from Rome to be its architect. It was he who replaced Bernini with Claude Perrault, marking the end of Italian influence and the establishment of a wholly French Classical style. It was he too who braved the devastatingly critical monarch in superintending the

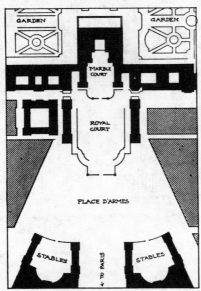

6. An example of the goose-foot consciously created in three radiating avenues from the palace at Versailles.

buildings at Versailles. The young king, involved as he was in wars of strategy but at the same time conscious of his position as the proudest ruler in history, lost no time in putting to work the architect, Le Vau, the painter Le Brun, and the garden architect Le Nôtre, while La Fontaine and Molière were called on to provide entertainments for the new royal palace. At first they were out of doors, since for six years the garden was building, rather than the palace. Fountains, grottoes, orangeries (the orange trees came from Vaux), the grotto with its gilded rays streaming from a sun disk into six maps of the world in the form of medallions—*Le Roi Soleil*, indeed, was in power. In

82

1666 Le Nôtre laid down the imposing steps from the great terrace. Behind the Apollo fountain the great canal was dug— a gigantic outdoor mirror, which has often been imitated but never surpassed, in town or country. This grand design has been the source of endless ideas for architecture, landscape and civic art for three hundred years.

At Versailles the avenues we call allées which stretch out on one side of the palace become streets on the other. Here, instead of a central axis are the three radiating avenues of St. Cloud, Paris and Sceaux, converging in the Place d'Armes. Previously, the town itself was merely a village of a few houses south of this point, but the land was given to the lords of the court and new houses sprang up, chiefly in the north quarter, where Hardouin-Mansart, the King's new architect, built the Church of Notre Dame.[4]

The little town of Versailles would not have been so important if its street pattern had not attracted such attention in other lands. There is a great similarity between it and the main streets of St. Petersburg, the Nevsky Prospect, the Gorokhovaya, and the Prospect Voznesensky—which Peter the Great with the help of the French architect Le Blond laid out radiating from the Admiralty built in 1705. Versailles was also the model when in 1709 the Margrave Karl Wilhelm of Baden-Durlach built himself a Trianon in the Hardtwald, a bizarre affair with two wings extending at obtuse angles from a circle. In the middle of the circle was a hunting tower, the central point from which 32 allées extended into the surrounding woods. Four fountains flanked the tower and beyond these were 24 small houses each with its own garden. Along the segment of the circle cut by the two wings were more houses for the servants of the court.

All this was quite remarkable for a prince's palace, but it was extraordinary as a pattern for a town. For the Mar-

grave, preferring it to Durlach, which was growing slowly, moved his court to the hunting lodge. The burghers came too, and built their houses along the walks of the park which led from the servants' houses and made the walks into streets. This followed an ideal sought at that time—the lesser houses having the Residenz for a central point. The Margrave pretended that he was the victim of a plot.

"In the year 1715, I was wandering in a wood, the abode of wild beasts," he explained. "A lover of peace, I wished to pass my time in the study of creation, despising vanity, and paying a just homage to the Creator. But the people came also, and built what you here see. Thus there is no peace so long as the sun shines, except the peace which is in God, and which you can, if you will, enjoy in the middle of the world. 1728." [5] These words are engraved on a stone at the entrance to the old Schloss and are a picturesque memorial enough, even if they do not record the real reason for moving the seat of government from one place to another. The old capital is now an unimportant suburb of the new, which came to be called after its creator, Karlsruhe.

So does improvement breed improvement, and as Voltaire observed, a similar event occurred in Paris, where "private persons, in imitation of their king, raised a thousand splendid edifices. The number increased so greatly that from the neighborhood of the Palais Royal and from St. Sulpice there were formed in Paris two new towns much finer than the old one." Paris is the supreme example of the grand in planning, where the opportunities were better taken than anywhere else in the seventeenth, eighteenth and nineteenth centuries. It was admittedly a comparatively simple feat to demolish the fortifications of Etienne Marcel, as Louis XIV did, and lay out the boulevards connecting the quarter of the Bastille with that of the Madeleine. These bastions had been gradually disappearing

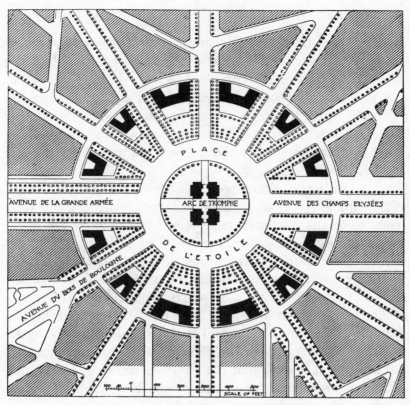

Image labels: PLACE DE L'ETOILE, AVENUE DE LA GRANDE ARMÉE, ARC DE TRIOMPHE, AVENUE DES CHAMPS ELYSÉES, AVENUE DU BOIS DE BOULOGNE, SCALE OF FEET

7. The climax of the axis extending from the Louvre to the Arch of Triumph by the erection of the Étoile. The circle itself, in its present form, dates from 1854 when it was designed by Alphand, landscape gardener under Georges Eugene Haussmann. The buildings about it are by Jacques Ignace Hittorf, architect of the Gare du Nord.

during the previous hundred years. But what a grand conception to make this ring road with its double avenues of trees—as noble an effort in street planning as the great colonnade at the Louvre was in architecture. Add to these the Place Vendôme, the Place des Victoires, the triumphal gates of St. Denis and St. Martin, and the Hôtel des Invalides—one of the finest

85

institutions of the Grand Monarque, with its great open spaces reaching to the river—and the result is an opening-out of the medieval city, which previously had only boasted the Place des Vosges as its one large unencumbered area. Add again the "Place" now called de la Concorde, the Ecole Militaire, the Elysée Palace, and a hundred other improvements made by Louis XV and Louis XVI and the basic framework for modern Paris is clearly seen.[6]

Moreover, the improvement fever was catching. Large villas with long formal gardens early appeared along the right bank, while the left bank, made more accessible by the building of the Pont Neuf, began to be filled with large mansions in the seventeenth century. Many of these town houses were built speculatively by architectural firms like Hardouin-Mansart and de Cotte, Bellanger and others at their own risk. Fiske Kimball points out that this initiative was spurred by the example of the royal works and that Versailles, then being remodelled by the artists of the Crown, was the prime influence.[7] At any rate, it is clear that the Invalides or other state undertakings soon became surrounded by the blossoming of hotels, courts, and private pleasure grounds and radiating stars were to be found among the older street patterns.

The role of the speculator in creating the beauties of the seventeenth and eighteenth century city is of great interest, by contrast with speculative patterns after 1830. It cannot be too often remembered that the majority of the world's most beautiful squares, crescents and circuses were conceived and executed by the business mind, with architects assisting in the designs and sometimes in the financing. It was the architect Hardouin-Mansart and his associates in real estate who persuaded Louis XIV in 1685 to buy the land now occupied by the Place Vendôme. The king was to pay for the facades of the buildings flanking the square, but financial difficulties en-

8. The development of the île St. Louis by the Parisian speculator Christophe Marie in 1617, using the grid-iron street pattern.

couraged him eventually to cede the land to the city of Paris on condition that the city build the facades. Mansart's original, more generous plan for the square was reduced in size and converted into an octagon, obtaining more land for the speculators by cutting off the corners, while the arcade was closed in order to give more space to the landowners. Meanwhile, the speculating architect and his friends succeeded in selling off lots to *nouveaux-riches* (mostly tax-farmers and government officials) who were to build houses behind the facades. The latter were finally erected by the city in 1699 and remain subject to esthetic control to this day.[8]

Wealth, fashion, and gambling also combined to produce one of the world's most admired cities—18th century Bath. Here again the architect and his patron were speculators, but it was also a dream of Roman grandeur which prompted John

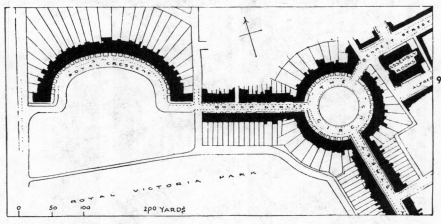

9. The Circus Bath, a product of speculation in eighteenth century England. The approach each case affords a view of building rather than streets.

Wood, chief architect of Bath's suburban extensions to recall in later years, "I proposed to make a grand place of assembly to be called the Royal Forum—another place, no less magnificent, for the exhibition of sports, to be called the Grand Circus; and a third place,—for the practice of medicinal exercises, to be

called the Imperial Gymnasium of the City." [9] These grand and nostalgic titles were applied to residential squares, crescents and circuses, the homes of aging and agued noblemen and social climbers, to whom doctors had recommended gambling as part of the "cure," the two occupations fitting together in the eyes of fashion like an easy glove, as they have at various times in other places, such as Baden and Saratoga in the following century.

Wood's Royal Forum, which came to be called Queen Square, was obtained on a 99-year lease from the landowner. Wood in turn parceled the land out on tenancies of 98 years. His practice was to engage builders to carry out a uniform exterior for the houses but to leave them free to make interior plans to suit the occupants. After having found a wealthy tenant to rent the building for a lengthy term, the builder took his agreement to a banker, who would then loan him the funds for construction.[10]

This method resulted in the restrained yet lovely ensembles in honey-colored stone which crown the eminences of Bath and give to that city a character and form which earned for it Swinburne's title "the Florence of the West." Grounded in the details of Palladianism, Bath's architects exercised control over land, views, approaches and facades, thus preserving the city from "the vulgarities of unmitigated ignorance" into which her builders might otherwise have blundered. How different from the suburban extensions of the next century described by Ruskin as "these pitiful concretions of lime and clay which spring up in mildewed forwardness out of the kneaded fields about our capital—upon those thin, tottering, foundationless shells of splintered wood and imitated stone—upon those gloomy rows of formalised minuteness, alike without difference and without fellowship, as solitary as similar—their sacrifice of liberty without the gain of rest, and of stability without the luxury of

change"—or from those of our own time, when the house is built to sell, its permanence and beauty left to chance, its grouping either a total disorder or a rigidly monotonous line. How badly needed is the architect and civic designer in those areas which are now shaping the service-industry city's most important future centers—the clusters of suburban homes of families who know nothing of the beauty that might be theirs or of the satisfaction to be gained from art as arbiter of the environment.

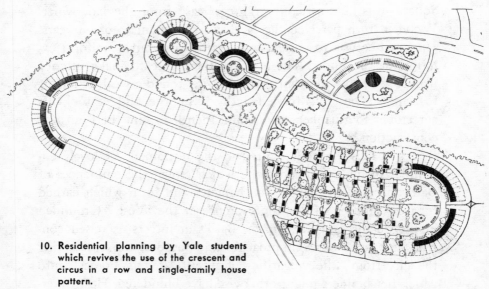

10. Residential planning by Yale students which revives the use of the crescent and circus in a row and single-family house pattern.

Residential squares, courts of honor and even crescents came to America soon after 1800 but the grand design appeared in 1791, at a time when the fortunes of Bath were declining and the French had just culminated their long series of experiments in radiating patterns with the *Plan des Artistes* for Paris. The plan of Washington was first suggested by Jefferson, who had designed the first building in America to be built on classical models and the first to be designed specifically for a

modern republican government, the State Capitol in Richmond. (The next work in the Roman manner, Bulfinch's triumphal column in Boston was not erected until 1789.) Jefferson's plan was sent to the designer officially engaged by the Congress to lay out the federal city; this was Major Pierre Charles L'Enfant, one of Washington's aides whose sketches of his brother officers had amused the President during the long nights of Valley Forge. L'Enfant had written Jefferson, then Secretary of State, asking him to be so good as to send some maps of existing "grand cities"—London, Madrid, Rome, Paris, Amsterdam and others—not for imitation but "to suggest a variety of new Ideas." Jefferson complied, including his own suggestion, a generous arrangement of squares, based on Babylonian and Roman precedents. L'Enfant criticized this, saying it could only be used "on a level plain," and adding: "Such regular plans indeed, however answerable they may be on paper or seducing as they may be on the first aspect to the eyes . . . must ever when applied upon ground . . . become at last tiresome and insipid and could never be but a mean continuance of some cool imagination, wanting a sense of the really grand and truly beautiful only to be met with where nature contributes with art and diversifies with objects." [11]

L'Enfant had been brought up in the gardens of Versailles, where his father was a painter to the court, and it is interesting to see that his own plan for Washington places the Capitol and the White House in approximately the same relationship as the Palace and the Trianon at Versailles. The radials and long views are his alone, but he was sufficiently influenced by Jefferson's plan to include in the final drawing a gridiron system of blocks, which makes the plan of Washington a distinctive variation on the radio-concentric theme. And after L'Enfant was dismissed by the President for his intransigeance in dealing with the Commissioners appointed to supervise the

The following text appears as handwritten labels within the sketch:

George town

Rock creek

St side

St

St

Penn[sylvania] Avenue

Presid[ent's] house

Capitol

public walks

another line for Canal... fine op[en]... park for those attached to the government

Tyber

St

St

Mud bank

The detached lots to be sold the first instance makes 288 lots

to be laid off in lots

11. Jefferson's sketch for Washington, D.C., based on his favorite Babylonian plan, and establishing an easy relationship between the Capitol and the President's House.

92

work of rearing the federal city, it was Jefferson who recommended that the Board of Commissioners be abolished and who urged Congress to appropriate funds for improvement of the nation's capital. He made bold to spend a third of the appropriation for the improvement of Pennsylvania Avenue, using as his model the Parisian boulevards, and subdividing the wide street into roadways, footways and reservations, in one of the last proposing some day in the future to conduct the waters of the Tiber Creek. It was Jefferson too who wrote the program for the competition for the Capitol and the White House, submitting his own design for the latter, and giving patronage to architects of exemplary training such as Stephen Hallet, *un architecte expert juré du roi.* One of these artists, Benjamin Latrobe, wrote to him in 1807: "Your administration, Sir, in respect to public works, has claims of gratitude and respect from the public and from posterity. It is no flattery to say that you have planted the arts in your country." That country had to wait one hundred and twenty-five years for an Administration to do as much for the arts as the president who first adorned with sculpture and painting an American public building.

In spite of Jefferson's attempts to regulate the height of buildings in Washington and to establish a classical revival architecture worthy of a capital city, Pennsylvania Avenue fails of its effect because it never had an architecture. The radioconcentric plan demands a third-dimension harmonious with its street pattern. This is not necessarily true of the other plan types, but the Metonian plan demands it, excels by virtue of its architectural form. Hence Pennsylvania Avenue, which to this day has never been built up in a harmonious line, and that section of the Woodward Plan of Detroit which exists, are meaningless street patterns which have no relation to the intentions of the designers (who, unfortunately, did not leave archi-

tectural plans behind them); but this is beside the point, for plenty of prototypes existed as a guide for the builders of the two cities.

It is not clear how L'Enfant thought of Washington in three dimensions; he left few drawings for posterity; Cooper accused him of considering buildings as accessory to streets "instead of the reverse, as is everywhere else found to be the case," [12] and thought that the land about Georgetown would have been more suitable for the central points of the city, as Jefferson had suggested. Perhaps the easy grid would have fitted "the perspective of American character" as Cooper and others have suggested; there is so much of Versailles in the plan of Washington that Henry James was prompted to remark that instead of statues of generals and statesmen, its intersections should have been decorated with "great garden gods, all mossy mythological marble." If the plan had emphasized buildings rather than streets, which is the method of urbanism to be proposed later in these pages, fewer mistakes might have been made. The first of these mistakes, under Andrew Jackson, was to place the Treasury Building across Pennsylvania Avenue, blocking the view from the Capitol to the White House.[13] Later, the Congressional Library was placed "where it neither confronts the Capitol nor preserves any reciprocity of sight with it," and where it stops one of the most important vistas carefully arranged by L'Enfant to be closed by the Capitol, the southwest view from the prolongation of Pennsylvania Avenue. The Washington Monument was apparently placed quite casually where it is today by the engineers in charge of construction, making the Macmillan Commission's work more difficult when it was instructed to revive and restore the L'Enfant plan in 1901. In fact, the whole history of Washington's planning has been the placing of isolated monuments and monumental buildings, rather than fulfilling the obvious need of creating a facade for the streets.

"Facade" architecture! This term of opprobrium has been used in the last twenty years to decry the achievements of those who attempt uniform treatments of the street. But the facade is all-important in city planning, and no one can prevent its re-emphasis in the urbanism of the future. A new artist will appear whose function will be the treatment of the facade. Individualists, lovers of architectural "freedom" (which in present-day terms means "anarchy") should look at their wretched legacy to posterity of badly-placed, badly-spaced, irregular, self-advertising buildings and deny that they are a substitute for "facade" architecture, which can be modest as well as bold, simple as well as decorated. Look at the speculator's triumph in the Place Vendôme, and then at the Porte de Saint Cloud—look at the old Washington Square and then at the new. Oh, lovers of the picturesque, your triumphant day has come, but it will not last; take Sullivan's advice and "be on hand at the awakening." Is it not people who should convey the irregular, the romantic, the picturesque note in the symmetrical square or the straight boulevard? Look at the great square at dawn and then at noon when everyone is having their *passeggiata matinale*. Look at the streets as they fill and empty with the business of the day. Can these effects be created by architecture? Should not architecture be a *background*, rich or subdued, fading or swelling into prominence, instead of blatantly crying "look at me!" Yes, look! Look at Bath, look at Paris, look at Nancy—look and learn.

The plans which have been described are all less important than that which rises from them. We do not think of the plan of Rome or of Venice; we think of the plan of Washington because the third dimension is either lacking or wrong. Our attention is drawn to the plan by default. We think of the radio-concentric plan because it bears more relation to its architecture than the other types; for this reason it becomes more interesting to us. But no plan has intrinsic merit except

as a diagram; without an architectural realization it is tedious to the eye. In reality it is made, or fails, because of its third-dimensional character—it does not read, as on paper, because the eye is blocked after traversing a very short distance. The plan does not translate itself from plane to perspective as in the compositions of a painter which channel the vision. The eye roves, takes in this fragment and that vista, is stopped by a building, or darts along its sides. The spectator turns, glimpses new aspects; he moves, and further compositions are revealed. We are thus more taken by the third-dimensional planning of Scamozzi, Vauban or Ledoux than by the diagrams of Francesco di Giorgio Martini or the "land use" maps which pass for planning in the modern city. We long for the wonders of Peiping or London in the time of Chaucer because of the color and detail in these cities which no plan can reveal and which are independent of the plan. We realize that the great moments which have been discovered in the search for the city are architectural and pictorial, not scientific or mathematical. Moments of artistic creation—the moments of Michelangelo, Bernini, Wren, Gabriel and Schinkel.

And American cities? There are those who would despair of them because of their "dull" plans. The grid, they say, has triumphed, "the very plan has conspired to rob the inhabitants of their rights to light and air and health." [14] It is true that among American cities the vast majority have adopted the trader's plan; they were, after all, founded and continued for reasons of trade or manufacturing; but in the great American city can be found all the planning types we know; it has absorbed them all. Yet the grid predominates; very well, can we as Jefferson thought discover virtue in this triumph? We know that the plan is but a traffic artery; we know also that Richelieu, Peiping, Priene, parts of London, Paris, Rome, Madrid, Babylon, Alexandria and Salisbury arose from an

orthogonal plan. Our most beautiful cities, Charleston, Savannah, New Orleans and San Francisco, are gridiron-based; our prettiest villages also. "I would be very sorry to abolish straight lines, for they are our means for attaining great things," wrote the Prince de Ligne, in his *Coup d' oeil sur Beloeil*, who also observed, "It is better to begin to design from elements that exist, for they force us to seek good solutions." There are indeed virtues to be found in the orthogonal plan, not the least being the fact that it can be manipulated. American cities are perhaps fortunate that they are gridiron cities; no pattern is easier to change, to block off, to combine into larger chequers than one in which traffic arteries can be discontinued by a municipal decree. Changes of this type are in fact beginning to be made; they are not usually changes for the better, but they are being made because the grid is flexible enough to allow them. Now that the American city is changing its economic base, its form will change very radically; far from being "set" the grid is only a beginning. The search for an American city has scarcely begun—if some have already grown weary of pursuit, it is because they are too easily discouraged. They have not taken the trouble to find out what the city offers, to discover what is there. The American city is not mile upon mile of uniform grid—it is mile upon mile of varying impressions, of pattern, material, color and texture, of cultural and social islands, of visible and invisible barriers, demarcations and connections, of individual lives and collective lives, of varied skylines and unmatched pavements. It contains things half-remembered—altered shopfronts, houses no longer houses, home sites that yesterday were wood-lots. To sharpen our senses as we explore the city is to find it a wonderland of variety, not of sameness. And because it is not static there is always the possibility of progressive change.

But where do we begin? We have seen something of

To and from below (first level)

To and from below (first level)

PARKING

SECOND LEVEL
(Public garage)

22 entrances—345 vehicles
45° parking throughout
Total—7642 passenger vehicles parked on LEVEL ONE and LEVEL TWO

Accesses

Accesses

■ Public lifts to all public areas

Service access

in
out

Shop's Storage

Loading and Unloading

Service

Shop's Storage

Hotel access

Club and Theatre access

Dept. Store storage

Theatre

Emergency Exit

Museum Storage

Celebrity Entrance

Auditoria shop, storage, and access

Shop's Storage

Loading and Unloading

Service

City Offices Storage

Service access

in
out

12. Manipulating the American Grid.

A proposed civic and commercial center for Phoenix, Arizona. The original blocks are combined into two super-blocks, facilitating traffic flow and providing parking underground. The change in the street pattern enables the creation of a civic square, inaccessible to automobiles, but which can be reached by their passengers from below. Designer, Charles Thompson.

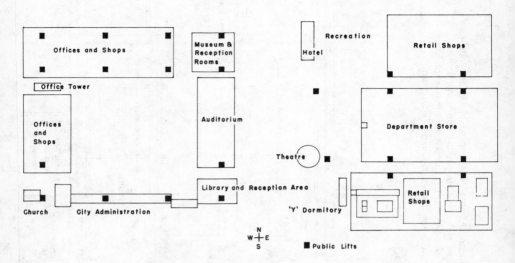

the nature of the city and the attitudes toward it that impede or hasten progress. It is now appropriate to look specifically at the American city in order to discover what is worth saving, what has been destroyed, and what can be added to the fabric. Where fools rush in, we may with wisdom tread more slowly, trying to establish a basis for the plan lest in ignorance we sweep away a valuable heritage or pass by a firm foundation for new things. How can a plan be made—how dare it?—without knowing as much as possible about the things we are dealing with? How can it be admired unless we know what else has been admired, what has been made "in the American grain?" How can we speak of the "open lot," the "skyscraper" or the "door-yard" without knowing why they were thought of and used? All these and other questions about the city can only be answered by developing *a sense of tradition*—the sense we have failed to achieve, allowing ourselves to be swayed by feelings of impermanence and the vicarious excitements of "the latest thing." We cannot exist much longer on the thread-bare notion that Amer-

100

ica is a "new" country still to be "discovered." America has been discovered, it has been developed, built and loved by many generations. They have searched, as we must search, and if we are to avoid blind turnings, it would be well to discover directions in which the main paths of tradition have led.

It is not possible to do justice to the richness of the American tradition within the framework of this book; but in the next part we shall examine certain aspects of it which seem to the author particularly significant and which are markedly different from the tradition of other countries. The aspects chosen are: land policy, the principle of community association, the industrial town and the pattern of suburbs—areas in which contributions have been made and which can guide us in the development of cities in the future.

PART 2 TRADITION AND EXPERIMENT

FIRE ON THE PRAIRIE

In the beginning there was land . . .

How often have we shaken our heads over the invest-
ments of an acquaintance who has "taken a flyer" in some
risky mining stock or manufacturing enterprise only to be re-
warded by a trunkful of worthless shares relegated to the attic
rather than the safe-keeping of the bank-vault! Yet the whole
history of American land, even of urban land, until not long
ago, is a record of the wildest speculation. It is a part of our
inheritance, and although the continent could have been
developed by other means, the speculator's role is of the great-
est importance in the founding and developing of the American
community.

"On parchment wings his acres take their flight,"

wrote Soame Jenyns of one of the Lords Commissioners of Trade and Plantations. Speculation was early fashionable. Speculators were kings and courtesans, writers and poets, high-and-low-born citizens. It was not necessarily a shady game although some, like Robert Morris, ended behind prison bars. The disappointment of not finding an Eldorado full of gold, abortive efforts at cultivating the silk worm, pinned all hopes during the Colonial period on land. Individuals, associations, proprietors joined to obtain land by royal grant and then dispose of it. "The London Company," says Gustavus Myers, "thrice chartered to take over to itself the land and resources of Virginia and populate its zone of rule, was endowed with sweeping rights and privileges which made it an absolute monopoly." [1] In the New Netherlands, any man who should succeed in planting a colony of fifty souls was to become a patroon with all the rights of lordship and was permitted to own sixteen miles along the shore, or on one side of a navigable river.

The possession of land seemed to Harriet Martineau to be the aim of all action in the United States. A member of Congress told her *that there was no character of permanence in anything*, all was fluctuation except the passion for land, which, under the name of enterprise, or patriotism, or something else that was creditable, would last till his countrymen had pushed their out-posts to the Pacific." [2]

Not until the 1840's did land become an investment; before this it was a gamble. Many gambles ended in failure; it is not enough to have land; there must be people on it. "The post-revolutionary wild land speculators in New York and other states for the most part neglected this condition. They were not developers but jobbers, interested in a quick turnover." So that when the 19th century dawned strange figures could be seen flitting through the primeval forests of the New York hinterland. Mysterious dispossessed noblemen, preferring to be known

as "Mr." in a freshly democratic society; agents of European kings, perennial British adventurers, and a native aristocracy, whose fortunes ebbed and flowed and to whom the prison walls were as familiar as the feudal estates of the Hudson. All seemed attracted to the untravelled wastes of Minewawa's thunder-land, lying west and north of the great river, where the virgin timber grew on fertile soil, enriched by centuries of falling leaves.

It was not this natural beauty, so artfully to be de-picted three decades later by a new school of painters,[3] which drew them to the scene. The Empire State, prepared for the market by financial genius, was being sold at retail.

The little group which had outwitted their rivals in the wholesale business were the uneasy possessors of outright grants, or land bought cheaply from a fledgling government. It was an investment to be disposed of quickly. Their customers were those who had ready cash. Le Ray de Chaumont, who came to collect debts owed to his father by the Revolutionary government stayed to take part in the land mania. He identified himself with the wholesalers among whom his famous associate, Gouverneur Morris, was the prime mover.[4] De Chaumont in-duced Joseph Bonaparte in 1816 to buy an estate of 150,000 acres in the Adirondacks, which, as "Count Survilliers," the new owner occasionally visited from his more comfortable landscaped grounds at Bordentown, New Jersey.

> "Here he forgot La Granja's glades,
> Escurial's dark and gloomy dome,
> And sweet Sorrento's deathless shades,
> In his far-off secluded home."

Before the general settlement of the region, the estate could produce no revenue, so the Count later sold out to John La Farge, New York business man and confidential agent of

Louis Philippe who, as King of the French, realized the insecurity of his job and invested considerable sums in American real estate. Madame de Staël also speculated in New York lands, but could not be persuaded to visit the Country of the Snows.

Thus a strange pattern developed—of sparse settlement and many things left to chance—but not quite all—land failures, land frauds like the celebrated Yazoo fraud, and constant movement of population, outside the few well-established centers such as seaports, head-of-navigation towns, agricultural settlements which had discovered a staple crop. From the days before 1830 stem some very familiar features of the American scene:

1. The open lot.
2. The almost universal desire to live under one's own roof.
3. The restless moving instinct.
4. The town that is not a town but countryside.
5. The city of voids and empty spaces, of overcrowding only in isolated places.

For luckily there were not only wealthy people and adventurers interested in land but thousands of smaller individuals who farmed and cleared as Volney and de Crevecoeur have described. And there was the "squatter." Regardless of who might own the land on paper, the squatter came, built a cabin and cleared a few acres. Cotton Mather refers to the first of them, the well-known William Blackstone, whose hut stood where Boston was founded and who was bought out in 1633 by the Massachusetts Bay Colony . . . as one "who by happening to sleep first in an old howel upon a point of land there, laid claim to all the ground whereupon there now stands the Metropolis of the whole English America until the inhabitants gave him satisfaction." [5] Pennsylvania was the first to deal with the squatters on any scale; by 1725 over 100,000 acres

108

1. The revival of the tradition of the open-lot under the influence of Andrew Jackson Downing. Belmont Place, near Boston, the seat of J. P. Cushing, Esq., partner of Thomas Handosyd Perkins in the China trade.

were taken over and improved by people who had no rights. The Proprietors compromised by surrendering land to the land-hungry; these concessions were made to save the investment in Pennsylvania as a whole.[6]

The squatter and the frontiersman are more important to our modern world than might at first thought be considered. It is not only that they did much of the real settling, while the speculations continued on paper; it is not only that the American temperament owes much to their tenacity over rights and property; it is that many of our present-day urban as well as rural forms are rooted back in the clearing, that impermanent Eden in the forest over which the individualist of the frontier toiled and sweated. "At the age of twenty-two years I could cut an acre in seven days," wrote Levi Beardsley in his *Reminiscences*. "Chopping is hard but clean work and I was fond of it. A man going into the woods with his axe soon makes an opening, which being enlarged daily, serves to encourage and

stimulate him to vigorous action." After the brush was piled the clearing was turned over, corn and even orchards often being planted the same season. Sometimes in wandering through the woods we find traces of these clearings in the foundations of a house and a few lichen-encrusted apple trees, but the tradition of the clearing lingers in the open lot of the suburban villa, the house placed in a "clearing," the ornamental trees scattered on the shady lawn. How different this placing of the house is from anything in Europe, where one does not see the continuous lawn in front of several houses or sense the feeling of the "clearing," which in spite of recent trends to enclosure still remains.

"You know that no American, who is at all comfortable in life, will share his dwelling with another," remarked James Fenimore Cooper in the 1830's. "Each has his own roof and his own little yard." This is in keeping with the standoffishness of our taciturn settler, whose migratory propensities have also lingered in his descendants. We have kept moving, not thrusting roots down into the soil, since frontier days—towns spring up, mushroom, even at this late date, or, since the house has now been put on wheels, huge flocks of trailer dwellings appear near production centers, and roadside towns appear at the bidding of the modern highway. This is all in our tradition—we have had our linear cities—the "road ranch" from which sprang long thin settlements along the trails of the covered wagon,[7] we have had mushrooming company towns, we have had stockaded towns or "stations" of Tennessee and Kentucky in which, despite the fact that they were built for protection, the cabins for individual families were spaced at wide intervals along the inside of the long fort walls. We have the widely spaced building pattern of the Eastern towns, which even today do not seem to be towns at all, often having no recognizable center. There was no feudalism, hence no feudal

village. The inhabitants come together in the town meeting, where the old sense of independence is reflected in the procedures. Truly the frontier is engrained in the American character, and the modern historian's tendency to discount it in favor of an examination of the city and the great fortunes, while the latter investigation is long overdue, should not obscure the very great importance of the hard, cruel, self-reliant life in relative isolation which has colored so many of our attitudes. The national approaches to art, to morality, and to governmental institutions are specialized approaches because of the character of early settlements and the artist, the planner or the politician who does not understand them is apt to become easily frustrated or despairing.

If American cities did not attain their real dominance until after Jefferson's time (although Philadelphia had been the second largest city in the British Empire for a period before

2. The linear town in America. El Rancho, New Mexico, which sprang up along the banks of an irrigation ditch.

111

1776) at least they fulfilled their historic role of the market and
the financial exchange. They were often "planted" and although
growing from small beginnings, they did not expand from an
encrusted center, as the feudal town sprang up from a village.
They were liable to grow in several parts at once, or to remain
unbuilt-on over long stretches of land already plotted into
streets. This was a source of considerable annoyance to their
founders, who often realized that speculation was a fickle mis-
tress. "Thus do we not only build castles, but city's in the air,"
wrote William Byrd II in his diary; he however tried to ensure
the growth of Richmond which he had laid out along the James
River by compelling the purchaser of a lot to build a house on

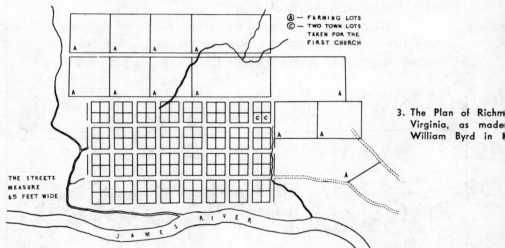

Ⓐ — FARMING LOTS
Ⓒ — TWO TOWN LOTS
TAKEN FOR THE
FIRST CHURCH

THE STREETS
MEASURE
65 FEET WIDE

3. The Plan of Richm
Virginia, as made
William Byrd in

it within two years. Earlier than this, much had been left to
chance. In 1672 Lord Ashley instructed his agent Sir John
Yeomans to lay out Charles Town "into regular streets, for be
the buildings never so mean and thin at first, yet as the town
increases in riches and people the void places will be filled up,
and the buildings will grow more beautiful." [8] Luckily for
Charles Town, or Charleston as it came to be called after the

Revolution, there was a growing merchant class who saw to it
that the streets were filled with comfortable houses all turned
to catch the breeze from the water, built of the bricks brought
over in ballast, and with streets of Belgian paving blocks; and
when William Penn, the Proprietor of Philadelphia, exulted in
1685 on a great increase in the value of town lots—"four times
the original price and over!"—his satisfaction was also due to
the activities of the burghers and merchants and their indus-
trious ways. But even the more prosperous of the Colonial cities
did not escape the blight that their European counterparts had
known for centuries; for besides the acres of vacant lots and the
capriciousness of trade, as new residential parts opened up,
older sections became consigned to secondary businesses and to
sheltering non-householders and the poorer people of the com-
munity. Thus in Charles Town signs of congestion appeared
early as the run-down houses were occupied by squatters for-
merly living in mud huts outside the old fortifications, and in
1735 a house in Market Square "divided into four commodious
tenements" was advertised, together with another "to let in
several apartments." The seeds of decay were already sown—
slums, tenements, overcrowding are not a modern invention.
By 1734 tenements had made their appearance in the South
End of Boston, which has been characterized by a Boston min-
ister as "one of the worst plague-spots in the city." Even
the suburb is no new invention—in 1739 the Shippen Brothers
advertised lots in Society Hill, then south of Philadelphia
proper, which they owned, stressing the fresh air of the country-
side and its nearness to a proposed new market. By the first
quarter of the 18th century these and similar successful spec-
ulations had created an urban leisure class and it only remained
for Daniel Dulany the planner of Frederick, Maryland to ad-
vertise himself as *a dealer in real estate* for a professional
standing to be acquired.[9] But not until John Jacob Astor began

to invest the profits of his fur trade by buying radish patches and farms up and down Broadway was the first of the really great land fortunes established. In all the world's storehouse of precious minerals none has since proved so valuable as the igneous rock of Manhattan Island.

English lords might have been expected to leave the third dimension to chance, since the nobility did not emigrate and all America was to the English a colony or a battleground; instead they experimented with it in London on their large holdings and with the help of architects like Robert Adam built the beautiful London squares. Large landowners in urban America however seemed to take even less interest than Lord Ashley or General Oglethorpe, the latter at least having provided Savannah with an engaging plan. William Byrd II, although possessing the finest library and the most sumptuous house in the country, and dressing so elegantly that he was known in London drawing rooms as "The Black Swan," did nothing to

4. Opposite page: Plan of the once-admired and now obliterated Hudson Square, also known as St. John's Park, in New York. Above: A view of Hudson Square.

beautify Richmond.[10] A hundred years later Astor started building tenements, a tradition which became his most permanent monument; although the Astors and others owned continuous blocks all over New York which they could have used to create desirable urban forms, as rich families had done in London and Paris. Even the church, so prominent in urban development in Europe and Spanish America failed to carry out its usual role of civic improvement. The religious edifices of Trinity Church may have been architectural milestones extending the length of Manhattan Island; but as a wealthy real estate holder Trinity handled its fortune like any other large American landowner, cutting it up into lots, leasing it or erecting on it scattered non-religious buildings.

An exception to this practice was Hudson Square, or

115

St. John's Park, where Trinity built a church, approving the design of John McComb, one of the architects of New York's City Hall. In 1803 the vestry decided to create a private square, the park in the center to be maintained by the owners of the adjacent lots. This was in the London tradition, but Trinity had difficulty in finding lease-holders even on the London 99-years' lease pattern (unusually long for America) and who would be willing to submit to the building restrictions imposed. In 1823 the vestry finally consented to sell the reversion of the lots in fee-simple and the square was completed. Mrs. Trollope found it both fashionable and beautiful . . . the houses on the other hand were too uniform, "when you have seen one you have seen all." The iron railing which enclosed the central park was "as high and handsome as that of the Tuileries," but in 1866 the site was sold to the Hudson River Railroad Company for a million dollars and a freight station built in the following year.[11] Today, as the motorist approaches the Holland Tunnel, surrounded by an awful confusion of truck terminals, warehouses, loft buildings and small factories, he has no idea that he is on a special plot of earth . . . the site of that rare phenomenon, an American residential square.

One of the reasons for the lack of large-scale, unified developments was the term of the lease (25 years or less on the Astor estate) and the use of small, individual open mortgages. London's leases were usually 99 years and they gave rise to large-scale improvement in the building of squares. In any case, the building activities of the very wealthy Trinity estate are pallid beside those of the Procuratia of St. Mark in Venice, which until the end of the eighteenth century handled its investments like a successful merchant and made use of its funds to embellish the approach to the Square, creating an ambience to make this city more splendid as well as more functional for trade.

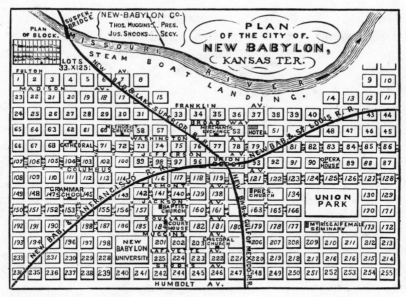

5. a. New Babylon on paper.

Large landowners, then, in the early days dealt only in land, their later descendants also neglecting their opportunities by behaving like small holders—millionaires playing with pennies. Industrialists and tycoons were no more civic-minded when their turn came and it is thus that a workable tradition of urban development has been delayed through the centuries.

b. New Babylon in fact.

For the West was even more thoughtless in creating cities. Town-jobbing and lot-selling reached its peak in the 19th century with the western settlements. Everyone speculated to sell on the basis of Martin Chuzzlewit's "Eden." Extravagant, baseless claims were made and thousands of disappointed people arrived on the sites of new towns to find them under the waters of a lake or at well-advertised "cities" to discover a few huts on the muddy bank of a river. In 1855 Colonel Barnabas Bates recalled that so many people had arrived to found cities in Nebraska that it appeared as if the whole state would be laid off in town sites. He therefore introduced a bill to protect the farming interests by "reserving every tenth section for farming purposes." Of the fourteen river cities in Kansas in the fifties— only three, Leavenworth, Atchison and Kansas City were surviving in 1867.[12]

Naturally "town-jobbing" made use of the grid—but now on a more generous scale. The *super-grid* was the result of the earlier plotting of the 640-acre section. This was a persistent practice from the start in North Carolina and in the map of Azilia can be seen the plantations a mile in length on each side with 640 acres in a square. The military papers recording Bouquet's expedition against the Ohio Indians in 1765 suggest a scheme for frontier settlements of one hundred families:

"Lay out upon a river or a creek, if it can be found conveniently, a square of one thousand seven hundred and sixty yards, or a mile on each side.

"That square will contain . . . 640 acres

"Allowing for streets and public uses . . . 40 acres
"To half an acres for every house . . . 50 acres
"To one hundred lotts at 5½ acres . . . 550 acres

 640 acres.

"The four sides of the square measure 7040 yards,

Townſhip A.		Townſhip B.		Townſhip C.		Townſhip D.	
1	1	2	2	3	3	4	4
5760 acres wood for the Town A	Commons A Commons	Commons B Commons	Wood for the Town B	Wood for the Town C	Commons C Commons	Commons D Commons	Wood for the Town D
25 lotts of 230 acres 1	1	2	2	3	3	4	4

6. Bouquet's scheme for frontier settlements employing the section.

which gives each house about 70 yards front to stockade, and the ground allowed for building will be 210 feet front, and about 100 feet deep." [13]

Bouquet's scheme resembled the already-mentioned stations of Tennessee and Kentucky, and it may have influenced Jefferson (who owned an account of Bouquet's expedition) in originating the form of *national grid* which was used after the passing of the Land Ordinance in 1785. This ordinance, devised for the disposal of Western lands, established the Hundreds (townships) of ten geographical miles square bounded by lines to be run and marked due north and south. They were to be divided into lots each of one mile square or 850 acres[14]—4/10ths of an acre marked by lines running due north and south, crossed by others at right angles. Jefferson wanted to push the idea further and lay out whole states in gigantic rectangles, but this was opposed locally in some areas and the states often had at least one natural boundary, such as a river. Land within them, however, was disposed of in sections; later the boundaries of townships were reduced to six miles. Travelling by air today it is easy enough to see the effects of this national super-grid upon the countryside with its long roads a mile apart running straight

A SECTION OF LAND—640 ACRES.

A rod is 16½ feet.	
A chain is 66 feet or 4 rods.	
A mile is 320 rods, 80 chains or 5,280 ft.	
A square rod is 272¼ square feet.	
An acre contains 43,560 square feet.	
" " " *160 square rods.*	
" " *is about 208¾ feet square.*	
" " *is 8 rods wide by 20 rods long,*	
or any two numbers (of rods) whose	
product is 160.	
25x125 feet equals .0717 of an acre.	

80 rods.

10 chains. 330 ft.

5 acres. 5 acres.

20 acres.

5 ch. 20 rods.

40 rods 10 acres.

660 feet. 10 chains.

660 feet.

80 acres.

40 acres.

80 rods.

CENTER OF 20 chains. 1,320 feet.

SECTION.

Sectional Map of a Township with adjoining Sections.

36	31	32	33	34	35	36	31
1	6	5	4	3	2	1	6
12	7	8	9	10	11	12	7
13	18	17	16	15	14	13	18
24	19	20	21	22	23	24	19
25	30	29	28	27	26	25	30
36	31	32	33	34	35	36	31
1	6	5	4	3	2	1	6

160 acres.

40 chains, 160 rods or 2,640 feet.

7. Diagram of a land section.

as a die until they meet some immovable obstacle, then shifting course only to start again on a line as direct as the surveyor's chain could make them.[15] It is thus no wonder that the great wide West is a country of open spaces, even in its cities. Western cities may now be coming of age, but as we travel down their broader and longer main streets the openings are still there. Even Wilshire Boulevard in Los Angeles until a few years ago was a thoroughfare of skyscrapers and vacant

lots. The buying and selling of land here as elsewhere determined the pattern of the cities; even the railroads, so important a factor in the development of the West, merely determined the location of towns, taking up where the river towns stopped; they organized land companies and advertised, they sold lots; they did not *build* towns. Emigrants lived in freight cars on sidings while the towns were raised by individual effort. Only in company towns, where the manufacturer was forced to build houses to attract labor, did any compact, organized town-building take place. Otherwise, while the two-dimensional pattern was inevitably fixed, the third dimension was left to chance, only rarely shaping into significance around a square, as in some of the Ohio and Illinois towns, or providing an architecturally-closed vista with the placing of a state capitol or a court house. The lost opportunities of creating beauty in American towns are endless; that is why we exclaim at the accidental effect and the picturesque skyline on the rare occasions when we find them, or take what pleasure we may in variations in color and detail. But beauty by accident has not been an adequate substitute for beauty by design.

The open lot and speculation have always gone hand in hand. Mass-building has often occurred, such as that which accompanied Cyrus Field's pushing the elevated railroad up the length of Manhattan, but for the nation as a whole the individual lot-buyer contracted separately for his house. The rows of brownstone houses which remain an interesting feature of the New York scene were the work of small speculators and construction firms. Mass-building in the form of lot-and-house group development or apartment building in several units is a comparatively new phenomenon.[16]

There had always been cyclical phases of the building industry but with 1929 the bottom dropped out of the real estate market as it never had before and life insurance com-

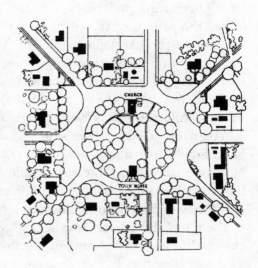

8. The circular central square of Tallmadge, Ohio.

panies, one of the important group of mortgagees, found themselves owning large blocks of real estate in the larger cities. This new situation, together with the companies' need to seek investment for their funds outside government securities and thus put their money into housing, resulted in the first tentative middle-income apartment house experiment of Metropolitan Life in the late thirties. It had been revealed that deterioration of the market had set in more quickly in speculative developments, due to over-building, reliance on an unimaginative grid pattern, lack of open space and other mistakes made by real estate after the first World War, and when the federal government decided to go into the housing business as part of its effort to lick the depression, it created among other devices the Federal Housing Administration. The government as part of its conditions for guaranteeing mortgages laid down certain standards, recommending better methods of subdividing and a certain level of construction. At a time when the public could

122

not afford to buy a lot and build on it, it was easier to buy house and lot as a package, which the developer had standardized in as close an approximation to the mass-production methods of the automobile industry as he could achieve—by large-quantity buying, careful planning and uniform housing units. The example of limited-dividend and public housing had shown what could be done in arranging units and by assembling large parcels of land. The second World War with its demand for defense housing on a large scale encouraged mass building, and finally the life insurance companies entered real estate on a larger scale instead of timidly, at Stuyvesant Town and Fresh Meadows, although it is difficult to see why they took so long with the examples of the French insurance companies building whole sections of Paris before them. The most spectacular of these urban redevelopment projects was Rockefeller Center, promoted by the Rockefeller family, but with its mortgages held by the Metropolitan Life Insurance Company.

These developments heralded an enormous change.

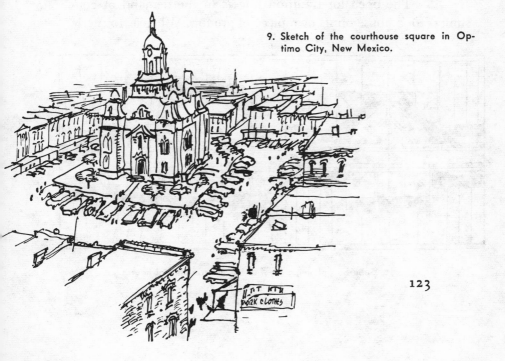

9. Sketch of the courthouse square in Optimo City, New Mexico.

123

The principle of large-scale assemblage and building was established and an earlier American tradition was superseded. As we have seen, large land holdings were a common feature of the first phase of the American tradition, but they were holdings to be disposed of quickly—part of the gamble that was the New World. Since then the established tradition has been one of parcelling out land in lots and individual building on them. Large-scale building by private individuals such as took place in London and Paris in the 18th century was very rare; the pattern was small-scale, and open mortgage financing the rule. Due to high cost of construction and the demand for cheap houses, the large-scale developer is now able to provide a commodity which the small developer used to provide and the prevalent form is becoming the lot-and-house group development. Levittown on Long Island is a well-known example of the trend, housing almost 70,000 people and is an illustration of the economies which can be effected by mass-buying, construction savings and identical plans.

The open lot tradition lingers in the demand of consumers for a house on its own piece of ground. Whereas formerly

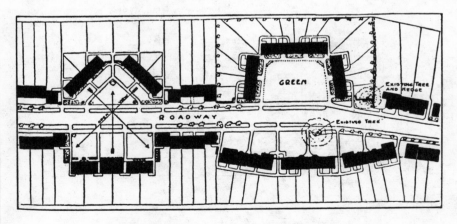

10. Suburban planning favored by the grouping of houses.

the open lot was part of a genuine tradition of independence, it now becomes an economy measure; although the house is bought with fittings and decorations complete, improvements of the ground are usually the responsibility of the individual owners. The owners shroud their basements with shrubbery to conceal them and it is interesting to compare the treatment of the lot in any suburb today with the open lot of the last century, say in Piermont, New York or Bordentown, New Jersey, the house set in the middle of its grounds with trees planted well away from it, the unmarked boundaries, the porch to provide shade. Although the dream of every suburban dweller today is Mount Vernon or Williamsburg on a landscaped lawn, there is no room for such fancies in the space he inhabits. He is living in a cell of small divisions, 7-foot ceilings and brick veneer. With the assistance of the government, commercial real estate speculation still rules, and whereas art once had a role in the form of interesting architecture, today it has been completely sacrificed. There is no room for decoration, for the crafts. Even in office buildings, which once proudly showed their sculptured cornices and doorways to the passerby, the arts have been abolished and the aim is to milk the property for all it is worth. As the Congressman told Harriet Martineau, "there is no character of permanence in anything."

And yet an important American tradition is being reaffirmed. This is marked by the increase in home ownership by

American families and it has been helped by the combination of the government, the mortgagee, and the real estate operator. It is inevitable that many more people in the United States own their own homes.[17] That they have not yet found a form of group development which will make a city is certain; suburban fringe development is still planless, yet the machinery is there to create large-scale planned communities for living the good life.

Unless metropolitan as opposed to city planning makes more headway soon, there will be no means of co-ordinating suburban and central district planning. The latest spur to the latter type was contained in Title I of the Housing Act of 1949 and its successors, down to the Model Cities program, all of which were designed to give Federal financial assistance for the rebuilding of so-called blighted areas, with latterly, coordination of social services as well. Urban renewal agencies are still engaged in trying to coax private investors, insurance companies, and other corporations to take part in the complex enterprise involved—land acquisition, project planning, and demolition all take time however, and urban redevelopment if it can surmount the hurdles still in front of it, will not be realized with the speed of a Levittown or a Park Forest, which were built on vacant land. Nor will it be possible of accomplishment without metropolitan-wide planning, since people will have to be moved to new projects built on vacant land while the slums are rebuilding. Perhaps the most immediately encouraging feature of the law is the provision that any project under urban redevelopment must be related to a comprehensive plan for the whole community. This will ensure that many more places will employ planners if only to satisfy this requirement, and that they will be forced to take a cold, clear look at themselves in the process. Planning in the United States is still in the "control" and educational phase; there are even now far too many people in high places who are unable

or unwilling to recognize chaos when they see it. It is up to American planners to convince these people that over-all planning for metropolitan areas is an immediate necessity; and to persuade the American public that the speculative builder alone cannot satisfy its demand for the good life in a beautiful landscape. But first the American planner must solve his own dilemma; brought up in an individualistic, competitive society, the principles of planning nevertheless demand for their execution a much more co-operative atmosphere than he now finds in the American city; and so he has become a frustrated person, always defending his principles but quite unclear as to their possible form of application. The American people . . . easy, friendly and highly democratic . . . have never developed a sensitivity to surroundings in the visual sense. A great fight has been won for better housing . . . at least, in this field, a principle has been established. In planning, the "form-will" (a word coined by the architect Dudok) has yet to be developed. If the planner really wanted to achieve his goals he would work more closely with the other disciplines, not holding up "the only way" to achieve a better physical environment, but exploring every possibility of working with people in all walks of life. One avenue would be based on the possibilities of pride and pleasure in civic form. The American people have that instinct, but it is buried deep under the "go-getting," "rugged individualism" slogans which have been their inheritance since the days of Herbert Spencer. It is time now to uncover it, to bring it to the surface as Jefferson had to do, in his time. "In a country which has no aristocracy of taste," warned he, "houses, grounds and towns must be surrounded by a maximum of beauty." The task is no more difficult than it was in Jefferson's day; the machinery has been created; in fact, the time is ripe. If we are to have large-scale redevelopments at the center and group residential projects on the outskirts on a generous scale for the first time in our his-

tory, it is only public indifference which will prevent their being better than they might be. And public indifference will end when we become acquainted not only with civic duty but with civic art.

12. A "habitable dwelling" or pre-emption fraud.

CHAPTER 6

A FEW RAGGED HUTS

For over a hundred years two problems have faced the urbanist: how can old towns be improved and how shall new ones be built? Americans have had experience of the latter problem throughout their entire history, but especially in the nineteenth century when the frontier pushed further and further west and European convulsions spilled thousands into a new and promised land. Experiments in town-building were continuous—most of them within the prevailing pattern of business and industrial expansion, a few outside it. The exceptions to the prevailing rule of town jobbing or industrial planning are an important part of our inheritance—important out of all proportion to their size. Not the least of their remarkable aspects was their testing of the principle of sharing—either of God's or

129

the world's goods, depending upon the beliefs of their founders. They are more notable for bravery than for art, and for giving courage to reformers of society's crowded center than for improving their own surroundings. Cities built for idealistic reasons—religious communities, early socialist societies, utopian experiments—might be expected to show some evidence of the theories which prompted their creation in their plans. In America, this was seldom the case. On the whole, the country was chosen as a site for utopias because of the large cheap tracts of land which existed here, remote from "civilized" society, and because its political liberty had an irresistible charm for persecuted Rappites and Icarians in their native lands. In the case of the sectarian communities, not only did they show a lack of forethought in planning, but, generally speaking, they avoided theories of social reconstruction and were, in fact, retreats where the members could exercise their religious beliefs

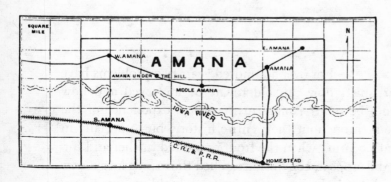

1. Plan of the Amana Villages.

and get along on a poverty-stricken basis, free from persecution. Such were the communities of the Shakers, the Inspirationists, the Perfectionists, the Mennonites, and others.

Many of these places can still be seen. Some, like the Amana villages, still function. On the whole, the best way of understanding them is through the eyes of visitors, who curi-

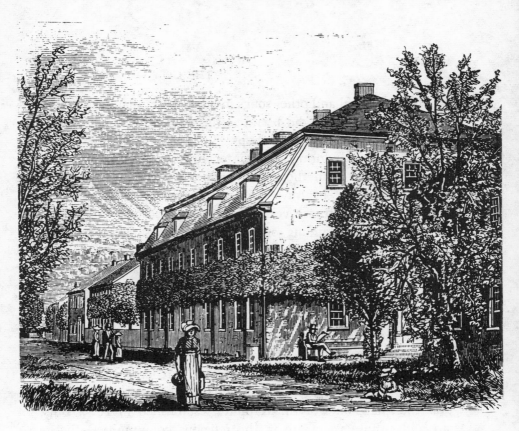

2. The Assembly Hall at Economy.

ously watched them at the height of their influence a hundred years ago. For example, at Economy, Pennsylvania:

> "When the Duke of Saxe-Weimar visited Economy, half a century ago, it was at its point of greatest prosperity. It had a thousand inhabitants. Every house was occupied, every factory fully manned. There was a fine museum, costly paintings (one of which, 'Christ Healing the Sick', by Benjamin West, now ornaments the house built for George Rapp), and much attention was given to music. Sixty or seventy girls, the Duke says, collected in one of the factory rooms, and with their venerated founder in their midst, sang their

131

spiritual and other songs in a delightful manner. 'With real emotion did I witness this interesting scene. Their factories and workshops,' he goes on to say, 'were warmed during the winter by means of pipes connected with the steam engine; and all the workmen had very healthy complexions . . . I was also much gratified to see vessels containing fresh, sweet-scented flowers standing on all the machines. The neatness which universally reigned was in every respect worthy of praise.' " [1]

The evidences of art which the ducal visitor observed at Economy were due to the influence of Frederick Rapp, the adopted son of the venerable founder, George Rapp, whose theories of separation from the established church in Germany had led him with his band to America. Frederick introduced pleasure gardens, a grotto and a labyrinth to Economy, which was the final home of the Rappites, established in 1825. But art and culture were rare in the religious communities—there were usually common schools, no higher education—and the towns were noted for their drab simplicity. They were also noted for the tyranny of their leaders, dissension among the flock, and all the abuses of privilege which were the inevitable accompaniment of communities founded on religious fanaticism. At the outbreak of the Civil War, the Rappites at Economy held half a million dollars in capital, which they buried in their back yards until the war was over. The society evolved by the 1900's into a limited partnership owning lands, oil wells and stocks in railroads, banking and mining corporations. In 1904 the property was split up among the few survivors.

The Owenite and Fourierist communities suffered economic collapse but were more productive of ideas for society. The town of Harmony, on the banks of the Wabash, which

Robert Owen bought from Rapp to establish his own community there, had its "trust" of intellectuals, and a fair share of advanced ideas and institutions for the times. The "trust" was a group of scientists and educational reformers, which loosely governed New Harmony (as the community was rechristened after the Rappites left to establish Economy) and managed to give the town seven constitutions, the last one placing in the hands of Owen, together with four other members appointed by him, the entire administrative powers.

The Owenite communities (over twelve of which existed between 1825 and 1830) were the first in the United States to be founded on a social theory. They were established to promote the ideas of Robert Owen, the successful Scottish mill-owner, who had become convinced that man is the creature of surrounding circumstances, that his character is made not by him but for him. The logical conclusion to this, Owen decided, was to raise his character and habits by improving living and working conditions.[2]

When, in 1800, he had taken over the mills at New Lanark, Scotland, which had been established by David Dale and Sir Richard Arkwright in 1784, Owen proceeded to put his theory into practice by establishing infant schools (the first of their kind), reducing the hours of labor of the workers and increasing their pay, which had been previously at rock-bottom. He remodelled the town and, as a result of his experiment, became one of the most sought after and popular persons in Europe, the attraction being that anyone who could improve the prospects of capitalism must be worth cultivating. He became one of the instigators of long-overdue factory legislation in England.

What eventually separated Owen from his manufacturing friends was the belief that developed in him as a result of his experiences that an equal degree of morality and hap-

133

piness presupposes equality in all material conditions of life. His subsequent experiments were based on an attempt to prove this theory. He proposed in England the establishment of industrial communities on a basis of mutual cooperation. Women were not to work in the factories, and beautiful gardens were to surround the model homes. When this proposal was coldly received by Parliament, he sought around for other solutions, a search which finally ended with the purchase of the Rappite settlement in Indiana.

> "Land of the West! we fly to thee,
> Sick of the old world's sophistry;" [3]

chanted Owen and his sons on their ocean journey to the young continent, where indeed a new life was awaiting them.

When the Owens took over New Harmony, it was a regularly laid out village with streets crossing each other at right angles, several large brick buildings, a public square, houses, mills, and factories. On January 26th, 1826, a strange craft rounded the bend of the Wabash River and proceeded laboriously to unload its passengers at the New Harmony wharf. This was the famous "Boatload of Knowledge," a keel boat built by the wealthy scientist, William Maclure, investor in the colony, to carry a cargo of intellectuals from Pittsburgh down the Ohio and up the Wabash. Its progress was watched with great interest by the whole of America, where Owen's influence had already been felt. He had addressed the Congress and shown plans of a model community in many cities. At Cincinnati his audiences were so impressed that a group of 75–100 families of "chosen spirits" organized a farm community at Yellow Springs, 75 miles north of the town. Being mostly people of refinement, culture and wealth, they soon tired of manual labor and returned home to rest their shattered nerves.

The "Boatload of Knowledge" contained people of

different caliber. Not only were there on board a dozen or so distinguished teachers, but also several scientists. The educators were followers of Pestalozzi, the Swiss reformer who employed the doctrines of Rousseau and the French Revolution and believed that knowledge was to be imparted in accordance with desire. The scientists were friends of Maclure, who was himself the father of American geology. They included Thomas Say, the naturalist, Dr. Gerard Frost, the geologist, and Charles A. Le Sueur, the archaeologist. Together with the beautiful and rebellious Frances Wright, who had founded the historic anti-slavery colony at Nashoba in 1825, and Robert Dale Owen, the son of the founder, then 24, these people came as the result of the elder Owen's call to practise their theories on the motley collection of individuals, numbering about 1000 men, women and children who had rallied to the experiment from every state in the union and from abroad.

It was unfortunate for Owen that he did not try to build up an industry that could not suffer in competition with the larger centers, as did New Harmony's. The Oneida Community was successful many years later in developing the manufacture of steel traps and later its famous Community Plate, from which it grew rich and prosperous. There was nothing so special to hold New Harmony together. Successful as its educational system was (Maclure's schools were genuinely progressive, with infant classes, manual training, equal opportunities for girls, and absence of corporal punishment), and in spite of an attempt to divide the work fairly, it was the economic factor which finally wrecked the experiment, mainly because so little attention was paid to it. Colonies of separatists broke off and settled round about. There was a good deal of dissension and quarreling.

The Duke of Saxe-Weimar's observations reveal the state of affairs in New Harmony only a year after its occupation.

"Mr. Owen . . . was glad at my visit, and offered himself to show everything, and explain to me whatever remained without explanation. As the arrangement calculated for Rapp's society was not adapted to his, of course many alterations would naturally be made. All the log houses still standing in the place he intended to remove, and only brick and frame edifices should be permitted to remain. *Also all enclosures about particular gardens, as well as all the enclosures within the place itself, he would take away,* and only allow the public highways leading through the settlement to be enclosed. *The whole should bear a resemblance to a park,* in which the separate houses should be scattered about . . .

"I had an ample conversation with Mr. Owen, relating to his system, and his expectations. He looks forward to nothing less than to remodel the world entirely; to root out all crime; to abolish all punishments; to create similar views and similar wants, and in this manner to avoid all dissension and warfare. When his system of education shall be brought into connection with the great progress made by mechanics, and which is daily increasing, every man can then, as he thought, provide his smaller necessaries for himself, and trade would cease entirely! I expressed a doubt of the practicability of his system in Europe, and even in the United States. He was too unalterably convinced of the results, to admit the slightest room for doubt. It grieved me to see that Mr. Owen should allow himself to be so infatuated by his passion for universal improvement, as to believe and to say that he is about to reform the whole world; and yet that almost every member of his society, with whom I have

conversed apart, acknowledged that he was deceived in his expectations, and expressed their opinion that Mr. Owen had commenced on too grand a scale, and had admitted too many members, without the requisite selection! The territory of the society may contain twenty five thousand acres. The sum of one hundred and twenty thousand dollars was paid to Rapp for this purchase, and for that consideration he also left both his cattle, and considerable flocks of sheep behind . . .

"I afterwards visited Mr. Neef, who is still full of the maxims and principles of the French revolution; captivated with the system of equality; talks of the emancipation of the negroes, and openly proclaims himself an ATHEIST. Such people stand by themselves, and fortunately are so very few in number, that they can do little or no injury . . .

"We amused ourselves exceedingly during the evening, dancing cotillions, reels and waltzes, and with such animation as rendered it quite lively. New figures had been introduced among the cotillions, among which is one called the *new social system*." [4]

Although none of the Utopian colonies could last for long—they were little islands always subject to swamping by the sea of manufacturing economies that surround them—several hundred existed in this country in the nineteenth century, and altogether they housed hundreds of thousands of inhabitants. Early attempts at city planning by methods different from the prevailing business system, they both suffered and survived by the power of their protest. New Harmony, indeed, still exists, looking back to a past not always fully understood. The first workingman's institute was founded here, the first women's club, the United States Geological Survey. It was a cradle of

the emancipation of women, an anti-slavery stronghold, a center of the public school system. Its influence was greater than its population, size or design.

The Duke of Saxe-Weimar, who observed other social experiments during his two-year stay in America, heard nothing but scandal of Robert Dale Owen's partner in so many ventures, the engaging Frances Wright. In Boston, she was considered *déclassée* (as indeed she proclaimed herself). In Philadelphia a lady of refinement and breeding described the beautiful agnostic lying in a drawing-room stretched full length on a couch, occasionally emitting such trenchant remarks as: "I consider bears to be of more value to society than men." This, the Duke thought (he was apparently willing to believe any gossip), she would soon be able to put to test, in the wilds of the Wolf River country, back of Memphis, where for $10,000 she had purchased the land for her Nashoba experiment.

3. "If it be but a few ragged huts. . . ." The clearing at Nashoba.

Nashoba was a bolder experiment than Owen's since it was an attack on the system of slavery. In its first stage the colony was scarcely more than a paternalistic move to emancipate Negroes for eventual transportation to Africa, an idea which recurs continually throughout the nineteenth century.

138

However, Miss Wright was ahead of her time and eventually came to the conclusion that Nashoba should be a cooperative colony where whites and free Negroes would live and work together and be educated as equals. This proposal was immediately and inevitably attacked, scandals were freely circulated and rumors of cohabitation among the colonists were eagerly discussed. The unique nature of the organization and the inability of its white members to survive in the mosquito-infested lowlands further hampered development and it survived only a short time. Never more than a handful of huts in a forest clearing, Nashoba was ever an idea rather than an actuality. Frances Wright's next venture was with the *Free Enquirer* in New York, where she continued to expound her ideas on slavery and the reform of society, becoming an early leader of the socialist movement. "What distinguishes the present from every other struggle in which the human race has been engaged," she wrote in her newspaper, "is that it is evidently, openly and acknowledgedly, a war of class, and that this war is universal."

The theories of Fourier, who spoke of Owen only with contempt, had the distinction of being applied almost exclusively in the United States, where in the forties and fifties, Fourierism attained the dignity of a national movement. Advocated in America by Brisbane and Horace Greeley, the highly artificial units were called Phalanxes, and were composed as follows: seven-eighths of the members were to be farmers or mechanics, the rest capitalists, scientists, and artists. All who wished would own as much stock as they wanted in the Phalanx. At the end of the year five-twelfths of the profit would go to labor, four-twelfths to capital and three-twelfths to skill or talent. There were no fixed classes, however; a man could belong to two or all three groups and at the end of the year get his share of labor's share, according to the work he put in, and his share of capital's share, according to the amount of stock he owned.

This compromise scheme between capital and labor

carried out in the main the somewhat fanatical principles of its founder. He expected that philanthropic millionaires would start the Phalanxes and was still waiting for these gentlemen to materialize when he died in Paris in 1837. Albert Brisbane,[5] the elegant American who was thoroughly at home in the drawing rooms of Paris and Berlin, had studied under Fourier and failed to be warned when the master expressed his belief that the earth was fast approaching the state when the oceans would taste like lemonade. Brisbane was really attracted to Fourierism by the idea that through it toil would be elevated and rendered attractive—a fascinating idea to a young gentleman of refined tastes. His *Social Destiny of Man*, published in 1840, was read by all. It converted Horace Greeley, who opened the columns of the *New York Tribune* to Fourierism. New Yorkers were mildly surprised, then bored, and ended by shouting "Mad Dog" at Greeley, who in 1842, founded the colony of Sylvania, modelled on Brook Farm and organized on the principle of "common ownership of property and the equal division of labor." It started with a capital of $10,000; membership shares sold for $25 each, most of which were bought by the editor of the *Tribune* himself.

4. Main House in a Shaker Village.

"The Sylvania Society bought several thousand acres of wild land, erecting a large common building and communal shops. The directing board, however, experienced difficulty in assigning jobs to everyone's satisfaction. Greeley decreed that a woman should rule the colony. Many of the three or four hundred colonists, among them wayward scions of affluent New York families, fled the rigors of the place, which, as Greeley later complained, could raise only snakes and stones. The Experiment did not survive the crop failure of 1845, brought on by an Independence Day frost. Some of the present occupants of Greeley, now a resort village, are descended from Sylvania colonists." [6]

But there were 41 phalanxes in the United States before the craze was over.

They needed the millionaires. None of them were more than miserably poor settlements, in which the Fourierist principles had no chance of being carried out. Brook Farm, which became a Fourier community in its latter days, was an exception, but even it could not survive the destruction of its main building. The cry "our Phalansterie is on fire" which echoed over the meadows one fine summer's evening spelled the end of Fourierism in America and everywhere else. It is one of the curiosities of history that the movement could have lasted so long. And yet when we see our own nature colonies, the religious cults of California and "back to the land" settlements of Henry Ford and others, the Phalanxes seem almost noble by comparison. The only sectarian community of purely American origin was John Humphrey Noyes' Oneida which flourished for many years but suffered from attacks on its marriage system, which was a combination of polygamy and polyandry. Bethel, Missouri

and Aurora, Oregon, owed their peaceful existence to the influence of Dr. Keil, their founder; they broke up shortly after his death in 1877. The Icarian communities which were composed almost entirely of Frenchmen got off to a bad start when they were swindled over a tract of land in Texas, but eventually became established in Louisiana. None of these communities contributed much to city planning, though a few, like the Amana villages, are interesting for their architecture.

Oleona, the dream of Ole Bornemann Bull,[7] a Norwegian virtuoso who fiddled his way across the continent in the 1850's, amassing a considerable sum of money in the process, was typical of the escapist communities which followed in the wake of the sincere early experiments. He invested his earnings in 11,144 acres of wild forest highlands near Coudersport in northern Pennsylvania, hoping to attract Norwegian immigrants to the spot because the tract resembled their native land. Ole Bull was a colorful and popular figure, both in America, where he introduced Adelina Patti on one of his tours, and in his native land. Oleona was to be "a New Norway, consecrated to liberty, and baptized with independence, and protected by the Union's mighty flag." Altogether nearly 800 colonists were attracted to the spot in 1852, when they were paid a minimum wage (if they were strong of limb) for clearing the forests and establishing the community. No less than four

5. The Icarian Domain.

villages were planned, by name Oleona, New Norway, New Bergen, and Walhalla. Bull set to work erecting churches, schools, a tannery, houses and a castle for himself on a nearby mountain top. There he spent hours with his violin, music echoing through the valley, and dreams of a new life in America passing in a delightful fantasy through his mind. Henry Clay contributed blood horses to the colony, and all America wished it well. Bull announced that he had contracted to make 2000 cannon for the government and took out patents for a new type of smelting furnace which he hoped to establish nearby.

Although much of the Ole Bull saga has been questioned by modern historians, who doubt that the castle was ever built, his later career is better documented. In 1853, he discovered that John F. Cowan, the dubious personage who had sold him the land, had apparently done so under a false title. Bull was compelled to relinquish his holding in 1853, which left nobody to pay the wages. The disappointed colonists were in desperate straits. The little Patti sang in Philadelphia for the relief of the colony, a concert which was attended by the President. The colonists eventually were forced to pack up and leave for Wisconsin, where they may have fared somewhat better. Left behind in the village store were twelve dozen high hats, which attracted curious lumbermen who came when the land was eventually purchased by timber lords (more than one of whom made their fortune there). These had been introduced by Bull for the official headgear of his people, and left behind at the colony's dissolution. The lumbermen joked about them, bought them and willed them to their sons. Some may still be found in the district more persistent than the Oleona structures themselves. The tract is now a tangled wilderness left by the lumber kings. Ole Bull himself became a neighbor of Longfellow in Cambridge, where he was introduced to Thackeray, who thought him amus-

ing enough to be put in a novel. He was certainly one of the most picturesque figures of his time.

Of all the 200 and more planned Utopian and sectarian communities which were started in the nineteenth century, the above are but a sampling. The reasons for their failure should, however, by now be clear. The most successful were those which imitated the prevailing methods of production, like Economy and Oneida, and did not threaten the rest of society with their aims. None could be successful in the long run because of their limitations and size—the Ambridge steel plants on the site of Economy are in many ways a fitting epilogue to this story and a lesson to would-be imitators of this type of development in an age of capitalism. As protests they were of influence and value, but they can never again be repeated. In Owen's day, when Americans had only recently changed from their agrarian economy to a new industrial society, much of the past seemed good, as indeed it was, compared with the squalor that manufacturing was creating in the big cities. Owen felt there was no need to accept the city as the norm, not realizing that it was the only basis on which industry could be quickly built up and markets developed.

Most of the thousands of small towns that were founded in the nineteenth century without benefit of planning

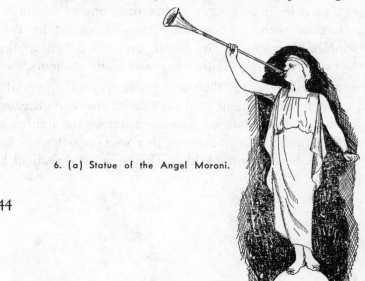

6. (a) Statue of the Angel Moroni.

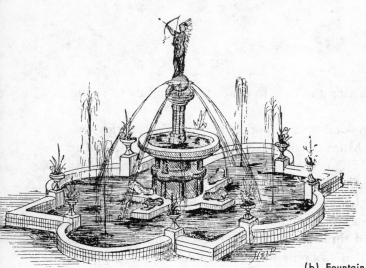

(b) Fountain in Salt Lake City.

had this advantage over the Utopian and sectarian communities—they owed their existence to an economic fact, like oil, lumbering, transportation, or some industrial plant. They might founder or decay through overspeculation or exhaustion of natural resources, but in a business society they had more chance of succeeding than those communities which thought of business only as an irritating but necessary adjunct to other more vital and spiritual things.

The success of the Mormon experiment in the Valley of the Great Salt Lake is a case in point . . . here a special effort was made to develop the natural resources of the territory through a carefully planned economy. The history of the development is important in American planning; a whole region was founded on its efforts and the West peopled with a new and energetic social group.

Men like Stephen F. Austin, the maker of Anglo-American Texas, and Brigham Young, the founder of Utah, who seldom appear in accounts of American planning, are even more important for study than their handiworkers, the surveyors and designers of their cities, who occasionally are treated at some length. The fact that they are political figures gives them an added importance—they knew something of the forces that

145

were shaping America and how to adapt their projects to changing events.

Nauvoo—one of the models for their later cities—was founded by the Mormons in 1839. It was built on the site of the small town of Commerce, about fifty miles up the Mississippi from Quincy, Illinois. Thither the Saints fled, under the guidance of Brigham Young, while their leader Joseph Smith was languishing in jail. They busied themselves by raising within the short space of three years "a city thrice the size of Chicago of that day." It had a population of over 20,000, due largely to the large numbers of followers that the sect was already attracting, and rapidly became the largest city in Illinois.

Following his release from the Missouri jail the Prophet Smith was able to put into effect his inspired plan for a City of the Saints. Nauvoo was laid out with broad, straight streets running at right angles to each other—a model to be followed by Young in the cities of the Great Basin. The Charter was "the most liberal ever granted to any American city." It provided almost complete independence for its citizens in matters of law and education.

When the Prophet was killed in 1844, his church did not fall to pieces, but the Saints in outlying settlements were mobbed and Nauvoo itself was threatened. Young, the new leader, determined to move far enough West to isolate his followers from all possible harm.

In comparison with other colonizers Brigham Young was outstanding in the support he received from his flock.[8] Although Penn had established his peace-loving commercial colony of Pennsylvania, Oglethorpe had settled English paupers in order to build the buffer colony of Georgia across the Spanish front, and Austin had founded the Republic of Texas and won "a contest of civilization," [9] Young managed to achieve a combination of similar objectives through the sacrifice and hard

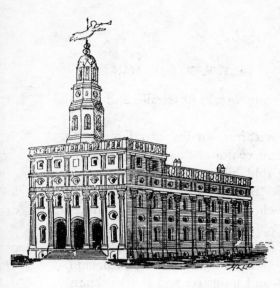

(c) The Nauvoo Temple, Illinois.

work of a people who believed that they, and only they, had found the true faith. Joseph Smith had revealed that the only way this faith could be practised was to bring "the seed of Israel" from all over the earth to a Mormon citadel. In the span of the Mormon Empire they built up between three and four hundred cities and settlements.

The great valley was not a particularly inviting spot, especially with the lure of the California gold fields a little further to the West. But Young had said "This is the place" for a reason. "The worst fear that I have about this people," he announced, "is that they will get rich in this country, forget God and his people, wax fat, kick themselves out of the Church and go to hell. . . . It is our duty to gather Israel, pay our tithing and build temples." There was the example of the disciple Samuel Brannan to be used as a lesson. Arriving in San Francisco by ship just before the Gold Rush of '48 with a party of Mormon colonists, he participated wildly in San Francisco real estate, became the organizer of mining and railroad companies, purchased a distillery, became a large landowner in California and Mexico, and for a time was known as the richest man in California. He "went to hell" by acquiring dissolute habits, divorcing his wife, marrying a Mexican woman, dissipat-

147

ing his fortune and dying "a sorry wreck, physically and financially." So went the Mormon story.

Mormon literature thereafter was full of references to the necessity of mining iron and coal and the undesirability of finding gold. Brigham Young told his people that they would get richer by staying at home. "Before I had been one year in this place, the wealthiest man who came from the (gold) mines, Father Rhodes, with $17,000, could not buy the possessions I had made in one," he boasted. Young was a careful business man. He preached the wealth, strength, and glory of England, based on her coal mines, iron and industry; and the weakness, corruption and degradation of Spain and Spanish America growing out of their gold and silver and their idle habits.

In 1849, "The Perpetual Emigrating Fund Company" was founded to make loans to converts in the United States and foreign countries who wished to travel to Utah. After establishing themselves in the Basin the borrowers were to return the money with interest. Thousands of immigrants gratefully availed themselves of the service, although in the early days many died of the arduous journey, pushing handcarts full of their belongings across the burning prairie.

Mindful of former persecutions, the Mormons made every effort to preempt all the choice lands to prevent occupancy by those who might oppose them and often headed off non-Mormons who entered the valleys intending to settle. Frontier opinion was with them—the disposal of lands at high prices was considered an imposition and the auction an affront. The supposed natural superiority of agriculture as a form of wealth was part of frontier philosophy. The resulting communities were unique farming-towns in which some of the Saints lived and tilled their five-acre lots, beyond the city boundary proper. Everything was on a broad and expansive scale, but the protection of the city was afforded the inhabitants who were only small-scale farmers at this time.

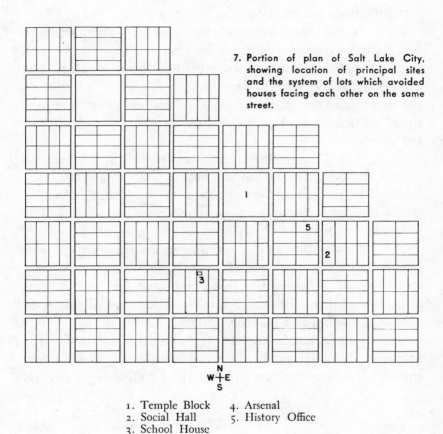

7. Portion of plan of Salt Lake City, showing location of principal sites and the system of lots which avoided houses facing each other on the same street.

1. Temple Block 4. Arsenal
2. Social Hall 5. History Office
3. School House

The Mecca was Salt Lake City. Young selected the site for the temple between the forks of City Creek. After that, plans for the city were drawn as follows:

The city was to be laid out in square blocks of ten acres each, with the temple block containing forty acres.

Each city block should be divided into eight lots, ten by twenty rods, the streets to be eight rods wide.

The plan designated that only one house be built to a

149

lot, each house to be located in the middle of the lot, twenty feet back from the front line.

It was also determined that upon every alternate block four houses were to be built on the east, and four on the west side of the square, but none on the north and south sides. The intervening blocks were to have four on the north and four on the south, but none on the east and west sides. Thus there were to be no houses fronting each other on the opposite sides of the streets.

The Temple Block was later reduced to ten acres to make it uniform with the others. Brother Brigham and the other leaders had the first choice of lots near the Temple. No dissatisfaction with this distribution appears in the records. The rest were drawn by lottery. No money was paid.

This method of city planning was nearly identical with Joseph Smith's original city of Zion, in Jackson County, Missouri. Several towns in the mid-West were laid out on this plan—among them Kirtland, Ohio, Far West and Adam Oudi-Ahman, Missouri, and Nauvoo, Illinois.

Large Church holdings were entered when in 1869 the Mormon titles were eventually recognized by the Federal government. In municipal government the Church duplicated its

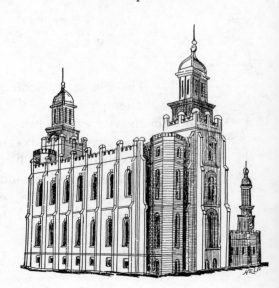

8. The Logan Temple, Utah.

spiritual functions, even to the extent that the Bishops were in charge of the management of the irrigation waters. They directed the construction of canals, the allotment of farm lands and water rights as well as the building of bridges, churches and forts.

But even Mormonism which had been the strongest and most successful colonizing influence of the nineteenth century, could not withstand the penetration of American industrial economy which was pursuing its relentless march on the heels and sometimes in advance of the Western "pioneers." Perhaps Young delayed it for a time, but in many ways he laid the groundwork for it in training a cheap labor force, developing the land, and building the cities. Inevitably, over half of Utah's industries and manufacturing establishments are now located in Salt Lake City. The state of Utah, blessed with the greatest variety of mineral resources of any comparable area on the face of the earth, was to attract iron smelting, coal mining, the giant plants of the United States Steel Corporation, the production and processing of valuable radio-active ores, and with the exception of tin, the development of every other important metal known to man. In this century, Utah has become a paradise for big corporations and large-scale commercial farming—a different "paradise" from that of the Mormon prophet, but none-the-less productive. The planning power of America's industrial hegemony has always proved stronger than that of the cities of dissatisfaction and promise.

Nowadays it is a commonly-held opinion that any enterprise which is not individualistic is counter to the American tradition. If the record of the utopian socialist and religious communities seems too atypical to disprove this contention, there are examples of the principle of association outside the frontier pattern. The presence of business enterprise in the valley of the Great Salt Lake merely underlines the fact that association

151

is appearing under different guises. Our extraordinary talent for business and industrial cooperation should not go unremarked . . . perhaps after all the modern form of association is best seen in great corporations, and small business and professional groups bringing together the most diverse strains and promoting through clubs, charitable organizations, drives and civic enterprises of all sorts, something which we have called the American community spirit. The American temperament lends itself well to civic organization; everywhere cooperation is taken for granted, as something no one would be so mean or shortsighted as to refuse. "The general instinct," Santayana has pointed out, "is to run and help, to assume direction, to pull through somehow by mutual adaptation, and by seizing on the readiest practical measures and working compromises. The omnipresence in America of this spirit of cooperation, responsibility and growth is very remarkable."

American business society, in perfecting an unrivalled system of administration, production and distribution, has both aided this spirit of cooperation and profited by it. Can society itself now profit by seizing the cooperative threads to create an environment for the industrial age?

There is a new and significant trend in our economy which may eventually bring this environment closer. Whereas business used to stand apart from government in the economic sense, today a forced association has joined the two in many fields where previously there was no spirit of cooperation, notably in residential construction and urban redevelopment, where private enterprise has been unable to do the job alone. Society must now find the means by which this cooperation can be made more effective, by creating new instruments and exploring new areas in which the increasing scale of joint business and government activity can make real contributions to our way of life. The modern community is a vastly more complex affair

than any hitherto known and it is only through active participation by business, industry, government and citizens alike that it can be made in any degree satisfying to our dream of a better life in an industrial society.

Today there is a new wave of Utopian communities in the United States, only a small proportion of which are linked to the spread of hallucinatory drugs. Many have arisen in protest against a way of life considered to be headed for world conflict and are situated in remote areas; others are to be found in the heart of the cities as a protest against racism.

As we have seen in the failures and successes of ideal towns in America, it is their *people* who were important in the story, not their location or size. "A great city is that which has the greatest men and women," wrote Whitman. "If it be but a few ragged huts it is still the greatest city in the whole world."

CHAPTER 7

INDUSTRIAL BLUEPRINTS

For a few uncertain years after Jefferson became president in 1801 nobody was sure that industrial development was inevitable. Some indeed thought that America should remain an agricultural-commercial society, a democracy based on roots in the soil. The impending war with the British, which would cut off trade, caused Jefferson, Madison and other supporters of the old agrarian economy reluctantly to accept manufacturing before the year 1812 in spite of the evils they knew it would bring. Cotton and woolen mills, forges and machine shops were quickly established and "the musketry of shuttles and sledges" grew loud throughout the East. In spite of many initial failures American industry developed remarkably quickly, and the whole outlook of the country began to

change. A new morality, based on the dignity of toil and the spiritual rewards of industry was propagated by those interested in manufactures, long before Herbert Spencer elaborated it into the heavy tomes of his *Principles of Ethics*. Alexander Hamilton used it in his recommendations to Congress on industry, to justify his advocacy of women and children working in the mills. "Women and children are rendered more useful, and the latter, more early useful, by manufacturing establishments than they would otherwise be," he suggested and the manufacturers agreed. Women and young girls began to leave the farms for the brick and stone monitored sheds along the rivers of Rhode Island and Massachusetts.

Scientific and engineering advances helped the trend to manufacturing. Steamboats (1807), turnpike roads (1817), large navigation canals (1825), and finally railroads (1830), the last particularly consuming huge quantities of capital, wood and iron (and encouraging speculation in land) accelerated industrial development and created new cities in their wake. By 1820, Harrisburg, Pittsburgh, Albany and Hartford were thriving centers; by 1830 Cincinnati, Louisville and St. Louis were busy ports; while ten years later Rochester, Buffalo and Cleveland had been established to develop the Great Lakes trade.[1] It is not these mixed centers, however, but the more specialized industrial community which forms so unique a chapter of the American planning tradition. Apart from the fact that they are still being built, the communities created entirely for and by manufacturing interests have an effect on our attitudes to city planning which is important even today. The siting of the early American factory town was different from the European. The rising industrial cities of England, like Manchester, Sheffield, Bradford and Leeds, were powering their plants by steam. Coal was brought from the nearby fields, and since they did not have to seek a source of power, manufacturers tended to

1. A Mauch-Chunk "Highway." Production of anthracite occasioned new towns after 1820.

settle in existing commercial centers or market towns. In America, until quite late the mills were powered by water, sought by factory builders in the smaller valleys and streams of the rustic countryside. Sometimes a convenient village existed but more often this decentralization into the woods and fields necessitated the construction of completely new communities along the Merrimac, the Thames, or the Connecticut. Today, as one drives through the back roads of Connecticut or Massachusetts, it is still possible to come on these factories in the woods, sometimes with their little regularly-laid-out housing developments still intact, more often decayed with the rise of twentieth-cen-

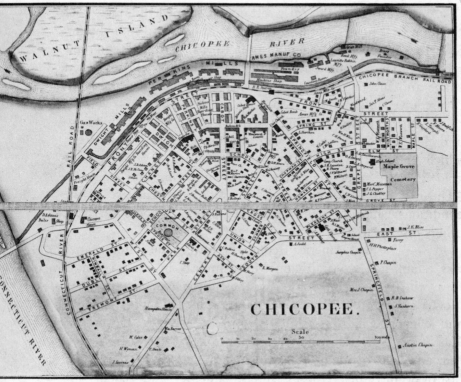

2. That the Boston Associates did not always use the grid-iron in laying out their industrial towns is shown in this radial plan of Chicopee, Mass. (1855).

tury automobile transportation. On the main roads one cannot escape the larger industrial towns, the Lawrences and Lowells, which were more successful but are also touched with the fingers of decay, not always apparent in the uniform rows of brick facades.

Thus, while schismatic preachers and utopian socialists described in the previous chapter were busy with their plans for new communities and cultures in the American wilderness, a more lasting pattern was being established by men who were in the main stream of economic events, not outside it.

157

Very often the early settlement formed the nucleus of the industrial town, as at Springfield, Waltham and Manchester. Sometimes, however, the industrial towns were built on new ground and were conscious examples of "planning." That is, their shape and substance were fashioned within a loose framework of predetermined industrial location, middle class and working class housing, a thoroughfare system, a group of civic buildings and churches. Such were the later towns of the East and West, which grew up overnight on the speculative development of gold, oil and other mineral reserves, lumbering and shipping. "The possibilities for their survival were as speculative as the conditions which brought them into being." [2] Some survived, others disappeared.

The first American company town of any importance was established at Waltham, Massachusetts in 1813-14, in a form which was later adopted by the Boston Associates all over New England. The beginnings of Lawrence, Lowell, Holyoke and Chicopee in Massachusetts, and Manchester, Dover and Nashua in New Hampshire were controlled directly from Boston, and thus became "the rational result of the decision of a board of directors. Houses, stores, churches and schools are laid out with the precision of a factory, without any direct geographical relationship to the other business activities or homes of the owners. The roots of the town are to be found not in genetic but 'architectural' beginnings; they go no further back than the blueprints of the engineers." [3]

Company towns are interesting to us as the kind of community the industrialists wanted to see in America and did, in fact, undertake to build when their society was unable to do the job. When they could avoid this responsibility, company towns were seldom built, unless for a special reason, such as control of labor supply. The industrialists, like other groups in nineteenth century America, were content with fortuitous city

growth, so long as there was somewhere for the workers to live. Only the most reactionary among them needed the company town as a weapon against their employees—when the town had been constructed and populated they assumed "police powers"— which lent it all the aspects of a feudal community.[4] Some of the later coal and iron towns, the southern cotton towns and the copper towns of the west have used this method of preventing labor organization.

"We are not philanthropists," observed a member of the Cheney family, whose mills at South Manchester, Connecticut, a typical latter-phase company town, employed three thousand hands in 1905. "We are just businessmen and we just live here."[5] The earlier towns, too, were founded on business considerations. Their originators were the Lowells, Cabots, Lawrences, the Appletons and Lymans, the Quincys, Perkins, Jacksons, Eliots and Thorndikes . . . the merchant princes of Boston who were to invest in manufactures or real estate. They all invested heavily in the cotton industry and ruled the new towns in absentia. "By securing property, life and liberty can scarcely fail of being secured," wrote Fisher Ames, the political philosopher of rising New England capitalism. His puritanism caused him to add: "My property imposes on me many duties, which can be known only to my Maker." The ire of others was roused by the formation of Robert Dale Owen's Workingman's Party in New York. "The attempt to get up a Workingman's Party is a libel upon the whole population," Amos Lawrence stormed. "It implies that there are among us those who are not working men."[6]

Francis C. Lowell, on a trip to Europe for his health, studied the English cotton industry and prepared to introduce the latest methods to New England. His friends, for old association's sake, were willing to finance the introduction of the power loom. The Cabots remained aloof, until 1828, after

which time Cabot Streets began appearing on the signposts of the new towns.

The cotton manufactory succeeded beyond anyone's wildest dreams. "The rumor of your profits will make people *delirious*," wrote Harrison Gray Otis in 1835, referring to an anticipated dividend from the Taunton Company in that year.[7]

What was the physical foundation on which these profits were piled?

From 1825 to 1850 the Boston Associates introduced manufacturing to the New England region, developed the water power, built railroads, mobilized workers and organized their life and conduct. Their city planning activities were patterned on Waltham. The cotton mills operated by the Associates integrated all operations into one unit and they maintained control over the tenements which were to house the operatives. They also owned shops for the manufacture of spinning machinery—a highly profitable "sideline"—if it can be so termed. The Waltham "boarding house system" served as a model for housing. The corporations built dwellings, not always tenements, to house the large numbers of men and women who were crowding into the factory towns. These they leased at low rentals to boarding house keepers and workers were directed to live in specific houses. "The corporations fixed the price of board, and deducted the charges incurred from the monthly wage bill, and this was paid over to the boarding masters." The matrons of the girls' houses were under the direct supervision of the cotton corporation. They were held responsible for any improper conduct and closed the doors at ten o'clock to enforce the curfew. Habitual church attendance was obligatory.

This form of control was a feature peculiar to Massachusetts and New Hampshire. Rhode Island, which had a similar labor scarcity, was able to enlist a force without having

to use the Waltham system. The latter was a concomitant of Puritan society. "Lowell is not amusing," wrote a French visitor at the time. But he added that it was sober. A candy peddler was excluded from Chicopee because it was deemed inadvisable that the operatives spend money on frivolous sweets.[8]

There were difficulties in making the system work. Overcrowding was common. Six girls often slept in one room in three double beds. In the back yard was a pigpen, operated by the boarding house in the interests of economy. Nearby was the well. In the forties, record epidemics of typhoid made the gradual abolition of the pens imperative. Such conditions exist now only in backward or rural communities, or in Negro districts in the south.

The story that the operatives enjoyed many cultural activities, attending lectures and improvement classes, is largely untrue. The girls worked from five in the morning until seven thirty in the evening, with two half-hour breaks for luncheon and dinner, at a wage for the unskilled worker of approximately two dollars and seventy-five cents a week. They were too tired to absorb much culture at any time. The legend is similar to the propaganda of modern Japanese industrialists, who also employ female wage slaves in their mills, and who make much of the classes in flower arrangement for their girls. However the Yankee girls who came to the mills had often received a fair education, unlike their modern Japanese prototypes, and the desire for self-improvement was strong in many of them. They did strive for more education, but what they got was largely self-taught. Their previous schooling also fitted them better to take part in the factory strikes, which were an important manifestation of the social unrest of the thirties. The abolitionist movement was then beginning in New England and the girls had no difficulty in identifying their plight with that of the Negroes. If these are slaves, they thought, then we are the white

161

3. The approach to Manchester, New Hampshire.

slaves, and they made up verses about the degradation of female workers, and went out on strike in protest against the longer, harder working hours.

It was thus the curious fate of many New England communities to be ruled by absentee landlords and to have very little say in the matter of employment, self-government or material progress. Such a community was the city of Manchester, New Hampshire. While not a company town in the official sense, its destinies were controlled by a single firm for over one hundred years and in such a way that no major decisions affecting the welfare of the inhabitants could be made without its concurrence. The Amoskeag Manufacturing Company founded Manchester, laid out the town, encouraged immigration and even as late as 1933, two years before its liquidation, had 56 per cent of the city's working population on its payroll.

The new community's name was not without significance. The company was to become the largest single cotton manufacturing establishment in the world, and the envy of the English city in matters of production. During the first World War it distributed four million dollars in dividends and accumulated profits of thirteen million in the short space of three years. But it was only adding to its reputation among investors: for the first forty years after its incorporation in 1831 dividends

averaged 11 per cent a year, under the able trusteeship of the Lowells, Cabots, Sears', Appletons and Lymans. Throughout its history the entire control rested on Boston financiers and lawyers, many of them descendants of the original trustees.[9]

The Amoskeag Manufacturing Company was incorporated in 1831. It bought up land for some distance on both sides of the river, owning at one time about 1500 acres on the east shore, where Manchester was to be laid out. Ezekiel Straw, an engineer employed by the company, was mainly responsible for the broad streets and sites for public buildings.[10] "The company laid out the site of a town with a main street running north and south parallel with the river, and with other streets running parallel with this and across it, reserving land for public squares; and having divided part of its land into lots suitable for stores and dwellings, sold it, bringing into the market by this and subsequent sales a large part of the land on which the city stands." [11]

In October 1838 the first public sale was held. Some streets had been laid out but only a few graded. Two years later the selectmen laid out the main thoroughfare, Elm Street, parallel with the river, two and a half miles long, 180 feet wide, with twelve feet on each side for walks and ten feet in the middle for a row of ornamental trees. This was bold planning, preceding Commonwealth Avenue in Boston by almost two decades.

The company's contribution to the future city was five public squares (deeded with the provision that the authorities would erect iron fences around them within a specified time) and a tract of land for a cemetery (reserving the right to a stream which flowed through it.) It also sold land at half price to the town for the building of schools, and following the Waltham pattern built overseers' houses and three streets of tenements, the latter buildings being rented at low rates to

163

employees, or on favorable terms to boarding house keepers on condition that they charged a fixed rate to lodgers.[12]

The company held four important sales of land, the last in 1845 coinciding with the building of the city hall. But it still held all the remaining land, some of which was auctioned off at convenient moments up to 1892. In 1846, the year Manchester became a city, the population had increased to 10,125. The first sewer had been built, and the city had its aldermen, members of the common council, school committee, overseers of the poor, and assessors. Temperance agitation had swept the town, and a "house of correction" had been built. The plan was beginning to be carried out. But so rapid was the subsequent growth, and so profitable had speculation become that some of the land reserved for open space was built over and over-crowded tenements were to be observed on every side.

A visitor, passing through on the railroad, may still see the early boarding houses near the station, while a walk along the main street discloses the early pattern of the plan—a wide thoroughfare, usually associated with Western rather than New

4. The Amoskeag Mills.

England cities, and a regular gridiron (checkerboard) of streets on either side. Then along the Merrimac, the mother plant, a monumental reminder of the social cost of the one-industry town in America.[13]

The decline of Amoskeag began in the nineteen-twenties, brought about largely by competition from Southern mills and, as some thought, by its absentee owners' refusal to modernize the plant and by their creation of a holding company to which liquid assets were transferred, ensuring the directors' financial safety when the crash came. The company went into bankruptcy in 1935. Fifty-two percent of the working population was thrown on the streets and the citizens themselves, tragically and at last, had the decisions to make for their own future. By 1937 a group of local businessmen had raised enough money to buy the great plant, lying inert and unproductive for a mile and a half on both sides of the Merrimac. Smaller industries were invited to occupy parts of it and in this new form, very slowly, the recovery began, until at the present time there are one hundred and twenty-six businesses where formerly there was only one. Some of these are national concerns such as United States Rubber and Sears, Roebuck, and the remainder local enterprises. That this is healthier for the city there can be no doubt, but it would be hard to estimate the social cost of Manchester's transformation, which, like Venice, proves the rule that cities can change their economic base and continue to function in spite of dire adversity.

New England having shown the way, industrialists were not slow to take up the new idea. There were occasional variations in its realization. The strict definition of a company town embraces the notion that the employer's interest in housing must be that of an employer, and not primarily that of a real estate operator or builder. He may provide the capital for

building or merely furnish the land. Be that as it may, many industrialists did build housing and sold it with restrictive clauses to their employees. The rental system was often considered a cumbersome device by the financing companies, but where used, low rentals, based on an insufficiency of accommodations, were often a means of maintaining a low wage scale in the plants. Before the growth of an organized real estate business, employers often had to use whatever means were within their power to get the workers, and housing was one of these.

Besides the spinning and cotton mill communities, company towns grew up in the anthracite coal regions in the forties, in the Pennsylvania steel towns in the fifties, in the southern coal regions in the seventies, and in the bituminous coal districts of Pennsylvania and West Virginia in the eighties. Four company towns were founded in the coal regions of Colorado and Wyoming in 1892, while more recent developments can be found in Wisconsin, Minnesota, and Michigan, the coal fields of Ohio and Indiana, the western metal mining region, and the mechanized farming areas of California. In the coal areas the rental system was formerly common: in Magnusson's survey made in 1916, thirty-four per cent of all the men employed by the companies investigated were accommodated in company housing.[14]

The most important single feature of company housing is the autocratic control which employers wield over the inhabitants of their towns. Though this is becoming more difficult since the legislation of the Wagner Act and the growth of strong industrial unions, forty or fifty years ago the control was still strong, and only the decisions of the Supreme Court sometimes served to break up this centralized rule. For most boards of directors the idea of model homes for workmen was synonymous with a poor financial investment. But for some, the idea that a hold over the employees might be obtained thereby, caused them to see the virtue of such a scheme.

At Essen, in Germany, and at Guise, in France, industrialists had housed their skilled operatives in cosy cottages, where they tilled their gardens and lived at peace with God and master. These were the operatives who were never dismissed in bad times, the key men who ran the plants, and were indispensable.

The hidden mysteries of company towns were revealed briefly to the world in 1894, when the glare of publicity illuminated George M. Pullman's model community outside Chicago. This experiment, since dissolved by action of the Supreme Court of Illinois, is interesting for its revelations of the antipathy of a democratic society to strong-arm methods in housing and planning.

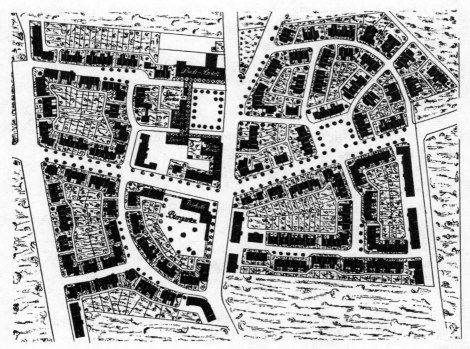

5. Plan of a Krupp industrial housing estate, Margaret-enhof at Essen.

"Thou hast made him a little lower than the angels and hast crowned him with glory and honor," was the text chosen by the Reverend E. Christian Oggel for his sermon on the founder of the fifty-million dollar Palace Car industry, delivered at the Greenstone Church in Pullman.[15] The church was one of several public buildings rented out to various bodies in the town, which also boasted a subscription library, a theater, a large administration building, a fashionable hotel, a park with ornamental water, and several hundred homes and three-story tenements, called block-houses. These last were usually avoided by the manufacturer in his self-conducted tours around the community. He preferred to dwell on the beauties of Vista Lake, the modern sewage disposal plant, or to entertain private parties at the theater, whither they would be brought from Chicago in the company's luxurious cars. This was perhaps a discreet avoidance. "The whole impression outside the center is crowded and unwholesome," observed another of the town's ministers, the Reverend William H. Carwardine, pastor of the Methodist Episcopal Church, which paid a high rental for space in the town's casino. He noted that the regimentation was like that in a soldiers' barracks, and the overcrowding far worse. In the block-houses, due to the need for taking in lodgers to meet the rents, there were three to five hundred under one roof, and sometimes only one faucet for every five families. "A civilized relic of European serfdom," he angrily termed the community, which was its founder's pride and joy. He quoted a Pittsburgh newspaper as saying, "This is a corporation-made and corporation-governed town and is utterly un-American in its tendencies." [16]

The admirers of Pullman's method saw clearly what he was trying to do. "Even when the operatives of a single works number several thousands," wrote an advocate of the Pullman System, "the master and his sons can be in immediate contact

with every man where the baleful influence of disaffection-imparting unionism has not been allowed to find place. *Masters have long since appreciated that it is to mutual interest to ameliorate the condition of workmen.*" Pullman's philanthropy, the writer maintained, was of the kind which "helps men to help themselves, without either undermining their self-respect or in the remotest degree touching their independence or absolute personal liberty."

Pullman, a poor boy risen to be one of the great manufacturers of the day, was one of the builders of industry who merit praise for their financial enterprise but who sometimes lack an understanding of the social forces at work around them. George Pullman happened to live in a period in which the

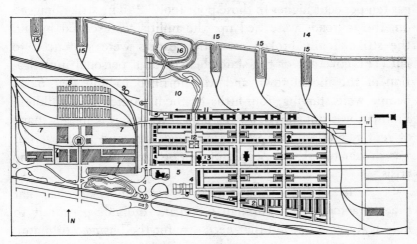

6. Plan of Pullman, Illinois, designed by the architect Solon S. Beman.

1. Illinois Central Railroad	9. Gas Works
2. School	10. Play Grounds
3. Theater	11. Pullman Main Track
4. Arcade	12. Market House
5. Public Square	13. Church
6. Hotel	14. Lake Calumet
7. Pullman Car Co. Works	15. Dock
8. Lumber Yard	16. Athletic Course

169

labor movement was growing in strength and making demands for human rights which appeared to conflict with the property rights of the rulers of industry. He chose to fight this democratic movement, even to ignore its existence, and as a result, he was to lose the town which was to have returned him six per cent on his investment. For in May 1894 the Pullman workers, who had been near starvation in the depression of the previous year and who had found their wages cut but not their rents, went out on strike. Having forbidden them to join the American Railway Union, Pullman refused to arbitrate. Other capitalists thought this foolish; Mark Hanna, when reminded of Pullman's fine model town, exploded: "Model — — — ! Go and live in Pullman and find out how much he charges selling city water and gas ten per cent higher to those poor fools." [17] The strike dragged on, the railroads were tied up, the militia were called in and the strike finally broken after the leaders were sentenced to jail. The governor of the state then made a personal investigation of the model town and was horrified to find that 6,000 people were starving, four-fifths of them women and children. Pullman was not moved by his appeal for reforms in the shape of rent reduction and production-staggering, and the governor was driven to ask the people of Illinois for funds to meet the crisis.

In 1898 the Supreme Court of Illinois decided that the character of the Pullman Company did not permit it to hold real estate beyond that necessary for the business of manufacturing, and by 1908 little more than the car shops remained in the possession of the Company. Booming Chicago swept around the little town, absorbing not only Pullman but "Bumtown" across the railroad tracks, where the palace car workers could frequent any of the twenty-eight saloons forbidden by the industrialist to locate in the model village.

But the building of company towns went on else-

where, as indeed it does today where new industries are established away from existing centers of population. Sometimes they developed into large metropolitan centers, as was the case with Gary, Indiana, which by the 1930's was the youngest metropolis in the country having a population of more than 100,000 people. Its inception, like that of the New England towns of the previous century, was "the rational result of the decision of a board of directors." A report of the United States Steel Corporation in 1905 announced the purchase of a tract of 8,000 acres of sand dunes at the southern end of Lake Michigan, where direct water connection with the Lake Superior ore region was possible and unusual rail facilities gave access to West Virginia coal and Michigan limestone. The sand hills were pulled down and the ground elevated by pumping material from Lake Michigan into the sloughs and hollows; a river was moved and three railroad rights of way relocated; by 1907 a construction camp was there—a long narrow street of shacks "engulfed in white sand from one line building to the other." Then the Gary Land Company took over and plotted all the land owned by the Steel Corporation, installing a water system for a city of 200,000 people. Lots were sold under certain restrictions (to guarantee their development a house was to be erected within eighteen months of the purchase date), and the sale of intoxicating liquors restricted. Two thoroughfares, Broadway and Fifth Avenue, each 100 feet wide were graded and paved, and soil was brought in for the planting of trees. From 1908 to 1921 Gary was a small but thriving city—after that period many of the scarcely twenty-year-old structures were razed and Gary became the industrial modern city that it is today, with new banks, churches, and hotels. Its growth is due to the fact that United States Steel was a magnet, attracting to the site other heavy industries.[18]

In spite of the fact that it is a city of the electrical

age and was appropriately named after the chairman of the board of directors of the giant corporation, Gary had none of the modernizing tendencies which industry applies to itself in order to improve its products and operations. The employment of a city planner was not so much as considered.[19] Its uninspiring

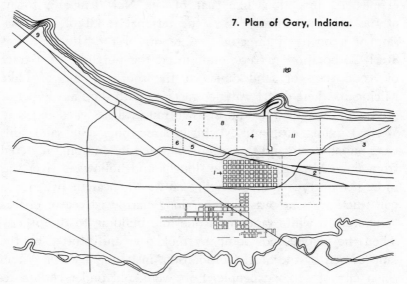

7. Plan of Gary, Indiana.

1. Gary Land Company's First Subdivision
2. American Locomotive Company
3. L. S. and M. S. Railway Terminal Yard
4. Indiana Steel Company
5. American Car and Foundry Company
6. American Bridge Company
7. American Sheet and Tin Plate Company
8. American Steel and Wire Company
9. Inland Steel Company
10. Gary harbor
11. Coke Plant

architecture, lit by the angry glow of the huge plants at night, and its mathematical grid were in those days evidence of an opportunity missed, of a corporation thinking only of making steel.

Gary might be described as a multi-company town, unlike Aliquippa, the steel-producing community planned by Jones and Laughlin. "The trouble with our town was that

there was no opposition party," declared Tom Girdler who worked his way up in the firm to become managing director. "There was in Aliquippa, if you please, a benevolent dictatorship. . . . I organized . . . a group which blossomed out as the Central Republican Committee. . . . With respect to Democrats these handmade politicians were almost as intolerant as Southern Democrats are intolerant of Republicans. Did that situation make it easy for me to run the Aliquippa works? I'll confess! It did. There was almost invariably an easy co-operation." [20] There are still many one-company towns, some of them excellent in their physical equipment and planning like Enka and Kannapolis, North Carolina; while Gary has changed, Kannapolis is still largely under the control of "Mr. Charlie," as Charles A. Cannon, chairman of Cannon Mills, is called by the townspeople.[20]

The importance of the industrially-founded town lies not only in its roots in the American tradition but also in the fact that it is a continuing phenomenon. These towns are still being built. They have lost favor with industrialists, who are now much more conscious of their public relations than formerly, since it has at times been only too easy for critics and labor leaders to capitalize on the inequalities of company control. Messrs. Comey and Wehrly in a report for the National Resources Committee in 1939 have made recommendations for industrially-founded towns which include: (1) the necessity for diversified industry; (2) management by a manager on the ground and especially by an independent agency set up by the concern itself; (3) a policy of selling homes rather than renting them. They attribute the failures which they discovered among company towns to: (1) the failure of the company or of the plant for which the town was built; (2) unintelligent (commonly absentee) management, characterized by niggardliness in public facilities; and (3) instability of employment.[21]

173

But whose responsibility is the provision of living accommodation when industry, as it will continue to do, chooses its plant locations where inadequate facilities exist? Not solely the federal government, whose town-building responsibility in wartime and in places like Oak Ridge is clear enough since the atomic energy program was government-sponsored and in its early stages a gamble; not solely the real estate developer's, to whom some industries like United States Steel Corporation seem only too willing to turn over all the responsibility for housing its operatives. Industry has learned its lesson; it will not build again the old-fashioned company town; but it would seem logical for industry to revive the tradition of new town building. It is certainly much easier to finance such enterprises today than it was in the years before government loans and mortgage financing for housing, and the employee is in a better bargaining position than he ever was before. Further, it would seem that industry has a responsibility to show that our business society can produce an efficient and good life in urban surroundings. There is a great deal of talk on the part of industrialists about the benefits which the people of America have derived from industry in higher living standards; flags wave over factories and employees are encouraged to join their own country club and health program. But with how much more conviction could the heads of industry point to the benefits derived if they could say: "We are providing working *and* living accommodations and our towns are a model to the world in design, comfort and beauty?" If they could say this, the State Department would not have to broadcast to the world a picture of Americans in old Colonial villages, as it has recently done, but could show other countries an American life created and supported today by completely modern methods. "In those things that concern the honor of the country we would like to be recognized as splendid, magnificent and very powerful," observed Alberti five centuries ago. Patriotism is

not lacking in the heads of our great corporations, but it is sad to see them place so much faith in radio and television advertising as the sole means of influencing people and nations when there are far more tangible ways of demonstrating their faith than in words and pictures.

Perhaps industrialists need a little reassurance of their traditional position as town builders. The service-industry city can provide them with a new opportunity—on the outskirts of larger cities, residential development (to accommodate those who commute to the city) is taking precedence over industrial development; at the same time the growth of long-distance road haulage can serve factories (tied economically to the city) far beyond this residential range. Existing country towns are not able to supply the manufacturer with favorable locations or rentals. These terms can only be provided if other values, of a retail and commercial nature, can be derived from the location. New towns can be built to realize on these commercial values and they can be financed through the savings institutions or insurance companies, who are already financing housing, shopping centers, office buildings, factories and amusement facilities separately. Why cannot these elements all be brought together in the creation of the new town? Some authorities think that the time is almost at hand when these elements will be financed together in planned communities well outside the commuting range.[22]

The only real problem here is a guaranteeing of steady employment and fair pay to avoid the difficulties encountered by the utopian communities and by old-fashioned one-industry towns which had no firm economic base. That is why industry must reinterest itself in community building and be willing to assume leadership. As the traditional builder of new towns for America, the industrialist needs only a little imagination to see that the opportunity is again arising for a new and major contribution on his part to the American way of life.

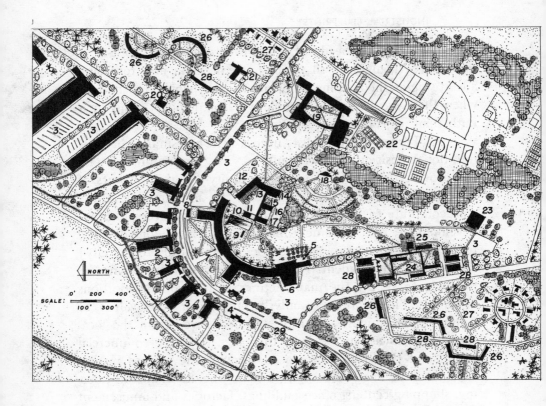

1. Large Factories
2. Small Factories
3. Parking
4. Gas Station
5. Tavern
6. Theater
7. Shops
8. Bus Station
9. Tower
10. Reflecting Pool
11. Industrial Museum

8. Plan for the center of a new type of industrial town proposed by the economist Richardson Wood and designed at Yale. Tied to a larger city for distribution purposes, it nevertheless lies well outside the commuting range and may be as far as seventy miles from the parent city. The shopping center, which is regional as well as local, provides much of the revenue for civic development. It shows the close relationship of stores to factories and the curved shopping center which minimizes walking distance. One of the esthetic considerations in the design of the town center was that industry need not be considered as something objectionable to be banished from sight behind a greenbelt, but that by being well-planned and designed it could be made an important and interesting part of the central complex. Large off-street parking lots are provided for the convenience of shoppers and industrial workers.

12. Hotel, Offices and Restaurant
13. Town Hall and Piazza
14. Post Office
15. Telephone and Telegraph
16. Library
17. Nursery
18. Music Shed
19. Junior-Senior High School
20. Fire Station
21. Clinic
22. Play Fields
23. Church
24. Dormitory Housing
25. Restaurant
26. Row Housing
27. Single Housing Units
28. Garage Space
29. Entrance from Main Highway

THE ROMANTIC MOOD

How convenient is the suburb as a butt for wits! How fortunate its development for the sages of literary magazines, for an intelligentsia which deftly pigeonholes it as "a capsule universe of church bazaars" or rails against its inhabitants who flee the city to enjoy a lower tax rate! What luck to discover the commuter—"a man who thrives on duplicated scenery"; to find a group which can be accused of both physical and spiritual isolationism! How dull would be the pages of *Punch* and the *New Yorker*, how empty the charges of Philip Wylie and Edmund Wilson against society, were it not for the existence of our urban fringe!

The reading public, unconsciously absorbing these ideas, might well believe that, God having made the country

and man the town, suburbia is the creation of the devil. Pursuing the matter into history, it could discover even more vehement protests from greater men—as witness Rousseau on the environs of Paris or Ruskin on those of London. In the eighteenth century Francis Coventry described Squire Mushroom's villa site as "the chef-d'oeuvre of modern impertinence." Today

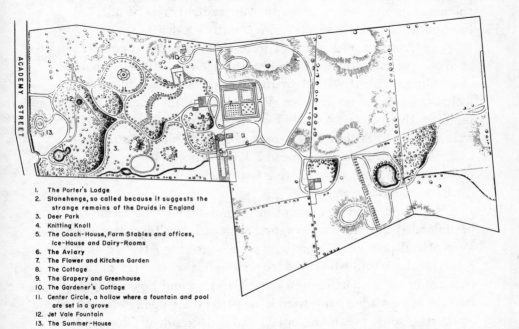

1. The Porter's Lodge
2. Stonehenge, so called because it suggests the strange remains of the Druids in England
3. Deer Park
4. Knitting Knoll
5. The Coach-House, Farm Stables and offices, Ice-House and Dairy-Rooms
6. The Aviary
7. The Flower and Kitchen Garden
8. The Cottage
9. The Grapery and Greenhouse
10. The Gardener's Cottage
11. Center Circle, a hollow where a fountain and pool are set in a grove
12. Jet Vale Fountain
13. The Summer-House

1. (a) Plan of the garden at "Springside" by A. J. Downing for Matthew Vassar at Poughkeepsie. Still existing, it contains all the accompaniments of the romantic mood, including a miniature Stonehenge, set on top of an artificial mound. In 1970 preservationists were trying to avert its development.

we talk of suburbia's "mushroom growth" in the same disparaging terms.

But all this fault-finding makes it too easy to overlook those who improved and enchanted the suburb. Especially easy is it to place categorical blame on the century which produced

the suburb in its modern form, as the origin of all our suburban troubles. An investigation would prove that the nineteenth century was neither to blame for the creation of the suburb nor responsible for its worst manifestations. The first error, if error it be, was made in preceding centuries, the second in our own. The much-maligned Age of Victoria was in fact a time of suburban improvements, some of which might well be adapted to cure the ills which afflict "town-country" today.

America and England were suburbanizing themselves at about the same time, well before the age of industrial expansion. The precedent was set by the rich, or by fashionable intellectuals. Even before Horace Walpole and his friends were building their closely-set villas at Twickenham, their cousins were moving to Society Hill, a part of Philadelphia. Boston was enlarging itself by similar means. Produced by an expanding mercantilism, these suburbs were within easy reach of town by carriage, coach or waterway.

Land as an investment instead of a wild speculation to be unloaded quickly was recognized by early realtors after the War of Independence. "Buy land near a growing city," advised John Jacob Astor, who lived to astonish the scoffers at his dealings in radish patches and swampland up and down Broadway. "I always advise my friends to place their savings in real estate near some expanding city," confided President Cleveland to another generation. "There is no such savings bank anywhere." [1]

"Buy the acre, sell the lot," was the cry. The results are plain to see. The seventy suburbs which are Los Angeles were mainly the product of the years since 1909, when Harry Chandler of the *Los Angeles Times* organized his Suburban Homes Company and bought up 47,000 acres of contiguous land, which within seven years had all been subdivided and sold. [2] And the jerry-built acres of Long Island are a product of the

twenties when tax-exemption as a stimulus to building was made a doubtful subsidy for development.

Perhaps the geniuses of the romantic movement saw what the clever fur-trader's policy might bring. More likely, they were influenced by the romantic writers, whose reiterated cry, "Escape, escape to the country!" was a reaction against un-bridled industrial horrors. In any case, the warning cries were loud. Rousseau, Jefferson and Jean-Paul Richter were early voices, and when Jefferson's French acquaintance Volney wrote in 1803 of the American pioneer as a victim of crude land spec-ulation, his book was translated by the very popular American romantic novelist, Charles Brockden Brown. What Goethe, Wordsworth, Shelley, Bryant and Poe left unsketched was filled in by Herman Melville. In *Pierre*, published a year before the creation of the first romantic suburb, the author imagines the city's cobblestones as the buried hearts of dead citizens which had risen to the surface. Not only do the hero's frightful trib-ulations occur in the horrid "side-glooms" of brick and mortar, contrasting painfully with his previously idyllic pastoral life, but the author must dedicate this masterpiece of romantic litera-ture to a mountain. By mid-century, the American literary air was heavy with the romantic mood.

More directly the fine arts helped to create romantic suburbs. The Hudson River School explored the wilds and pictured them, while Thomas Cole, its master, translated both dreams and experiences of Nature's most awesome moods in paint. The popularity of his canvasses helped to destroy linger-ing American fears of the wilderness. Ramée, Parmentier and Downing introduced the picturesque style of gardening; A. J. Davis and James Renwick built castles, Gothic libraries and churches. The picturesque site was chosen, the savage woods extolled.

While most of the Utopian communities in the wild-

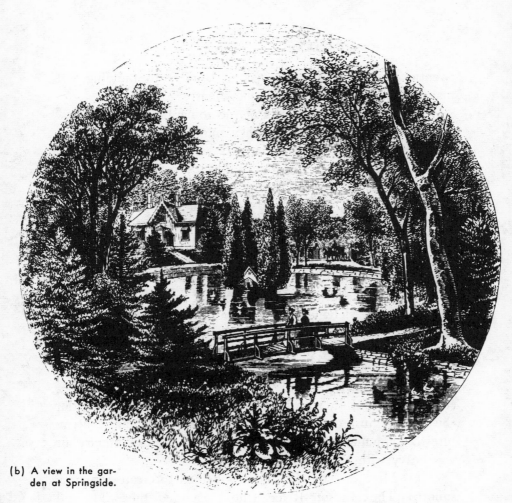

(b) A view in the garden at Springside.

erness were founded by early socialists or religious refugees, it may be said that planned romantic suburbs were the creation of the business mind (and for that matter, all other types of planned suburb too. A. T. Stewart's checkerboard Garden City on Long Island, for which he bought 8,000 acres and provided a railroad connection, is an example of planning by merchant princes.) Discounting the possibility of extensive planning at Ravenswood, Long Island, for which A. J. Davis designed villas in 1836, the first of the romantic suburbs which we can truly

call planned was sponsored by a business man of an unusual faith. It provides a link between the wilderness-Utopias of the time and the purely practical considerations of living close to, but not in, the growing city.

Like Pierre Lorillard's later Tuxedo Park, the suburban paradise envisaged by Llewellyn Haskell in the Orange Mountains cannot strictly be called a product of real estate speculation. Haskell, whose portrait bust reveals the features of a second Alfred, Lord Tennyson, was a Perfectionist, and Llewellyn Park was in the beginning a home for believers. It was not as wholehearted an experiment as John Humphrey Noyes' contemporary Oneida colony. Haskell was the head of a large chemical concern, and wherever his business happened to call him he preferred to live nearby in the country. Moving to New York, and perceiving that the railroad network had already spread outward across the marshes, he saw that it would be possible to build in New Jersey. Llewellyn Park was created for businessmen and intellectuals who could afford to do likewise.

It is probable that the development was suggested to Haskell by Downing's friend, the architect Alexander Jackson Davis, who by 1850 was ready to essay a complete landscape based on picturesque principles of gardening. Davis formed a partnership with Haskell, and poured forth a series of villas in many styles for the park from 1853 to 1869. He also built a house for himself which was later burned. It is recorded that he directed much of the landscaping, although some of it has been attributed to Eugene A. Baumann, one of the several German, Swiss and Austrian landscape gardeners who gained their reputations in America during the fifties and sixties.

Perhaps Davis also chose the site, considered extremely unconventional at the time. The first romantic suburban community has, appropriately enough, a situation which might have been depicted by Salvator Rosa. Twelve miles west of Fifth

Avenue, and roughly parallel to it, the rocky hills rise to an eminence of six hundred feet, from whence a spring gushes down the eastern slope and hanging woods depend. In those days, the tidal marshes stretched away below to Bergen Hill, the last natural barrier before the Hudson. In the last twenty years the prospect has been enriched by the appearance of the towers of Manhattan, which can be seen from some of the leafy villas on the higher ground.

Before long an area of 400 acres came under control, and a fifty-acre strip running up the hillside from the gatehouse was set aside as a common park. This was called The Ramble— a prototype of the interior open space now considered so desirable in community development, but not, unfortunately, required by municipal law. A covenant was drawn up (a type of legal document now much more common than it was then) which stipulated that no house was to be built on less than an acre of ground, and no building was to be used as a shop, factory or slaughterhouse. There were to be no fences, by voluntary agreement. There was, however, nothing in the original deed to set up social qualifications, which have become an unsavory requisite of many exclusive suburbs in modern times. Llewellyn

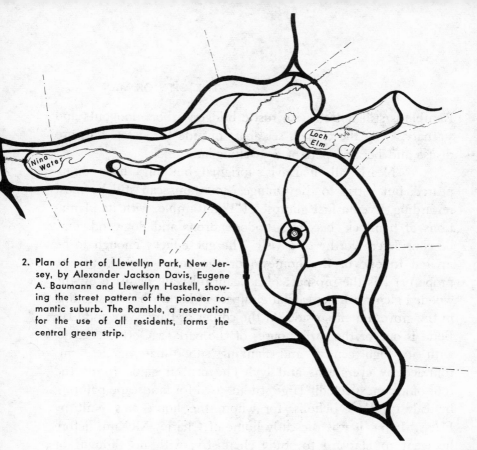

2. Plan of part of Llewellyn Park, New Jersey, by Alexander Jackson Davis, Eugene A. Baumann and Llewellyn Haskell, showing the street pattern of the pioneer romantic suburb. The Ramble, a reservation for the use of all residents, forms the central green strip.

Park was to be "a retreat for a man to exercise his own rights and privileges." [3]

Needless to say, Perfectionism did not last long in an imperfect world and the sectarian atmosphere soon gave way to the secular. The presence of professed atheists and recluses did not make community relationships entirely harmonious and much outside comment was caused by marriage ceremonies held at sunrise under a great tree near the eastern end of the park. The reported burial of a young woman "with only a shroud between her body and Mother Earth" caused something of a scandal; these irregularities coupled with Haskell's financial difficulties made it necessary for the wiser businessmen in the community to take over its administration. But they retained the romantic pattern of architecture and landscape, and The

Ramble is still dotted with rustic bridges, arbors, lookouts and statuary. Only the chapel, set apart outside the gates, fell into disuse and became part of a dwelling-house.

Nearly all of Davis's original buildings have disappeared, but a trip to the Orange Mountains can still be most rewarding. Even a first glimpse of The Ramble, with its plantations of hemlock, beeches, rhododendrons and dogwood, may be considered worthy of a visit. The guest lucky enough to be invited to one of the homes (for the entire park is private property) has the prospect of a beautiful walk or drive up the wooded glen, with occasional glimpses of largish houses nestling in the groves on either side. At the corner of Park Way and Oak Bend is one of the early houses of the park—a Gothic cottage, with its high central and flanking subordinate gables, surrounded by evergreens and ivy. The central gable forms the roof of an unexpectedly large studio, used for landscape painting by Edward W. Nicholls, for whom the house was built by Davis.[4] Later, it was the early home of Charles McKim, before he went to Harvard to study chemistry, with no thought of architecture in his mind save memories of this picturesque cottage—a fitting nest for the fledgling who was to develop into an eagle of American architecture and planning. Afterwards he was to return to build the larger houses of his generation within the park, none of which unfortunately remains in an unaltered state, although his Casino at the nearby suburban development of Short Hills is still standing and is an early example of what we have now come to call the community center.

The Davis cottage and gatehouse may be the only completely original buildings, but the roads have not been changed, and the passing of almost a hundred years has increased the beauty of the landscape. Only the rush of unplanned suburbia disturbs the eye without the gates. The contrast is enough to

186

shock the most insensitive observer into a realization of the advantages of planning.

Several influences now becoming stronger made romantic planning more acceptable. Chief of these was the movement for new parks, born of the growing concern over crowded conditions in the cities. In their designs these parks were invariably romantic or "English." Fessenden's *New American Gardener* in 1828 contained Parmentier's observation: "Our ancestors gave to every part of a garden all the exactness of *geometric* forms; they seem to have known no other way to plant trees, except in straight lines; a system totally ruinous to the prospect. Gardens are now treated like landscape, the charms of which are not to be improved by any rules of art." Downing affected the English style to the point of snobbishness. Ignaz A. Pilat, who made the first botanical survey for Central Park in 1856, and most of the entrants in the subsequent competition to choose the designer, worked in the picturesque manner. Olmsted and Vaux, the winners, alone succeeded in rendering the romantic method practical. They were even able to justify it on scientific and social grounds.

Downing's English partner, Calvert Vaux, had a house on 18th Street in New York and here in the early spring of 1858 was drawn the plan which was to influence the design of every big city in America.

More than four years before Downing's first (1848) advocacy of a park in New York, William Cullen Bryant, who was the friend of Cole and Davis, had written editorials in the *Evening Post* suggesting a large "central" reservation for the city on its unoccupied lands. "While we are discussing the subject," warned the poet, "the advancing population . . . is sweeping over them and covering them from our reach." Due in part to the publicity given it by this newspaper, the park in 1850 be-

187

came a political issue in the mayoralty race. The winner of 1851, Mayor Kingsland, who had been supported by the *Evening Post*, was an ardent "parkite." "There is now ample room and verge enough upon the island for two parks," wrote Bryant, suggesting the site of Jones Wood on the East River be used as well as the central lands. But New York was not to have a waterfront recreation ground, the site being considered by Peter Cooper and other prominent citizens too valuable for commercial purposes. In 1853 an act was passed for taking the Central Park lands alone.

The necessity for this seemingly bold undertaking was obvious enough to New Yorkers, who were then taking their strolls in tiny Bowling Green, the busy City Hall Park, and Greenwood Cemetery, where, following the example of Bostonians in visiting Mount Auburn, the citizens found their recreation among the dead. The private pleasure grounds like Niblo's, Vauxhall and Contoit's lasted through the forties, but they soon succumbed to the spread of new building. Thus there was ample support for a project which would belong to the public and remain in its name forever. New York's was only the first.

By 1868, the idea had spread to other cities. The New York Commissioners commented: "Baltimore has laid out and improved its Park under the enlightened action of its Commissioners. Philadelphia has already secured grounds of great extent . . . and the subject is under discussion in Providence, Albany, Troy, Cincinnati, Pittsburgh, Chicago, St. Louis and Louisville." [5]

First in collaboration with Calvert Vaux and later on his own, Frederick Law Olmsted designed many of the new parks. Among his creations are Prospect Park in Brooklyn, Buffalo, Chicago South Parks, Mount Royal at Montreal, Detroit's Belle Isle, and the Boston Park system. Almost all the large urban parks to be found in American cities today owe their in-

spiration to the action of New York. Central Park, stocked with swans from London and Hamburg, became a symbol around the world—a symbol of urban land for the use of all.

An examination of the rejected plans reveals how different was the Olmsted-Vaux design from any previous conception. Full of Victorian fancies, the unsuccessful competitors were lavish with ornamentation, carpet bedding and wriggling walks—one of them going so far as to include a large map of the world in flowers. While these exercises of the imagination cannot rightfully be condemned . . . present day planning being what it is . . . they were all inferior in taste to the winning design and outdone by its provision for the recreational needs of vast concourses of people. A combination of technical innovation (the separation of cross-traffic by underpasses) of engineering skill (roads and paths economically following the contours of the land) and the skillful managing of the open spaces, mark the plan as the greatest single achievement of its time in physical planning. Olmsted also introduced novelties in his use of native trees and shrubs and in a harmonious blending of the axial or formal style of layout with the naturalistic or informal method. He himself always expressed a preference for the design of Prospect Park in Brooklyn where he worked under fewer restrictions, but the position and importance of Central Park give it a prior claim on our attention.

The history of the park is well-known, except for minor but significant details, such as the primary opposition of real estate interests and the subsequent wild speculation in adjacent property when it was discovered that the park was not going to be "a great bear garden for the lowest denizens of the city" as the *New York Herald* put it, and that William B. Astor and Edward Everett would be able to stroll unmolested along its leafy lanes. In fact, at a later date, the *Herald* was forced to change its views completely and in a leading article

state the true facts of the matter: "When one is inclined to despair of the country, let him go to the Central Park on a Saturday, and spend a few hours there in looking at the people, not at those who come in gorgeous carriages, but at those who arrive on foot, or in those exceedingly democratic conveyances, the street-cars. We regret to say that the more brilliant becomes the display of vehicles and toilettes, the more shameful is the display of bad manners. We must add that the pedestrians always behave well." [6]

Olmsted knew all this before anyone else did. The park was an acknowledged success when in 1870 he spoke before the American Social Science Association in Boston. After describing the opposition to the plan by the directors of banks, mining and railroad companies, he went on to say: "You may . . . often see vast numbers of persons brought closely together, poor and rich, young and old, Jew and Gentile. I have seen a hundred thousand thus congregated . . . and I have looked vainly among them for a single face completely unsympathetic with the prevailing expression of good-nature and light-heartedness. Is it doubtful that it does men good to come together in this way in pure air and under the light of heaven?" And he added, with emphasis, "The problem of public recreation grounds should be made a subject of responsibility of a very definite, very exacting, and, consequently, very generous character." [7]

Roads that followed the contours of the ground and a system of planning that brought "the country" into the heart of town were inventions that could be applied to communities as well as parks. In fact, the ideal was to make the community park-like, as the very names of some of these developments indicated. In 1844 Joseph Paxton had made the attempt at Birkenhead, where his public park was surrounded by villas whose gardens gave onto the central open space. From Olmsted's own

description of Birkenhead Park one can tell how strongly he was influenced by its layout.[8] Downing and Sargent spurred on the villa craze by warning against the holding of large estates: "The whole theory is a mistake; it is impossible except for a day; our laws render the attempt folly,—and our institutions finally grind it to powder." All signs pointed to romantic planning in the suburbs, on limited areas of land.

But again we must await the planning of a whole community before the romantic theory can be expounded at its best. Since American cities were most easily enlarged by the extension of their gridiron street system, the opportunity could only come through the building of a completely separate unit. The romantic houses of Town and Davis, Renwick or Eidlitz were therefore usually found on suburban plots along straight roads; only occasionally was Vaux offered a romantic site at Sargent's Wodenethe or at Frederick E. Church's most wonderful "Olana"; or Davis the proper situation for a castle at Tarrytown. On these occasions the landscape was made as romantic as the houses, but

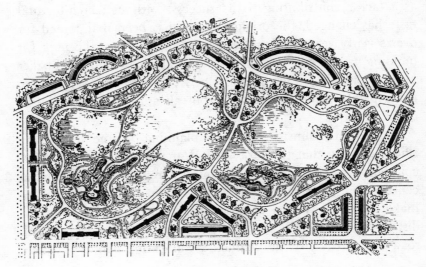

3. Birkenhead Park, near Liverpool in England, by Joseph Paxton was visited and admired by Frederick Law Olmsted, the designer of Central Park in New York.

they were not communities like Llewellyn Park. Even the New-porters took Downing's advice and built their palaces on tiny plots which offered no scope at all for romantic planning.

The opportunity came again in 1868 when E. E. Childs commissioned the now-established firm of Olmsted and Vaux to plan "a suburban village" nine miles out from the then business center of Chicago. Olmsted pointed out how dull and flat were that city's surroundings and proceeded to romanticize the 1,600 acres by introducing a curvilinear street system, a central park along the Des Plaines River, and planting thousands of trees to shade the prairie land. These measures would not in themselves have made Riverside a romantic suburb; Vaux's architecture was needed to complete the ensemble. The English architect did a good many of the early building plans, but un-fortunately not enough for Riverside to retain a romantic char-acter to the present day. They must have been popular; his letter book for 1870 mentions that the price of land had risen from $300 an acre (and no sales) on a paper plan to $40 a front foot in three years. The unity of the scheme has been cited as a factor contributing to its success. Although architectural taste has changed, the original layout has been maintained for over seventy years, and successive attempts to use the park for building have been forestalled. Like the Van Sweringens' Shaker Heights outside Cleveland and Coral Gables, Florida, Riverside is a separate incorporated town, but all are essentially suburbs of larger cities.[9]

With Olmsted, suburban planning became more scien-tific. Realizing that the post-Civil War movement to the cities could not be stemmed, he set out to improve the big urban centers and their surroundings. Riverside was an attempt to make the southwestern part of Chicago a desirable residential district for the middle class. Although there was already a rail-road line to the city, he planned a connecting parkway, which,

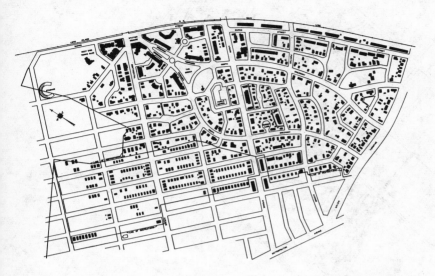

4. Forest Hills Gardens, Long Island, financed by the Russell Sage Foundation and designed by the architect Grosvenor Atterbury with the Olmsted firm. The influence of English Garden City practice is revealed in both plan and architecture.

in spite of many promises by Riverside's promoters, was never built. He had proved in New York that parks would increase the value of surrounding residential property; at Riverside the park was suggested with this fact underlined. It was all very practical and a far cry from Batty Langley or Sir William Chambers—"fantastically crooked layouts," stated the prospectus for Olmsted and Atterbury's Forest Hills Gardens in 1911, "have been abandoned for the cozy, domestic character of local streets, not perfectly straight for long stretches, but gently curving to avoid monotony." This, it should be added, was after Olmsted's death, when the firm's style had begun to change.

While Riverside and the subsequent Tarrytown Heights still clung to the romantic mood, the "domestic" suburb was gaining ground. In England, Bedford Park (1876–77) with

193

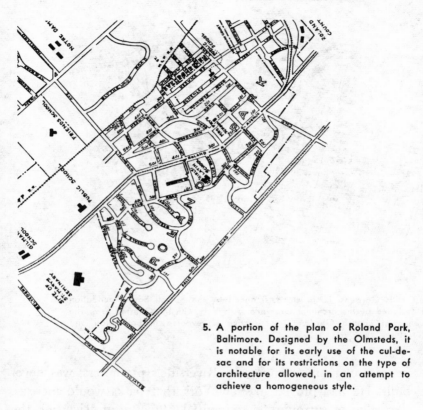

5. A portion of the plan of Roland Park, Baltimore. Designed by the Olmsteds, it is notable for its early use of the cul-de-sac and for its restrictions on the type of architecture allowed, in an attempt to achieve a homogeneous style.

its trim little gardens and "Queen Anne" houses by Norman Shaw was to be an inspiration for the garden city movement, that cosiest of all planning developments. It was noticeable too that company towns like Port Sunlight in England and the notorious Pullman, Illinois, bore traces of a revived interest in the Beaux Arts, which began almost immediately to change the character of suburban planning. The Olmsted firm resisted this influence until Forest Hills. Its Roland Park at Baltimore, begun in 1891, is a romantic conception making early use of the cul-de-sac road along ridges and ravines; this subdivision, however, was planned in sections and does not show the unity of River-

side. After this, the curvilinear street system was used mainly to solve the problems of difficult topography. Palos Verdes, laid out by Olmsted Brothers in the twenties, is an example of this kind of planning, and a glance at the street map of Los Angeles or San Francisco shows that it was resorted to in hilly suburbs like Bel Air and the outskirts of Berkeley. But the Country Club district of Kansas City, Venice, Florida, and hundreds of other latter-day products of the real-estate art have modified the romantic pattern so much as to make it a matter of curving pleasure drives and hidden approaches. We should, therefore, be careful to limit investigation of romantic planning to the strictly romantic period in art and architecture, which came to a close in the seventies. Even before the Civil War this period was waning, and Riverside coincides roughly with its end. After that, occasional frenetic outbreaks like the summer colony at Oak Bluffs on Martha's Vineyard serve as evidence of the time-lag which architecture invariably shows in comparison with its sister arts.

These rare examples of residential parks may be regarded as among the most important American contributions to nineteenth century planning. They went beyond the theories of John Nash, whose scheme for Regent's Park in London included forty or fifty villas until it was pruned by the Treasury. His picturesque hamlet at Blaize Castle and the quaint Park Village in London, with its water, trees and Italian villas, were but foretastes of the total romanticism of Llewellyn Park, where houses and landscape were planned according to one rule of taste. As essays in town planning, the American schemes helped to break the strangle-hold of the gridiron, and, to a lesser extent, their interior parks avoided the still-ubiquitous all-over planting of private lots. In a later stage, they announced the principle of separating business and residential districts. Above all, as Riverside shows so clearly, they proved that suburbia need not

be universal, that a suburb could be planned as a unit, and thereby promoted the idea of self-contained neighborhoods within the urban pattern. Those of us who are confronted with the problems of suburban planning today may have been able to modernize these principles, but not to improve on them.

Although it is but a few miles from Manhattan to Llewellyn Park, the typical industrial world of America lies in between. It is a land of marshes and sea-birds, factories, airports, giant smoking cities, black rivers and criss-crossing railroads . . . a scene of peculiar fascination to the curious visitor. Ludwig Bemelmans has called it "the country of beautiful *dreck.*" "Is this America?" asks the bewildered new arrival from Europe, beginning to bristle with prejudices against the unplanned disorder he now expects to see everywhere. But even industry has planned, as the last chapter has shown, and there are many places to be found where nature and art have been joined instead of ignored. Some of the American pleasure resorts are examples of a consciously-created environment; and in their efforts to discover a haven where the heat of summer in the city can be left behind Americans have built whole communities in a romantic mood.

If the sight of New Jersey's waste lands is puzzling to a European visitor, what will be his impression when confronted with their opposite, the "cottages" of Newport? Suburban palaces will be a complete novelty; for the environment of the ten-mile drive is unique in the world, beside which the extravagances of Hollywood seem like the simple life and only Hunt's Biltmore or the works of Horace Trumbauer loom large enough for comparison. Newport is indeed a special phenomenon in its planning, and such was the fame of its founders and the genius of its builders that an influence spread widely enough to be important in the story of the growth of American suburban communities.

The scenes of sedate revelry, for which the town is famous (unlike Tuxedo Park, which had sporting pretensions, the Bellevue Avenuers' pursuits are mostly sedentary), are created of a strange juxtaposition of seascape and marble, fragrant rose hedges and carved stone. They have their beauty and their incongruity. Strange again is the sight of three-million-dollar Genoese palaces on suburban plots and metal gates which required a year's toil by fifty artisans, opening onto drives but a few yards long. Strangest of all is the fact that, redeemed by the presence of the sea and by their mellowed half-century of life, these monuments to an American "aristocracy" retain an undoubted charm which makes us grateful for their continued preservation.

It was the all-embracing sea and the balmy air which attracted Newport's first summer visitors, rich planters and their families from the West Indies and the Southern states who

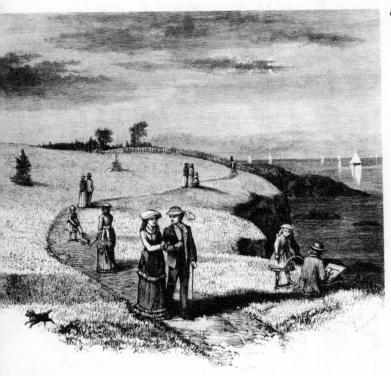

6. The Cliff Walk, Newport, R. I.

journeyed there to stay in farms and boarding houses. The towns-people came to be grateful for their presence, for the once-flourishing commercial port was never to become an industrial city. Three gray stone mansions are left to remind us of the Southerners, whose fortunes, also, built on molasses and cotton, were eventually to be no more. It was the fashion then to lease a farm house for the summer, rather than to live in town.

The second invasion came in the 1850's when the comfortable literary set of Boston discovered the town. The Longfellows and their children; Julia Ward Howe, Colonel Higginson, Helen Hunt and the brothers James; and two painters, William Morris Hunt, and the New Yorker, John La Farge, could be found at the Cliff House, nicknamed the Hotel Rambouillet, or at Mrs. Dame's boarding house on Broadway, then an elm-shaded street of picturesque houses. They too admired the fine summers and the scenery. Longfellow's poem, "The Skeleton in Armor," had its origin there; and William Ellery Channing's most impressive sermons were inspired on Newport's lawns. "Nothing ever did for me what Newport did; the rest, the rest, the repose; its romantic soft charm!" declared the respected Unitarian. "It is a pillow of rose leaves."

As early as 1845, real estate activity had begun in earnest, with the purchase of 300 acres by a syndicate close by the old town. Trees were planted for house lots along laid-out streets. And so a suburb grew. Although the fashion of summering in hotels at Saratoga and Elberon continued well into the eighties the idea of the summer home was eventually to sweep all before it. Pioneering Newport built over 60 such homes during the winter of 1853–54 and to the fête held in 1859 came the "Exiles of Eden," those former residents of Newport who had gone to other parts. It was a great success, and many kept coming back year after year to the new suburbs of the once-important Colonial town.

The most active developer of the point of land which later housed the millionaires was a tailor's cutter from New York, Alfred Smith, who came on business to Newport for a client and stayed to make it a trap for unwary visitors.[10] Associated with the original syndicate, he bought in 1851 about 140 acres surrounding what is now the middle part of Bellevue Avenue and persuaded the town council to extend the latter into the plot. Then he would drive around in his gig showing strangers choice bits of property and more often than not could talk them into a sale. His enthusiasm was catching. He was a forerunner of the real estate promoter who later was to flourish in the west and all suburban America. In spite of the small size of the plots and the high price of land, which trebled within three years after 1850, his victims were better off than they knew. The prestige of Newport was growing and it has not yet declined appreciably.

Smith later persuaded Joseph Bailey to invest $27,000 in the property which is now the most exclusive private beach in America. He and the two other promoters of Newport, General Alfred Hazard and Edward King, whose family had settled in Newport after the Revolution, also succeeded in opening up the Ocean Drive, which turned the tide of development westward. Frederick Law Olmsted and his son were responsible for the layout of this greatest of all American pleasure drives of the last century and at about the same time the engineer, George Norman built the Newport Water Works. (Norman is remembered by city planners as the man who introduced public utilities into over forty American cities.) With the building of the Casino, by Charles McKim and Stanford White, the stage was ready for tremendous social activity.

By this time the Civil War had come and gone and the post-war boom was rapidly completing the industrialization of the country. The greatest of the fortunes made were in New York, since Eastern capital and combines controlled American

enterprise, and although one might live comfortably enough in the city or on the Hudson for part of the year, it was necessary to go to Saratoga for the hottest days. Saratoga and Southhampton were palling. (Weren't Paris or Vevey more amusing and just as accessible?) But there had to be an American mecca. The third and greatest invasion of Newport was soon to be the New Yorkers, with a sprinkling of Philadelphia names like Biddle, Drexel, Widener and Cassatt adding to the general lustre.

Pierre Lorillard, who later abandoned Newport to develop Tuxedo Park, was the first owner of "The Breakers," a low rambling structure with a tower. The second was Cornelius Vanderbilt II, then preoccupied with the affairs of the New York Central Railroad, for whom Hunt built a palace when the original house burned down. Between the rambling summer "cottage" and the Genoese palace lies a world of changing taste and fashion inspired by the need of America's first families to establish a cultured frame for their newly-born positions.

It was natural to place the more powerful industrialists and financiers at the top of the social tree, for although there might be older and more illustrious families extant, there were none who exercised so much influence in directing America's political and business life. With characteristic American directness, these men supplanted the pre-Civil War "aristocracy" and created their own. The supremacy of their wives as leaders of society has never been challenged, and the extravagance of the lives in the August season at Newport has been newspaper copy for half a century. Mrs. Nicholas Beach inaugurated dancing receptions, Mrs. August Belmont, wife of the great banker, the three-hour formal dinners, and Ward McAllister his famous fêtes-champêtres. Mrs. Pembroke Jones set aside $300,000 for entertaining at the beginning of every six-week season but sometimes a single ball cost as much as $100,000. Harry Lehr, the successor of Ward McAllister, was jester to Mrs. Stuyvesant

Fish's queen. His "dog's dinner," at which a dachshund became unconscious from the rich food, scandalized the nation's pulpits at a time when unemployment was at its height, forcing the "cottagers" toward originality rather than extravagance. Thus, for the debut of Lena Morton, daughter of a vice-president of the United States, a ballroom built of glittering columns of ice hung with smilax and roses was introduced. It was a stormy night and nature destroyed the fancy with a blow. It could not, however, level palaces of stone. The new three-and-a-half story "Breakers," designed by Richard Morris Hunt, had on one side a semi-circular porch resembling the apse of a cathedral with interior walls finished in light green cipollino marble, mosaics

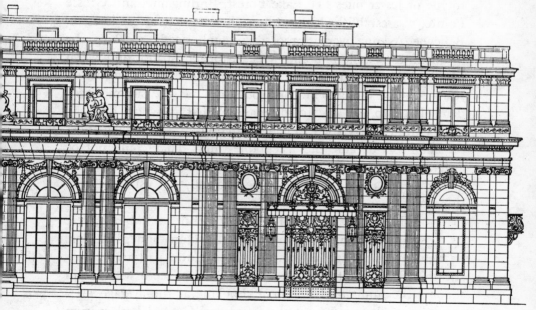

7. The romantic mood gives way for a moment to the classical tradition. Elevation drawing of Rosecliff, the Oelrichs house in Newport, designed by McKim, Mead and White. 1902.

depicting a bathing chamber in Pompeii and loggias decorated with Italian Renaissance designs. William K. Vanderbilt's Marble House, also by Hunt (now owned by the Preservation Society of Newport County) has an imposing Corinthian portico on the front, while the drawing room blazes with crystal and gold. Stone from Caen, yellow French marble and a panelled vestibule sixty feet high are other features of this show-piece, the portable furnishings of which are worth more than a million dollars.[11]

It is, however, only too easy to dwell on the luxury of the third Newport succession at the expense of its real influence on American art and architecture, landscape gardening and community planning. The pattern for the exclusive suburb, prototype of lesser ones like Lake Forest, Burlingame, and Grosse Pointe, was established here when offending street car lines on Bellevue Avenue were uprooted, metaphorically speaking, by William K. Vanderbilt and Mrs. Astor's husband; and when Mr. Van Alen swam at Bailey's Beach in a monocle and white straw hat out of sight of "our footstools" as the summer residents liked to call the townspeople. What Newport did, the rest of the country tried to copy. Large houses of varying styles on small lots became the acceptable thing. They could not be as grand as Newport's best, but they could be ostentatious enough, and, as is so often the case, the copy was usually a poor thing by comparison with the original.[12]

The chief virtues of this first period of suburbs were its close interlocking of planning, architecture and gardening, its rich invention, its breaking of the gridiron pattern by substituting the romantic plan, and in its real concern with art in shaping the human environment. Looking at the average present-day suburb one can see the difference. Central Park was an innovation; Riverside the beginning of a great middle-class exodus; even the public Cliff Walk at Newport which ran around

the great estates was a symptom that times were changing and that communities were becoming interdependent. Newport was not Versailles. Even on the Hudson people were now able to buy their farms instead of leasing them from landowners. If Llewellyn Park chose to ignore this fact of change, it was too small to be important. But the country as a whole could not ignore it, and in the planning that went on toward the turn of the century the knowledge that *all* Americans had a stake in their communities was a constantly growing reminder to developers that gestures in this direction must be made.

The coming of the service-industry city has given a new impetus to suburban planning. Suburban areas are now growing three times as fast as the central districts and these suburbs themselves have grown three times as fast between 1940 and 1950 as they did from 1930 to 1940. The fastest rate of increase has been in the urban-rural fringe, or "interurbia" as it has been called by Richardson Wood. This is "blue-Collar" country, the unsewered, single-family landscape beyond the older suburbs, and it is absorbing the greatest part of the increasing population. This will place an additional strain on the finances of the urban center; the suburban dweller does not usually pay taxes to the central city although he must make use of its transportation and other facilities. This calls for more effective metropolitan-wide planning, perhaps on the lines of re-nucleating the metropolitan region suggested by Paul Windels;[14] yet the growing consciousness of the problem is still mainly directed to solving each situation independently. A community's planning activities seldom go beyond the town line.

Municipal particularism is a problem here, but as well as inter-town rivalries there are always to be found conflicts among suburban dwellers themselves. When applied to com-

munity planning, these rivalries are magnified, and the community recognizes them when a town is zoned residentially in conformity with its various income groups. But even where zoning is non-existent the differing desires are apparent in political groupings. The farmer's needs seldom are vocalized, except in opposition, though he is frequently opposed to such "improvements" as the granting of recreational and other community facilities for city folk. The factory worker may want an efficient bus service and neighborhood markets. The commuter wants sewerage, branch stores, a boat basin and a train schedule —he builds his own country club. The wealthy send their children away to school and may not be vitally interested in the local educational system, but they are concerned with the tax rate and the possible encroachment of factories on favored residential districts. How can the community develop in order to satisfy them all? If it cannot, who is to say that we can create

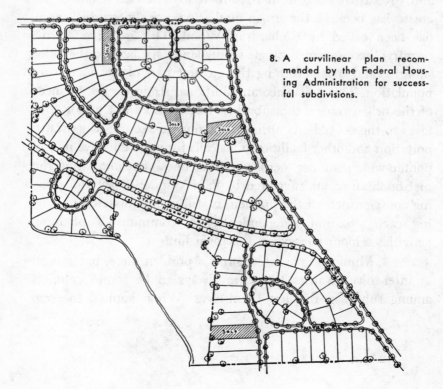

8. A curvilinear plan recommended by the Federal Housing Administration for successful subdivisions.

the best of all possible worlds on American soil? Even though the living standard may be higher in a given community than anywhere else in the country, what kind of living will it enjoy if special interests stifle the ability to direct and channel change? For change these communities in any case will, in obedience to the economic laws which have operated in all civilized places since the beginnings of tribal association.[15]

Meanwhile all mortgage financing favors the home

9. The romantic plan of Lake Forest, Illinois, originally planned by the landscape gardener David Hotchkiss (1856). The rectangular market square at the town's center was designed by the architect Howard Shaw.

1. Railroad
2. Market Square
3. Park
4. Park
5. Park
6. Park

builder on the edge of town,[16] to the neglect of the central city; the desire to escape is fostered by the banker and the federal government; and the Federal Housing Administration continues to approve suburban building with romantic or curvilinear plans. It is late in the day for the romantic suburb to be coming into its own—as a fashionable pattern, rather than a self-contained elysium. These newer suburbs with their curving streets are often merely dormitories. Far too many of these new areas where American families are seeking the best conditions in which to bring up their children provide no inducement for these children to stay there when they are older or offer at best a divided life for heads of families and women. Instead of looking forward to being the center of something, or attempting to be as self-sufficient as possible, these communities spend a great deal of time behaving like King Canute faced with the incoming tide.

That most exclusive and romantic of suburbs, Lake Forest, near Chicago, has a formal and well-planned market square designed by the architect Howard Shaw. If the less expensive but more important residential areas would try for the market place instead of the garish shopping center they could with confidence look forward to making a more important contribution to the creation of the new city which is surrounding them and of which they are a part. And if in their designs they would acknowledge the virtues of introducing order in the Grand Design—that order which encompasses the picturesque, an incidental not a major element in all the great schemes ever conceived or carried out—the newer areas of our cities would demonstrate our coming-of-age in urban planning, our recognition that both tradition and experiment lead in one direction only—toward the continuity of implanted forms which has been established in our history but at times so sadly broken off by following dead ends.

206

The importance of this continuity, together with an approach to civic design for our modern world, will be brought out in the concluding chapters. But first it is necessary to turn to an examination of the sister arts, to see how their employment can reinvigorate new city planning.

PART 3 MODERN CIVIC ART

ARCHITECTURE
LANDSCAPE ARCHITECTURE
DECORATION
PAINTING AND SCULPTURE

THE COMING REVOLUTION IN ARCHITECTURE

Should architecture be considered an art or a science? Not long ago this question would have seemed unnecessary; today there is reason for asking it.

Architecture is unique in functioning where art and science meet. It has a social function, a scientific function, and an esthetic function. Perhaps that is why it is called the *Mistress Art*—or used to be. Just now the proportion of art in architecture is a doubtful factor. Other functions of architecture are assuming relatively greater importance.

Consider the social function. An interesting development in the thirties was the appearance of new forms of building—modern factories, community centers, low-cost housing. Architects developed new plans—they had to. They also learned

to get maximum sunshine in winter and to exclude sun in summer, and many other advances connected with space arrangement. They tried to make all planning more practical, more flexible, for all kinds of people. A worthy aim!

The result has been a noticeably lop-sided development of technique over content. The approach is all from the plan. "The plan is the generator." Some most unfortunate buildings have resulted from this one-sided approach—just as bad as the cheese-paring, minimum-standard approach. How long can people live in practical, flexible space when they cannot admire it from the outside—even when they are told it is "good for them"? Architecture is not just treatment of space, nor just a matter esthetically of mass and line. People want more than "clean lines" and "organic planning."

Then consider the scientific function. Architects have been forced to become engineering-minded due to advances in techniques and the production of new materials. This has been good for them. But in America, where the engineer is traditionally so important, they have tended to bow before his greater strength—even to identify themselves with the engineering discipline. This is unfortunate. Engineering is clearly a separate science. But carrying the slogan, "form follows function," to its logical conclusion has led many architects into an exaggerated pseudo-scientific attitude toward building.

Architecture partakes of so many skills that we must be careful not to let any one of them engross it. At the moment, there is a tendency to overemphasize both sociology and engineering, both of which are essential items in the architect's equipment, but which lead to grave errors if they are unleavened by art. The way to correct this state of affairs is to put art first. Architecture is first and foremost an art, but it is an art with social and scientific content and foundations. If one recognizes the fact that art is the key in this ordering of skills,

212

architecture immediately becomes stronger, more able to stand on its own feet.

What architect nowadays proclaims he is an artist? The ones who do are suspect. One of the last American architects who claimed this distinction and practiced it was Louis Sullivan. Most architects would prefer to be called technicians, planners, or businessmen. Buildings of distinction are always designed by artists. Run-of-the-mill buildings can be designed by planners and businessmen. All the latest New York buildings, including the UN complex, were planned by architects who fancy themselves economists, sociologists, or businessmen.

The way out for architecture is difficult. It involves a completely different training for the young. It demands boldness and no cringing. We cannot afford to wince at the words "beauty" and "proportion."

If we can accept the reality of beauty in architecture, a change will have come about. If we continue to hope for beauty as a by-product of design, good buildings will not be the result. A positive approach to esthetics is essential if architecture is to survive as a useful profession.

Beauty or fitness should not be confused with architectural style. There never has been any one style used exclusively since the Industrial Revolution, and it is safe to say that this will remain true. Architecture is an Old Farmer's Almanac in that sense—anything is possible and no doubt everything will be tried: If Buckminster Fuller stops beating his head against an aluminum wall, somebody will find him another material. If the Colonial Revival loses favor, there will always be someone to interpret for us a new style based on some past epoch. In spite of its long cycle (the Colonial Revival is now over seventy years old) architecture is as subject to fashion as fashion itself.

Probably the last thing we should look for is consist-

ency and yet to be entirely inconsistent is certainly not our aim. Perhaps there is some way of providing a thread of principle on which the many-colored beads of architecture can be strung.

First, let us see if the matter of principle is important. An English lady once spoke with the writer on what some people consider to be the esthetic deterioration of the English village, with its present-day architectural variations and departures from the original theme. Her argument was that variation of style was the charm of England and the more of it the better. There are many who would agree with her. There are others who think of the earlier charm of these places when architecture was governed by a Rule of Taste. Both points of view are inadequate today. Variety too easily can slip into chaos and a Rule of Taste, if imposed from above, can be criticized as artistic dictatorship. If the architect, or those whom he represents, is not to bring chaos or work under dictatorship, what can he do, what principle can he follow? The answer—it is not a simple one—is to design buildings and groups of buildings that are beyond criticism, or at their lowest evaluation, pleasing. This is as much a duty of the architect as scientific planning or providing a weather-tight roof, which have always been part of the architect's work. The quality would have to be such that it pleased a vast majority; there are always a few who cannot be won by any form of visual grace.

"It is all a matter of humility," remarked one of Britain's better-known architects to the writer recently. He would commission several architects of markedly differing styles to develop a new town—providing they measured up to this first requirement. Yes—admirable—even though the interpretation might vary among judges. With the public—our final judge—such a policy would certainly be popular.

We might go so far as to agree with this architect that the problem is one of taste and not of style. The greatest

mistake that we could make is to believe that there is only one manner, one way of building. Preferences we should have, but not prejudices. And of course, humility . . . *humility before the past and before the taste of the people.*

Perhaps it would be useful to look more closely at these various styles. How sincere can an architect be and still remain misguided? Who are the blind and whom are they leading?

The architecture of the fifties and sixties is too familiar to need much description. Variations on the Neo-Georgian or "Colonial" style, together with astylar functionalism, accounted for the greatest bulk; there were also popular "regional" styles in various parts of the country, and a growing interest among artistic circles in the so-called "International" style. Traces of the Pan-Hellenic Beaux Arts revival can still be seen in public and commercial buildings, but these have been growing fainter with the years. The skyscraper was effectively smothered by the depression but slab-like office buildings and hotels had a remarkable vogue after 1950. Possibly factory building achieved a new and vigorous expression under the influence of the late Albert Kahn—to some minds the outstanding architectural figure of the period which ended with World War II.

This last was largely a technical achievement, and it is not necessary to speak of advancing technology here, except to say that it has made easier the building of any architectural project we wish to make a reality. Technology only becomes vital in esthetics or so in some developing countries. Otherwise, it should never be allowed to dictate style, except in certain types of utility construction. Even where technology has freed the architect from petty worries, there still seems to be a lack. This may be because we have begun to deny our architectural inheritance—"that which has been created and admired." We are concerned nowadays with offshoots. Without nourishment of the main stem, great architecture can never develop.

1. The firm of McKim, Mead and White inaugurated the Colonial Revival in 1886. The Pope House (1900) at Farmington, Conn.

What are the possibilities of these styles?

The Colonial is a poor reflection of McKim, Mead and White's first bold revival in 1886. It is now not only archaeologically incorrect, but has not developed any quality which justifies its continued use. Only when post-Colonial Greek Revival grandeur is attempted are the results even a tour de force. The Harvard Houses distorted the earlier tradition by blowing up a simple domestic style larger than life-size and making it look ridiculous. Early American Georgian is not a suitable model for revival. It was an architecture which depended for much of its effect on craftsmanship, and that is a feature which places limits on a modern revival. This style could perhaps be reinvigorated by tracing its Renaissance origins. Then, of course, it would be something quite different from what we now see.

Astylar functionalism may account for as great a volume of building as the Colonial, possibly more; it is impossible to say because no one can measure it. It is the "architecture without columns" sponsored by development corporations and visible in plain blocks of apartment buildings, offices and stores all over the country, outside the small house field. Although one cannot deny that adequate solutions are to be found in this way of building, too many of its adherents use it because they

are afraid of offending. It is usually the product of fear and does not offer any hope for the architectural future, except to save it from the bizarre.

The second-growth or "regional" styles are not important; Cape Cod and Spanish Colonial are almost always too "folksy" to be architecture. They are bearable on their native heaths but incongruous on the urban fringe. They lie outside the great tradition, as Colonial in the better forms does not. The English Tudor and the Norman of New York and Chicago suburbs are also beyond the scope of architectural criticism, although Walt Disney can turn them to good use in creating a world of make-believe. Perhaps the most successful regional type is the "prairie" house invented by Frank Lloyd Wright, in spite of the fact that its usual location in big city suburbs somewhat belies the name.

The International style denies the great tradition more openly. It is a reaction against "styles." "It was generally proclaimed by the fathers of the modern movement that it represented a complete break with the past and could not possibly be compared with any other historical school. This contention, which is commonly made by all artistic pioneers at all periods, we will treat with the contempt it deserves." [1] Or, as another writer puts it, "it is a sign of the vulgarity of this building manner that it professes not to be a manner." [2] In spite of the hostility of these statements it is true that building is not invisible, that initiators breed followers, and that in the act of revolt, the modern movement creates a stylistic conception of its own, which may be examined with the others. The interesting early constructivist period, of which R. M. Schindler and Josef Urban were the representatives in the United States, has largely given way to a romantic mannerism, with a less exacting set of rules. The architects of the international-mannerist style are interested in the idea of factory-produced homes and it is

217

probable that in this the future development of the style lies.
When the machine for living is actually made by the machine
it will presumably have reached its ultimate goal.

What has happened to the Classical style? The most
recent revival began in the eighteen-nineties, reached its full
force before the First World War and has since been gradually
disappearing. This seems to be a case of the main stem being
pushed aside by an offshoot, namely the Colonial, which has
picturesque and historical associations dear to the sentimental.
But this concentration on superficial associative qualities will
eventually weaken the Colonial to the point where it is no
longer admired, for public taste rarely gives its blessing for long
to the watered-down. There are evidences that the saturation
point has already been reached; the post-war turning to other de-
vices, such as the "ranch house," is still the most conspicuous.

It is possible to find good buildings among all these
styles, and especially in the Neo-Georgian, which comes nearest to
the great tradition, but very few which qualify for the encomium
of great architecture. Is this because times have been bad or
otherwise non-conducive to great art? The architect often
blames the times. This is not entirely fair. Certainly opportun-

218

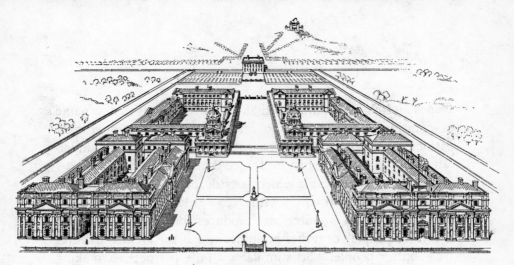

3. View of Greenwich Hospital. Begun as one palace by John Webb in 1663 it was carried to completion by Sir Christopher Wren who joined Webb's building and Inigo Jones's Queen's House (center background) in one grand design, enlivened by the work of sculptors, woodcarvers and mural painters. In the building on the left there is a large painting by the American, Benjamin West.

ities have existed, even during the depression, when federal projects sometimes took the place of private contracts. A great many public buildings were built in the thirties, almost all the large-scale permanent housing projects and a fair-sized volume of private homes. In all these it was the architect's role to suggest and that of private or public sponsorship to modify. Whose was the greater failing, the architect's or his client's? Was a great opportunity ignored? Are architects getting stuffy—even provincial in outlook? Their grandfathers were never provincial—they made the grand tour, studied all periods and looked at architecture with an appraising eye. The greatest men of our British branch—Wren, Chambers, Kent, Inigo Jones, Vanbrugh and Soane—all visited or studied abroad, and their buildings reflect the gain. Those who could not, read the books. One of the greatest of American architects, A. J. Davis, who never travelled abroad, made good use of his partner's famous library. Nowadays the great books are dusty on the shelves. To build well you must know great architecture, and be able to bring order out of disorder. And the architects are not alone. Look at the primitive

shapes and childish fantasies that are forced on us in the name of painting, as if we had no intellect or warm human sympathies. The artist is in the vanguard no more when he underestimates his public, when he forgets that his model is Life.

There is a fault which goes deeper still; a new generation is being indoctrinated with Neo-Puritanism. The puritanical approach in architecture produces buildings which are "good for people" or rather buildings which the architect thinks are good for people. This stimulates a false perspective, making the architect a patron instead of a useful interpreter. Architects appear to look with envy on wealth and with fear on popular taste. It is envy and fear which lead them to exert whatever power they have through intellectual channels and impose their ideas through puritanical restrictions. "Thou shalt not build for pleasure," "Thou shalt not be extravagant," "Thou shalt not exercise the imagination." "The devil will be after you if you do not conform." Architects, like painters, have grown introspective. Doubts and fears assail them at every turn. Ingrown attitudes are common, deifying the pure, the simple and the good. Architectural jargon conjures up "clean lines," "organic planning," "the human scale." Visions of Lutyens and Trumbauer! Where are the bold men, the Grand Manner and the joy of building? Where is the architect who offers more than bricks, steel and "space relationships" for payment received? Where is an architecture to be proud of?

A great deal is said these days about experimental architecture. Many of us who are concerned with city planning would like to see much more experimentation. We should like to see the forbidden paths cleared of the weeds of time and explored a little further. We should restudy architecture in order to discover the great tradition, particularly with a view to interpreting it in modern construction methods and new materials. When the architects of the Renaissance were building they did not hesitate to improve old forms with modern methods. Their

system of construction was usually separated from the forms of their architecture. Was this wrong? But there is no moral code for the use of technics. Why do we now have to make such a fuss about emphasizing construction? Sullivan was superior to any such rigid theory. The Wainwright and Prudential buildings appear to have two steel piers to an office . . . yet every other pier contains no steel and is treated in just the same way to provide a uniform exterior.[3]

Again, we might try to make architecture truly international; not colonial, regional or parochial. In the Federalist period, American architecture was just that; in the romantic revival too, and in the eclectic revival. It was international in the grand sense of the word, in style. The truly international forms are so in *time* as well as *place*. The continuing classical tradition in France is international as well as French, because it draws from the best sources of the past. A modern French building by an architect like Paul Tournon in the traditional, using the latest method of ferro-concrete construction, is almost always admirable, in space arrangement, in choice of material, in elegance. The Eglise du Saint-Esprit in Paris is a building to be preferred, a building of taste. And you will find that many people will admire such a building, although some will be surprised to find that it has an efficient heating system.

Students of architecture should be sent abroad again to cultivate an international mind. Painters now have the opportunity to study the world's masterpieces in American museums, but the world's great architecture is immovable. These trips would teach us what we have lost in taste and flair and how much we have to learn about the building complex and its setting. The current emphasis on intuitiveness and self-expression is very limiting. If the student once knows good architecture he is on the way to creative activity. Have we, in contemplating our own navels, found a better source?

And is it possible that in damming the classical stream

we have cut off the element which sustained architecture in its greatest periods and which we cannot even now do without?

Leaving the architectural styles and turning to city planning we shall find three approaches which, positively or negatively, have to do with esthetics. The first is the "official" approach, typified by the schemes for cities all over the country by city planning commissions or established professional planners. Since these schemes seldom make any recommendations concerning architecture and deal mainly with traffic engineering it would perhaps be unfortunate to examine them for their esthetic implications. If most of these official projects were carried out tomorrow, the cities which they "replan" would not look very different from what they do today. Relieving traffic congestion is necessary and vital, but it should not be called planning. It is unfortunate that when architects go into official city planning they end up as traffic consultants like all the rest. Perhaps they should not be blamed for this—they are forced into the mold—it is nevertheless regrettable that those who have been trained to see in three dimensions should be employed to work in two.

4. Elevation of buildings on the north side of the Place de la Concorde by Jacques Ange Gabriel, which were Thomas Jefferson's favorite "modern" examples. Originally designed for visiting ambassadors and their

"Utilitarian" city planning can never accomplish its purpose because it can never win any friends. It does not include the architectural solution. Who cares about the plan of the Piazza and the Piazzetta? The plan only provides open spaces; it is the architecture that brings everything to life. Opposite the Doges' Palace is the Libreria by Sansovino, built over two centuries later in a different style, yet the Piazzetta has unity . . . perhaps because both are great buildings.

All the great town-planning schemes of the past have been successful because of their architecture, but we have forgotten this elementary fact. Ensembles of great architecture! Settings for the human drama. But today we have no settings . . . only a stage cluttered with junk from the old-fashioned melodrama called "The Landlord's Dilemma." (The best explanation of why our cities are ugly is still to be found in G. B. Shaw's first play, *Widowers' Houses*.)

At this point we will interject the foolish notion that no city planning solution can be good unless it is also beautiful. What nonsense! Forget about it at once. Cover up all sites with giant superblock apartments or identical office buildings.

staffs, the building on the left came to be divided into private "hotels particuliers" while that on the right was turned into the Garde Meuble de la Couronne (or Royal Warehouse), today the Ministry of the Marine.

223

Concentrate on cutting new expressways through the congested urban mass. Their lines are so clean and their surfaces so smooth! Look at the curve of that new bridge! But America is not Pulteney Street or the Rialto, and people don't do their shopping on bridges. And, as yet, they don't all live behind those dead, expressionless superblock walls. There may still be time.

The second approach is the product of a syndrome which has its basis in early 19th-century gardening. It is the theory of the picturesque applied to city planning. Without going into its earlier development by Price and Knight, the current theory may be described as expounding the beauty of studied irregularity. So far only a few of the new towns or larger planning schemes show any evidence of this method—when they do, it becomes a style known as "suburban." There is nothing positive involved and the whole idea has been the amusing toy of art historians until now, when it is fast becoming a cult among certain of the younger architects. It is interesting to speculate on the possibilities of an esthetic method which would unite different styles of building in one scheme, but although this is a realistic aim, the spokesmen for the picturesque, or Sharawaggi as it is solemnly called, have so far remained apologists for the last century. To see beauty in a heterogeneous collection of buildings may be a salve to the conscience, but you are more likely to finish by defending the slums and the status quo than proposing any definite town planning system. Sharawaggi is the antithesis of the Grand Manner in planning. Whereas the latter can be applied to small-scale villages as well as large-scale metropolitan areas, the former if used in large-scale projects would frighten even the most devoted admirers of Richardson or Norman Shaw.

224

In the United States there is a tendency to admire the picturesque wherever it can be found. Since there is very little architectural beauty to admire in the mass, the emphasis is either on the "quaint" or the "spectacular"—"old" Williamsburg or the skyline of New York. There is admittedly something esthetically interesting in these curious assemblies of architecture. But pursuit of the picturesque is not for architects. It is a sop for those whom architects are not allowed to satisfy in better ways.

The third approach to city planning which may be considered of importance esthetically is the approach through modern architecture. Every young architect remembers Le Corbusier's famous statements: "The styles are a lie" and "The plan is the generator." What is curious is that they have swallowed this dogma hook, line and sinker. To believe that "architecture has nothing to do with the various styles . . . The styles of Louis XIV, XV, XVI or Gothic are to architecture what a feather is on a woman's head," it is necessary to substitute another esthetic, by concentrating on form and materials. "Mass and surface are elements by which architecture manifests itself. Mass and surface are determined by the plan. The plan is the generator. So much the worse for those who lack imagination!" [4]

Now if you want to create architecture from the plan and with emphasis on form and materials, there is absolutely no reason in any free country why you should not experiment in this way as much as you wish. But to say that it is the *only* way to create architecture, and to attack the method which created the Petit Trianon, is to make people wonder whether your own solution is as good as it pretends to be. But comparisons are odious, even in making esthetic judgments, and are only made here in order to prove that today the old proverb "People who live in glass houses shouldn't throw stones" has a

5. The octagon house of Orson Squire Fowler, the famous nineteenth century phrenologist, which once stood on the outskirts of Fishkill, N. Y. Designed on Fowler's principles of hygiene, it collapsed as a result of poor construction.

more literal meaning than formerly. The most recent evaluations of modern architecture tend to place their emphasis on the work of engineers like Pier Luigi Nervi, designer of the Sports Palace outside Rome, whose new approaches to form and construction and creation of uninterrupted spans have achieved for modern architecture what architects have mostly been unable to do with limited engineering "know-how."

As for the theory that beauty proceeds from appropriate use or from the plan, a quotation from the eighteenth century philosopher Burke may prove apposite:

". . . If, where the parts were well adapted to their purposes, they were constantly beautiful, and when no use appeared there was no beauty, which is contrary to all experience, we might conclude that beauty

consisted in proportion or utility. But since, in all respects, the case is quite otherwise, we may be satisfied that beauty does not depend on these, let it owe its origin to what else it will."

Let it be understood that we are not condemning the search for beauty by any means which an architect may see fit to employ. Nor are we condemning the modern style for those who find it pleasing. It has a place. Let us remember that there are many roads leading to Rome and we should be free to choose any route we please. We should also be versatile enough to practise more than one manner of building.

There are many other tenets of the so-called "International" school—a misleading term suggesting that its followers seek a wider frame of reference than is in fact the case. One is the dangerous rationalization that "fine building makes a fine society." This is to read a meaning into architecture which it was never meant to possess. Let us agree that the *program* behind a building concept is important to society—as witness

21 JUNE

21 MARCH

21 DECEMBER

6. Gaston Bardet's analysis of Le Corbusier's "City of Shadows." He reveals the emptiness of the Swiss architect's claim that his city will always have light. Gaston Bardet takes the city on June 21 at noon, i.e., as Le Corbusier had presented it, and shows what happens during the rest of the year.[5]

George M. Pullman's intentions for his town in Illinois, Hitler's subsistence homesteading, or the significant housing program of the USHA. In each case the scheme is either fine or foul according to its authors' objects, not because of its architecture, which in the bad program is sometimes better than in the good. If you categorize architecture or planning as bad because it was done by absolute monarchs or thieving speculators, you will

7. Breaking the solid walls of Park Avenue with voids of glass.

have to rule out most of the best-known examples of the past and present, and you will find yourself in the same difficulties as a well-known critic, who is reduced to describing a doorway as "despotic" instead of placing it more accurately by its shape or style.

The esthetics of the international style have been welcomed, like the towers of Manhattan in 1910, for their novelty. A Bauhaus architect has said that they consist largely in "the disposition of the masses." Quite true. The fact is that *all* art depends on this elementary principle. It is a principle, not of architecture, but of existence. The statement could only be made by persons who know nothing of art in general; and it never is made except by those who, not being artists, think that the one poor esthetic principle of which they are cognisant is the whole of art. The fact is that all great art begins where theirs ends, as Ruskin said, with "the disposition of the masses." The same may be said for the much-repeated phrase "fitness for purpose." It may be the first thing required of an architecture that it "shall answer its purposes completely, permanently and at the smallest expense." But it is not the last thing, nor is it the highest thing.

Looking at the latest modern apartment house development in New York, one is struck by a curious fact. The esthetic pleasure is gained almost entirely from the contrast between the great white buildings and their surroundings—the nineteenth century slums and the industrial blight. Should the purity of the buildings be smeared by rain and soot the contrast will begin to fade. Or, should the whole of the upper East Side be rebuilt in the modern manner, the contrast will no longer be there. Where will be the esthetic pleasure then? Meanwhile be wary of the architect who talks glibly about the social basis of his architecture. He may turn out to be a thinly disguised technocrat who wishes vainly to reform the world through

technics and design. To examine the "methods" of art without tackling the essential "content" may take more than a lifetime and lead exactly nowhere. And do not let anyone be convinced that a particular way of building is the only one. It should be a virtue to be master of more than one style. Even though you may not wish to go all the way with the famous aphorism, "Architecture is the decoration of construction," those who will not admit that it is more than half true are doomed to constant disappointment in their professional life. "So long as any given styles are in practice all that is left for the individual imagination to accomplish must be within the scope of those styles, not in the invention of a new one. For who is to come after you, clustered Columbuses? to what fortunate islands of styles are your architectural descendants to sail, avaricious of new lands? When your desired style is invented, will not the best we can all do be simply to build in it? and cannot you now do that in styles that are known?" [6] To these wise words might be added the lighter touch of a famous nineteenth century artist in style, Oscar Wilde. "Nothing is more dangerous than being too modern," he warned. "One can grow old-fashioned quite suddenly."

If we are to use more than one style, as is inevitable in a democratic society, what is to be the unifying esthetic principle? One proposal is to consider esthetic satisfaction not only as beauty which you wish to display, but as a necessity you are forced to meet; that is, to develop the positive approach to beauty which has been suggested in these criticisms. This implies, certainly, a fraternity among architects, especially where city planning is concerned, for while a man of science can for a while pursue a lonely path, architects and planners can never do so. A much closer link with the public is also necessary—and one not too difficult of attainment once architects recognize their duty to society. This prime duty is to build so that the

architect is a trainer of good taste and an inspirer toward the goal of beauty, or the form of beauty, as Plato puts it. The artist is a First Perceiver; the one who in the first place perceives the significance of combinations of shape and color which escapes the ordinary man. This is not to say that the ordinary man cannot perceive it in his turn; he can, but he is without the specialised training that an architect should have for *creating* beauty. To the architect beauty is a goal; to the public a source. In a positive and realistic sense, beauty can be dynamic and active in the world, driving men forward to realise it as creators and to comprehend it as recipients of the beauty of works of art.

If architects will reinclude in their social art the search for beauty, they can do so in their various ways, practising various styles. And if the goal of beauty is included, could this be the unifying principle for city planning? If the positive approach to esthetic problems were revived—if these problems, instead of being ignored like an unmentionable disease, were brought out into the open and aired—it is just possible that we might see healthier city planning all around, and that synthesis which artists should be demanding. "Behold, I will lay thy stones with fair colors, and thy foundations with sapphires . . . and all thy borders of precious stones."

These lines are written at Chantilly on a warm summer afternoon. A yellow leaf falls silently into the pool below the waterfall—the park's great staircase and the chateau's towers are reflected in the gently stirring surface, and beyond, the green allées stretch like never-ending ribbons into the forest. For what was this lyrical inflection of nature's voice created? Not for utility, surely, but entirely and frankly for pleasure. This quiet river winds through five or six of the loveliest creations in France—Senlis, Mont l'Evêque, Châalis, and Ermenonville, where the tomb of Rousseau himself bears testimony to the

fact that France has built and gardened in many styles and to suit all moods. The stream is perhaps a living symbol—that taste is many-sided and various and that beauty manifests itself in different forms, but where that taste is cultivated a harmony prevails.

Soon it will be time to return to Paris, the Mecca of all city planners, with its miles of tree-lined avenues, squares and public gardens, its monuments of architecture, its facades which none have dared to criticise because there is nothing yet built to rival them. Yes, and its slums, too—but even though Paris has slums, it has the other, and few cities can make this boast. The architects of Paris made mistakes, but they made fewer in proportion. They went to a school that raised a principle of beauty, to a state-founded academy of architecture. They applied the principle to projects as diverse as the Place Vendôme and Chatenay-Malabry. The result is what we see— a blending of styles of the generations between Perrault and Tournon and a unity of performance absolutely unequalled. In city planning their method was to create an order which could encompass and absorb a certain amount of disorder, which could create a whole with individual parts. Their genius has not passed unobserved:

> ". . . the training of the French school upon which
> the architectural training of all Europe is more or less
> modeled, is a most valuable training in qualities and
> accomplishments that are common to all architecture.
> Founded as it is upon the study of the classic orders, it
> confers or cultivates a perception of proportion and
> relation of adjustment and scale, in other words of
> that sobriety, measure and discretion which, in what-
> ever style they may be exhibited, or whether they be
> exhibited in works not to be classified under any of

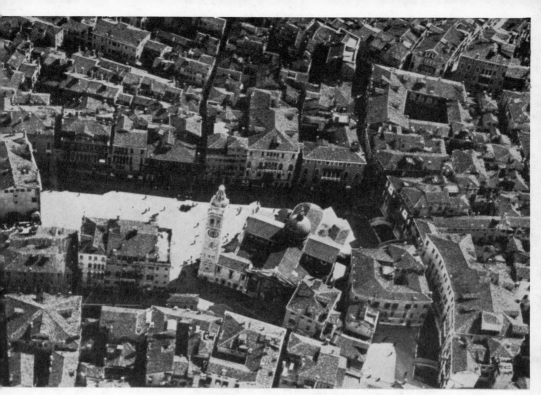

1. The Campo Santa Maria Formosa, Venice, once the scene of bullfights and alfresco performances; today it is an open market-square. Two canals skirt its borders and the baroque campanile of the earlier church is dated 1611.

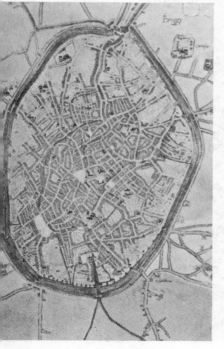

2. Plan of Bruges by Jacob van Deventer. Filled-in watercourses and ever-widening fortifications create a sinuous, concentric street pattern. For a theory of the origin and development of the medieval city see text.

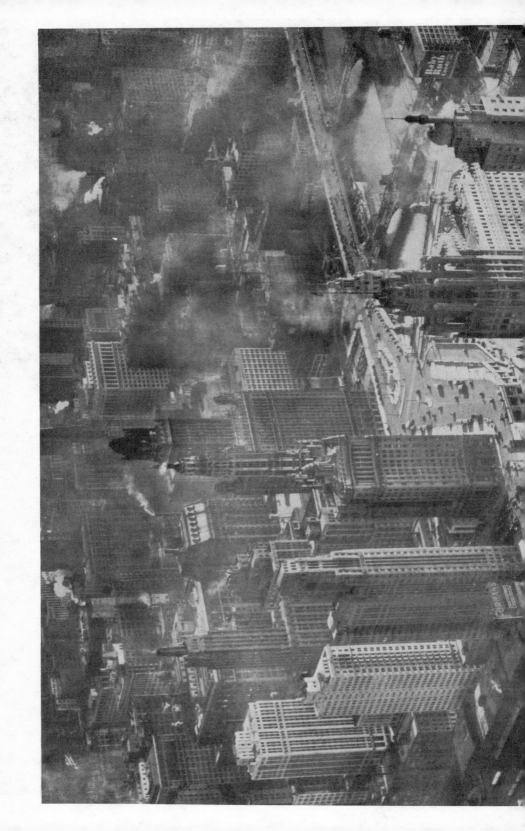

3. An airview of downtown Chicago. In the center foreground, Michigan Boulevard crosses the Chicago River, which is bordered by Wacker Drive. To the far right rises the mosque-like top of a former Shrine Temple, and next to it stands the Tribune Tower, concealing much of the Wrigley Building. The building with the concave front at the center is the London Guaranty Building.

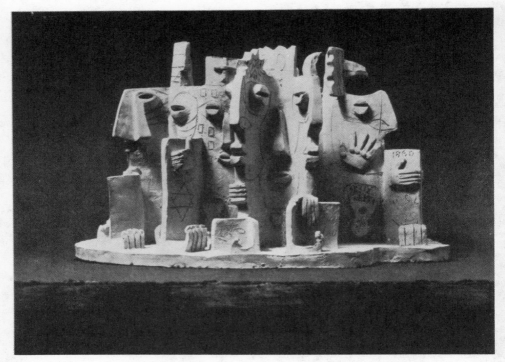

4. *The City*, terracotta by Peter Grippe, 1942. An anthropomorphic view showing the city's fascination for the artist, which remains a fascination rather than a challenge.

5. *Mental Calculus* by René Magritte. The modern artist sees the city as grim and picturesque (in the paintings of Shahn, Guglielmi or the earlier "Ashcan" School); as a melancholy haunt for outcasts (Edward Hopper); or as a magic place (di Chirico, Dali, Magritte). Pre-occupied with its faults, artists today rarely contribute to the vision of the city's future.

6. Sixtus V and Domenico Fontana: Radioconcentric plan for Rome, 1587, from a fresco in the Hall of Sixtus V, Vatican Library. The six-branched star radiates from S. Maria Maggiore (upper center); this fresco does not clearly show the connecting links.

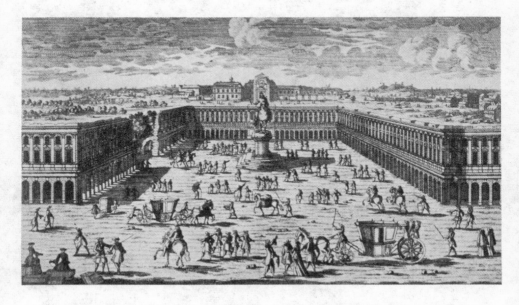

7. A view of the Place Vendôme as originally designed by Jules Hardouin-Mansart. The interior was to have one side open to the river, arcades and the simple square form. This was changed to an octagonal, non-arcaded square when the facades were erected. These stood alone until the lots behind were sold to individuals, who built their own houses employing such architects as Pierre Bullet, designer of the Porte Saint-Martin.

8. Washington, D.C., circa 1861, with the Capitol dome uncompleted.

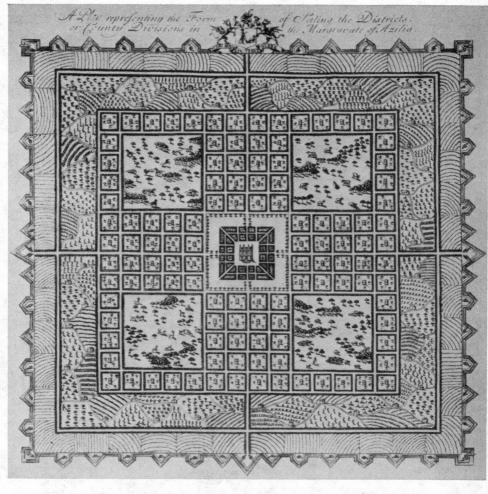

9. The Margravate of Azilia. An early use of the section in a regional planning scheme for part of the present State of Georgia.

A Plan representing the Form of Setting the Districts, or Countie Divisions in the Margravate of Azilia.

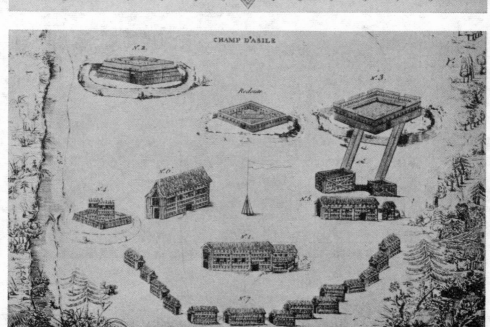

10. Near Galveston, Texas, refugees of Napoleon's army after Waterloo founded a community: The Champ d'Asile.

CHAMP D'ASILE

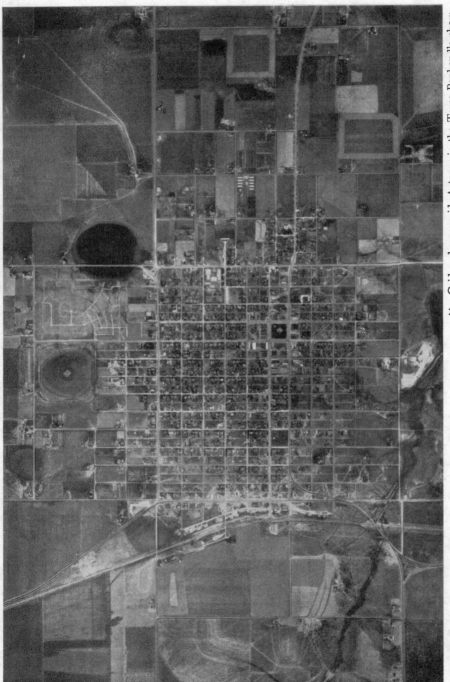

11. Grid and supergrid. A town in the Texas Panhandle showing the division of land according to Jefferson's principles.

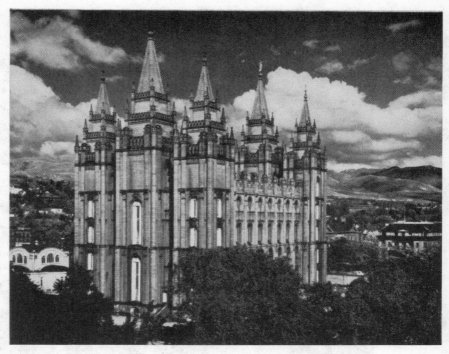

12. The Great Temple of the Latter-Day Saints in Salt Lake City.

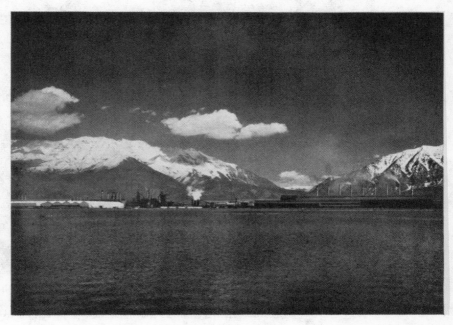

13. The United States Steel Corporation's new plant at Geneva, Utah, built during World War II by the federal government.

14. A. An early photograph of George M. Pullman's notorious model town, designed by the architect Solon S. Beman. The ornamental water is now filled in, and the vacant land on the left is completely urbanized.

B. View across the town of Pullman, Illinois, toward Lake Calumet. The "block houses" are in the background.

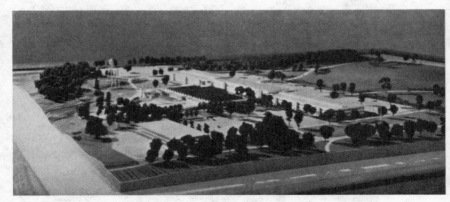

15. The new tendency of industry to build plants outside the cities and to pay attention to esthetic considerations is shown by this view of the International Business Machines' new plant at Poughkeepsie, New York, where the landscape of buildings, road and parking lots has been treated as a whole.

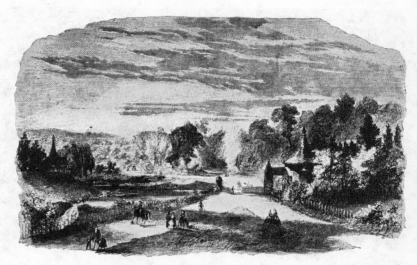

16. Alexander Jackson Davis: Entrance and Gatehouse to Llewellyn Park, New Jersey, the first romantic suburban community in the United States.

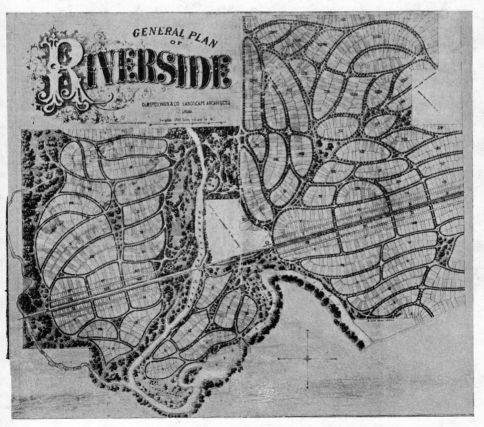

17. Olmsted and Vaux: Plan of Riverside, Chicago, 1869.

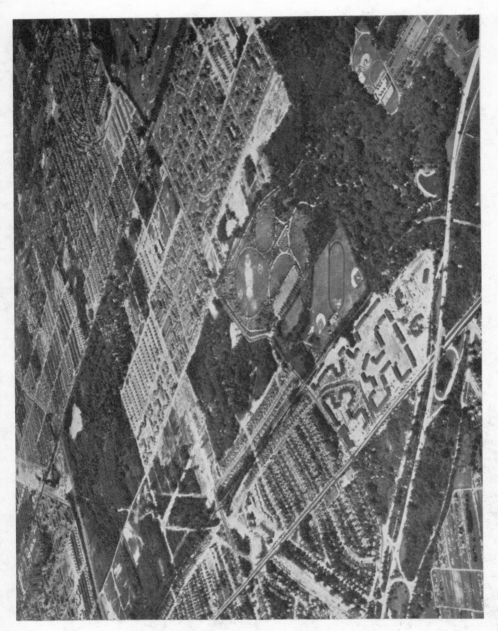

18. The homes of American families in the service-industry city. The very high percentage of projects in group-development form, with mortgages guaranteed by the federal government, is a modern trend, as is the indication of the attempt to plan. View of Flushing and Bayside in Queens, Long Island. Fresh Meadows, the housing development of the New York Life Insurance Company, is in the upper left-hand corner, and in the lower right Alley Pond Park. The two main highways, crossing in the lower center, are the Union Turnpike running diagonally to the left and the Grand Central Parkway at the bottom.

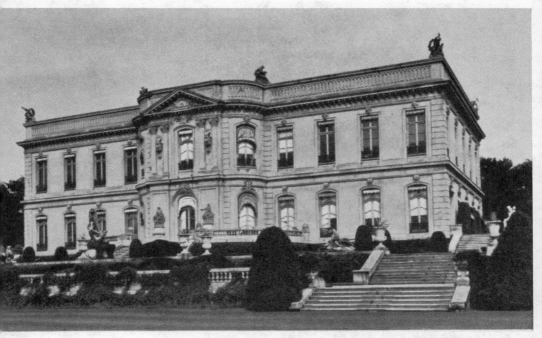

19. The Elms, Newport, by Horace Trumbauer, an example of the continuing classical tradition on a lavish scale.

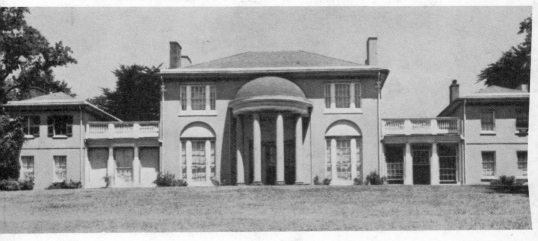

20. One of America's important architectural contributions in the classical tradition was the Federal style, which achieved a scale and sophistication rarely seen in Colonial times. Tudor Place, Alexandria, Va., designed by William Thornton, one of the architects of the United States Capitol. Circa 1812.

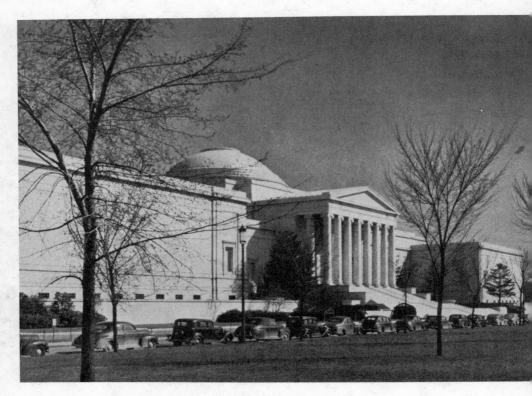

21. The National Gallery of Art, Washington, D.C. Demanded by James Fenimore Cooper a hundred years before, this building in the classical tradition rose in the 1930's to mark the increasing national interest in art and the desire for buildings of magnificence in the national capital.

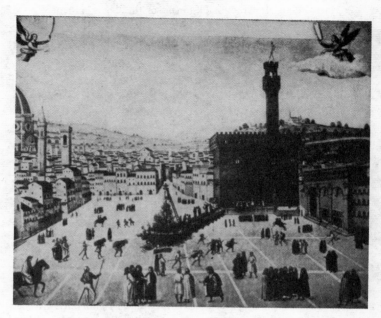

22. *The Burning of Savonarola* by an anonymous Florentine artist, circa 1500.

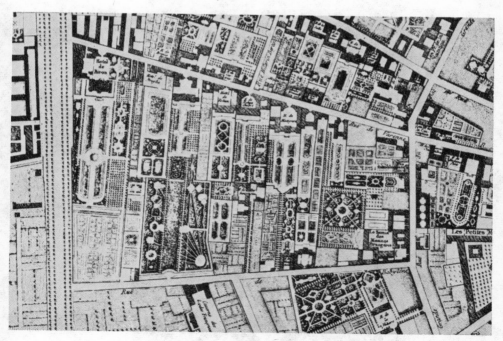

23. Enlarged portion of the map of Paris by J. B. Jaillot, 1775, showing the private gardens in the Faubourg St. Germain. The house and garden on the farthest left is the Hôtel de Biron, at one time Rodin's studio and today the Rodin Museum.

24. Cours de la Porte St. Antoine from a seventeenth-century engraving. The widened spaces flanking the gate, used for recreation before the boulevards were laid out later in the century, continued in use even after the establishment of the Cours-la-Reine.

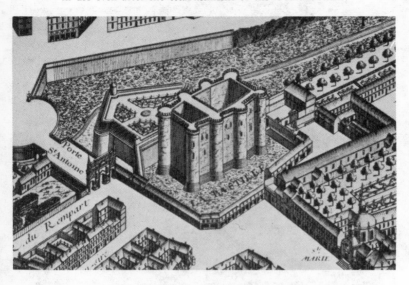

25. A design by Ludwig Hilberseimer for a linear community. Greenery extends in strips between the different sections and is scattered through the concentrated settlement blocks.

26. A Parisian "Mail."

the historical styles, so plainly distinguish the work of an educated from the work of an uneducated architect. . . ." [7]

Let us ask ourselves a question. Why, with all our modern wealth and resources, have we dared to put aside the tradition of fine building? In condemning our inheritance we condemn ourselves and neglect our duty to society. As Picasso puts it, "When I imitate the ancients (that is, when I incorporate their influence into my painting) I know I am right. When I imitate myself I know I am wrong." In music, Arnold Schoenberg is reported to have said before he died, "I confess at times to a desire to return to an older style," and Stravinsky has become "a counter-revolutionist against himself," as Olin Downes has put it.

Do not think that this is a recommendation to revive past styles. There once was a man who created a style by writing about a certain period in the past and without designing a building. Half of London and many American cities bear its traces. His name was John Ruskin. But he had not wanted this to happen. "We do not need any new style," he said, "but by all means let us have some *style*." If we try for humility as he urged, instead of following false trails, we may live to see a better result than he was able to observe in his own lifetime.

A change is about to take place in any case. A reviving interest in scale and proportion and in architectural decoration cannot but be helpful to civic design, eliminating the curse of forced originality which for the last twenty years has succeeded only in creating a new disorder. That this movement will eventually assume the proportions of a revolution there can be no doubt; architects should be anticipating it now, instead of looking back to the early thirties, when "something new was in the air." If they must look back it should be to 1910 when their

profession was still responsible for civic design, but it would be healthier to work now toward the day when architecture and city planning are again united in an approach to the city through third-dimensional grouping in the Grand Design.

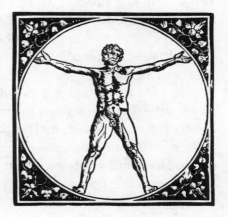

CHAPTER **10**

THE LEAF AND THE STONE

There are primitive communities in many parts of the world today in which tree worship is still practiced. There are also to be found in highly civilized communities certain advanced groups—mainly architects, planners and their disciples—who worship all forms of greenery indiscriminately. So great is the devotion of these latter-day hamadryads to the forms of nature that they wish to be surrounded by them at all times and in all places—even in the heart of the city, where until recently nature was seldom seen. This new cult is trying to abolish the old and seemingly irreducible dualism between nature and man, the tame and the wild, the country and the city. In doing so, it denies many hitherto-cherished concepts of civic design, some of which must be mentioned here to put the new movement in perspective.

235

There used to be a region called the country and a place called the town. Since Ruskin's day this distinction has become less clear: "At least fifty acres of beautiful country outside London," the sage of Denmark Hill once railed, "have been Demoralized by the increasing urge of the Upper Classes to live where they can get some gossip in their idleness and show each other their dresses." Since the mid-nineteenth century the situation has grown worse—more people want to live closer to nature *and* to the dress shops, to fresher air and wider spaces; it was not long, therefore, before a solution in city planning terms was forthcoming.

"There are in reality not only, as is so constantly assumed, two alternatives—town life and country life—but a third alternative, in which all the advantages of the most energetic and active town life, with all the beauty and delight of the country, may be secured in perfect combination . . ." [1] So wrote Ebenezer Howard, the inventor of the garden city, proposing the adoption of *"town-country,"* a not-altogether happy solution for the problems of contemporary living. Note the phrase "beauty and delight of the country,"—a typically town-bred way of referring to cultivated nature; one feels that the countryside would be unhappy partner in this forced marriage, under the subjection, in fact, of the town itself which still dominates the planner's thinking. Is there not a confusion here? In trying to improve what Henry James calls "the terrible town," not only Howard, but every other nineteenth century utopian planner was trying to change it into something else, not realizing that towns must be allowed their own diathesis in order to be effective as communities. As a result almost all the ideal towns proposed in the age of antipathy to urban "ugliness" lack any atmosphere or character which would ensure this popularity. Even the garden city, dissolved in green, lacks appeal to any but the dedicated, in much the same way as the meatless dinner

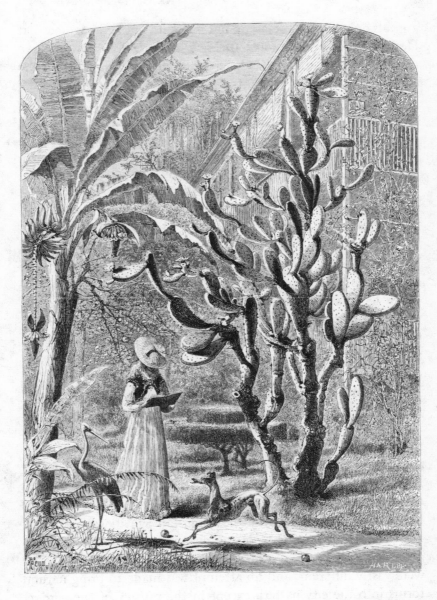

1. A Garden in Florida.

237

appeals only to the vegetarian; but it should not be imagined that Howard's idea was without influence. As several authorities have pointed out, his theory has been more effective in changing the character of the city itself than in creating its antithesis . . . town-country or the garden city proper.

This is not to deny that the forms of nature have their legitimate part to play in man's own private place, the city; in the furnishing, the elevation, and especially in the plan. We need not subscribe to the extreme views of the Abbé Laugier, who in his *Essai sur l'Architecture* published in 1755 suggested that French cities be planned like forests to avoid "the excesses of regularity and symmetry;" nor will the problem again arise which confronted the courtiers of the Margrave of Baden-Durlach when, escaping from their too flattering attentions, he sought refuge in a wood. The city plan, being an art form, will never be an exact mirror of nature, in spite of the pseudo-biological approach of the devotees of "organic planning;" although it may with virtue acknowledge the presence of nature and heighten our enjoyment of man-made environment by contrast.

What is the evidence of history in the attempted resolution of this problem? A few general observations can be made here. First, it is clear that with only occasional exceptions there is a hard and fast line drawn between town and country until well on into the sixteenth century. This is not to say that town extensions, and even suburbs, did not exist—one had to travel outside the walls of Athens to visit the garden of Epicurus or Plato's academy, and by the Augustan age it was positively fashionable to live in the not too distant country—but the character of the city and of even the nearest cluster of Roman villas were vastly different, and no attempt was made to bring natural forms into the city pattern except in the privacy of the garden. Sometimes it happened that nature was already there and was

238

not destroyed when the city grew, but mostly the city was quite literally streets, buildings, fountains and squares—bare of natural ornamentation. The Greek enthusiasm for idyllic and restrained natural scenes worked in another direction—that of implanting man's works outside the city's gates. Inside the city, trees were sometimes planted around springs and fountains—vestiges, perhaps, of primitive tree-worship—or in a "pious grove." Sometimes greenery was introduced into the agora, but this was not a common practice since the stoas provided shade. The Roman temperament, less restrained, drove men to seek retreats in wilder nature, which Marcus Aurelius found in the mountains or at the seashore. Pilgrimages to lonely places which were to have so important an effect on attitudes toward wild nature, became a matter of *force majeure* in the early Christian era when persecuted souls were driven there to practice their beliefs. "How long will you shut yourselves up in the prison of smoky cities?" Jerome exclaims in one of his Epistles, full of wonder and admiration at the desert, "blooming with Christ's flowers;" but this feeling for wild nature was not held by everyone and it is only well toward the end of the eighteenth century and the advent of Rousseau that the fear of lonely mountains and wild ravines is completely banished from men's minds. (The delicious shudders of the Romantics at the sight of fearful mountains were in themselves a symbol of the escape from fear.) Thus it was that the medieval and early Renaissance cities walled out nature almost completely, although by the fifteenth century when cultivation had spread for miles beyond the ramparts, the practice of planting trees along country roads and on the banks of canals for the purely utilitarian purpose of providing shade had become established in France and in the Low Countries. The tree-lined road or body of water occasionally crept into the city itself (it noticeably did not do so in Paris), but for the most part greenery in towns until the seventeenth

century was confined to gardening of various kinds and gardens, being private, were seldom an integrated part of the city plan. A view of Turin after the fire of 1659 shows many walled gardens where none were before, but their introduction changes the public aspect of the city not at all.

The seventeenth century brought nature into the city plan in a unique and unsurpassed fashion, but first let us look at the preceding century, which gave us the first modern cities and in which certainly we should expect to find evidences of the coming trend. The Italians of the Renaissance, who were pioneers in the discovery of modern landscape, arrived at the new attitude simply by reviving a late classical feeling for esthetically agreeable scenery and the change was neither drastic nor sudden. Wild nature was still kept in its place and even to men of the later Renaissance the idea of "town-country" was unthinkable. There was the world and the city—the latter certainly to be escaped from, when the weather was too hot or the plague threatened, but always the center of government, and of culture,—a separate place. A glance at a painting of about 1500 by an unknown hand, "The Burning of Savonarola" dramatically shows the contrast—the vast Florentine square, its decoration only the patterned pavement, with the crowded buildings of the city behind, all scorching brick and stone, and beyond the low wooded hills, crowded with verdure, though not with habitation. Or take the much later and more accurate drawing of Florence by Nicholas Poussin looking from the left bank of the Arno toward the Palazzo Vecchio and the Duomo; nothing green breaks the architectural skyline save for half a dozen sentinel cypresses growing inside the walls of private gardens. These views were of the existing city, but the ideal, different as it was in design (this is the period of the radio-concentric fortified plan) was no different in its concept of nature. This is an important point; if the admission of nature had become

240

part of contemporary urban thinking one might expect to find evidence of it in the plans of Leonardo, Fra Giocondo, Giorgio Martini, Vasari and Scamozzi; in Filarete's Sforzinda or in Palma Nuova, which was actually built at the very end of the sixteenth century on ideal lines. Replete with squares, circuses, avenues and other novelties of the period though they may be, one may search among them in vain for any hint of the admission of nature. Alberti had talked of planted squares; from the evidence we may assume that he meant gardened areas in their centers; even so, this greatest of authority's words were not followed in practice. The Piazza Colonna and other new spaces in Rome were adorned only with fountains and obelisks; although here perhaps the introduction of life-giving water can be considered as a triumphant entry of another of nature's forms into urban life. Certainly the first "modern" city improvement which comes at the end of the sixteenth century under Pope Sixtus V, who built the Aqua Felice, made much of the lavish supply of this most precious of nature's gifts. Here again, one may search unfruitfully in this most modern plan for any trace of wild or tamed vegetation; indeed, the scheme destroyed large areas of cultivated land without replacing it. An observer of the time remarks: "Those poles, placed throughout the city in straight lines across vineyards and gardens, bring fear to the souls of many interested persons who are not unaware that, in order to make a road without turnings, many a neck has to be twisted. But, on the other hand, it gives great public ornament." [2] The total length of roads opened by the Pontiff exceeded 10 kilometers and Hübner in his biography of the enterprising Pope describes them as being cool and shady— without benefit of trees. It is on this observation that one may pause to sum up the reasons for the absence of green forms in urban planning until the seventeenth century:

1. The city was considered a separate entity, set apart from the influence of wild nature. Pleasure and edification could be obtained from trees planted on tombs or sprouting from ruins, and sometimes islands of green on relatively inaccessible ground remained in urban surroundings.

2. The cities were still small and the countryside accessible.

3. Streets in most towns were narrow and the buildings, built right up to the thoroughfare, high enough to cast a shade across it. Moreover, by the sixteenth century the new style of building, which derived from the antique model, provided interior courts, with gardens in their centers, or behind. Controlled nature lay hidden here, forming a *hortus conclusus* of urban living.

4. The new art of city planning had a definite esthetic, based on the ancient models, about which as Karl Lehman points out very little was known, but which nevertheless were imagined as perfectly controlled forms. When Alberti suggested that the width of plazas be at least three times the height of the surrounding edifices, he was putting forward a new theory, but one which had a sense of past tradition. He was lifting the problem of scale to a contemporary importance with perspective and motion. The introduction of trees in perfectly scaled surroundings would have spoiled the proportion. (Today when the modern architect introduces the tree standing between the glass tower and the puny figure of man on the ground he is using it to give scale, in an attempt to reconcile the other two disparate elements.) To give the Renaissance and Baroque planners their due, it is impossible

242

to imagine trees in the Piazza at Venice, in the Piazza del Popolo in Rome or in the proposed Place du Thrône, the Place de la Concorde or the Place des Vosges. In the last-named, trees were planted much later and luckily have been kept small by pruning; but in the eighteenth century Circus at Bath, based by its planners again on the antique style, the mistaken grove of plane trees in the center, which was never intended by the designer, has grown to enormous proportions; in these days of sentimental tree-worship the city fathers have not yet been able to summon up enough courage to wield the axe.

The Renaissance city in its more advanced forms remains the truest expression of the power of man to create an esthetically satisfying environment. It had, as we have seen, no need for nature within the gates. It is thus possible to draw the conclusion that the controlled introduction of nature had to wait until new forms were invented which demanded a recognition of the part which nature could play in the plan.

Green space as part of the organic structure of the city comes with the seventeenth century and the establishment of new forms based on changing social behavior. The French models were also antique, but this enterprising nation soon adapted them to new uses. The notion of opening pleasure gardens to the public is largely French, although the garden of Sixtus V's Villa Montalto in Rome had been almost as accessible as the pontiff's person was in those days. The significant change comes with the building of Marie de Medicis' Luxembourg Palace in 1620. These grounds have been open to the public for over three hundred years. They were not, however, specifically planned for public recreation, unlike the more popular forms of open space which were just then appearing.

243

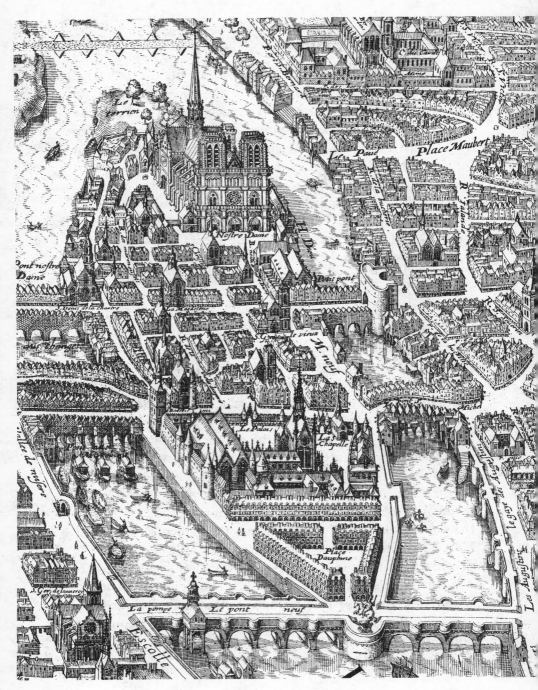

Le terrien

Pont nostre Dame

Pont nostre Dame

Noftre Dame

Place Maubert

S. Paul

Pont pont

Dens de la chartre

La Magdeline

S. Germe le vieux

Le neuf

S. Eschange

Le Palais

La S. Chapelle

Michel

allee de nefere

Place Dauphine

S. Ger. de lauxerov

La pompe

Le pont neuf

Efcolle

2. The Place Dauphine on the tip of the Île de la Cité in Paris. One of the first open spaces created by the movement for new squares which started in the reign of Henri IV. Originally it contained no trees, as the plan of de Chastillon (1607) indicates.

The idea of recreation for townspeople did not orig-
inate with the seventeenth century; it has been prompted
through history by charitable motivations, reforming impulse or
the desire for public acclaim. The apochryphal words of Mark
Antony:

". . . he hath left you all his walks,
His private arbours and new-planted orchards,
On this side Tiber; he hath left them you,
And to your heirs forever; common pleasures,
To walk abroad and recreate yourselves."

are based on evidence from Plutarch. Deeded areas like this were
usually on the outskirts of the town, however, and by the six-
teenth century the use of "prairies" or meadows outside the walls
was fairly common. In crowded Paris, still contained with fif-
teenth century walls, the margins of the Seine and the quais were
in great demand; Sauval describes the quai from the Pont Neuf
to the Pont aux Changeurs as being the only promenade of any
consequence in the city early in the seventeenth century. Henry
IV made the situation worse by making a large private garden
for himself by the new arsenal, but almost immediately there-
after bowed to public pressure by beginning work on the Place
des Vosges. A royal act of 1605 shows the idea of this plaza linked
to that of a promenade under porticoes in the Roman manner,
and the Place Dauphine begun in 1608 on the bow of the cité
was also then empty of verdure. Nevertheless, it was such innova-
tions as the Place des Vosges—public places growing out of the
older palace court designs—which placed France instead of Italy
at the head of the urban planning movement in the Baroque
period.[3] Now come two inventions which slowly began to
change the aspect of the city. One, a facility for sport, was the
Mail. The other, much more important, was a form of prom-
enade known as the *Cours*. "Le Cours", wrote Sauval, "is a

245

new word and a new thing, invented by Marie de Medicis. Before her regency there was no other way of taking the air save on foot and in gardens, but she introduced the habit of promenading *en carosse* in the cool hours of the evening. To do this she planted allées of trees on the edge of the Seine, to the west of the Tuileries gardens." Actually, there had been earlier *cours*, the difference being that the new one was planted. Before 1620 the wide space both within and without the gate of St. Antoine by the Bastille was a famous *Cours* and a carnival atmosphere, not at all elegant or aristocratic, prevailed there at certain times. The Cours-la-Reine became more fashionable, but the bourgeoisie of Paris went there too. "In the Cours-la-Reine," wrote Evelyn in 1644, "beaux and belles take the air as we do in Hyde Park."

The *Mails* (there were several of them in 17th century Paris) were of an even more popular character. The game was a species of croquet, played with a ball, mallet and wickets and the courts were always treed. They were situated along the ramparts, or on the river. Two of the earliest lay between the gates of St. Honoré and St. Denis along the ramparts. The land had been rented out to a Florentine in 1597 for the game of "Palmal," and the conditions of lease stated that the allées were to be planted with elms having branches no lower than ten feet above the ground. By 1605 another long court had been made by the river near the arsenal and by the end of Henry IV's reign there was a circle of green under the ramparts from the river to the Bastille.

This then is the beginning of the marriage of nature with the urban complex, a union arranged by the French, as Sitte remarks, to suit their philosophy of human control in all things which Malebranche raised to its height in the seventeenth century. We should remember however that the new city planning which was just appearing was based on social

usage; the green allée was being introduced not as decoration but as function. The *cours* and the *mail* were not tree-decorated avenues; they were recreation areas. The tree-lined avenue for traffic does not appear until the reign of Louis XIV, who levelled hills to make the grand route from Paris to Versailles in 1664–65. This was outside the city, as were the Bois de Boulogne and the Bois de Vincennes which were made into public promenades at about the same time as Charles II was improving the old deer forest of Hyde Park for the same purpose. Then, finally, into the city came the boulevard which Louis XIV, prompted by his planner-minister Colbert, laid out in 1670 on the site of Etienne Marcel's crumbling fortifications connecting the quarter of the Bastille with that of the Madeleine—"to serve in all its length as a promenade," as the official bulletin describes this innovation. The conventional theory that French city planning reproduces the forms of chateaux gardens—the allée and the patte d'oie—appears somewhat superficial in the light of the specific urban innovations of the time.

Paris was never modeled on a garden, but it was the first school for the introduction of nature into cities, and the least idiosyncratic one. By the mid-eighteenth century, before London had many of its green squares, Paris had conquered the problem of the treatment of open space in cities. She had a manicured air and a fresh look, with her public and private pleasure grounds, open squares like the Place Vendôme and the Place de la Concorde, green avenues and Elysian fields. Everything was in its place, like smaller jewels in the Monarch's crown. And while large parts of the city had the appearance of a beautiful garden, the gardening became a part of the architecture, to produce a hitherto unequaled urban ensemble.

While the neo-classical French tradition of planning still persists, it may be said to have lost favor steadily (except for spirited but short-lived revivals such as the Arcadian City

Beautiful movement after 1890). Its place has been taken by another school of thought which owes its philosophical background and origin to late eighteenth-century Romanticism and the followers of the Picturesque. In the art and literature from the end of the Baroque period to 1840 are to be found all the prompting for this inevitable change, and from the technological advances that have been made since then stem the formal differences which give so many of these places their outwardly different appearance.

By the end of the eighteenth century most plans were heavily treed—the London squares—sheepfolds in town, products of the fashion for landscape gardening—are the most obvious examples, but Ledoux's plans for Chaux, Jefferson's ideal American town plan, and Washington, D. C. itself, are others. All these were before the age of industrialization had made green areas in the city a necessity and were stimulated rather by a theory than by social demand. This theory, which for town planners meant a search for beauty in studied irregularity, had become the dominant one by 1810, and is clarified by its chief exponent Sir Uvedale Price in his comparisons of the towns of Tivoli and Bath. "At Tivoli . . . nothing is more striking than the manner in which the general outline of the town appears to yield and vary according to the shape of its foundation; the buildings advancing or retiring from the eye, according to the nature of their situation, while the happy mixture of trees completes the whole." [4] At Bath, on the other hand, "whoever considers what are the forms of the summits, how little the buildings are made to yield to the ground, and how few trees are mixed with them, will account for my disappointment, and probably lament the cause of it."

Here we have the beginnings of a modern approach in which natural forms—the ground, trees, water are to be admitted as elements *de jure*. They are however, still elements of a com-

3. The "Orange Grove" in Bath, planted with
trees early in the eighteenth century.

position, and it remained for the romantics to welcome them
as living symbols of nature among the feeble works of man.
The romantic movement's imprint on city planning has been
treated elsewhere, but the emotion that stimulated it is worth
summing up in a quotation from Jean-Paul, the most fervid of
romantic writers:

"When the postillion's horn reminds me that he is
leaving behind the narrow, pointed, dilapidated, inorganic,
pinched pile of rubble which is called a city, for the pulsing,
all-pervading, budding tumult of nature as yet not murdered,
where one root clasps the other . . . where all small life en-
twines to form One Great and Infinite Life—then every drop
of my heart's blood retreats before the pitch-wreaths, the trench-
forms and the sponging rods with which the artillery crowds
out our blue morning."

Here we have come full circle to exaltation of nature
combined with positive hatred of urban surroundings. Misopoli-
tan feeling becomes stronger throughout the nineteenth century
as the city grows more horrible—the utopians, reformers like
Buckingham, architects—all the planners of ideal cities repre-
sent a movement to approximate nature in their schemes. A
distinction must be made between this essentially romantic no-

249

tion and the drive behind the introduction of green forms into existing cities, which by 1840 had become a matter of dire necessity. Urban recreation for the masses of people during the thirties and forties consisted of walking in cemeteries or in zoological gardens, and it was inevitable that in the expanding industrial centers the idea of forming green lungs to enable the city to breathe should take hold, as it did in the utilitarian town planning movement in England between 1825 and 1845, and in the new parks movement in the United States after 1850, starting with the political battle over a central park for New York during the administration of Mayor Kingsland. The losing fight for green space commensurate with the increasing size of cities has continued in both countries ever since, both New York and London winning small victories in favor of recreation from time to time. With a few exceptions, such as the Boston park system and the London green belt, recreational needs have not been tied in with a city plan, and this campaign cannot be called the *primum mobile* of a new approach to natural forms in urban surroundings.

The notion of the eventual abandonment of the city for a life in more "natural" surroundings has a strange persistence; it received an enormous impetus from the garden city movement after 1898. If Ebenezer Howard had been a Frenchman and a descendant of the Abbé Laugier, this new form of community might have been built with a forest at its center; as it was, the diagrammatic form bears a remarkable resemblance to plans by the French architect Ledoux for the town of Chaux. This was an unlikely source of inspiration for Howard; he nevertheless acknowledges a debt to James Silk Buckingham, whose proposal for a model town of Victoria had been published fifty years earlier. Victoria had a beautiful park for a setting—a park decorated with ornamental fountains and flower gardens, in strange contrast to the austere life the inhabitants

were supposed to lead. This setting comes close to Howard's
idea for the physical scenery of Garden City, and, as Professor
W. A. Eden points out in the most careful estimate of Howard's
contribution to date, it is significant that the central portion of
Garden City is entirely given over to open green space.[5] How
eagerly the earlier followers of the romantic revival would have
endorsed this concept may be left to the imagination; but to
place Howard's attitude in the proper perspective, much of the
remaining space and in particular the preserve of land surround-
ing Garden City is given over to productive cultivation. The
neo-romantic concept of open space in cities has nothing so
practical to recommend it.

Turning from prototype plans to those which may be
more accurately termed contemporary, it appears at first glance
that the picturesque-romantic school has triumphed over the
advocates of controlled natural forms (neo-classic), who have
not been heard from for many years. While utilitarian planning
still holds its place, neo-romantic urbanism predominates among
the intellectuals of the planning movement. What are the
evidences?

1. The two most popular over-all forms are a modifica-
tion of the curvilinear plan (which originated in the
last years of the romantic period) and adaptations of
the linear plan (of technological origin). The curvi-
linear plan was introduced into the United States by
Alexander Jackson Davis and Andrew Jackson Down-
ing and used later by Olmsted and Vaux. It has been
modified by the cul-de-sac and adapted to modern
traffic requirements (e.g. a more gently curving street
pattern, less arbitrary forms). In this country, it has
seen popular adaptations in the activities of subdividers
(Levittown) and in the shape of completely new

towns (Norris and Oak Ridge, Tenn.). In England, it has reached official status, being employed by municipalities and housing authorities (Becontree, Wythenshawe). It is frequently used because curved streets are thought to be pleasanter than straight ones, a notion not devoid of sentimental implications, or because it can be easily adapted to irregular topography. The modified linear plan appears, with the foregoing, in the work of rationalist planners like Le Corbusier. It may take the form of urban units arranged along a communication spine, or of a series of superblocks, connected by traffic arteries or linear parks.

In both cases the detailed planning of residential areas is likely to derive from picturesque antecedents, although its rationalization will often be based on scientific argument. "Free" arrangements of buildings in green space have taken the place of the more strictly disciplined *zeilenbau* pattern and although

4. Trees.

density and economic requirements often necessitate group in the form of courts or squares, the most "advanced" school of planners prefers the staggered row and the isolated tower in picturesque balance.

2. The character of contemporary architecture now approaching full popularity is romantic-mannerist in feeling, with emphasis in the case of the International school on silhouette, and in that of the "Organic" school on horizontal line (identity with nature and the earth.) Both schools rely heavily on landscaping or the proximity of natural surroundings to offset or complement their architecture. In the case of the "Organic" style, green forms are used in conjunction with the building to reach toward the uncultivated or to tie the building to the ground. In the case of the "International" style, they are introduced to provide scale and for purely esthetic pleasure in foliage and branch structure. This demand for the proximity of natural forms is philosophically based on the contemporary ideal of a harmony between nature and man, of "biological decency" toward the forms of nature; *not*, it should be noted, on the rival principle of absolute control of nature by man himself. This partnership of man and nature, the feeling of "oneness" has been largely spurred by the writings of Dewey, and to a lesser extent by Riegl and Minkowski, whose anti-compartmentalized worlds in which the sciences and the arts, technology and creativity are to be brought together have an extraordinary attraction to the architect trying to create an environment of universal appeal. His failure to appeal lies in the impossibility of providing a satisfactory form of urbanized nature which will fulfill all the outdoor social needs

253

of urban life, as city building based on picturesque principles alone must always fail. As long as the focal point of the city, the very core of its activity, is treated as an island of green, these intellectualized plans will remain unsatisfying.

It is on Le Corbusier's shoulders that the major responsibility rests for the wide-spread attempts to dissolve the city in an ocean of green. Beginning in the twenties with an awkward mechanical solution for the metropolis, he then moved through the period of the "radiant" city and until he arrived at a new conception: "We may try another: the installation of a 'green City' . . . all around it an immense countryside will be freed; fields, meadows, forests . . . NATURE CAN BE ENTERED IN THE LEASE! Nature lived before the town arose; the town chased her away, filling her place with stones, with bricks, and with asphalt." Describing the "green city" he remarks significantly: "The pact is signed with nature . . . Through the four seasons stand the trees, friends of men. Great blocks of dwellings run through the town. What does it matter? They are behind the screen of trees." [6] In America, Ludwig Hilberseimer actually shows how the city can be made to dis-

5. "Great blocks of buildings run through the town. What does it matter? They are behind the screen of trees."

appear in trees—"the city will be within the landscape and the landscape within the city."

To recapitulate: In the theory of city-building there have been periods in which 1. the city excluded nature except in the manicured form of gardens, which have never formed an integrated part of the overall plan 2. the forms of nature were used with the forms of architecture to create the plan, and 3. the forms of nature have been given a role approaching dominance in the plan. It has been suggested that the first two were creative and appropriate attitudes, but that the third is based on a misconception of the urban function in contemporary society. It remains then to indicate an alternative approach. Obviously, the Renaissance and Baroque attitudes have lost their relevance; the city has grown too large to draw a line past which nature cannot cross, and social needs have changed since the days of the Sun King.

But is there an approach which can be satisfying to contemporary social and esthetic needs?

First, let us be aware that any attitude toward nature is fundamentally a part of our whole conception of the city; not just a matter of providing recreation space and green lungs for an expanding urban population. We must accept the existence of a continuing dualism in the concept of environmental planning. The search for town-country can lead only to extreme solutions such as those already outlined. Perhaps the distinction between urban and rural surroundings should be heightened rather than decreased; but in any case a pragmatic approach should reveal the role which each should play. What is "country," in planning terms? A resource base, to be preserved, cultivated and constantly renewed in fertility. Its population will always be less, acre for acre, than that of the city, but access to the amenities of life will become increasingly important. And "town"? A processing and distributing center, requiring larger

concentrations of population; also, if we can agree with the Aristotelian concept and with modern urban sociologists, a cultural fountainhead. Whether or not the giant city, through decentralization, will become smaller and the countryside become interspersed with new centers as a result, as Lewis Mumford suggests, there is likely to be a continuing urban form and a continuing rural pattern, distinct in function and design. For the urban center, with which we are concerned here, this condition of things will mean a continuing search for solution to specific urban problems, based on the existence of urban concentration.

Green forms will be always necessary and an integrated part of the urban pattern. Their use should, however, be preceded by a better social investigation than the dis-urbanists have made. We have now achieved a scientific analysis of the *quantity* of open space necessary for recreational purposes. Standards of the National Recreation Association and the American Public Health Association are admirable in their thoroughness and have been broken down into various types of open space development with suggested general locations for each in the city plan. These recommended open spaces however do not usually take an excessive proportion of the total area of the community and there is sufficient reason that they should not do so, green space being expensive and usually difficult to maintain in urban surroundings. The introduction of green walls, green verges, extensive tree-lined boulevards and purely decorative green areas which are undesirable for recreational use is to be discouraged, as is the whole concept of greenery for its own sake. Trees used for shade, noise buffers and windbreaks are, on the other hand, highly desirable, and, when they are properly integrated with social use, extremely effective in civic design. The introduction of trees into the very heart of the city can be accomplished in this way; the trouble is that our neo-

romantic approach has envisaged something like the New England village common occupying the center of megalopolis. It should not be imagined that the scientific introduction of green forms will produce a city resembling Baroque Paris; on the contrary, this approach should result in the creation of new city patterns; the absolute control of natural forms in the modern city should be the only similarity noticeable between it and that first great period of nature in towns. The writer will yield to no one in his admiration for the adventitious tree or green space, seen unexpectedly as a foil to architectural works; certainly we should welcome the casual hand or the occasional picturesque note, and in this we should be following the Italian renaissance tradition. Here we come close to gardening, and the

6. Primitive Tree Drawing.

gardens of a city should be many and various—like paintings on the wall of a living-room, their form and content may differ widely.

The plea is thus for realistic urbanism, rather than neo-romantic dis-urbanism, and it is to be expected that a change in attitude on the part of urbanists would produce a very different type of plan from the ones now being advanced. Open space in cities not planned as amorphous green areas dotted with trees but given a form complementing and increasing en-

joyment of architecture—with grass and trees only where they are essential to the plan.

We should be thinking in terms of the spaces for pageantry and parades, for street markets, for games, for the place where the statue of the founder stands, to satisfy the needs of all members of the family—not in terms of parks alone. Natural forms will appear in some of these spaces, not by any means in all. It is a question of interpreting social needs in terms of open space design, of exploring beyond the stock limits of commercial, traffic and recreational areas to determine a better social basis of urban form. The promenade, the market square and the carousel were right for seventeenth century Paris: our complex activities and interests today surely require outlets more imaginative than a stretch of grass, trees and shrubberies can provide. With new outlets should appear new forms; the recent proposals in England for urban *precincts* have already suggested forms very different from the usual block, street and square. Certain classical principles of tree planting would also completely change the character of the modern parking lot.

A rejection of the neo-romantic attitude to urbanised nature would also have a salutary effect on architectural design. The architect would not be able to take refuge in the trees and would be faced once again with the challenge of spatial unity— the relationship of structures and space which demands that consideration of proportion and fine building, which is civic design. "Today the urbanist fills his open space with trees," comments the historian Pierre Lavedan, "but he would not think of filling an apartment with furniture in this way. Furnishing should never destroy the impression of unity—it should be subordinated to architecture, to the great advantage of both elements." This urban lesson still remains to be learned by those architects, landscape architects and civic designers whose love-affair with nature is based not on understanding but on impetuous desire.

CHAPTER **11**

COMMON PLEASURES

"I would not pause here, my son, to tell of a carrousel which took place at the beginning of the summer," counselled Louis XIV, "were it not the first of the magnificent diversions to be mentioned in these *Mémoires*. If, during your lifetime, you are of necessity involved in such matters as well as in more important ones, it is proper that I should bring to your attention the legitimate use that we can make of them. I will only tell you, as we would tell an ordinary individual, that the reasonable pleasures were not given to us by nature without a purpose, that they offer us relaxation from our work, give us new strength to apply ourselves to it, bring us health, calm the

259

troubled soul and the unsettled passion, inspire humaneness, refine the wit, temper the morals, and take away from virtue something of that too bitter quality which makes it sometimes less sociable and, in consequence, less useful.

"A prince, and in particular a king of France, can also learn something more from these public diversions; that they are no more our own than they are those of our court and those of all our subjects."

Diversions and entertainments, flags and banners, parades, shopwindows—glimpses of clouds racing across the sky, a view of the sunset, crowds in the square—the ephemeral moments of the city should be considered as part of civic design. They must be admitted to the canvas. Often their quality cannot be planned for—this would destroy the casualness or spontaneity of the occasion—but they should occupy a place in the designer's mind. It is of course probable that they would occur in spite of the designer, but that is not an excuse for a lack of sensitivity on his part, or a neglect of the opportunities which careful siting, choice of background, variation in height or contrasts in function can provide. There are, further, situations in which the artist or the civic designer can make suggestions or important matters of detail, like that of color, which might otherwise be forgotten or left to chance. "We are so grateful for any little attention shown us in the streets," remarks Halsey Ricardo,[1] citing the example of flowering window boxes and colored awnings seen by the passenger on the omnibus. But, he goes on, they might as well not be there for all the impression they make on the general lack of color in the city; if the street itself had a color scheme how much more interesting would be these incidental points of color, which could be brilliant notes in a larger symphonic whole.

260

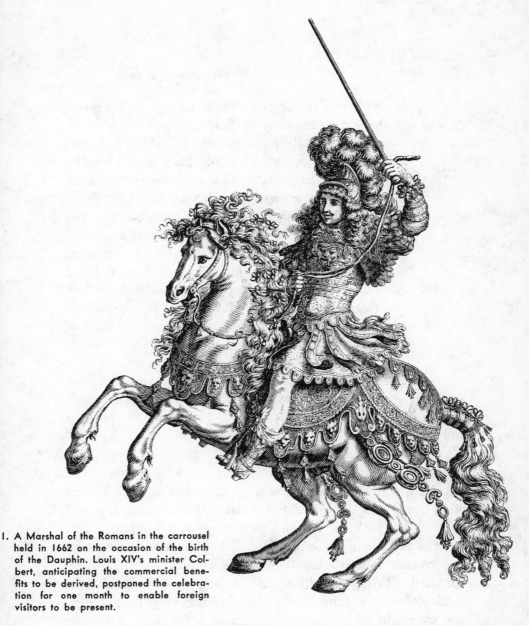

1. A Marshal of the Romans in the carrousel held in 1662 on the occasion of the birth of the Dauphin. Louis XIV's minister Colbert, anticipating the commercial benefits to be derived, postponed the celebration for one month to enable foreign visitors to be present.

A description by Talbot Hamlin gives us a glimpse of what we are missing:

"Perhaps nowhere in the world are magnifi-

cence of form and color so combined as in such a group as the Forbidden City in Peking. Below, foundation and enclosing walls stuccoed and stained a rich, soft red that fades into all kinds of varied sienna shades; white marble balustrades; rich oxblood red columns with grillework between in green or red, picked out with the gilt of hinges, handles and braces; beams and bracketed cornices chiefly in pure cobalt and emerald green, accented and patterned with white, darker blues and greens, and sometimes with touches of red and gold: crowning all, sweeping roofs with decorated hips and ridges, all in a shiny yellow porcelain tile—this all makes for a visual experience of stunning richness and power." [2]

Color has rules that have been forgotten. Have we remembered for instance that blue and yellow are colors which cannot contain an architectural form? They tend to spread it and prevent definition. The Greeks used blue as background for their sculptural friezes, where it was proper to do so, and they used bright colors in lines and small quantities. The Greeks, indeed, had architectural codes which dictated among other things structural mechanics, sculptural ornamentation and color rules, which the Romans were never able to grasp. Color came back later in the medieval city, but the art of using it in architecture with relation to the civic complex has again disappeared. "When sculpture and painting were divorced from architecture," says John Dewey, "our towns became drab things" (or, we might add, in some cases, garish.) For what is the use of a building that stands out in color from its fellows like a sore thumb? An art of civic color is needed . . . schemes for whole areas of the city, as Halsey Ricardo worked out for London or Bruno Taut for Magdeburg. And the expediency

of painting every house in different pastel shades as developers have done on Long Island is not to be considered a solution. Even the bold Levitt and Sons are afraid of color. We should accept it as a challenge. It is not necessary to get rid of the competing signs along our business streets, which some think would improve their looks, but we might try to put some order into their arrangement and their shades of neon gas.

If the art of color is neglected in our cities, we feel the lack of another element still more. We have not completely forgotten the art of using water in civic design, but seldom is its quality fully exploited. Only at large exhibitions frankly given over to pleasure and display can one nowadays glimpse the potential. Paris in 1937 and New York in 1939–40 gave us such glimpses. Paris had the advantage in her river, but New York did not neglect her opportunities. Every evening at the World's Fair a "Ballet of the Fountains" took place. A spectacle which grew from small beginnings—subdued jets springing to life in power and illumination—it could never be called ballet and scarcely ever art, though artifice was there in plenty. Confectionery of a delicate kind abounded. But whether the slow sculptured foam of the opening passages or the gigantic frosted edifice of the climax, the affair was clad in architecture—dress of a nature which one remembered although so quickly changed; and in spite of a synchronization striving to be modern, the eye found images of old-fashioned things . . . of living water in the mosaic pools of Master Bernard—the incredible extravagances of Richelieu's marble cascade and his musketeers who fired a drenching salvo—of water lights at Pillnitz—the smoke of gunpowder drifting across the Thames . . .

Triumph and usefulness—how are they connected?

Turning the pages of a volume of designs for fountains for the London of the last century, the following picture of extravagance might catch the eye:

"The structure is composed of ten tons of Sicilian Marble with four tons of Red Aberdeen Granite, the latter forming the four corner pillars, which are polished and surmounted by capitals carved in the semblance of flower leaves, etc. The four streams of water come from White Marble lilies into as many polished granite basins, and on the pediments over them are carvings to represent the Queen, the Prince Consort, and the Donor of the Fountain, the fourth side having a timepiece. A Lion and a Brahmin Bull are also among the sculptures. The whole structure rests on three hexagonal granite steps and is surmounted by something resembling a steeple, and giving the fountain at a distance a Gothic effect. It is, however, not confined to any special style of architecture, and it would be difficult to say what ideas of taste have been adhered to, or which canons have been most violated in the design." [3]

This fountain was a product of the Metropolitan Drinking Fountain and Cattle Trough Association. Today this organization sponsors a modern drinking fountain in the design of which both architectural extravagance and architect have been dispensed with. Having admired its inviolability to damage, the ready accessibility of its mechanism, the suitability of its height for children, its anti-squirt devices and hygienic principle, the curious may wonder how many fountains and troughs have been provided and when the work was begun. The answer is over five thousand, and the first in 1859.

Five thousand ceremonies of dedication to use! Five thousand first sips from the cup by frock-coated gentlemen and eminently charitable ladies! Then the crowd surging around to drink in turns. At least this was so at the opening of the first public fountain at Snow Hill, 1859, amply fulfilling if only for a day the then idea of the Association to offer an alternative to the public house. And when it is remembered that, near the

Elephant and Castle, there was at that time one pipe into which you could not squeeze a little finger and from which the water ran only twenty minutes a day and not at all on Sundays, some competition against the beer barons may very well have been desirable.

It seems difficult and probably not essential to separate the two themes of ceremony and water; probably an investigation of aquatic illumination cannot reasonably be excluded either. Turning to *Hydraulia*, an account of London's water works, we meet a ceremony of a different kind, conducted three centuries earlier, with equal though less self-conscious dignity:

"'On Michaelmas Day, 1613, the Lord Mayor of London, the Recorder and many of the worthy Aldermen rode to see the cistern made . . . under the superintendence of Robert Mylne, Esq., then Engineer to the New River Company'. . . . the first issuing of the river thereinto . . . was performed in this manner:

"'A troop of labourers, to the number of sixty or more, well-apparelled and wearing green Monmouth caps, all alike, carrying spades, pick-axes, and such like instruments of laborious employments, marching after drums twice or thrice about the cisterns, presented themselves before the Mount where the Lord Mayor, Aldermen and a worthy Company beside, stood to behold them'" and one man on behalf of all the rest delivered a rhymed oration. He concluded by enumerating the workers:

> "'First here's the overseer, the tried man,
> An ancient soldier, and an artisan.
> The clerk, next him, mathematician,
> The master of timber-work takes place
> Next after these; the measurer in like case,
> Bricklayer and engineer, and after those,
> The borer and the pavier. Then it shows

265

The Labourer next; keeper of Amwell-head,
The walkers last: so all their names are read.
Yet these but parcels of six hundred more,
That (at one time) have been employed before.
Yet those in sight, and all the rest will say,
That all the week they had their royal pay.
 At the Opening of the Sluice.
Now for the fruits then: Flow forth, precious spring,
So long and dearly sought for, and now bring
Comfort to all that love thee, loudly sing,
And with thy crystal murmurs strook together,
Bid all thy true well-wishers welcome hither.'

At which words the floodgate flew open, the stream ran gallantly into the cistern, drums and trumpets sounding in a triumphal manner; and a brave peal of chambers gave a full issue to the intended entertainment.' " [4]

The crowds of 1613 at the New River Cistern must have awaited the issuing of that gallant stream with the same expectancy that each evening in the summer of 1939 greeted the flowering of the water ballet in America. The reaction, elemental in more senses than one, is probably essentially the same. Crowds have always known the delight of water, which when active demands a generous audience. After all, the Greeks used their springs for "the art of conversation and social festivities" just as we of the 20th century have used our rivers, though unlike those "pagans" we are not prone to admit that this idolized element has any but its strictly utilitarian uses. Water is a symbol of life . . . and of infinity. "Derrière la surface plane du lac ne sont pas les peupliers illusoires, mais la vie intense des eaux." Narcissus can see his own reflection, but not the object of his desire. This is the true romantic agony—the blackness of incalculable depth, the illusion which can never be resolved.

266

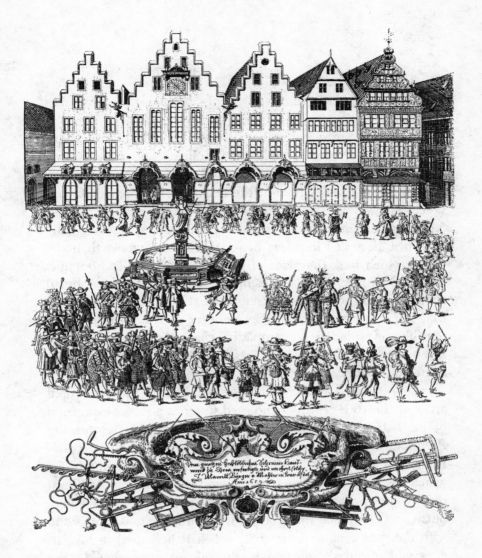

2. Carpenter's Guild Parade in Frankfurt-am-Main, 1659.

Perhaps, then, some division should be made. Water
in agitation—the fertility symbol—is conducive to mass ecstasy
or ritual; also to individual exaltation, spiritual or otherwise.
Water as a mirror is inviolable, its images are holy, it is an
instrument of fearful meaning. As decoration, water has been
used in civic design for visual, oral or tactile effect, but its power

may often be observed to go deeply beyond the casual impression.

No country has realized the philosophical implications of formal water more readily than France. The 16th century small castle reflected in an ornamental moat led up to the perfection of the canal garden at the height of the French Renaissance. The wide canal at Versailles, 5413 feet by 203 feet,[5] whose cross arms extended to a length of 3510 feet, in spite of its magnificence, occupied less area in relation to the whole than the canals which took the place of gardens at the earlier Fontaine-bleau, Chantilly, Bury or Dampierre. Sometimes these broad sheets of water were used for naumachia, but it can be assumed that Rapin's comment that they were for the stimulation of the sensible, fine-minded, contemplative characters which medievalism was supposed to produce, was in fact a sign that they developed from literary ideas.

It was a Frenchman, Bernard Palissy, the persecuted artist of the 16th century, who used water as a direct expression of his natural philosophy. This had its roots in the growing Protestantism of the time (his dates are surmised to be 1510–1589) but was tinged with his theories of political liberty for which he had plunged his native town into revolt and had been thrown into prison. Water for him was the symbol of freedom, but it was combined in a curious way with religious motifs and with the simple natural materials which Palissy used in his gardens and grottoes dedicated to the pursuit of wisdom in the manner of the Protestant intellectual movement of the time. In spite of this complexity in his work, Palissy's enamelled basins "like meadows strewn with summer flowers," and his gardens, where the saints were to live as shepherds, must have been as charming as any medieval painter could depict. The framework for these creations was the rigid little square of the period into which, unlike his contemporaries, he introduced much that was free and poetic. A stream had usually to cross

268

the center, dividing the space by wide allées into four equal parts. At the ends of these were cabinets of different shapes and materials. Here rocks, there enamelled stones, further off clipped trees; water distributed everywhere in abundance, flowing in the squares, oozing from the rocks, falling from vaults and arches, spouting from the ground and surging through pipes of varying sizes to play delightful tunes.[6] He was absorbed with variety and change in natural forms and studied them in the light of his knowledge that "wisdom alone is pleasing to God." Chapels and hermits, rocks surrounded by water are significant characteristics of the gardens of Palissy's time. All the central part of the garden described above is on a small island made by a little stream which came from a hanging rock and flowed round the garden. Its slight interlacing is an artistic fancy developed many years before the coming of the elaborate parterre.

Palissy made the gardens of the Medicis at Chenonceaux, particularly the garden on the left side of the Cher, the aviary and the fountain of the rocks. Two beautiful fountains, caves and grottoes mark his influence at the Parc de Francueil, but Chenonceaux was probably the only place where this predecessor of Le Nôtre designed the gardens with freedom. This artist, no less than any other who has ever concerned himself with grottoes, linked them with the water theme, in the macabre fashion which nowadays makes grotto architecture, and the uses to which it was put, a source of genuine psychopathic information. Palissy introduced pools for reptiles into all his grottoes; and in his garden for the Queen at the Tuileries, according to a description by a visiting ambassador, was one in which fish, snails and lizards, tortoises, frogs, toads, shellfish and other aquatic animals crawled over the rocks or swam beneath the water. So did a branch of architecture which started in Roman times as a nymphaeum become a vivarium of the lowest form.

These were early days for the development of any con-

sistent theories about the decorative use of water. People were still occupied with its engaging habits when used for games and practical jokes. Water jokes may have appeared in Hellenistic times, certainly in Roman. At Chatsworth is a copper weeping willow deriving from the Byzantine tree and pineapple fountains, which have their oldest remaining example in the Vatican. Waterworks became a universal delight—even Leonardo designed them and many Italian gardens lay claim to description only for their fantastic tricks. "Never," says the Duke of Wurtemburg, "need a man ask for water if he sits on a bench—he will get it soon enough."

Fountains and watercourses only became leading motifs in Italy when the later perspective devices were introduced in the sixteenth century. Then they were deliberately introduced, as at the Villa Lante, to help the symmetry and continuity. The citizens of Rome in that century took more delight in water than in

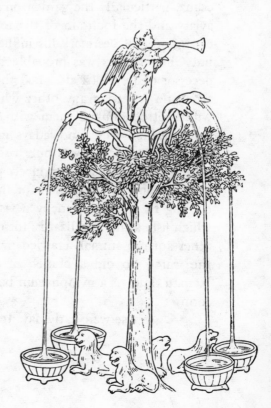

3. A Silver Tree Fountain.

trees or flowers and just at that time too the Italians were the first to make headway with another kind of display, the fireworks at their religious festivals.

An effective marriage of fire and water was obtained by the *gerbe*, a term which had been formerly used to describe the sheaf type of water fountain. The celebrated pyrotechnist Ruggieri describes a variety of the gerbe called the "plongeon" in which small quantities of mealed powder were packed between each scoop of composition to produce an intermittent turning. The recoil of each puff of powder forced the gerbe beneath the water. "Skimmer" rockets performed in the same porpoise-like way, but required a considerable area of water for safety's sake, and sky rockets were often fired under water, an elaborate use of waterproofing material being necessary for the preliminary fixing.[7]

Three hundred years later, after the water of the landscape period had flowed past in the romantic dreams of a few solitary pedants, fire and water rose to new heights and a larger audience in a select London suburb, where against the Crystal Palace's glittering facade of glass were waterworks laid out on a scale unknown to Versailles.

"There were fountains and terraces, water temples and cascades. An elaborate system of hydraulics supplied water from two high towers for a series of fountains and basins at three different levels. From Chatsworth came the inspiration of a cascade temple, symbol, so visitors were doubtless edified to learn, of abundance gushing from the feet of Fortune." [8]

When in full operation, nearly 12,000 jets were in play and about 120,000 gallons of water were simultaneously displayed per minute. It was these waterworks that involved a great part of the huge expenditure which caught the Palace in financial troubles. That is why water systems on the scale of the Crystal Palace or Wilhelmshöhe were not lightly undertaken,

except sometimes by impressionable potentates. Modern city governments do not have the same excuse with the invention of the electric pump and the possibilities of using sea or river water unfit for drinking.

"What would one do if he were a Duke and had half a million a year?" asked Andrew Jackson Downing. Build water-works, of course. At least that is what the Duke of Devonshire decided when he gave Paxton a free hand to make Chatsworth an object of pilgrimage from all over the world. The pilgrims reacted in an appropriate manner; here is the record of one from America, describing the last of the great fountains:

"The Emperor fountain plays a *sublime* single jet, to the height of 267 feet! It quite takes one's breath away with its living beauty. It is projected upwards with a force which seems almost supernatural, and like the fall on the American side at Niagara, comes down, not like water, but a great shower of diamonds and floating precious stones. When there is a gentle breeze, it waves to and fro like a gigantic white plume. To see it to advantage then, one should stand at some distance in the park, so that its snowy form, richly variegated if the sun shines, is relieved by the dark background of foliage. When the wind is high, it throws the spray to so great a distance that they are obliged to shut off the head of water." [9]

For this fountain eclipsed all others in the world. It was to have played for the first time as the Emperor Nicholas crossed the threshold of Chatsworth, but he never came, and was entertained instead at Chiswick by an escaped giraffe swimming across the lake—surely as unique an incident as the one the Duke had intended. However, the latter was pleased with all that had been done and when the fountain got to work, wrote in his diary "It is a glorious success—the most dramatic object and a new glory to Chatsworth. O Paxton!"

Paxton was indeed enchanted by the idea of water.

272

He had been drenched in the spray of half the cascades of Europe, had visited aqueducts, and climbed into the tank at Wilhelmshöhe to measure accurately the thirteen jets. On this last occasion he reported to the Duke with considerable satisfaction that with enormous outlay the fountains could not be played together, or for more than forty minutes. Mostly he was occupied with elaborate calculations for reservoirs and pipe laying which began by bringing down the scorn of engineers and ended by astounding them with his accuracy. Volumes of water ascending or descending held no terrors for him; he worked empirically and flowered for the first time the giant Victoria Regia lily by a process of mathematics. The Lily House has gone; the rock garden where he made a great waterfall, and the great cascade remain; and in spite of the criticisms of Loudon, who shared Shenstone's somewhat arbitrary opinion that the eye should always look down upon the water, the original fan and sea horse fountains must have been superb. On the occasion of the Queen's visit in 1843 these fountains were illuminated with blue, crimson and green lights, which at a given signal burst into a blaze of fire. On the strength of this and similar evidence the author once sought to connect Paxton with the inauguration of firework displays at the Crystal Palace, but learned that they were commenced only in the year of his death (1865) by C. T. Brock, who succeeded in persuading the directors "that fireworks were not really of an immoral tendency" and pointed out that glass, foliage and fountains provided a background which could not be duplicated elsewhere.

In our own century, we have accepted the function of water and sunshine as purifiers. The crowd is actively participating in the ritual of immersion as unselfconsciously as the medieval court ladies who bathed in fountains surrounded by their male attendants. Hardy's prophecy that the tourist would turn from the Alps to the sand dunes of Scheveningen has been amply

borne out by the cult of the beach, which comes nearest to dissipating that other fear of water, contained in its real and mystical pervasiveness.

What, then, can we look forward to as a source of pleasure in this instrument? If we accept it as an element of the dream world and use it in such fantasies as the night display in New York, where colour, light, music, and the reflections of the opaque black bed from which it sprang combined to bring the crowd together in a ritual mood, pleasure will be a result. Art may not be present, comprehension will. An activity of the night, a method of return which all experience, may be the result of power used in a moving way. Pleasure gained by ritual may not be the highest form of art but it is surely a product of desire.

That other adventures are possible with this relatively unexplored material it has been the object of these few descriptions to draw attention. Displays of exhibition scale are not often to be seen nowadays except in the gardens of a Du Pont or in some foreign civic place, but the experience of a contemplative mind like that of the obscure potter, who, because his stained glass was no longer in demand, took to creating brilliant water pictures could surely be produced today. The nearest equivalent of Palissy's glittering pools are the glass-floored swimming baths lit by coloured floods. Our water ceremonies, too, are dull compared with that previous opening of the sluice in 1613. We are as uninquiring about water as the 19th century citizens of London whom a distinguished prelate apostrophized in his verses on the new water supply:

> "Amwell! perpetual be thy stream,
> Nor e'er thy springs be less,
> Which thousands drink who never dream
> Whence flows the boon they bless." [10]

274

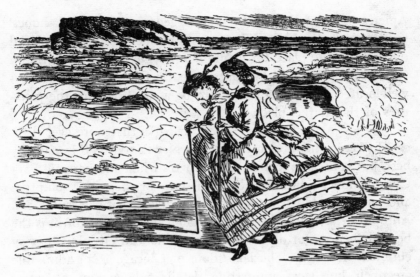

4. "On the Beach at Biarritz" by the Punch artist John Leech.

Perhaps we are now displaying much more than Paxton's ingenuity with water which defies the laws of gravitation, but of the kind that lies darkly romantic between 18th century groves we seem nowadays to know very little. The 18th century, as usual, knew the material it used and its capabilities.

The *panache* and the *oriflamme* have been forgotten. The fountains no longer play. The calculated use of water awaits the poetry of a modern La Fontaine:

"Art knowingly squandered water in a thousand ways,
From jasper table springs a bursting jet
To fall in pearls, in vapor and in dew."

It is a far cry from the author of the *Fables* to Robert Moses, but the common pleasures are as much desired by

275

Americans as formerly by periwigged courtiers and honest townsfolk. In the United States far too much emphasis is placed on parks as the place for common enjoyment and too little on the streets. Not only this, but the parks themselves are seldom well-located or inviting enough to be a substitute for the pleasures of the market-place.

We can find few American parks that were ever dedicated to enjoyment. Central Park in New York fits this category best, but it became less so in the 1930's when an energetic Park Commissioner arbitrarily removed some of the park's sculpture and put up buildings utterly out of character with its spirit. San Antonio's river park, threading through the heart of town, is the best in theory ever developed in an American city, but its execution is not ideal. The lake shore of Chicago is an admirable greenbelt but lacks interesting detail and remains a fringe. Public beaches are fine, but they are no substitute for interior open space which would break up the ubiquitous block-system.

It is worthwhile recalling a few scenes in the pre-industrial American city, to show how lacking the modern city is in some of the primary forms of outdoor recreation. The early squares were meeting-places, primarily, or, in cases like City Hall Square, in New York, scenes of civic enthusiasm and solidarity. (It is in this square that public demonstrations take place; the coming of the public water supply was celebrated in the form of a fountain display.) In the modern city, neighborhood squares could make up for the lack of these amenities. New Yorkers and Philadelphians in the early 1800's both had their pleasure gardens, which were places of public entertainment. Here again, entertainment has left the parks, except for the ubiquitous band concert, which is a poor substitute for these lively open-air festivals. In 1803, New York had its Vauxhall Place, and several other locations for open-air theatricals, promenading and conviviality up and down Broadway. Vauxhall

had its orchestra platform built away among the trees, and an elaborate apparatus for firework displays, with a mound from which to view them. It had booths, boxes, flying horses and a theater which was used during the suspension of performances in the City Hall park.

The best description of one of these places of entertainment is given by a young girl who visited Columbia Gardens near the Battery in 1803. It was "enclosed in a circular form and little rooms and boxes all around, with tables and chairs, these full of company, the trees all interspersed with lamps twinkling through the branches; in the center a building with a fountain playing continually; the rays of the lamps on the drops of water gave it a cool sparkling appearance that was delightful. This little building which has a kind of canopy and pillars all around the garden, has festoons of coloured lamps that at a distance looked like large brilliant stars seen through the branches. (The whole place) gives you an Idea of Enchantment. . . ."

Although we have no wish to take our entertainment as people did in the nineteenth century, it is unfortunate that in the process of this country's industrial expansion we have lost the idea of enchantment. Only traces of this remain in the enjoyment of the circus, and of a fountain of music and light at a World's Fair. The modern park, it may be understood, is a hybrid in which eighteenth century beaux and present-day swimmers in bathing dress have somehow been trapped in a scene for a middle-class comedy of manners, amusing to the spectators but not very satisfying to the participants who are playing to an awkward convention. Too much policing of our minds and actions, excessive commercialization of the entertainment industry and too little regard for what Olmsted called the custom of gregariousness, have all been responsible for the eclipse of a valuable trend.

But in countless towns all over the country fashions come and go, inspired by the magazines, and often by the movies. . . . Occasionally a trend holds fast—like the neighborhood block party, with its dancing in the streets—and becomes a fundamental part of life. None of them obscure the common pleasures of people tending their gardens, sitting on their porches in the cool of the evening, or taking a spin in the car when the day's work is done.

All throughout the West and as far East as the suburbs of Cleveland, it is still considered unfriendly to plant a hedge or build a fence around your property, so that the neighbors can't call hello from the street or pass the time of day on their back porch. As we have noticed, the openness of the garden plot with its lawn stretching down to the sidewalk is a feature peculiar to the American scene. It suggests the openness of community housing developments and is an indication that Americans would adapt themselves, like other nations, to the propinquity of living in group housing or apartment projects; as, indeed, they have.

Porch-sitting, lawn parties, and the charming folk-art of the average American garden are all part of the good open-air tradition of American life.

In the big towns this desire for friendliness manifests itself in other ways. It is in part responsible for the orderliness of crowds. Central Park has proved less dangerous to visitors since lights were installed and policing became more regular. Actually, the streams of people which ebb and flow on modern Broadway seem to be made up of the most good natured people imaginable. Considering how little Broadway has to offer, this is perhaps surprising. But the habit of sightseeing enters into this phenomenon. It has become a tradition. In cities like Portland, Oregon there are regular turnouts in Spring and Fall to see the new fashions displayed in the department store windows. In

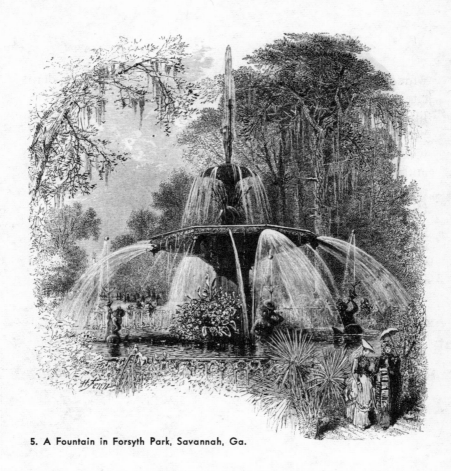

5. A Fountain in Forsyth Park, Savannah, Ga.

New York and other cities, the Easter displays are an attraction, part of it being centered in the gaily-dressed crowd itself. First nights in Hollywood, visiting celebrities on Fifth Avenue, baseball games, and many other attractions have developed the crowd psychology to a point where the crowd has a life of its own and is held together by the thread of common enjoyment. At the same time the serious planner cannot but consider this manifestation to be anything but a substitute for something better. The only element of participation comes through being in the crowd itself. It is a commentary on urban development that what begins so well in the small neighborhood peters out into mere

279

window gazing in the big towns. The complex of our modern city, which is such a perfect mirror of modern society, reveals so little to compensate for the loss of a community life that it has become part of the designer's task to offer new suggestions which will make that life fuller, richer, and replete with amusements and innocent pleasures. If he can develop a sensitivity to surroundings which goes beyond form and structure to include a talent for the employment of color, of water and light, of pageantry, and of the other elements which, with the spontaneous inventions of crowds, help to create a more congenial urban atmosphere, he will be perhaps astonished but certainly gratified by the generous public response.

6. The shop window achieves greater importance in the nineteenth century. A sporting goods establishment in the Rue Neuve des Petits Champs, No. 103, Paris. C. 1820.

AN ARTIST IN THE STREETS

"I like the idea of there being someone in the picture who points out to us what is taking place," suggests Alberti in his *della Pittura*, "who motions with his hand to look, or who, with angry mien and menacing eye, warns the spectator away. Thus whatever the painters do by themselves or with us contributes to the adornment and instruction of the subject for our profit."

"By themselves, or with us!" How sadly have painters and sculptors been separated from life . . . from our own lives and from our surroundings! Where now is the integration of art and life that Alberti knew and saw around him in Florence? that the voice of Ruskin called for in vain throughout the nineteenth century? that our own critics and philosophers seem to have lost sight of entirely?

Where do we look for art today? A beautiful woman trying on her jewels before a mirror has no greater pleasure than any one of our school children, artisans, teachers or other members of the public who come to the art gallery to enjoy its collections of treasures. From the decoration of the Ishtar gate to the Florentine realists, to the arts of America and the latest school of modern painting, they may range at will over the riches of this public palace where the objects of man's creative power are stored up . . . but it is significant that they come from an outer world in which visual pleasures have been forgotten or denied. The sensations of the street are purely vicarious, no substitute for beauty by design. The hunger for art springs from the starvation of the eye.

Alberti's pointing figure is symbolic. The figure is sometimes the painter himself, invisible, yet beckoning us to see things that only his vision can create. If we observe him we can discover a vision of great importance to urbanism—the artist's creation of the city, in two dimensional planes which become all dimensions, and occasionally of enormous significance, in actual solid form.

The painter and the sculptor have seen the city as no one else can—and they have built many of the civic complexes we most admire. "If some of Piranesi's ephemeral visions . . . his prisons, his Arcaded Bridge, his Ancient Campidoglio . . . had endured as solid and lasting buildings in Rome, the whole world would have run to see them as it goes to see the Piazza Navona or the Piazza S. Pietro, the issue of kindred imaginations." [1] When we think of Piranesi's influence on the great French architect Ledoux we can be grateful that the visions at least were put on paper. But many visions of the city have found their expression in stone. As the innovator, the artist has the advantage of turning at once to the highest sources of inspiration. When John, the prophet of Ephesus, gave us the city

282

"prepared as a bride adorned for her husband," a theme was provided which could immediately be put to use in manuscripts, drawings, on walls or in clay. The vision of the heavenly city occurs at the very end of the Book of Revelations, a strong enough directive to sculptors to create it in stone as a culminating motif in their most elaborate compositions. The chapters of this Book give much of the subject matter for the decoration of Romanesque cathedrals . . . the tympanum over the door may perhaps show Christ seated within a mandorla surrounded by the symbols of the four evangelists, while beneath are the twenty-four old men gazing upwards. A small house or temple (edicule) often occurs here as a frame, occasioned by the transference to stone of an idea presented to the sculptor in the form of a manuscript. And that which begins as background assumes more and more importance as the art of building religious edifices advances. The facades become more complicated until they appear as cities of sculpture, with each figure set in its temple or arch. (See the tympanum of the Portail de Ste. Anne, Notre Dame de Paris). Here we can observe the buildings of a foreshortened city, the receding archivolts peopled with statues giving the appearance of streets in perspective. A public art, an open book wherein people could learn all that was necessary for them to know, and an exercise in movement, in receding planes and civic design.

Little cities are to be found not only in stone on Gothic cathedrals but in the work of painters. In all probability the painter was the first artist to depict the city but his work has been more easily destroyed. We have Roman paintings of the first century after Christ which show imaginary cities very clearly, and in perspective, while in Mayan and Incan art the edicule is quite common. An attempt of early painters may be seen in the room from the Boscoreale in the Metropolitan Museum of Art in New York. Here is a disembodied city float-

1. The Virgin and Child. Part of a 12th century reredos to be found in the Church of Carriéres-Saint-Denis, outside Paris.

ing in air, and only parts of it are visible, leaving the imagination to fill in the relationships. We see the city in stained glass, in illuminated manuscripts . . . this lasts for hundreds of years, and then suddenly . . . the painter leaves behind his magic mirror and steps out into the street itself.

The period of about one hundred and fifty years during which the city enters painting and the artist in turn enters the city begins with the discoveries of Alberti. (*De Re Aedificatoria* is mentioned as being in the hands of the public in 1452).[2] Destined to explore the visible universe so recently discovered, Alberti's wisdom, based on a searching Christianity married to ancient philosophy, compels him to think of architecture entirely as civic activity, of the glory which it brings in utility and arrangement to the civic complex. For him the highest good is the public interest, the basic unit of society the family, and the logical grouping of society the city. (Like Aristotle, he calls the city a "natural" phenomenon). Alberti does not neglect the importance of trade as the life-blood of a community and in

284

his "rules" for city building contained in Book 8 of his *De Re Aedificatoria* he forgets nothing that can contribute to comfort and pleasure of all groups and all ages, including "Porticoes raised above the level of the ground one-fifth part of their breadth," for shops with galleries above, "where the old men may spend the heat of the day."

It is not so much Alberti's rules that interest us here —"I would have a square twice as long as broad"—"A proper height for the buildings about a square is one-third of the breadth of the open area, or one-sixth at the least"—as the fact brought to our attention by Fiske Kimball that they were immediately translated into third-dimensional form in the paintings of Luciano Laurana and others. It is not so curious as one might think with only a superficial glance that civic design in Renaissance painting anticipates actual building. A direct line can be traced from Alberti through Laurana to Bramante and Raphael. As Kenneth Clark has pointed out, painters showed a better understanding of classical models than their architectural contemporaries.[3] Moreover, painters such as Botticelli were often called in to give judgment on buildings, and the civic designs in their paintings were not, therefore, mere exercises but real attempts at architectural composition showing a high degree of technical mastery.

If, as is generally believed, modern perspective stems from Alberti, it was developed by the painters into a real instrument for civic design. Before Laurana's panels at Urbino it is hard to find paintings in which whole buildings and streets appear as complete compositions; formerly interiors, loggias, or arches were used but now the city begins to appear; a dream city, of course, but soon to be translated into reality. Laurana paints his circular temple in the place of honor in the Urbino panel but it is executed in stone in the famous Tempietto of Bramante (1501-1502) who was Laurana's successor at Urbino.[4]

Everything in Laurana is an experience of Renaissance ideas of grouping in centralized compositions. There is nothing of the Baroque individuality which gives buildings a separate existence, and so these are typical Renaissance compositions contrasting with later groupings built by Michelangelo and others.

Thus the magic mirror is now reversed. Like Alice, the painter has taken us through to another world, a real world in which we find artists building cities. There is the work of Michelangelo on the Campidoglio and the Piazza Farnese, of Vasari and the Uffizi, of Bernini with his great square before St. Peter's. And where the artist did not actually create civic complexes we may be sure that he was advising. Ghiberti was co-architect of the Duomo and in the case of Michelozzo and

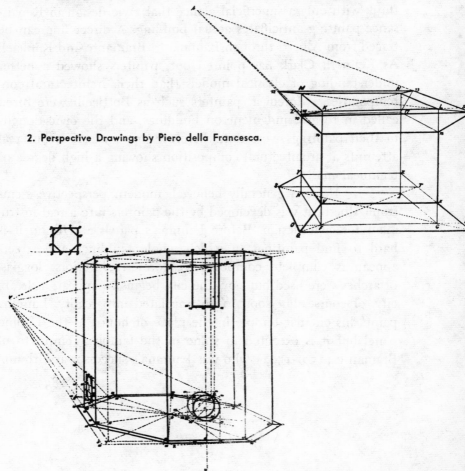

2. Perspective Drawings by Piero della Francesca.

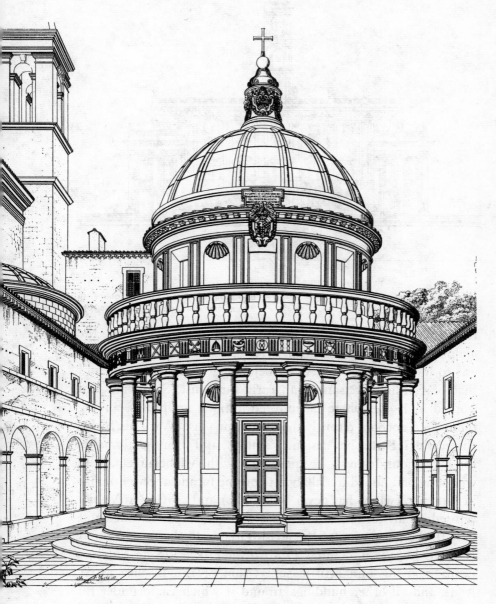

Giorgio Martini it is hard to tell whether they were architects, sculptors or civic designers.

The vision of the artist triumphs in the final shape of

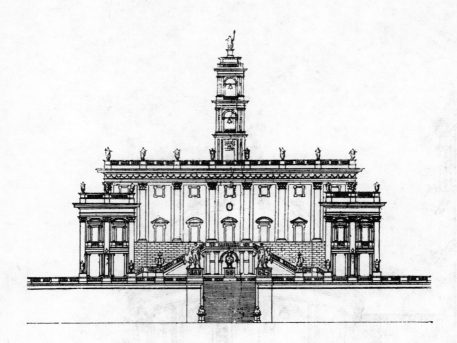

4. Elevation of the Capitol Square in
Rome, the creation of Michelangelo.

the Piazza San Marco where Jacopo Tatti called Sansovino, the
sculptor, was commissioned in 1536–37 to do the library which
was to house the rich collection belonging to the Republic and
that of Cardinal Bessarion, an early humanist. Sansovino had
worked in Rome where he restored antique sculptures, among
them the Laocoon, recently discovered in 1515. With his friend
Andrea del Sarto he designed statues and triumphal arches
for a religious festival; he quarrelled with Michelangelo, with
whom he had hoped to collaborate on the facade of San Lorenzo
in Florence (which has never been built) and arriving in Venice
refused an invitation from Francis I to go to France, due prob-
ably to the persuasion of the artist Titian and the poet Aretino.
In 1529 he was appointed *Proto della Procuratia de Supra*, a
position giving him artistic supervision of the Basilica of St.
Mark and all other buildings around it which came under the
jurisdiction of the Procurators.[5] In 1537 he was given the com-
mission to build the Library. By placing the magnificent struc-
ture where he did, setting it back from the Campanile and by

288

fixing its height at fifty-one feet, approximately that of the older Procuratie Vecchie across the square, Sansovino gave the piazza its present shape. Scamozzi, who completed the Library after Sansovino's death, followed the sculptor's general design in carrying out the Procuratie Nuove, although he persisted on raising the new building a story above that of the Library. Where the Fabbrica Nuova, built in 1810 for Eugene Beauharnais, now stands on the western end of the square, formerly stood the church of San Geminiano with its facade by Sansovino, further evidence of his hand. In its modern form, St. Mark's Square thus owes its shape to a sculptor's art.[6]

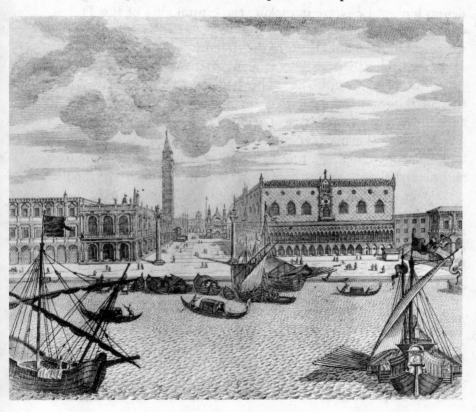

5. A View of the Piazzetta in Venice, showing the Palace and the Library.

If Sansovino gives us the chief lessons of sculpture in the matter of civic design, we may also learn from Michelangelo, who by demanding the destruction of the houses before the Palazzo Farnese, fashioned a square; or from French painters like Charles Le Brun whose profession was primarily decorator but who ordered the theme of the gardens at Versailles—recapturing the story of Apollo rising at his far-distant fountain and setting in the grotto of Thetis. In England we find Inigo Jones, a designer of scenery for masques, creating Whitehall which vies with Wren's later scheme for Greenwich Hospital as the most important complex of the London area. And gardeners too . . . Le Nôtre in making the central allée of the Tuileries gardens so important was able to give Paris its great axis which culminated afterwards in the Arch of Triumph at the end of the Champs Elysées. "We ought to have a Le Nôtre to form our plan," wrote the Abbé Laugier, "that he may put therein taste and thought; that there shall be more of choice and abundance of contrasts. There governs a cold uniformity which makes the disorder of our cities regretted. We should look upon the cities as a forest that there may be order therein and nevertheless a sort of confusion. We should have this and possess in an eminent degree the art of combining." It is the great contribution of the artist to cities that he has been able to combine, that the arches of the Libreria echo the arches of the Doge's Palace, although the buildings are separated by centuries; that Palladio described the library as "perhaps the richest and most ornamented edifice built since the Ancients," and that all the squares and places that we have mentioned are more desirable because they have been fashioned by the artist's hand.

Where the inspired touch has lingered urban form has been enriched. Would we pause at the Arc de Triomphe without the attraction of its sculptured reliefs by Rude? in the Piazza della Signoria without the work of Donatello? in the main

square of Bologna if it were not for Giovanni di Bologna? in front of the Paris Opera if we could not admire the decorations of Carpeaux? Can we still find room for the artist's inventions in our cities, in the manner of Raymond Sube's obelisks on the approach to the Pont du Carousel, which rise up at night transformed into lighted pylons? The truth is that not only have we forgotten the artist as an inspired creator of cities, but that we are willing to do without the artist as decorator or as inventor; in fact, his entire range of talent has been sacrificed. John Dewey examines the case of sculpture, "for ages an organic part of architecture" showing that its achievement of "independence" from building finding a home in public parks and "in rooms already overcrowded" [7] has not coincided with any notable advance in the art. We have forgotten that ornament gives *scale*, a place for the eye to rest as it moves about the surface of a building, in an erroneous belief that scale is a matter of size. We are willing to look with Veblen at the "backs" of buildings, and to voice no complaint when the plain back becomes the uninteresting front.

We have lost the art of "combining." We have not allowed the artist his place in the city, either as the originator of civic design,—a position to which he is by tradition fully entitled—or in his capacity as decorator. There is no public art, in which the vision may come from an individual, while the reality exhibits a collaboration, or combining, of all the arts.

It has been shown elsewhere that collaboration has existed at certain periods in our urban history. The artist has been in the streets. Even today he sometimes can be found there, "exploiting his own medium to the point of independence." This is not a desirable state of affairs, for the artist or for the city. Witness New York! A vast output of sculptural decoration exists there, good, bad and indifferent, not only in the obvious places like Rockefeller Center, but on the door-

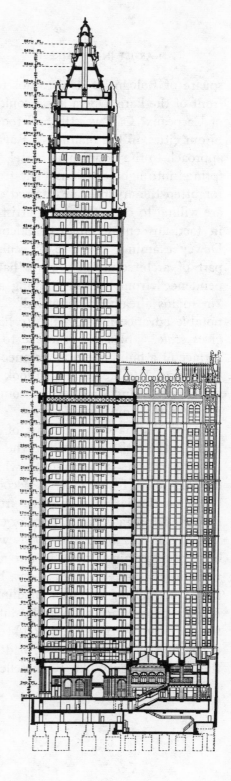

6. The Woolworth Building in New York, by the architect Cass Gilbert. The section shows the early use of service mezzanines to house the mechanical equipment. The building is notable for employing sculptural órnament at all levels.

292

ways, cornices, canopies, and brackets of less important buildings scattered all over the city. It is not seen or admired because it is always incidental. It has none of the effectiveness of earlier New York City ornament—the discreet yet original ironwork of handrail and hollow post, for instance, which adorned whole streets of houses before the brownstone era. Nor have we the *integrated* ornament of a whole building which Sullivan attempted and which actually was achieved in Cass Gilbert's Woolworth Building, that half-forgotten giant which the well-known architectural critic Montgomery Schuyler in 1913 called "shapely and proportionate as well as over topping." That it was not all "brute bulk," seemed to Schuyler to be due to "art and man's device" which flattered and satisfied the eye. This building has worn extremely well. It is no longer white, but the detail of its sculptured shapes on the substructure and on the tower is strong enough to be seen from a distance, while close up the eye does not take offence over what in another context would be uninteresting decoration. The eye is grateful to find sculptured forms—creating an architectural form—they are there to provide scale rather than to "exploit their own medium to the point of independence."

As recently as the twenties businessmen catered to the pleasures of the eye. Since the enormous strides made by the advertising fraternity however, business architecture has been forgotten. Decoration has been eliminated; this fits perfectly with the new business philosophy which scorns pleasure and favors the useful, a Veblenesque attitude which is considered helpful to the development of both business and science. Architects have helped to spread the idea that decoration is costly, frivolous and superfluous, that modern architecture is "cheaper" than eclectic architecture (which is not necessarily true), and that astylar functionalism is correct for business use. This may be so, but not for public use or enjoyment.

293

It is not so much that the glorification of the individual has forced an infinite division of the world of art, as Baudelaire put it long ago in the 1840's, or that, as he savagely charged, it is the painters who have killed painting or the architects who have killed architecture; it is that the *client* has disappeared. "The business-managed city of Carthage" supported the arts; the business-managed American city pays them lip-service. The industrialist occasionally fosters art with the aim of improving the design of his product (Container Corporation of America) and sometimes a business corporation collects paintings which it shows to the public (International Business Machines). But the responsibility felt by a few individuals of the business world is not generally shared—"the man who makes a chair is not obliged to sit in it," complained James Fenimore Cooper of the American businessman, "and is therefore content to consult his profits merely . . . The American people cling to their own uninstructed fancies in preference to the outlines and proportions of the more approved models." In 1832 Cooper thought the wisest thing the United States could do was to appropriate thirty or forty millions for the formation of a navy, "so that no power shall ever again dare trespass on our national rights," but the next wisest measure, he believed, would be to appropriate one million for the establishment of a National Gallery, to form an American taste. This would take the emphasis away from "vulgar exhibitions of individual vanity" and in fifty years the cost would be returned fifty-fold in the improved artistic quality of goods for export.

Cooper, after an absence of eight years in Europe, saw "the towns increased, more tawdry than ever, but absolutely with less real taste than they had in my youth." For taste to obtain in city-building, he thought, schools were necessary and strong artistic influences. Naturally he pointed to France; and anticipated the inevitable hostility his words aroused by attribut-

ing it to the American disposition to resent every intimation that we can be better than we are at present. This feeling of inferiority he deemed one of the surest signs of provincialism and quoted the French saying, "on peut tout dire à un grand peuple" (one may say anything to a great people). It is likely that the much-travelled author drew on the example of Colbert, whose development of French trade was based on the principle of first promoting those to do with national defence and second those to do with the arts, obtaining by this policy the monopoly of great men and skilled artisans in the service of his country. "We should see to it that we have in France all that is beautiful in Italy," the minister announced in forming the French Academy in Rome in 1666, and in 1671 he added an Academy of Architecture to the Academy of Painting and Sculpture in Paris which had been established twenty years before. The matter of quality was important in Colbert's thinking—high standards of workmanship, good materials and great art were the ingredients of his formula for the glory of France. "They are attempting to cull the flower of all that the entire world produces," said the Venetian ambassador in admiration of Colbert, who had obtained the monopoly of mirror-making from Venice.[8] After the academies came the Gobelins works for tapestries and furniture and the Savonnerie for carpets; the tradition was carried on in the Sèvres works founded by Madame de Pompadour to compete with Dresden porcelains. Artists were imported and French artists sent abroad for training, assured of work when they returned, either in the King's service or with private patrons, who were encouraged to compete with the state. Colbert's national planning—his canals and harbors, his factories, his exploitation of marble quarries and iron ore mines—is not familiar to most people, but nobody is unaware of the importance of French art and taste, carried through the years by state encouragement and patronage.

Although our cities do not immediately show it, no one can say that America is a tasteless nation. We have already seen that taste's clear flame has burned on the American hearth. "Good" taste has been with us too; is with us now, causing some superior people—poets, painters and novelists—to turn in revulsion to the untasteful, crude or vulgar. The bizarre, of which we have enough, is the opposite of "good" taste. But where is the true taste? And what is our true record?

Nothing shall be said against us in trying to foster the arts of design. It has already been shown that Jefferson, among others, planted them deep in the soil of Virginia. As President, Jefferson did not appoint a secretary of the arts [9] but he was ready to announce a Declaration of the Arts. President Buchanan appointed the first Commission of Fine Arts in 1859, after 127 artists had petitioned Congress saying, "the time is now at hand where we may assume a position in the world of art as enviable and exalted as that which we have attained in our social and political relations." [10] It was abolished a year later, Congress refusing to appropriate the requested funds; the embellishment of the Capitol by Brumidi and others, however, met with congressional approval. The Library of Congress is another rare example of the collaboration of artists (most of whom had worked together before.) In 1897 the first bill for a government bureau of the arts was backed by the Public Art League of the United States, a second bill was introduced in 1901, leading to the establishment in 1909 of the National Fine Arts Commission. The painter George Biddle irreverently refers to this Commission as a group of old geese in his autobiography, after they had objected to his mural for the Department of Justice, partly on the grounds that his style was "somewhat French and very Mexican," in fact, "intrinsically un-American." He felt that the Commission had exceeded its coordinating function and that its standards were based on those of the American Academy

in Rome. At the present time, the Commission is important only in connection with the development of the National Capital; of much greater significance was the establishment by the 75th Congress of the National Gallery of Art, made possible by the gift of Andrew W. Mellon. Since then we have seen the ill-fated attempt of the Coffee-Pepper bill to establish a Department of Fine Arts—a measure supported by seventy artists' organizations and twenty labor unions. We do have now the National Endowment for the Arts and Humanities, which gives grants to individual artists. We are also from time to time made aware that the State Department, whatever the qualifications of its personnel in artistic matters, sends exhibitions of American art abroad to acquaint the world with our progress in painting, sculpture, and design.

It would be comforting to think that with the coming of the National Gallery which Cooper had demanded over a hundred years earlier and the greatly increased attendance at art museums all over the country that the artist, once called by Alberti "divine," is now being reintegrated with society to make his necessary contribution to the national life—in painting, in decoration and in surrounding us with beauty. But, as our critic said, "we can be better than we are at present." The artist, except for a favored few, is still starving in his garret; and in spite of the perverse minority who have retreated from the world, it is not a case of self-immolation. There are no clients for worthwhile work, the businessman having decided to advertise in magazines instead of in his offices. In this new medium he employs the artist, but not as he would wish to be employed. And public art?

Edward Bruce, the corporation lawyer turned artist who organized the first generous federal subsidy of mural art, has said: "The Public Works of Art Project . . . brought to the artist for the first time in America the realization that he

was not a solitary worker. It symbolized a people's interest in his achievement. No longer was he limited in his appeal to a group of fellow artists or to pleasing a small minority of specialists . . . he had become the spokesman of his community." [11] And it is noticeable that during the brief period of federal subsidy in which over 3,600 artists were employed there was a new faith in American art, both at home and abroad. Not all of it was memorable; but patronage must of necessity be prodigal to raise the standards. As Louis Hautecoeur has put it, "It

7. The arrangement of the artist John Steuart Curry's mural in the Department of Justice, Washington, D.C.

is enough that posterity keeps a few of the works commissioned by the state to fulfill its function. It takes many dead leaves to make the soil needed to bring forth a few choice flowers." [12]

In order to put the artist back into the streets, a new client must be found. The vacuum of patronage must be filled, if necessary, by the state, as in Mexico and France, and to some extent in Great Britain. The Federal Government must do more to support the newly-formed Art Commissions in the fifty states than Congress has so far been willing to allow. (For instance, the city of Hamburg contributes more in this area annually than the entire sum devoted yearly to the arts from the Federal treasury here.) Similarly, it would be unimaginative to leave out the potential contribution of private and public museums and galleries, some of which, notably the Virginia Museum of Fine Arts, the Museum of Modern Art, and the San Francisco Museum of Art have done much to foster the art of the environ-

ment through city planning. There are also societies such as the Municipal Art Society in New York which continue an older tradition of civic art. These various organizations which are so prominent a feature of American civic life could all contribute to a government-sponsored program in the arts. The aim of patronage—a climate in which the arts can flourish—would encourage private initiative, as in seventeenth and eighteenth century France the royal patronage encouraged it; a democratic government can do likewise, by providing a framework to which private threads can be attached. Public buildings, streets, parks and urban redevelopment projects all need the inspired hand of the artist—would not his inspiration spill over into the private tracts surrounding them? But the initiative must come from government—it is too late to assume that a revolution of taste will spring from our business-managed cities themselves. As Hautecoeur points out, it is the role of the state to protect the arts (as we protect our national monuments and spectacular scenery). It is the role of the state to educate the public in the arts. It is also the role of the state to become the chief client for works of art, commissioning artists, architects, decorators, craftsmen, and musicians. The private client on the scale of Newport or New York of the early skyscrapers no longer exists, most of the collections having already gone to museums. Only if we are willing to spend generous amounts of money out of taxes for the necessity of art will the American community begin to change in appearance and in atmosphere. Then someday, we can perhaps again walk into an American square with its American sculpture and murals, its public fountain and its tree-shaded terrace, its frame of American architecture and its clear American sky overhead and say to ourselves thankfully: "Here is a place in which the power of art at last has been acknowledged!"

PART 4 AN APPROACH TO CIVIC DESIGN

A CITY CALLED BEAUTIFUL

"Happy is the city," wrote the architect Thomas Hastings, "whose development in the cutting of new avenues and the building of new squares and parks has been governed by the laws of art. . . . If there is less beauty in modern architecture than in that of former times," the designer reflected, "it is, I believe, because we architects are not working in unison . . . every man is for himself, more thoughtful of making a personal impression than doing a beautiful thing." [1] In moments of despair over the contemporary lack of popular support for city planning, it is salutary to recall that the original impetus to modern urbanism was contained in the idea of unison among architects and of urban beauty which crystallized in 1893 on the shores of Lake Michigan. Those who have since abandoned this quest for beauty have thrown away the most

important tool for arousing interest in city planning; they have denied a great tradition; and although they do not know it, they are helpless and their hands are tied without the aid and power of art.

A conditioned hatred and envy of wealth, which extends into the ranks of our intellectuals, has enveloped the names of Saint-Gaudens, McKim, White and Burnham with a miasma of suspicion based largely on their crime of subservience to the Robber Barons. That they also built for the public, not always at great profit to themselves,[2] is often overlooked; if it is remembered, the accomplishment is at once denied by attacks on the style of their civic work, which is no longer acceptable. Much of this criticism centers on the World's Columbian Exposition of 1893; in particular Louis Sullivan's remark to the effect that the Fair would hold back the growth of an American architecture for fifty years is quoted in reinforcement.[3] (Whether in modern society there can be any such thing as an "American" architecture is a debatable point. Possibly all architecture worthy of the name and built in this country may fairly be so termed.)

Apart from the fact that the architecture of the Fair was excessively admired[4]—the undoubted fact that the enterprise at once became a symbol which influenced people far deeper than the logic of simple construction may have some relevance here[5]—its attackers ignore a fundamental contribution to American civic art: the restoration of the principle of coordination. This went much further than the introduction of the much-publicized "uniform cornice line" or the quite arbitrary decision to employ a single color scheme. "For the first time," wrote the critic Montgomery Schuyler, "a number of architects had been able to cooperate in the execution of a prearranged architectural scheme of great extent and importance. For the first time sculpture and painting had been introduced upon a great scale, as integral parts of an architectural whole."[6]

Henry Adams, a critic not easily deceived, observed that many trends had fused in the White City—that it was, indeed, a symbol of national unity. True, it was a "trader's" city, but then so were Corinth and Syracuse and Venice, none of them the less beautiful for that. Above all it was the *conception* that appealed to this philosopher, musing under the

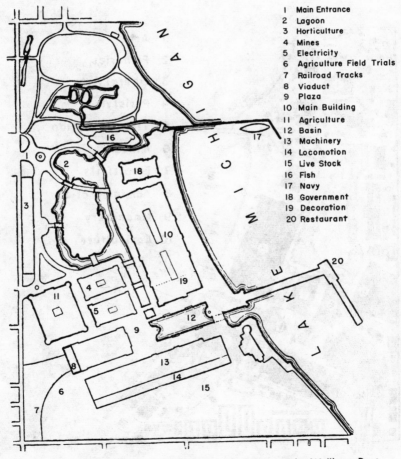

1	Main Entrance
2	Lagoon
3	Horticulture
4	Mines
5	Electricity
6	Agriculture Field Trials
7	Railroad Tracks
8	Viaduct
9	Plaza
10	Main Building
11	Agriculture
12	Basin
13	Machinery
14	Locomotion
15	Live Stock
16	Fish
17	Navy
18	Government
19	Decoration
20	Restaurant

1. (a) An early sketch for the White City by the architect John Wellborn Root.

305

dome of Hunt's Administration Building—the thought that here a city had been built, at prodigious cost, to crumble of course like paper, but in it the three American strains had met: the pioneer frontier strain in the construction; the cooperative planning strain of Washington and John Quincy Adams; and the searching Jeffersonian strain, playing on an international theme and accepting only the best the arts and sciences could offer.

1 Arts
2 Fisheries
3 Liberal Arts
4 Peristyle
5 Transportation
6 Mines
7 Electricity
8 Administration
9 Machinery
10 Agriculture

(b) The final ground plan designed by Frederick Law Olmsted.

"Chicago (meaning the Fair) was the first expression of American thought as a unity," said Henry Adams. "One must start there."

As the late John Gaus once reminded us, an official planning movement stemmed from the Fair.[7] About two decades later the movement began to proliferate into separate endeavors[8] but before this happened a remarkable flowering of American civic planning had appeared. That this was a product of the teamwork first undertaken in Chicago is significant; it suggests that the Renaissance principle of collaboration was consciously if briefly revived in an age otherwise characterized by its "rugged individualism." Collaboration in civic art had not in fact been seen since Jefferson's time, although there had been a sympathy of aims as late as the 1850's among followers of the Greek Revival. When even this was destroyed by the Civil War and the second railroad age had begun, the changing American city faced its most desolate period. Old centers and squares were swept away, carved through by railroads or destroyed by new building; no sense of unity remained. The most important architectural figure to emerge was Richardson; his own civic buildings and those of his imitators, which by the late eighties had dotted the cities of the East and the mid-West, at least had the unity of a style, but there is no hint in them of the civic complex or indeed of anything approaching due consciousness of the total central form. These buildings would have lent themselves admirably to the plans of a precinctual nature suggested by Camillo Sitte but his essentially anti-Haussmann crusade came ten years too late. The Richardsonian architectural innovation remained a monument to the exuberant genius of one man, whose death in 1886 left a gaping void into which stepped a team of architectural experts excited by a new faith— their testament fashioned by the urbane Boston Public Library which slipped smoothly into place across the "square" from an

already isolated Trinity Church. And "the ten architects who collaborated in that remarkable enterprise, the World's Columbian Exposition, signed the death-warrant of the still-lingering Richardsonian-Romanesque." [9]

Saint-Gaudens' often-quoted remark on the Fair [10] is revealing in showing an awareness of the great collaborations of history. It is doubtful, however, that the idea of collaboration among artists—already well established at the Beaux Arts in Paris—would have lain fallow much longer. What Oliver Larkin calls a Renaissance complex[11] had already developed in some American artists. Perhaps a more significant name for this would be *Arcadian Revival*, since the school, if it may be so termed, was devoted to ideals part Greek, part Roman, part Renaissance and part Romantic. The way had been prepared in the seventies by Pater and Symonds in literature, by Böcklin and Hans von Marées in painting, by Jarves and Norton in collecting; and toward the nineties it was possible for an artist to reconcile the pagan rite with the Christian festival, the satyr with the saint. The symbolism of La Farge and the heroic naturalism of Saint-Gaudens ". . . a child of Benvenuto Cellini smothered in an American cradle," as his friend Adams called him—are more easily understandable in this context; as are the Italianate pilgrimages of George de Forest Brush; the winged goddesses of Abbott Thayer; and the allegorical figures of Kenyon Cox. It was no accident that the aging Puvis de Chavannes was admired by the Arcadian architects—no one stood better than he for the idyllic in art. In this country he has overshadowed the more versatile La Farge, a painter now overdue for examination by contemporary critics.

It is thus that Frederick Law Olmsted, who introduced the Wooded Isle at Chicago, was in a sense creating the Sacred Grove of Puvis de Chavannes or Böcklin's Fields of the Blest. The island (which can still be seen), the romantic lake and the

shimmering reflections of the white palaces symbolized something already familiar to Americans but never before translated into terms of a city—this was the triumph that Burnham's collaborators enjoyed and the dream they fulfilled. Their creation was perfectly of the time, and if they thought of themselves in terms of a Renaissance collaboration it was with a realization that modern civic planning is more than a matter for the individual to achieve. Would Sullivan or Wright, given the opportunity, have made this concession to the times?

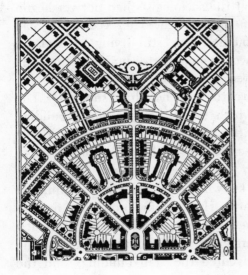

2. An arrangement of buildings and streets typical of the City Beautiful period.

The introduction of an acceptable civic style would in itself have been nothing, and, since architecture is subject to violent changes of taste, no lasting glory; the collaborators of the Fair have earned a more permanent reward for their penetration into the rough-and-tumble world of city planning. As has already been suggested, the term, "City Beautiful Movement," has obscured equally important contributions made by its protagonists in the period between the Fair and the first World

War. Since this brief account cannot be a history of that movement it remains only to bring out certain innovations in planning theory and practice made by Burnham, his colleagues and contemporaries. The least of these is Burnham's stylistic conception of the city, although his remark, "the relationship of all the buildings is more important than anything else," [12] was a novel idea to thrust before the American speculator. The immediate inspiration for his civic work was French. Where else could the American architect turn for inspiration in those days? It must be remembered that the sociologists had not yet begun to examine the city as an entity,[13] the land economist had not yet appeared, the "housers" were still trying to devise a "model" tenement that would appeal to builders, and the philanthropists such as Robert Treat Paine were advising people to shun the city and move to the "healthier suburbs." The Garden City movement which began its community-building activities in 1904, was on the whole anti-city in concept; the subtle ways of planning described in *Der Städtebau nach seinen künstlerischen Grundsätzen* had not been put into English. On the other hand, Paris was known to all, and especially praised was the recent work of Baron Haussmann, prodigious money-spender and skilled civic surgeon. Here was a forthright approach to appeal to Americans—large and bold enough to capture the minds of men who had invented the "tall building" and the "palace car."

No critics have been more severe with Haussmann than the French themselves,[14] yet even they have been forced to admit that in seizing strategic points and opening up their approaches he taught us to "make no little plans." In making the most of the city site, the American City Beautiful planners moved a step forward. Edward H. Bennett's scheme for Telegraph Hill in San Francisco is an excellent example of this new point of view, as is Jacques Gréber's avenue linking the City

Hall and the Art Museum in Philadelphia, proposed and built much later. In a sense, these were the fulfillment, a century afterwards, of L'Enfant's recommendation to choose strategic points and prolong them "on far-distant points of view." Bennett's little-known scheme for Detroit, reviving in part the Woodward plan, is an imaginative projection of this idea. Many of the forgotten plans for cities made between 1900 and 1915 by Robinson, Nolen, Griffin and the younger Olmsted show a feeling for the advantages of the site and an understanding of the third dimension in civic art which is not nowadays always so evident.

Burnham and Bennett, co-authors of the Plan of Chicago (1909), far surpass Haussmann in their understanding of the city as a whole.[15] Indeed, a glance at the frontispiece of their book on the plan will show that they regarded Chicago as the center of a region and extended their planning far beyond its boundaries. That this most fascinating of Guérin's drawings was too fine in scale and soft in color to reproduce easily from the book perhaps accounts for the neglect of the City Beautiful's regional side. It was not until 1920 across the world in Great Britain and in Russia that the regional planning concept was revived in official schemes. Neither can we allow the modern planner to claim the distinction of observing the city as a poly-nucleated organism, subject to overall control. Although the term, "Master Plan," was not made part of official usage until the New York Regional Plan Association enshrined it in the planner's vocabulary, the early plans were much more than a series of "improvements" dotted here and there about the city. Chicago is perhaps the best example of the master plan approach, but other plans made before World War I produce similar evidence of the feeling for the part and the whole. The 1910 plan for New Haven[16] by Cass Gilbert and Frederick Law Olmsted, Jr. shows residential areas separated by ring roads,

311

the latter connecting the different parts of the city in a simple and easy solution; it was not until twenty-five years later that London and Moscow adopted the ring-road principle. This plan also shows an inner greenbelt or continuous recreational area, forming a protective buffer for the city's residential districts. Parts of this greenbelt were laid out shortly afterwards; then the idea was forgotten, to be revived after a lapse of thirty years in the New Haven Plan of 1942. The plan of 1910 is the Master Plan of a period which had not discovered how to make the plan a reality; but the work that was being done then prepared the public for an acceptance of city planning that is vitally necessary to the realization of our modern civic development.

The rebuilding of the Triangle area in Washington was the last great triumph of the City Beautiful movement. Circuses and crescents appeared in the plan and are promised for completion in the most recent designs for Pennsylvania Avenue. Let us hope that the area designated as a park but which became a parking lot will also be restored. The Triangle even as it is remains a great monument and a tribute to the imagination of the 1920's and 1930's although the area has not been well-treated by critics of classical architecture and planning. Frederick Gutheim in his book on the Potomac River refers to it as an overpowering huddle of official architecture. So, however, was the Forum of the Caesars, which is nonetheless universally admired. In any case, this was the moment for the arrival of the City Beneficial, in the creation of which the social scientists, the economists, and the reformers are perhaps at last to have their opportunity. The realization that they were preceded by a movement guided largely by esthetic principles but not unaware of its responsibilities to society should be an added incentive in their task. It is easy enough to criticize the City Beautiful movement because it created so much that we now see around us; when the City Beneficial has arisen our *ex post facto* judgments may be equally severe. Perhaps neither should be

judged entirely by its creations, which in the art of city-building are so often smirched by compromise, but at least partly on the intent of its originators, which must be unwoven from the social fabric of the times.

Although the classical revival of 1800 and the neo-classic revival of a hundred years later offer us important evidences of the American tradition, there were, as we have seen, too few connecting threads to bind them into a lasting pattern. Is it then that we have no continuing tradition, except in our institutions? No possibility of continuity for creative arts or for their environment? Wherein lies the American promise?

We see the great land and wonder. We know how it is used, how divided, how built on. We follow the tradition of the frontier, once lawless, now hallowed by historians, appearing and reappearing in the town plans, the system of lots, the forest clearings, the manners and morals of the city. We see the cities in the wilderness—the cities of expediency, hope, promise and revolt. We watch the land misused, restored, conserved—the great cities spreading, assuming new shapes; we search for the conscious hand at work among the habitations of men, creating an American urban form.

The conscious hand! Is this what we are searching for? The hand that is sure in purpose, the hand of the philosopher and practical man combined, whose aim is direct, whose faith in America is sound, who is willing to take the best that is in all nations, unafraid to borrow and to improvise? The sharing hand which grasps the hands of others? Has there been too much unconscious groping in the past, too little aimed at posterity, too much at the fleeting moment which is the present? "It is in vain you bend the bow if you do not know where to aim the arrow," Alberti warned the painters. In our concern for the city, do we, above all, need direction, having left so much to chance?

We think of Jefferson, of whom the Marquis de Chastellux observed "it seemed as if from his youth he had

placed his mind, as he had done his house, on an elevated situation from which he might contemplate the universe," and yet who scrambled among the politicians to plant the arts and sciences in America; who created a style of architecture, even an American order of architecture, while unafraid to borrow from his first and consistent model, Palladio.[17] Today the search for an American style goes on, confused by a frantic pursuit of originality as Hastings observed years ago, resulting only in the creation of at most a *mood*. We hear of an American style of architecture from Frank Lloyd Wright, of the American school of painting from every museum. Few realize that this is sectionalism, product of a needless sense of inferiority. As long as there is American stone, American vegetation and American light there will be an American architecture and painting; as long as there are Americans there will be an American literature. And still we search for something different—some mark which sets us off from the rest of the world—instead of aiming high and coming to grips with universal values. Have we, like Jefferson, "consulted the arts in order to shelter ourselves from the elements," or have we merely consulted the weather? Have we aimed to build well, or just to build differently?

Building well takes time, and that dimension we have ignored. A continuing tradition such as schools and academies might have provided is lacking, the establishment of higher education having been subject to violent swings of emphasis in one direction or another. We are not educated to appreciate the visual arts, although that situation is changing in a few institutions and we are discovering our illiteracy in the process. The authors in Jefferson's library of art are vaguely familiar, but we do not know what is inside the covers. Alberti, Vignola, Palladio, Scamozzi, Gibbs, Chambers—the great books of architecture and civic design! Who has read them today? and who has followed the Jeffersonian tradition, broken off after 1820?

If it had been followed we should have had a scale, a better artistic heritage and a pride in the cities. Look at Jefferson's planning for Richmond, for Pennsylvania Avenue, for his academical village; look at his patronage of the arts, remember his introduction of monumental style—and then wonder if our attitude is not the same as his contemporaries. "It was felt that a public man might indulge in artistic matters during his hours of relaxation, but scarcely pursue them seriously." [18]

The conscious hand is perhaps more apparent in other forms of planning. We have ruthlessly cut down, but we have also laboriously built up. When, after 1890, something had to be done about the land as a reservoir of food and power the first step was the Forest Reserve Act of 1891 which authorized the President to set aside timberland reserves for the nation. Harrison, Cleveland and McKinley withdrew from sale or settlement about 45 million acres during their periods of tenure. Since then we have seen flood control, soil conservation and even river valley resource planning in the TVA made instruments of public policy and conservation has become an accepted principle. The pity is that we have not practised conservation in our cities. Also, since 1937 we have had a public housing movement. Housing has broken a path: it has not been afraid to borrow from the experience of other nations; it has given us a good example of the functioning of the autonomous agency within the framework of the cities; by the 1960's, however, the autonomy was being challenged as an arbitrary exercise of "urban removal" and the late Charles Abrams found that public housing had been down-graded to an appendage of the renewal process.

Except in the great dams and river valley projects the conscious hand (which is planning) has not yet rediscovered the monumental scale which is so well suited to the American scene. The cities themselves are large in scale; one has only to

journey from any part of the world to see the difference. New York harbor, so greatly improved and enlarged through the efforts of John W. Ambrose, is gigantic by comparison with most European ports; London, though vast in area, looks like a toy village to the American arriving from Chicago or Detroit, which are much less numerous in population. The scale of Europe is the scale of Charleston, Alexandria or Fredericksburg. Let us turn for a moment to the creations of bold but usually uncelebrated engineers whose special imagination has brought new forms (or better, new *arrangements*) into urban life. Making the city work is usually an unspectacular job, but in the following examples one's imagination cannot but be stirred . . . this is more a matter of historical understanding rather than of visual experience, since much of what has been done cannot be comprehended by the eye.

It is no accident that the European first thinks of skyscrapers and superhighways when he thinks of the American city. It is the boldness of these creations which appeals . . . they represent the sum-total of American enterprise, ingenuity of getting things done . . . and perhaps (let us face it) they are the most significant aspects of American urbanism. Certainly they are the monuments by which historians will judge us and are already beginning to judge us.

But the total "arrangement" has not been celebrated by historians,[19] and to descend with Thomas Wolfe into a great railroad station, for instance, is to find something typically American, not wholly seen but felt as atmosphere. Here the voice of the air speaks loud and clearly—and the twentieth century city, perhaps even the city of the future, seems to find its perfect expression:

> "The station, as he entered it, was murmurous
> With the immense and distant sound of time.

> Great, slanted beams of moted light
> Fell ponderously athwart the station's floor,
> And the calm voice of time
> Hovered along the walls and ceiling
> Of that mighty room. . . ." [20]

The Grand Central complex is much more than a railway station; in fact, the sight of a train is rare. It is a place occupied daily by a group exceeding the population of a major city (500,000 people) and a yearly number exceeding that of the Soviet Union—yet it has no inhabitants. One can buy all the necessities of life there (and all the luxuries), do business, sleep and leave anonymously with all the other anonymous guests. It is quiet, so quiet that one longs for the sound of a locomotive, which will never be heard because the steam train has been banished forever from this precinct. It is most-certainly the only railroad station where a bishop could speak from a balcony to hushed thousands in the concourse below, appealing for $10,000,000 to complete the building of the Cathedral of St. John the Divine. (The Episcopal church has seldom launched a campaign so successfully.) Under the blue vault is the feeling of being in a vast Beaux Arts cathedral. Nothing is bared, no structural members show, no space-time depot this—yet. . . .

It is the hidden engineering which is the marvel—the concealed mechanism which provides access to the many shops and offices in a score of buildings, besides providing the framework for New York's most prestigious thoroughfare—Park Avenue. The station arrangements were daring enough—the first and perhaps the last to bring in the tracks on a double-deck fan cut deep into the heart of Manhattan's granite; but the idea of covering the tracks with streets and buildings towering above was a major inspiration as well as a profitable speculation. Walk-

317

ing along Park Avenue, one is reminded only by the thin line
of their expansion joints along the pavement, which separates
them from the bridge on which the street is carried, that these
office buildings with their curtain walls are not built on level
ground.

To stand one foot on the pavement and one on the
doorsill of a building is to feel a slight vibration only in the
pavement as a train roars by underneath. The buildings are
raised on independent steel columns sunk down to bedrock on
layers of asbestos and lead; Grand Central itself is built upon the
same bridgework that carries the track.

The recent obituaries of Colonel William Wilgus
gave a measure of tribute to his engineering innovations at
Grand Central. It was undoubtedly he who conceived of tracks,
streets, bridges and buildings all in a single structural entity;
the double-deck track fan to save space and the loop connection
to circulate the trains. It was he who worked out all the details
with the first official architects, Reed & Stem, but to these win-
ners of the competition for the new station goes the credit for
the device for looping Park Avenue around the station on "ex-
terior circumferential elevated driveways" instead of through
the centre of the station athwart the concourse as Wilgus had
suggested. It was probably the architect Whitney Warren,
cousin of William K. Vanderbilt, the railroad czar, who planned
the "low monumental effect" of the station itself and attended
to the selection of the interior marbles. New Yorkers can per-
haps be sorry that a more famous architect, Stanford White,
did not win the competition. His building would have been
60 stories high (the tallest then existing) crowned by a jet of
steam shooting 300 feet into the air; at night red lights were to
play on this vaporous column to guide all shipping into New
York harbor.

The engineer makes our lives convenient; he also im-

318

proves our health. If the Grand Central-Park Avenue complex is placed at the head of our list of significant urban facilities, certainly next should come the Chicago River. In Chicago there is to be found the most impressive American street (Michigan Boulevard, a western Prince's Street), but the visitor would do well to walk along it as far as the river for a special reason.

Chicago presents all sorts of visual effects which New York cannot offer. For one thing, the city can be seen from the Outer Drive—one doesn't have to cross a bay or a river to get that impression. At dusk, driving up from the University, past the Promontory apartments of Ludwig Mies van der Röhe, the Loop district suddenly comes into full view, Grant Park making a quieter foreground to the black towers, which carry in places enormous electric advertising signs to give a shimmering pattern of light on the highest levels. Then there are the effects of the wild Chicago weather. In a snowstorm blowing in from the Lake, each particle is etched against the Wrigley Building flooded by a battery of searchlights from below—a spectacular sight. One feels very close to the elements in Chicago and very sure that skyscrapers are gimcracks; playthings of the moment in that city "whose only permanence is change."

But the River and its Sanitary Canal is the social conscience of Chicago and the reason that its miles of beaches are so safe from water-borne disease. As one stands on the bridge that takes Michigan Avenue across the Chicago River, it is as well to know that there is more here than meets the eye. True, the eye is kept busy enough. A rough circle of towers, individually placed, is all around—the Wrigley Building, the Tribune Tower, which Colonel McCormick once tried to make safe from atomic bombs, and the Marina Towers are the principal eye-catchers. If one is lucky enough to be thereabouts when a ship is passing through, several bridges may be raised, while the city's mighty traffic flow stands still. But the most significant

319

phenomenon seems insignificant enough—it is the murky water itself, glazed over or steaming on a foggy day; for this river, which until 1900 poured into the Great Lakes, now runs into the Gulf of Mexico. Engineers have reversed the flow. In 1900 the drainage canal was completed after twenty years of planning, several years of labour and fifty million dollars in cost. Previously floods would sweep down the Chicago and empty stockyard wastes into the lake; when the reversal was completed deaths from typhoid dropped to almost nothing. Cutting through the watershed to the Des Plaines River accomplished this; nor was that all. The Sanitary District became the vast regional scheme, taking over the watersheds of nearby rivers and reversing their flow to prevent the sewerage from towns along the shore flowing into the lake. This is a partial safeguard for Chicago's thirty-two miles of sandy beaches, the envy of other lake-side cities like Cleveland, where a larger river pours industrial waste to pollute the waters of Lake Erie for miles offshore.

The Chicago River thus becomes a man-made facility in a fantastic setting of architectural hedonism. Its thread alone provides the unity—this part of the city forms a cross-roads; the magnificent main street cuts through, the two-level Wacker Drive snakes along its "banks" and the buildings that have clustered here can be seen with foreground. Who would give away this view for anything in Europe?—so violent, brittle and emotional is the prospect that one cannot fail to respond to its extraordinary challenge.

The situations providing an aesthetic and intellectual stimulus are quite rare. Two of them have been mentioned. New complexes will appear in time and perhaps the East River Drive in New York is one, with its succession of covered decks, tunnels and views. The West Side Highway, completed earlier, is not of this class; the engineering is a feat—covering the railroad and creating a great parkway to replace Riverside Drive,

but the uninteresting park landscape that covers much of the surface dulls the view. San Francisco's Golden Gate Bridge is magnificent but with this we arrive at the single engineering accomplishment, and, by definition, our "significant arrangement" *requires more than engineering structure.* Significant form in American cities seems to be accompanied always by a story—it is a narrative picture, if you like, in observing which the spectator must understand something of American history, American ways and American enterprise. On a street in modern Rome we may be able to observe: "Here Caesar walked;" in the great American city we can sometimes say, "Here someone—now who was it?—had an idea." And yet—are not these forms intimately related with our lives? The danger in substituting the triumphs of engineering for the sensitivity of architectural scale and proportion, which involves the presence of art, is discussed in the next chapter. But it is as well to emphasize here that mere size as an aim will not do—the monumental scale is not a matter of bulk, or height or of bridging vast spaces. If we were to rely on the scale of engineering achievements we should have no relationships whatever. Consistency, proportion and detail are all important elements of the monumental; even a village can achieve this. We have an example of the monumental in the "New" State House in Boston. The designer of this building, Charles Bulfinch, America's second great architect, whom Jefferson counselled on his European tour, achieved the monumental scale. His conscious hand led him to "improve" Boston, and as chairman of the board of selectmen for twenty-one years he was able to "modernize" whole sections of the city. Franklin Crescent was his, the Federal Street theatre and rows of fine town houses; moreover he provided for new systems of drainage and street lighting, and widened many of Boston's narrow streets. Imagine Boston with the Bulfinch scale, recalling how cleverly it built up to focal points, and then think of the "im-

provers" of New York or Boston today who care nothing for relationships or scale. See the monumental scale of Commonwealth Avenue, a concept attributed to Arthur Delevan Gilman, destroyed by the admission of one tall building at the corner of Berkeley Street and the Bulfinch and Benjamin houses on Beacon Street opposite the Common suddenly dwarfed by a similar intrusion!

The size of Colonial buildings was small, but the monumentality was brought in; the size of the Federal period somewhat larger, and the monumental was triumphantly achieved; the size of modern buildings is any size and there is no monumentality. There is no conscious hand; no chance for it to function. When the historian George Dudley Seymour attempted to regulate the height of buildings around New Haven's Green he was defeated; the architect Albert Simons has been somewhat more successful in Charleston. The lack of support for such moves is bad enough; but when modern civic centers are built, as those recently in Chicago and Detroit,

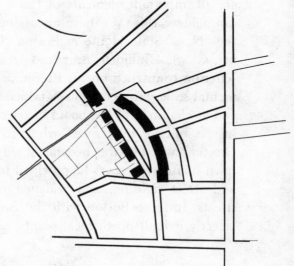

3. Franklin Crescent in Boston, designed by Charles Bulfinch. The buildings no longer remain, but the curved street exists in the central commercial district.

322

there is no scale, but gigantism, no detail, no relationship to the rest of the city. This is a worse phenomenon, showing that we have much to learn before the revival of civic design, which is almost upon us, catches us unprepared and ignorant of the fundamental principles of proportion and decoration.

The challenge to our world is this: Can we in everyday building operations, in planning industrial towns, in pulling down and rebuilding sections of old cities, in putting up shops on Main Street—can we in the pursuit of these ordinary operations be aware of the Grand Design? Rules and regulations will not give us the desired result—the zoning code is not the artist's inspiration; it merely saves us from greater or lesser crimes of owners and builders. Some say that our interests are elsewhere—(and it is true that we have had no artistic education—none!—in our schools or in our families and no one has even taught us the periods of art as they have those of history)—

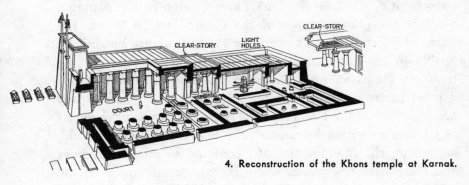

4. Reconstruction of the Khons temple at Karnak.

that we prefer to tinker with old motors and will never take an interest in our surroundings. "Too restless, they build the most majestic vessels, engines that have an archaic splendor beside which Karnak is the work of mud-pie makers, but the houses are random recollections, the scamped work of a mind bored with anything that will not move." [21] Others shake their heads

323

and say that the market and its artificial land values demand that we shall build tall buildings *here* or none at all, small buildings *there*, to save taxation, or to follow a trend; but we see this pattern continually breaking down; once again quite recently with the assembly of large plots of land. A city suddenly is told that a score of acres in the heart of town is to be disposed of—a railroad is selling off its freight yards—or a larger operator buys up an area of several blocks for redevelopment. Within such areas any scale is possible; it will not do to say that economics determines the exact shape of the city. The small lot, which conditioned city building for so long, is disappearing.

Paradoxically, now that we have begun to assemble land on a larger scale, we have forgotten how to apply the monumental. Absorbed as we have been with the problem of the individual lot and the individual building, we are still placing a series of individual buildings on these larger sites, missing opportunities all along the line. *The next step in city planning must be the reintroduction of the Grand Design.* It was the virtue of Jefferson that he introduced it to America, but he was unable to implant it strongly enough to ensure a continuing tradition. He passed on the desire to Latrobe and Bulfinch, but it must be remembered that the romantic current had already begun to flow in the Federal period of design through the novels of Charles Brockden Brown and the first Gothic revival buildings. Also, the monumental was confined to public buildings and there were few places where commerce attempted it; the best known are Alexander Parris' Quincy Market and Bulfinch's Tontine Crescent in Boston, Latrobe's Merchant's Exchange in Baltimore and another by Strickland in Philadelphia, and A. J. Davis' Colonnade Row in New York City. Throughout the romantic period from the 1830's to the 1860's an extreme individualism prevailed, and there remained only the very slim tradition of making government buildings important in an age

during which government counted for very little. The opportunity returns with the consolidation of railroads after the Civil War when the problem is posed of the great termini, and immediately thereafter the advent of the tall building reopens the whole question. Just at this time American architects begin training at the Ecole des Beaux Arts; there was no school in

5. Merchants' Exchange, Baltimore. Benjamin Henry Latrobe.

England, none of importance in Germany, and Gottfried Semper had only just started his school in Zürich. In France architects were using cast-iron, steel and even the new reinforced concrete by the 1880's, so that the Americans returned equipped to deal with the problems raised by the railroad terminal, the large department store (Sullivan), the big warehouse (Richardson), the hotel (Adler and Sullivan), and the cathedral. But the

325

6. The square at Hampstead Garden Suburb. Here garden city followers achieved esthetic order relying less on picturesque detail than on the Grand Design. Buildings by C. F. Voysey, Barry Parker and Sir Edwin Lutyens add much to the interest of the square and its neighborhood.

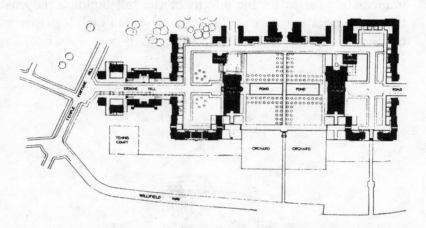

opportunity of the large scheme was seldom offered and that is why the World's Columbian Exposition was so important a manifestation of what American architects could have done if given the opportunity. Its legacies—San Francisco's Civic Center, which we may regard as one of the very best civic complexes in the United States, or Foley Square, in New York, an intriguingly shaped group of buildings where for once the staircase assumes importance—may be counted on the fingers of two

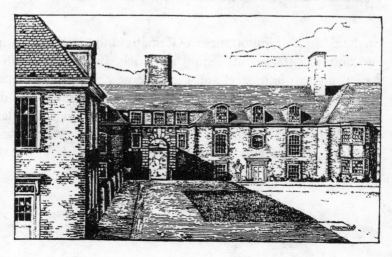

hands. There was no return to the residential square, which would have given space and importance to residential areas, and with the exception of the Villard house in New York and a few early apartment house groupings, there has never been an attempt to treat the problem of dwelling units in the manner of the Grand Design. Housing projects, public and private, tend to impose a pattern rather than establish a design, and with a few exceptions such as the Carl Mackley houses in Philadelphia and the Mills houses in Charleston there is an avoidance of the direct and simple forms which a conscious hand would unerringly implant. It is as though, in turning from the Beaux Arts training and concentrating on solutions to individual buildings which is the present vogue in American architectural schools, the baby has been thrown out with the bath water and the most important contribution which architecture can make has been forgotten.

It should by now be clear that we are not proposing a new movement of old forms, or a revival of an old movement in a new dress; but *a principle of composition* married to a recognition of *the power of art*, which will enrich (or save from poverty) our civic design on American soil. The Grand Design can be applied to housing projects, industrial complexes or any new forms that may appear as society changes; similarly it does not reject advances in technology, but welcomes them. If science frees us from bearing walls, our choice of forms is widened, and the Grand Design is thus made easier to express. But once let technology, or fashion, or ignorance *dictate* our choice of forms and the principle is lost, while the forms of art are forgotten, like flowers in a garden smothered by coarse weeds. Art must be nourished and cultivated or it fades away and presently cannot be found. The new movement in civic design will cultivate the arts and the artists, will provide the continuity which is essential to urban life and progress, and will establish the framework

327

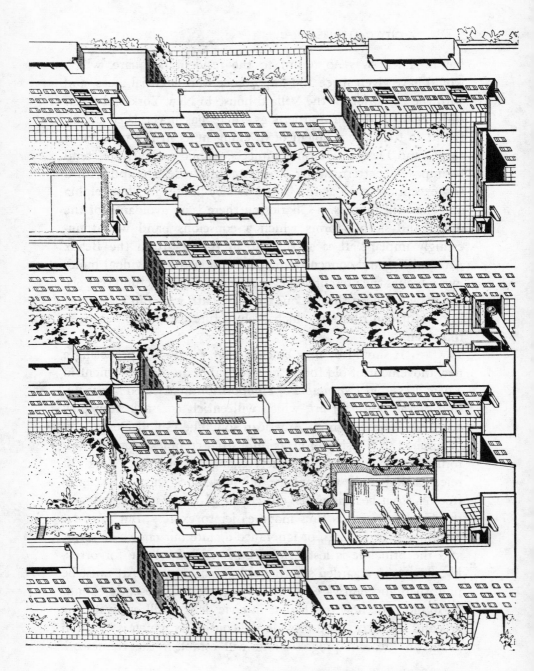

7. The Carl Mackley Houses in Philadelphia. An early housing development by Kastner & Stonorov, and W. Pope Barney which remains one of the best, avoiding studied irregularity and concentrating on a bold, simple plan.

within which that wonderful flowering of urban culture—that new Augustan age of cities which material progress is making possible if we have the will to shape it—can be the reality and not the dream of our modern world.

CHAPTER **14**

IN ALL DIMENSIONS

What is Civic Design? Thomas Adams, in his *Outline of Town and City Planning*, thought that this term should be applied to the art of city planning, to distinguish it from the act or machinery of making plans. "To be an art," he suggested in his introduction, "city planning must be creative design, directed by intelligence, and applied to the forms and masses of buildings and the spaces about them. It must recognize the essential unity between buildings and landscapes, between forms and uses of buildings, and between architectural and engineering elements in structures." Sir Patrick Abercrombie, perhaps the greatest living exponent of the art, has described it as being something infinitely more difficult than architectural design; but it seems difficult only because we have had so little experi-

ence in doing it and because the problems of scale are not just architectural ones. It is, as Abercrombie says, something more than architecture and something different from city planning as it is commonly practised. Perhaps as a creative profession it can be described as a combination of architecture, planning principles and landscape design, and a method of coordinating all the creative arts which must be given urban expression if we are to achieve an integration of art and life.

It may be thought that Civic Design is a subject not worthy of profound consideration because the words suggest perhaps a flavor of the icing on the cake, or, alternatively, an art applied to the city structure. This, of course, has been our mistake—considering Civic Design as something which comes after "planning." In reality our cities are ugly, congested and unfunctional because we have neglected the visual aspects in an attempt to make the city work, and you cannot make the city work unless you know what you are making it work for. This brings in the social basis of planning and the only kind of Civic Design that is worthwhile is the kind that has a real social basis, deeply rooted in the social instinct for cooperation, organization, and individual expression.

The approach to the city through social design is not quite the approach of the social scientist. The social scientist has been making studies of the city from the point of view of identification of groups and their interrelation in the social structure. He has not yet been able to tell us what would be a favorable urban atmosphere in which these groups could function or if he has made the attempt, the result has been given to us in terms of values or of desirable social goals. The closest that he can come to the design element in the community pattern is in terms of amenity, and amenity, although a useful word in the general sense, cannot be exactly interpreted in terms of the city structure. It may be said that the sociologist and anthro-

pologist, who are doing such valuable work in discovering who we urban dwellers are and how we act, are not able to help directly in the conditioning of the urban environment except as clinical experts. The civic designer, on the other hand, because he is a creative person may be able to help more directly in creating the amenities of life because his approach and the results of his approach will actually condition the life that goes on in cities. He has to start where the social scientist leaves off; no one would say this was a desirable state of affairs, but since work on such a complex thing as the city cannot be in the form of a controlled experiment, a collaboration tends to break off at the end of the research stage and the designer has to proceed alone. A suggestion for remedying this anomaly will be made in the last chapter.

We have seen that a greater role must be given the creative professions in city planning, to lift it out of the plane of workability and expediency on which it now rests, to change something of the surgical approach of the city planner to that of the artist. Civic Design which is so closely a part of architecture and the allied arts has a tremendous power, the power to move us deeply; even to evoke the highest forms of social cooperation through its appeal to the individual and to groups; and to project an image of our most cherished national traditions. And why has Civic Design been so neglected, even forgotten for so many years? Why is it that this power to recreate inspired environment is no longer used as it was used even by speculators in former times, when they built the Place Vendôme in Paris, the Circus at Bath, or Washington Square in New York? We are building in a greater volume than they were then, and yet the result is not design. The answer is of course, that we have forgotten art in order to be comfortable, and in the pursuit of that fallacy we are becoming more uncomfortable every day. The money that is spent on highways can only be

compared with the second railroad age after the Civil War when the railroads, as the highway engineers are doing now, spent lavishly to acquire the finest urban sites regardless of other uses to which they might be put. The creation of urban facilities without regard to anything but specialized pleasure or convenience cannot result in well adjusted urban conditions, and we are finding out the hard way that we are wasting our resources in the city because of misdirected attempts to achieve limited objectives.

Why otherwise are we allowing the highway engineers to build Chinese walls that separate neighborhood from neigh-

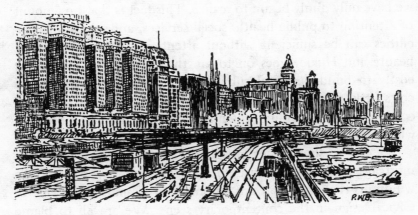

1. Railroads on the lake front at Chicago.

borhood and neighbor from neighbor? Walls of cars moving at fifty miles an hour, poisoning the air with carbon monoxide. Why otherwise are we building schools and power plants and tunnels and housing projects without any regard for the form that they are forcing the community to take? Why are we lacking in what Joseph Hudnut has called the "homely ordinance" of architecture in our city streets [1]—an architecture which has the power to give them life and to create an atmosphere of urban charm? We have allowed the opposition to triumph.

333

Our housing projects, if we can look at them for a moment in a different way from the usual one, are testimony to the triumphant opposition. If their architecture were better than it is, one may suppose that they would be in competition with the private builder and nothing must interfere with the design activities of the developer whose triumph in the suburbs is a pale testimony to the ghastly monument called good taste. Housing projects remain an evidence of the philanthropic approach—they are vastly better than the slums in questions of comfort, but how do they look?

Julian Huxley has called our attention to a fact that we have only dimly begun to realize. This fact is that no amount of attention to public health, social services, and educational facilities can be sufficient without attention to the question of beauty and Huxley goes on to say that it is only a litle more costly to build beautiful suburbs than ugly ones. It probably costs little more to build beautifully because there is a certain economy in fine building which is beyond the resources of those who build badly.

We should not imagine that the developer or the mortgage banker or the insurance company or any other of the windmills that we tilt at are especially to blame for the lack of Civic Design in the contemporary scene. We are all to blame in one way or another for the condition in which we find ourselves and it behooves us to examine our own approach very carefully if design is to be improved. There are many architects interested in Civic Design, but what would they produce if given the chance to rebuild parts of our cities? Too many architect-planners verge close to being technocrats. The technocrat is a man who believes in an elite group of specialists to run things for us and he is much influenced by the fascination of getting things done through a kind of social engineering. The theory of technocracy has spread widely among our architects

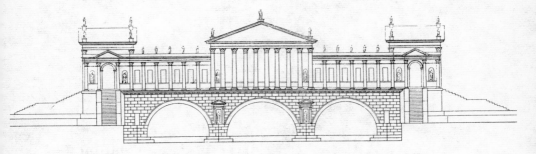

2. Project for a bridge by Palladio.

and the result has been an exaltation of technique with lavish compliments being paid to the engineer as the true architect of our time. Now, we may agree with anyone who says that the triumphs of engineering as evidenced by modern bridge design are beautiful but we may be going overboard when we say that a bridge is more beautiful, for instance, than a cathedral which has something of many people and many ideas woven into its structure and which is after all a more human thing than a bridge can ever be. This romanticizing of technique shows a confusion of judgment and a loss of the measure by which we judge our surroundings. We may not have to judge between the icebox and the cathedral but let us at least be aware of the difference in value between these two products of man. To base our Civic Design on the same set of values that we apply to the design of iceboxes or automobiles is to lose all quality, all atmosphere and all the opportunity for achieving greater significance in civic art. We must remember that the machine is a tool to be used and not an end in itself and that the machine

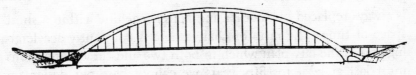

3. A modern bridge of reinforced concrete proposed by the French engineer Eugène Freyssinet for the Hudson River.

335

4. The west front of
Notre Dame de Rouen.

is always replaced by another and better machine within a short
space of time. The ratio of change here is constantly accelerat-
ing and in the city plan which in both two and three dimensions
must last at least for fifty years we cannot base our design on
constant change. We must have standards and fundamentals

which we may assume will last at least a generation and we must bring this fact to the attention of all those who are destroying the city by slavish subservience to the machine god. One fundamental here, for instance, is the separation of pedestrian and automobile traffic and of fast moving and slow moving traffic. Such a fundamental should be kept as a constant aim and not be subject to the whim of the technocrat who will seize all the latest traffic notions as they come along.

The striving for originality for its own sake, the cult of the new for its own sake, prevents the tradition of quiet anonymous building from continuing use on the part of our better designers; because since the day that one architect built his house over a waterfall and another raised his house on stilts, they seem to have felt it necessary to make every solution different

5. Dymaxion House designed by Buckminster Fuller.

337

6. The quiet vernacular of houses in St. Augustine, Florida.

from the one built yesterday. This denies to us the pleasures of a quiet street architecture and the unassuming court or square which were once just as much a part of the American tradition as they were of Paris or of London. Boston and Philadelphia have fine examples of this quiet vernacular in granite or in brick; and many of our southern cities still retain whole streets of unassuming buildings where variety is to be found in architectural detail and in textures. The latest spur in the frantic search for originality is to build houses with all four walls of glass or to build apartments in which nothing relieves the horizontal line. A leading modern architect recently answered a modern sculptor's plea for more sculpture integrated with building by saying "I couldn't possibly have any sculpture on my buildings. It would spoil my beautiful clean surfaces." These beautiful clean surfaces, of course, are a legacy to us from Adolf Loos who, if still living, would probably no longer be using them.[2] So that originality after all sometimes becomes a dead thing in the hands of those who are striving to produce it.

Then there is the cult of the ugly . . . a very specialized approach promoted by the historian who in desperation to find something new to write about, parades before us the atroc-

ities of the lesser architecture of the nineteenth century. It is all very well to defend the nineteenth century for its inventiveness and its boldness, but it is impossible to praise the nineteenth century building types in which no attempt was made to create fine architecture. Alexander Jackson Davis, Renwick, Richardson, and McKim, Mead and White produced beautiful buildings but many of their contemporaries set about destroying the city for the civic designer in a way which had no parallel until the recent activities of the highway engineer. Perhaps from that time stems the denial of our American tradition in Civic Design and the neglect of elements like the quiet street, the residential square and the pleasant waterfront, as at Charleston where it seems as if you can actually lean down and touch the water; these things were once an important part of community design.

The sooner we apply the highest tests or measures to our cities the quicker we will realize what is missing or what is wrong. Among the several principles of Civic Design which can be used as measures one can think only of the elements of *accent* and *surprise* as being consistently employed: the element of *accent* gives a sense of identification; it was, as we have seen, a principle of medieval planning, but it is to be encountered in the domes of the state capitols and in the central skyscrapers of any average American city; the element of *surprise* is often unconsciously achieved in the downtown sections of the larger cities—Trinity Church at the end of Wall Street being a good example, or the curve of Tremont Street coming into the Boston Common. Other more important elements are conspicuous by their absence from the contemporary scene—that of *ornament*, for instance, which gives a sense of scale, a place for the eye to rest, and which is so self-consciously avoided in the United Nations Secretariat in New York. What of the element of *order* which gives a sense of repose or the element of

7. (a) The element of accent provided by the Bankers Trust Company in a view of Broad Street, New York.

(b) By the tower of the Civic Center in Springfield, Massachusetts, Pell and Corbett, architects, 1913.

monotony which excites expectancy? That they have ceased to be employed for reasons already given is no excuse for our not having modern equivalents of the Rue Royale, that modest interval between the Madeleine and the Place de la Concorde. All monotony and no order is the present-day rule in the suburbs, while anarchy without any well-emphasized climaxes is the "order" of the central city—formerly New York's Park Avenue could be mentioned here with its rows of restrained, anonymous apartment buildings leading to the tower of the Grand Central building; these apartment buildings, however, have made way for new office buildings, the architects of which were determined to replace solids with apparent voids, thus destroying the original effect without putting anything in its place.

8. View of Fifth Avenue in the early 1930's, looking south from 54th Street, showing the varying heights and styles of architecture.

And what of the element of *repetition* which gives the spectator a sense of rhythm? Or that of *apparent size*, which gives a sense of illusion? The latter is to be found in the lingering tradition of the false front in Western towns—it was of course superbly used by Renaissance architects and by their classical forebears in the composition of temples and pantheons where the mass of the building is made to seem larger by the porch attached to it or by smaller flanking dependencies. The *monumental* element has appeared during the periods of the classic revivals and only then. Michelangelo's element of *terribilità*—the fashioning of the giant fabric by the artist's hand, accomplished in the exterior of the apse of St. Peter's—one does not expect to see very often; Richardson might have approached it if given the opportunity, say, to design a grain elevator in Buffalo; the engineers cannot achieve it because art is an essential to the effect.

All these elements can be consciously applied to make our cities more interesting in form and detail. It is time that they were examined by city planners and citizens alike. Neither the professional nor the layman has any scale of esthetic values at the present time. We are denying a basic human need by not undertaking in the cities any experiments in visual planning, "for even apart from their usefulness," as Aristotle tells us, "the senses are loved for their own sake; and above all others the sense of sight."

Civic Design should be an expression of what people want, but do not know how to express for themselves.

"If you seek and express the best that is in yourself," said Louis Sullivan, *"you must search out the best that is in your people*; for they are your problem and you are indissolubly a part of them. It is for you to affirm that which they really wish to affirm, namely, the best

that is in them, and they as truly wish you to express the best that is in yourself. If the people seem to have but little faith it is because they have been tricked so long; they are weary of dishonesty, more weary than they know; much more weary than you know; and in their hearts they seek honest and fearless men, men simple and clear in mind, loyal to their own manhood and to the people. The American people are now in a stupor; be on hand at the awakening." [3]

And so we must begin to educate ourselves, in public thinking (as well as public speaking), in three dimensions as well in two. We have passed the stage of the two-dimensional land-use diagram; it will not satisfy people much longer; neither will it satisfy the authorities in charge of urban redevelopment and new towns. We must develop ideas—visual ideas—on American city planning which include satisfactions of the eye, of civic pride, or urban feeling. There has been so much anti-city prejudice in our upbringing, there have been so many prophets of its doom, that to spend time on visual aspects has seemed morally unjustified. With the eyes of the world focussed on us, how long can we afford to neglect the things we see around us? Surely our concept of the City Beneficial must include some aspects of the City Beautiful? How much longer can we coast along on the modest reputation for good-looking civic design achieved by Radburn, Greenbelt and Baldwin Hills Village?

Here are a few touch-stones for civic designers which should provoke further thought on the subject and perhaps encourage some experimentation:

1. The indiscriminate bringing together of buildings of different character in the modern city calls for education in esthetics by and for the city planner. "By the city

343

planner" because he is neglecting esthetics as his strongest weapon. (There is not yet a Secretary of the Arts in the President's cabinet to do the job for him.) "For the city planner" because he has to learn the rules. The architect, who once was the guardian of urban esthetics, has given up trying.

2. We must learn not to create space patterns from space-flow diagrams for people to follow in their daily lives, but to create *space* in which people can form their own patterns . . . a secret known formerly to urbanists of the Renaissance. We should be at liberty to direct and channel the eye . . . a secret they also knew . . . but not to control human activity.

3. Remember that all the other creative professions are open to us. Could we not include scene or stage design, painting and sculpture among our skills? Would not this make us surer of our skill in architectural composition or city planning? Vasari created a whole urban complex—and he was a painter.

4. In falling back on a romanticism of materials, we have forgotten the role to be played by the artisan. Workmanship and detail must be revived . . . if it is missing, we notice it. All the great civic complexes have brought in all the arts; detail and variety are extremely important. What you see close up must never be forgotten . . . massing and balancing are not enough.

5. It is not because you insist on saying new things that they will be new. Nobody can invent art. One cannot tell whether the early paintings of Raphael are by him or his master, yet a great art came out of this studio. The cult of originality denies the quality of being unassuming and humble.

344

6. In city planning, sociology, engineering and pressure salesmanship are rated higher than esthetics. While this remains true, can you blame people for not being interested or informed? Art is the greatest interest-arouser we have yet discovered.

9. The Porta di San Paolo, Rome.

7. Civic Designers will get nowhere while they cling to an esthetic based on spatial relationships and materials. They must include a third consideration: the positive attempt to create beautiful surroundings. Beauty does not take care of itself, and the saying that beauty is but skin-deep is but a skin-deep saying. Let everyone who admits that beauty is real cease to ignore the fact of its existence.

8. Civic Designers must be integrated properly with all city planning activity, where they must function as guardians and promoters of everything to do with vision. There are plenty of other technicians to worry whether or not the heating functions or the plumbing works. Art begins where utility ends.

9. People must be taught a visual approach to their surroundings. Taste is automatic with those who cultivate artistic perception.

10. Broaden the slogan "fitness for purpose" to include the purpose of esthetics.

"When I lived in Chicago," recalled a friend recently, (he might have said Boston or New York) "I learned to shut my eyes to the ugliness around me. But I lived to pay for this escapism. Moving to the country, I found I could not appreciate its natural beauty. The forced urban discipline had been successful. I could no longer see."

The psychiatrist has a name for the action of shutting out the unpleasant from our thoughts and can cite more unfortunate results than this. It is a disease which has also spread among those who deal with the visual arts. In its mildest form only the picturesque can be appreciated . . . a quaint old cot-

tage or an irregular skyline . . . in its most violent, only that which is positively ugly, crude or distorted.

The esthetic sense must be trained or it will wither or become perverted.

Sullivan said: "If the mind feeds on beauty, it will reproduce beauty. If it feeds on filth, it will reproduce filth. The mind will inevitably reproduce what it feeds upon." Let us keep our eyes closed, if we will, but remember that we are responsible for our actions.

Beauty has a reality too, but only to those who acknowledge it. The possibility of beauty should be the sustenance of Civic Designers . . . beauty as a positive aim, not as a by-product of design. And it will never tolerate slums or congestion.

Do not imagine that we shall curb all the evils of the city with this new weapon. It will make us stronger, nonetheless.

10. The Old North Church, Boston.

THE SOCIAL BASIS OF URBAN ESTHETICS

Although city planning is a comparatively new technique, its professionals have been faced with a larger number of responsibilities than may be considered proportionate to the development of their professional skills. Economics, demography, social communications and other fields have had to be mastered in haste to keep up with the variable nature of modern civic problems. We are now under a new obligation which is based on a change in the world situation. It is, of course, inevitable that changes in the political and economic sphere should reflect in one way or another on the city since the city is the market place and increasingly the center of all of our more complex human activities. The new responsibility involves the appearance of a mid-century attitude toward the

city which is different from the attitude, say, of the 1890's or even of the 1920's when the Horatio Alger-Chamber of Commerce optimism of civic growth and expansion was still current. It is now quite obvious that the hand of the artist has become necessary in order to remove from the city areas of ugliness as well as misery and to replace them with the useful and the beautiful or the city will not function in the way that we now desire. It has been discovered, rather late in the day, that the esthetic is intimately related to the economic function in urban planning.

The world situation has brought about a new attitude, especially in the United States. Since the end of World War II this country has been forced into a position of enormous political, economic and cultural responsibility, a responsibility which it has been unable or unwilling to shed. This is not the occasion to analyze all the trends which have emerged from this situation but it is evident that one of them is a growing consciousness of the unfortunate heritage which years of neglect have produced in our environment, both rural and urban, and the determination to do something about it. Not only in the United States is this attitude apparent, but also in France, Britain and many other countries where of recent years more and more attention has been paid to redevelopment of older parts of the community. It is also apparent that in large areas of the world like the Indian sub-continent, Africa and South America, the extraction of raw materials, usually followed by industrialization, is focusing attention on the urban centers that are growing up as a result. Forces are at work in these new centers of industry and trade which are inevitably producing an intense interest in the urban environment. "It is significant that the countries which have gone furthest along the road to economic justice and political equality, those in which individual rights are almost adequately safeguarded and opportunity for individ-

349

ual development are most widespread, are precisely those in which urbanization has gone furthest." [1]

This new aspect of the human interest in cities is reflected in numberless ways. In Britain it was the result of the war itself; in the United States it has been a matter of an awakening of conscience; in South America it has been a sudden jump in the rate of development which has wiped out the usefulness of earlier means of transportation and of production. It is possible to say now that all thinking on city planning has become sharpened, and that it is sharpness and scale which are the keys to many city planning activities now going on. Naturally former methods of planning will continue to be employed but one type of planning with which we have been familiar now for many years—the two-dimensional diagram of land allocation with perhaps some social emphasis on housing and mechanical emphasis on traffic facilities is not going to satisfy many interests in the city from now on. There are people in all countries who are beginning to look at the city more closely and to demand a community which is satisfying in more dimensions than two. It is true that some famous plans of the past appear to be two-dimensional in emphasis; one of these is the *Plan des Artistes* done at the time of the French Revolution; [2] this was a plan conceived in all dimensions and assured of a three-dimensional technique because of the age in which it was born. There is no guaranteeing nowadays that a two-dimensional plan will be satisfactory when built up; in fact three-dimensional quality has been lacking for the past two decades. Street planning without reference to architecture has been the order of the day. The public has been indifferent to visual anarchy but it is learning fast. A witness to the change in emphasis can be cited in the recent plans for Les Halles in Paris and the Federal Government's interest in "beautification" programs for

cities as well as its emphasis on conservation and natural beauty in the wider environment.

It would be unwise to assume that a re-examination of the city, and as a result improvement in the esthetic quality of city planning, will be immediately effective, particularly in the underdeveloped parts of the world. For many years there will be deficiencies and lacunae in programs of development both of natural resources and of city building. The Twentieth Century Fund once forecast that even in highly developed countries the largest difference between estimated needs and demands will be in urban redevelopment, highways, and conservation works.[3] Even so, with increasing numbers of our population committed to the theory of abundance and sharing which is now bound up with our older traditions of material progress, we may expect to see more attention being given to the city as a fountainhead of culture and wealth, all critics of the city and of its value to society notwithstanding. It is a curious fact that as we examine older societies—as a civilization recedes further into history or at least far enough so that we feel safe in making an estimate of its contribution—our attention focuses on the urban agglomerations which that civilization has produced. At such a distance the anthropologist finds himself prone to examine cultural manifestations in the forms of art. We may assume that in our own case, history will judge us largely on the communities we build just as we judge people who built in other times. Although it would be misleading to put an undue emphasis on art in city building certainly the esthetic aspect looms large in such estimations. One of the questions that is now being put in places as far separated as Rio de Janeiro and Stockholm is: How is it possible to build to satisfy the eye while we are satisfying the social demands of our time? In the United States where the esthetic effect has often come by accident

351

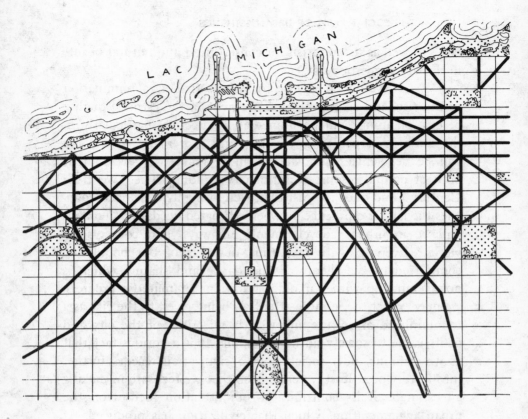

1. The Chicago Plan of 1909, which, after the 1893 World's Fair in that city and the MacMillan Commission's Report on Washington in 1901, provided the greatest impetus to the city planning movement in the United States. Its regional character is apparent in this abstract of its traffic pattern.

rather than design (the picturesque skyline of the average larger American city is one of these accidents) the esthetic problem and detailed question of scale and decoration have long been ignored. We have preferred the approach of Jane Addams and Edward Bok, Jacob Riis, and Theodore Roosevelt who tried to reform our surroundings by other means. We listened only briefly to Daniel Burnham and Edward H. Bennett who preached the commercial value of beauty to the business mind.

352

We have long imagined that it was correct to admire novelty in spite of warnings as to where this attitude would lead us from Americans and foreigners alike. Latterly the wave of neo-Puritanism has made visual elegance unpopular whereas at an earlier period in our history a certain native exuberance of spirit acted as a compensation for the miles and miles of urban ugliness. Our surroundings are judged either on utilitarian considerations or occasionally on the "good" they do to people. If architecture is appreciated esthetically it is as a single work of art unrelated to its surroundings. If we believe that art is a major civilizing influence and that there should be a better integration of art and life as our philosophers are constantly demanding, then the art of city building must become in our time the mistress art.

2. The letterhead of Colonial Williamsburg, Incorporated.

City planning will more and more assume the quality of an art the nearer we come to regarding the city as a cultural entity and the more we integrate neglected human skills and crafts into its fabric. We shall not, however, achieve approbation by those growing numbers of people who are demanding

that the city be a positive expression of culture unless we are also willing to cultivate new approaches. One of these must be the inculcation of the sense of tradition which is missing from so many of the planning schemes of today. The faster we travel, the more we advance in technology, the more comfortable we become and the safer from the accidents of nature, the more we regret being cut off from our ancestors by the air-conditioned, streamlined, mechanical civilization with which business and industry surrounds us. Evidence of this longing for identification with the past is to be found in recent increases in the number of historical studies and in the rediscovery and restoration of historic shrines. This too is a phenomenon which is occurring in different countries. It would be folly on the part of the city planner to continue in the tradition of the 1950's and 60's when so many planning schemes ignored this demand by sweeping away everything in their path. It does not need much imagination to see that a completely different approach to city planning will be necessary in order to integrate the past with the present while we are planning for the future. We shall have to learn what the past has to offer and where the points of departure may be found, for the past contains dross as well as the pure metal. A cool eye and a warm heart are necessary for this task; the traditions worth building on are there, but they may be obscured, neglected or forgotten. Sometimes it may be necessary to go against the stream as the Utopians and Louis Sullivan did. The rewards, however, will be great.

There is irony in contemporary attitudes which exalt "social" planning over planning which aims to satisfy the esthetic sense, as if the latter were inevitably frivolous or anti-social. It goes without saying that environmental planning should be based on social needs although it is not a corollary that planning which ignores social needs must necessarily be bad. Many examples from the past can find justification for modern use although

their origin was based on an entirely different set of values from those now obtaining.

Nevertheless, a social program which carries conviction is necessary to the success of any undertaking. Two neglected social needs have been mentioned; they are

1. The satisfactions to be obtained through public art.
2. The sense of continuity with the past.

There is a problem, however, in relating the program of planning to the physical result of that program. It is posed in the question: Can social needs be automatically objectified in specific urban forms? The difficulty here is that basic social needs are not often composed of images of objects in the mind of the program-maker. "Home" (typified in house and garden) can perhaps be visualized in a general way, but there are an infinite number of variants in the execution. When we come to basic needs like "security," "influence on others," "reputation" it is impossible to visualize them in physical form. We are thus confronted with a possible danger—a purely social program of urban planning or improvement may eliminate entirely the "duality of happiness that flows from the senses and the imagination." We must therefore be careful of relying on the social program alone to supply the human satisfactions that are implicit in the making of such a program at all (this prompts the suggestion of a dualism in planning organization which will be referred to later). We must remember that the satisfactions and pleasures which the social program is meant to secure are in the last analysis strongly esthetic—imbued with the variety of nature and the infinity of art. The need for moral values woven into the program and perpetuated by it becomes less and less as the evils are removed. We do not say "abolish the slum because it is ugly" (although the effectiveness of this approach has

355

occasionally been spectacular) but remove it because it is evil. If, however, the buildings replacing the tenements are ugly in their turn the program is in danger of failing in its social objective regardless of any achievements in comfort and better living standards. The theory that the just social program will automatically result in "good" solutions is thus destroyed by experience.

What connections then can we find between the social basis of planning and the objects that we see around us as its result? We could base our physical design on existing social habits but we would be in danger of perpetuating false traditions if we were not well grounded in the motivations which produce the habit patterns. Furthermore, the habits are constantly changing and are influenced tremendously by the theater in which they take place. The once-leisurely atmosphere of the meeting place along the Via Tornabuoni has been shattered by the noise of the trucks rattling by. The American pastime of watching the view from the front stoop is disappearing with the change in pace of modern traffic and the enticements of new forms of entertainment. It would seemingly be wiser to examine more fundamental social motivations which must be

3. House with porch on street side at Riceborough, Georgia.

expressed or catered to by the urban planner. This is a field for a research analyst of special training but one or two motivations may be mentioned here to give a clue to the necessary types of investigation.

1. *The Drive for Individual Expression.* In urban form this drive has found expression in domestic architecture, public monuments and civic benefactions, often of a curious physical character. It is not a motivation which will disappear although its vagaries may be curtailed by economic and social limitations. We have all enjoyed the equivalent of a highly colored folk art in house design not fed by superimposed ideas of taste enforced by social pressure. We have seen the subjugation of this exuberance in the monotony of modern suburban developments or in earlier civic domestic architecture such as the brownstone row. We must decide whether or not freedom of expression uninhibited by standards of taste should be fostered by urban planning. If we decide that it has a place in modern society then our planning may be very different from any currently being practised because the question of freedom of expression in individual buildings will be uppermost in the planner's mind and he will leave room for it in his designs. We may also find that certain crafts and forms of decoration should be revived with positive direction in order to enrich the possibilities of individual expression in urban surroundings.

2. *The Drive for Identification of The Individual with The Group.* If this drive is strong (and we are told by social psychologists that this is so) the need for individual expression may be somewhat subordinated to the desire for social identification. The street and the neighborhood are involved here and conformity certainly plays its part. In the present state of building economics this drive may perhaps be satisfied in other ways than by urban planning—through social activities and group organization. In physical form we are likely to see in

this mechanized age the larger unit of planning with houses and other types of buildings being produced in large quantities, perhaps indeed satisfying the need for group identification in a visual sense. Possibly both drives can be satisfied in a superficial way by encouraging conformity in developments and also artistic expression and variety on the part of artisans and individuals.

3. *The Drive for Identification of Group with Group.* In a larger sense this is the drive of our political natures—getting people together in groups, in regions, in nations and finally in an international way. It is the essence of the word community in its widest definition. If this drive for co-operation were not there one could feel hopeless about civic design; but it *is* there, latent, and must be understood by the urban planner in order to achieve his program. It is perhaps the most neglected of the three motivations, one which requires constant stimulation and encouragement to be important in the urban scene. It could be productive of extraordinarily effective physical plans and our aim must be to discover a type of planning which will satisfy this particular demand for identification. Questions of regional style, social communications and national pride will have to be studied with much greater understanding if satisfactions are to be gained on this level.

The connection between programming and the physical result is not determined by analyses of popular taste or specific economic trends. The planner and the architect worry about popular taste which is always strong, wilful and seems to ignore their best efforts. Probably it is because the first two motivations that have been mentioned are ignored by planners that they rail against something they often consider vulgar. Certainly taste needs educating, but it cannot be denied by wrathful individuals who wish to be free of the mob. It is probably a sign of progress that it is no longer necessary to catch the butterfly of taste and pin it to your drawing board as Sir

Gilbert Scott did so successfully in England and to a lesser extent the firm of McKim, Mead and White in this country. We have advanced from this position but are liable to go too far in another direction if we ignore the democratic process. Public taste is not the ephemeral thing it is supposed to be by disappointed architects. If people do not like a certain building it is more likely the building that is at fault, not the people. "What is wrong with people is their temper, not their taste; their patient and trustful temper, which lives in houses taken for granted and subscribes to public buildings from which it derives no enjoyment," said Ruskin. Most people are happy enough with urban building and planning that has quality, although

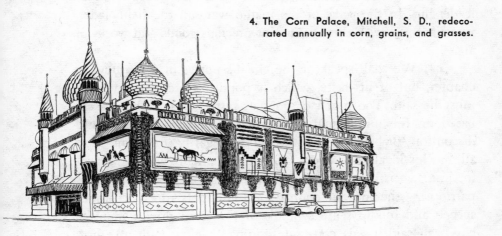

4. The Corn Palace, Mitchell, S. D., redecorated annually in corn, grains, and grasses.

they will break out into bizarre fancies if left to their own devices. It is obvious that complete license cannot be given to this tendency but if we believe that the city is a worthwhile expression of culture and art, if it is, in fact, a form of art, then allowances must be made for the infinite variety which a healthy art form is always producing. There must be room for houses

359

with crystal stairways (or can only Texans afford them?), and for gardens lighted by natural gas, for ornamental plaster-work and for turrets and towers.

Let us remember that just as "good" architecture will not produce a good society, neither will a "good" program necessarily produce desirable city forms. Art must have something to say in the process—art as an expression of man's basic needs and desires. Furthermore, the client must have something to say—the man whose needs and desires are expressed. We have already spoken of the government as client . . . that necessary spur to a revival of the arts. This is not to assume that government is perforce the best client—sometimes business or private individuals may surpass its efforts—it is more a suggestion of leadership. In the wake of the man-o'-war sail the richly-laden merchantmen with their bounty of precious goods and works of art.

We shall speak of the client's power in the following chapter; but of his taste, which is popular taste, a word more must be said. Too much of popular taste is, as we have seen, based on the unimaginative alternative between comfort and discomfort, or between sentiment and vulgarity. But man, after all, has his ideals, and there is another element that has appeal for him, when his imagination can be stirred. That element is patriotism—the idea of country.[6] Monuments, dress, customs, speech and folkways are symbols of the third drive which, as has been said, needs constant fanning to glow with any brilliance; patriotism is partly sentiment but it is also allegiance to a culture, a country or a civilization. This is an abstract intangible virtue unless symbolized in learning and in the arts.

If elemental patriotism is to be transmuted into the Albertian ideal of service to others and to all, it is not enough that its artistic manifestations should be wholly of the past, which, if clothed with style, with manner and with a beautiful

360

27. Fifth Avenue shop window display at night. Designer Jeanne Owens.

28. A fireworks display of the eighteenth century.

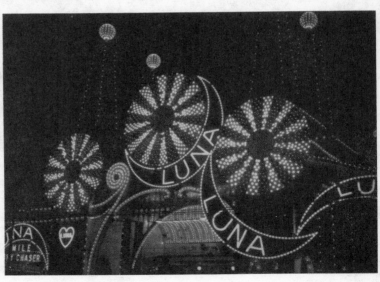

29. Luna Park in Coney Island.

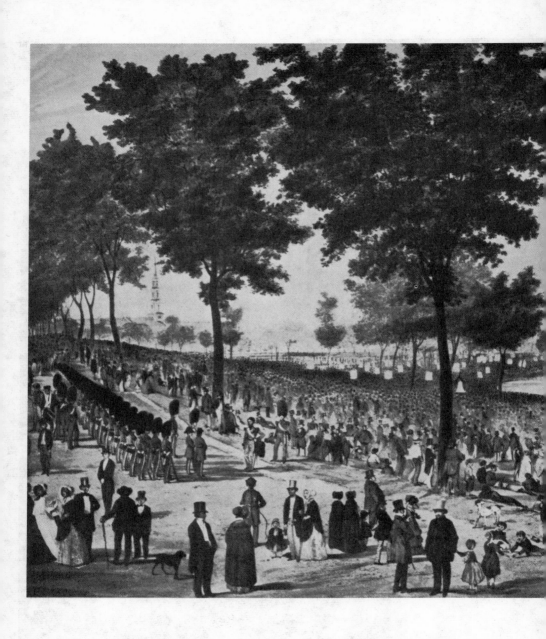

0. View of the Water Celebration on Boston Common in 1848.

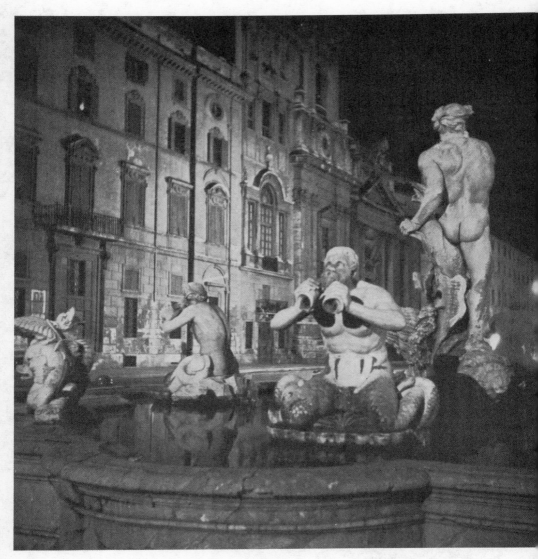

31. Piazza Navona at dawn.

32. A fresco from Boscoreale, showing how an artist of the early Roman Empire depicted the imaginary city.

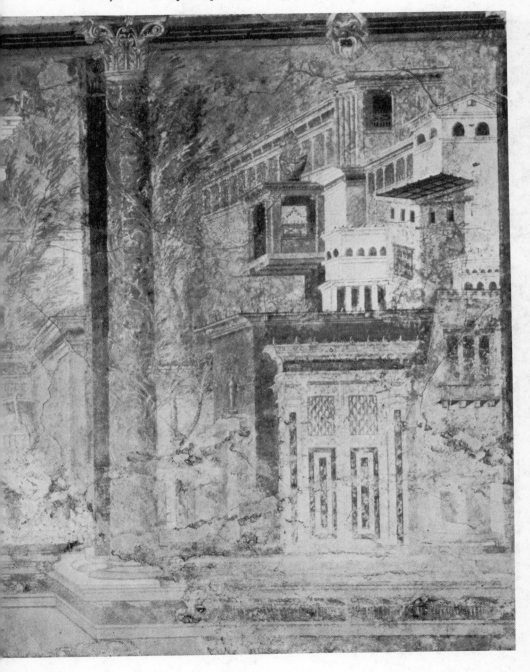

33. View of an imaginary city done in inlaid wood, a panel in the Palace of Urbino. School of Piero della Francesca, often attributed to Luciano Laurana and characterised by Sir Kenneth Clark as an illustration for Alberti's *De Re Aedificatoria*.

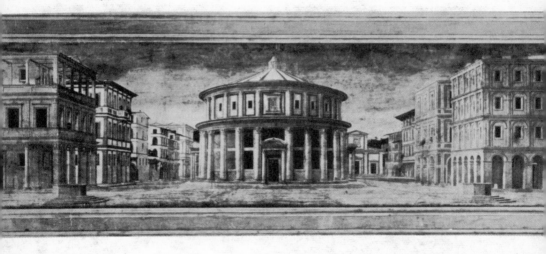

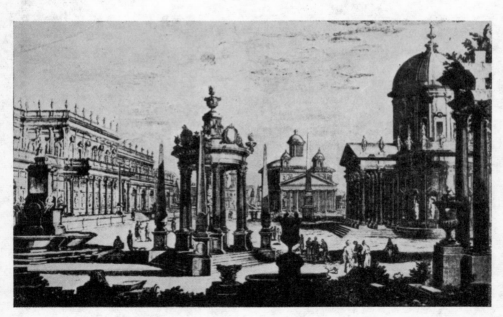

34. Stage design by Giuseppe Bibiena.

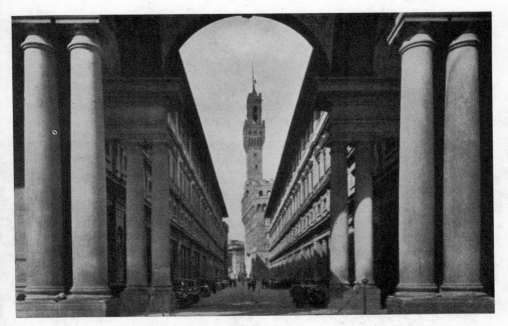

35. An artist's creation in the city, The Uffizi by Vasari. Both buildings have arcades, forming and inviting the view.

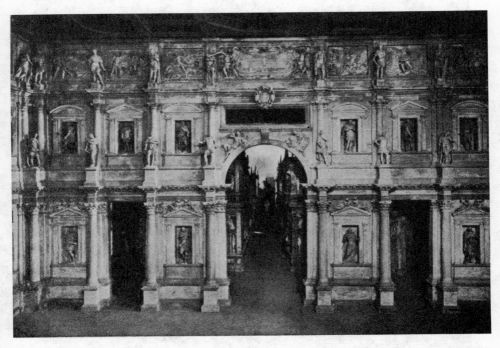

36. Teatro Olimpico in Vicenza (1580–1585). Palladio's device for creating the impression of a city.

37. An important American mural. *The Ascension* in the Protestant Episcopal Church of that name at Fifth Avenue and 10th Street, New York, by John La Farge (1886).

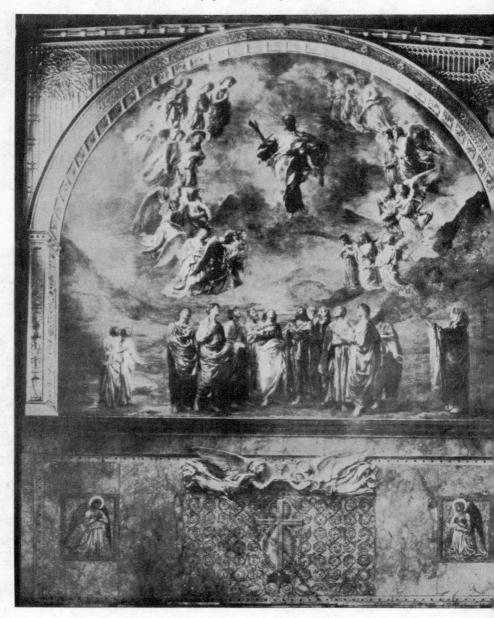

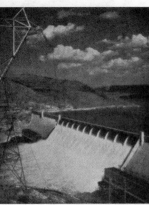

38. Grand Coulee Dam.

39. Mount Shasta from the open highways.

40. A New England town in its setting of trees. Hancock, New Hampshire.

41. Graveyard, New Orleans.

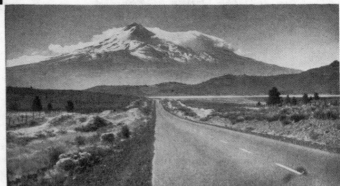

39.

40.

41.

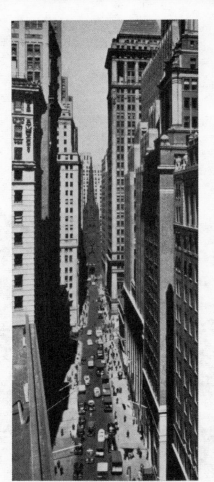

42. Although largely accidental, the elements of order and climax which are contained in this well-known view of Wall Street and Trinity Church, make it one of the most striking of American urban compositions.

43. A cross-section of Grand Central Station showing its intricate and compact design.

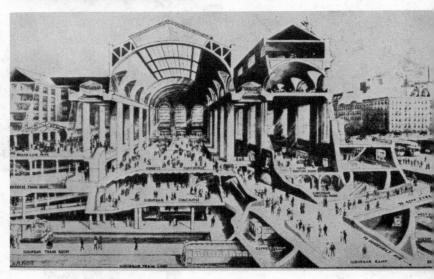

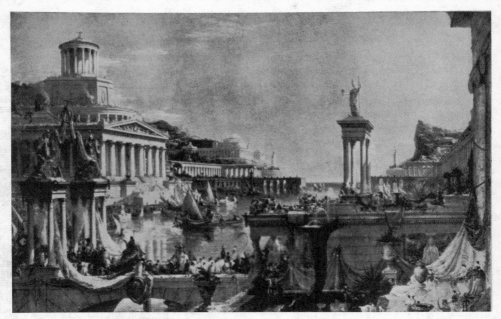

44. *The Consummation of Empire*, by the American painter Thomas Cole, painted in 1836. The romantics painted cities in order to tear them down, the next two in this series being *Destruction* and *Desolation*.

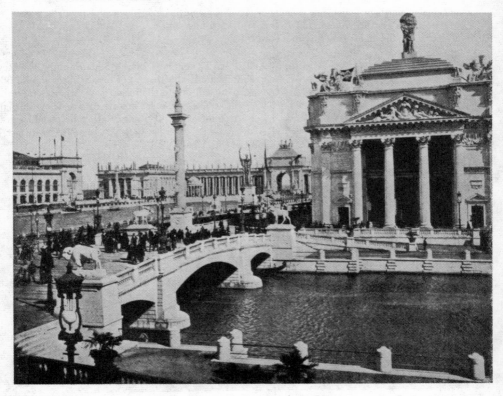

45. The White City in Chicago. This city was also torn down, but not before Henry Adams had described it as the meeting-place of all American strains. The uniform cornice-line and color scheme and a unified design produced an orderliness lacking in American planning since the time of Jefferson.

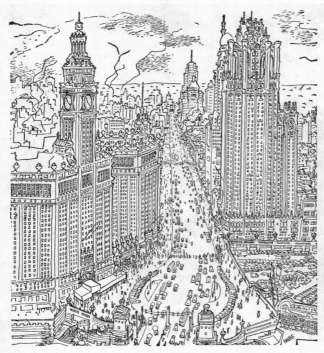

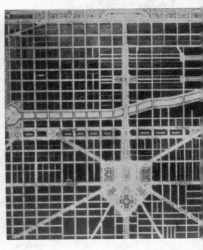

47. Central portion of the plan of Chicago, 1909, by Daniel H. Burnham and Edward H. Bennett.

46. Looking north on Michigan Avenue, a sketch by José Bartoli. In the left foreground is the Wrigley Building and on the right, the Tribune Tower.

50. *The Human Scale*. Saint Mark's Square during the Revolution of 1848. The city is a theatre of life. Squares will be filled with people who will create their own patterns, violent or peaceful. The creative designer must beware of space-flow diagrams used by the technocrats of planning. Rather he should consider the Renaissance idea of space in which man is free to act his part upon the stage. (At right.)

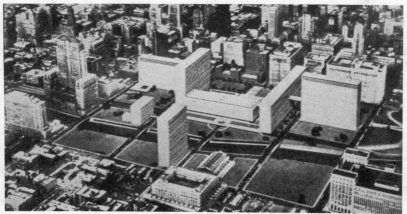

48. The Chicago Planning Commission's early suggestion for a new Chicago civic center showing the contemporary French influence of Le Corbusier's plan for the center of Paris. The center was finally built elsewhere.

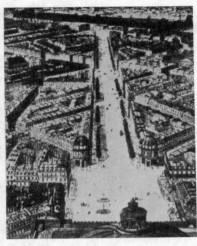

49. Avenue de l'Opéra, Paris. The creation of Georges-Eugène Haussmann.

51. Restoration of the Colossus of Nero in front of the Temple of Venus in Rome. The best known sculpture on a colossal scale in America is the Statue of Liberty.

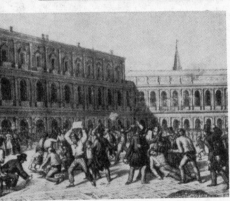

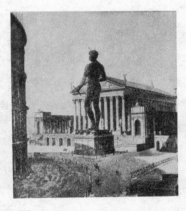

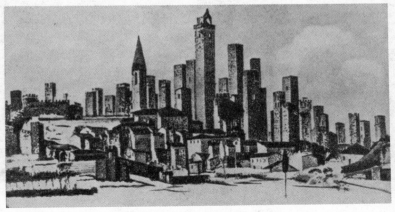

52. The problem of the two scale is not a new one. Here it is seen successfully mastered in a reconstruction of San Gimignano.

53. Detail of ornament on the Guaranty Building, Buffalo. Adler and Sullivan, 1894–1895. The exterior walls are of warm red terracotta.

54. The center of Abbéville. Note the attempt to incorporate a modern bus terminal.

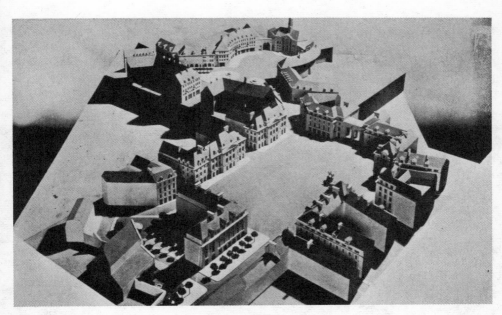

55. Reconstruction scheme for the Place Jeanne d'Arc, Orléans.

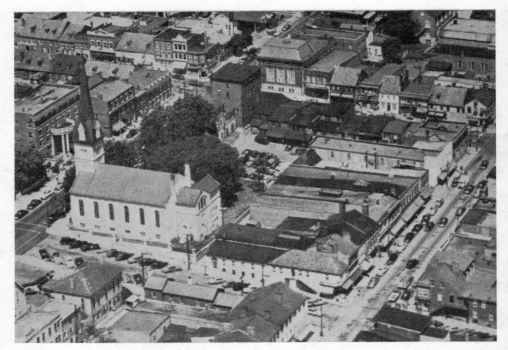

56. The cars parked in the center of this photograph mark the former public market-square of Fredericksburg, Virginia. On one face is a fine brick building of 1812, its ground floor arcade filled in with masonry.

57. Photograph of the bricked-up arches in the square. That the citizens have not forgotten its former importance as a center of community life is evidenced by this scene of an out-of-door painting show held there annually.

shape, becomes real to us at once. No, if the third drive is to be counted on—if patriotism is to be a continuous and living force—we must clothe it with the art of our own time, for man is a sensuous animal and he will most sincerely appreciate the monument, the building or the civic place which not only gives him a sense of identification with country but which is beautiful in itself. The Frenchman genuinely admires the Champs Elysées and the Arch of Triumph because he knows he is the inheritor of a beautiful place which the world admires. Only he can appreciate fully what this place stands for in the history of France, just as only an American can appreciate fully the old brick buildings above the river at Yorktown, but he is conscious of the attempt to build beautifully and this makes his patriotism stronger, his generosity greater, his culture more humane. Man's wish, as he stands before the glory of the past, is to be worthy of his inheritance and to express his own age in the most fitting manner within his power.

Pride of place is probably the easiest motivation of any to enlist, and when fully realized, the strongest. When draped with the cloth of beauty this may mean that even our cities can be noble monuments one day—when the wars, the treaties, the budget-balancing and the daily grind have been forgotten, and only art remains.

CHAPTER **16**

THE NEW URBANISM

 The skill which can put into physical focus
the social drives described in the last chapter has largely been
forgotten. In the late Renaissance and until the mid-eighteenth
century the shell of the town was developed by speculator and
architect (sometimes combined in one and the same person); so-
cial institutions were commissioned by church and crown; cities
and towns built *de novo* were designed by military engineers,
architects, surveyors and amateurs of taste. In the eighteenth
century municipal authorities multiplied and urbanism began to
embrace the idea of "improvement"; street layout and street wid-
ening, lighting, waste disposal and bridge building slowly became
a function of government rather than of private enterprise. Very
little was thought about control of urban growth or problems of

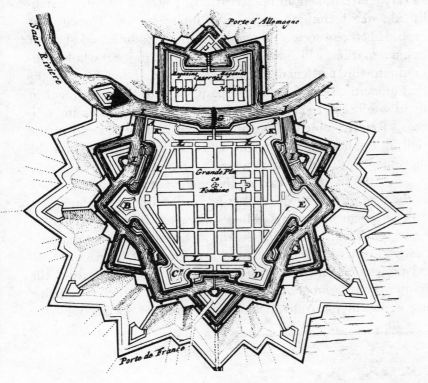

1. Plan of Saarlouis founded by Louis XIV in 1681, and fortified by the French military engineer and architect Vauban (1633–1707).

excess population until the nineteenth century when solutions like colonization, "utilitarian" open space proposals and model factory villages began to appear as a result of urban congestion. In the middle of the century men first began to view the city as an entity, largely through the eyes of Ruskin whose interweaving of history, politics, art and life in recreating cities like Amiens, Florence and Venice paved the way for later sociological, ethical and economic urban studies. Like Gounod's Faust, which now seems

363

so very conventional an operatic form, Ruskin's "Stones" established a new technique in the art of interpretation. The city was exposed before a society which had hitherto complained about it or ignored it but which now could not refuse to see it whole. Furthermore this particular city had died [1] and the awful thought that modern cities might not be permanent or the investment in them safe began to color the thinking of municipalities and citizens.[2] Reform joined with improvement and by the end of the century the housing movement, conservation programs, and the movement for public health were well established.

In the early years of the present century the function of the professional town planner was still fairly well defined. He was, although not always called so, a *civic designer*; very often he was an architect or a landscape architect who practised civic design. Daniel H. Burnham and Sir Raymond Unwin were typical professional men of this period. They operated within the framework of a *program* laid down by others, sometimes changing or modifying it to include amenities not specified by the

2. Elevation of the first "Improved Dwelling for the laboring classes" to be built in Brooklyn, New York, in imitation of those in London. This housing group which was built at the corner of Hicks and Baltic Streets was financed by a leading local citizen, Alfred T. White, and constructed under the supervision of the architects Messrs. William Field & Son in 1877.

364

promoters, as Olmsted did at Riverside when he included a central park along the Des Plaines River. These modifications were usually the result of the design process. Scientific and economic ideas came from outside; from a Shaftesbury, a Howard, a Parliamentary Committee or a private corporation—and it was rarely that the town planner exceeded physical limits. It is true, of course, that the exigencies of city building often forced him into the role of entrepreneur and he who wishes to see a design project realized will presumably always have to be at the very least an accomplished tactician. Until the end of the first World War, however, decision-making or control was not the town planner's concern.

When town planning became a function of government after 1910 the civic designer was put in an anomalous position. The sociologist, the social engineer, the economist, the lawyer and the political scientist—program-makers for physical planning and housing—began to take over some of his former design functions. Where facilities were to go, how the site was to be planned, types of street layout and even appearance were often predetermined. Specialists began to appear—highway traffic engineers, housing consultants and industrial experts reserved whole areas to themselves which the civic designer had once considered his own. Planning was becoming a much more complex affair and less and less of it was being translated directly into three-dimensional form. Also it was running in separated grooves which a proliferation of autonomous agencies had created in order to expedite their special programs. The civic designer and his patron had become separated by a spongy layer of "experts" which was absorbing much of the power of both older parties.

This situation accounts for the varied definitions [3] of the planner's function which are current and the pretensions of many "planners" to assume powers that they might more modestly disown. It may be asked whether or not in a democratic so-

365

ciety either the private owner or the proper branch of government acting for the people, as the case may be, can still be the originator and controller of the program for planning. If the answer is "yes" ("no" would surely be an invidious claim on the part of the planner) then the sandwich should be inspected for possible extraneous matter in the filling. It is likely that as a result of this inspection most functions exceeding the powers of research and interpretation of research or recommendation could be removed. The planner who is not a physical designer would then properly be called a technician also. Although he would certainly assist in "the making of informed decisions" he would be relieved of the responsibility for them, which responsibility should rest squarely with the client or agent of the client, to whom alternate solutions would be presented. Planning on the technical level could thus properly be called the making of recommendations. Perhaps, as a gesture to tradition, the physical planner might be consulted at an earlier stage than is now sometimes fashionable, so that the alternatives might be more clearly envisaged. The hierarchy would appear as in the diagram.

SOCIETY or Representative Segment

CLIENT (Owner, corporation, institution, government agency)

and MANAGER (Representative of Client) ADMINISTRATIVE

		TECHNICAL
CREATIVE DESIGNER	↑	RESEARCH ANALYST
(Civic or Regional) → RECOMMENDATIONS ←		
with architects, landscape< Pooling & fusion process >with natural and social		
architects, painters, sculp-		scientists.
tors, craftsmen.		

The "administrative" planner would not, of course, cease to exist; but he would be subject to directives. Administrators are required in any modern functional body, and not least

in large planning organizations. It is probably better that they be termed managers rather than planners, to work for the client as a watchdog or expediter; as Colbert worked for the Crown, an estate agent for the local landowner or an efficiency expert for a modern business concern. Planning powers might be delegated to him by the client but would not exist on the technical level.

This organization of the planning function would make clear-cut the role of the civic designer, restoring some of his early powers and reducing those of the socio-natural scientist. It would also prevent the assumption of specialized research powers by the civic designer who is very rarely qualified to undertake them. Placing these last two functions on an equal footing to produce joint recommendations would undoubtedly improve the quality of these recommendations and where differences of opinion occurred the result would be more stimulating than harmful, as they might be on a higher level. Visual imagination could be fused with economic or social standards, for instance, as some of the better planning work of recent years has indeed shown.

A permanent dualism on the technical level is inherent in this suggestion. It is not to be imagined by any but the most confirmed technocrat that in our complex modern society the designer can encompass the function of the analyst or vice versa. Each should of course know enough of the other's technique to develop a common language. Neither should make decisions, which are thrown back where they belong, to the client whose responsibility is to society itself. The ancient art of trying to influence the client could still with profit be employed; there is little to fear from irresponsibility, however, when society actually exercises its planning powers.

Further it is desirable that no one in this organization on the technical level should call himself a "planner." He might

be a civic or regional designer (probably not both nowadays because there is a dualism implied here also) or an urban analyst (but preferably a sociologist or economist or whatever his basic discipline happens to be): this in spite of the fact that all will be engaged in the production of plans. The client, however, is the real planner—a most important distinction which is often forgotten and is only occasionally remembered when a day of reckoning arrives. *It is absolutely essential for the future of planning that the client or program-maker be responsible for all important decisions, regardless of any unwillingness to assume this role.* This enables a democratic society to fix responsibility clearly, unhindered by the mysteries of technical jargon or drafting technique. It is obvious that the client will have to be better informed than he sometimes is now in order to arrive at a proper decision; but decision-making right or wrong, remains his task.

We are concerned here with the civic designer, whose position has been clouded by circumstances. We should prefer to see him take his place in the sun. Who will doubt his value to society in an age which has rediscovered the city, which exalts civic virtue and which concentrates its entire powerful cultural apparatus within the city limits?

It cannot be too strongly emphasized that we are discussing "visual" planning *not* drawingboard planning. In this we are following the advice of Sitte; although it is not necessary to agree with all the principles of visual planning expressed in his book.[4] The term "visual planning" is undeniably limiting and savors of esthetic caprice, "forced spontaneity" and trick devices intended to appeal to the eye alone. The term third-dimensional planning is much better but even this can be interpreted as referring to the shell of the community. We have chosen the term Creative Urbanism to describe the new approach and the

objects which should result from this approach may be called the product of creative design.

Creative Urbanism is the product of the pooling process already described which should take place between the natural and social scientist on one side and the creative urban designer on the other. The knowledge, skills and techniques which can be employed here are too numerous to mention. But some indication of the creative designer's technique should be outlined here. The creative designer should presumably have a background in the arts although it is not essential that this be so if the artistic talent, notably freehand drawing and drafting, can be developed rapidly while the designer is taking his professional courses. Architecture is an excellent background and one which has the merit of traditional acceptance and a record of success. Landscape architecture, painting, sculpture, and the graphic arts are all useful preliminary disciplines. It will be noticed that engineering which should be considered as a science is not included; this is not out of disrespect for the achievements of engineers. It is merely due to the fact that in our suggested organization engineering appears among the natural and social sciences. It is logical enough that the engineer, or the lawyer, or the political scientist can become a creative designer if his inclinations and talents veer in that direction.

The skills and knowledge that should be acquired by the creative designer include some things which are at present minimized in planning curricula. One is the sense of tradition which must be particularly sympathetic to the ways and man ners of our social background. Designers who look on the city as a place in which a break with the past must at all costs be made are not designers at all and are better classed as technocrats. Second, the designer must have at his fingertips an artistic resource which he may not have obtained during his training in architecture or the other creative arts. This is a knowledge and

understanding of the role that art plays in social institutions and physical surroundings. It is essential that a knowledge of the arts, of decoration, wall painting, the use of water, greenery and even interior decoration should be part of the creative designer's body of knowledge on the theory that the minor arts, as they used to be called, must be re-integrated with urban life. Beyond that the designer must be made sensitive to atmospheres, ephemeral qualities in the landscape and to acoustic problems, all of which demand special training or application. Third, and here "visual planning" becomes an apt term, questions of scale and proportion, apparent size and other relations must be thoroughly studied, not only in the way that Sitte describes but especially in relation to problems of density and economics suggested by the social scientist. We talk glibly about

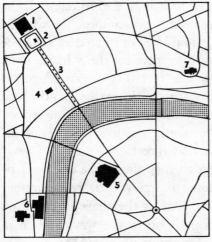

3. Lethaby's Golden Bow of London, described in the text, to improve a city which he called "as structureless as one of its own fogs."

1. British Museum
2. The New Square
3. The "wisely extravagant" avenue
4. Covent Garden
5. Waterloo Station
6. Westminster
7. St. Paul's

density, bulk, coverage, flow, area and illumination without any knowledge of the effects of our standards established for them on design, except in a very mechanical way. These mechanical standards have done a great deal to produce uniformity of a very unimaginative kind. We must know better what we are

doing in establishing such standards and where we can break away from the uniform monotony which is deadening civic design by its too rigid application.[5]

How does the creative designer approach the city?

An older method was to "take strategic points and prolong them on far-distant points of view," as Domenico Fontana demonstrated in Rome at the end of the sixteenth century or as L'Enfant did in planning Washington. Elbert Peets has called this "esthetic engineering." [6] Lethaby suggested its application to London in 1896 in a proposal which has never been carried out, although it has all the simplicity of well-founded logic. "Take the golden bow," he says, "the curve of the river from Westminster Abbey to St. Paul's Cathedral; Waterloo Bridge bisects this curve and if you draw a line from the end of the bridge straight ahead through crowded London, you will find it leads straight to the British Museum." The triangle formed by the British Museum as the apex and the line between Westminster Abbey and St. Paul's as the base includes the whole of central London. Southward the line of the bridge projected hits the Obelisk which is the point in the center of a star of roads in south London. This line, he says, should be the axis of modern London; make it into an avenue, broad, and the center planted with green, lined with the statues of London's great men—Erkenwald, London's forgotten saint, Mayors Fitz Alwin, Fitz Thomas and Walter Harvey, Bishop Braybrook and Stow, the humble chronicler, London's poet Chaucer and Christopher Wren, its first and last great architect. Create a square in front of the museum into which would jut Hawksmoor's Church, and move the Egyptian Monument now on the embankment to stand in the square's center, placing a golden milestone where this new cord intersects the Strand.[7]

Lethaby's idea, of course, is colored by the planning theories of his time but it is his boldness which would have

provided something that London has always needed, namely direct communication between north and south, with the river becoming a life-line of the town. This imaginativeness is the element that we have lost in city planning since we have let those who call themselves practical men take over. Where is such imagination to be found in the plans of London made since his time, many of whose features were forecast by Lethaby (the green belt in 1896 was one of his pioneering ideas)? What Lethaby was really proposing, and what we must now propose, when we have educated ourselves to do it, is to revive the visual approach—the approach that the arts had and which the architect and city planner have lost in the rush of the automobile to our modern cities. We have tried the scientific approach, which sometimes results in an improvement and sometimes merely proliferates our troubles as many new highway systems have done. This approach is lacking in the quality of imagination which will stir people and give them something they can point to with pride. Architects and planners bemoan the fact that there is no public support for city planning, but there will be no popular support until we include in our city planning approach the positive attempt to make cities more beautiful, which is a lasting basis for popularity. You may try to make cities more livable and nobody will thank you for it. There are probably no thanks due, because the aim of making cities livable does not necessarily include what Julian Huxley has called "our next step in civilization"—the positive attempt to make our environment a work of art. Alberti put the matter thus: "When we lift up our eyes to Heaven, and view the wonderful Works of God, we admire Him more for the beauties which we see, than for the conveniences which we feel and derive from them." [8]

Now art is something like yeast which should be fermenting all the time in the lives of our citizens and it is automatic when people are trained in art and in the appreciation of

372

art. This is a matter, of course, for our schools and we are be-
ginning to see in this generation the results of including the
arts in the grade and high school curriculum. New methods of
art teaching have heightened our perceptions and we now know
more about color and form at least in the world of painting
than we did once. Although we may think it difficult to bring
the art point of view to bear on cities when it seems so difficult
to solve even their most pressing problems, it is possible that
*if we include the artistic approach as part of our daily thinking
then our practical solutions may change in character and be-
come a better fusion of form and function, of the practical and
esthetic.* The Greeks were practical people but art was so auto-
matic with them that it did not have to be discussed and they
built beautiful cities. The traders of the Orient, businessmen
though they were, developed standards of art for their caravan

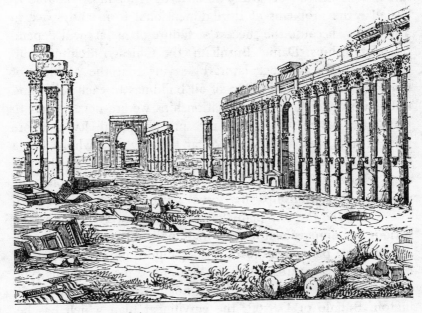

4. The great avenue in Palmyra.

373

cities, like Palmyra in the desert, which have seldom been surpassed. We who are presumably much better businessmen but certainly are not following in their footsteps as beautifiers of cities should with our infinitely greater financial resources, be able to combine business and art to a higher degree than it was possible for these earlier peoples. "If absolute monarchs," Thomas Sharp, a leading English civic designer, has pointed out, "were able to plan complexes we now admire, why cannot we with our greater wealth and technique plan admirable complexes for ourselves?"

Art does not spring full-blown from a society, neither will our cities blossom with the forms of art unless we consciously apply them, but as architects and planners we must make a beginning and that beginning ought to be a visual re-education which will enable us to see again the city in three dimensions instead of two. The civic designer must be able to visualize the problems of third-dimensional form and space in a new way, because the success or failure of his art will depend on relationships. Daniel Burnham, the Chicago architect, surprised the Chicago speculators by saying that the problem of that city was the relationship of all buildings to each other and unless we understand these relationships we are never going to plan cities which will have a measure of appeal. Even before this we had been taught to look at the city as a whole, but a totality is only the sum of its parts and in examining the city as a whole, defining its sprawl and zoning its functions, the problem of relationships in a visual sense has been overlooked.

Take the city plan that we have today. We know the various two-dimensional forms which make it up: the orthogonal or rectilinear plan which reads like a palindrome, the same either backwards or forwards; the radio-concentric plan which is typified by parts of Paris but which is not lacking either in Washington, Buffalo or Detroit; the curvilinear plan which has be-

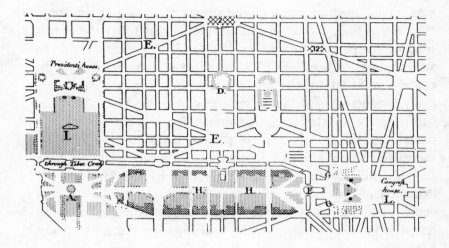

5. Part of L'Enfant's original plan for Washington, D. C. executed in 1791. The dotted areas identify "the well-improved fields" noted in the margin of the map as green plots. They mark the land set aside for parks, such as the present Mall, and the White House grounds. The herringbone shows the emplacement of buildings then in existence on either side of the Mall. Fifteen areas, shown by cross-hatching were set aside for the states where each one could place a memorial to those "whose achievements rendered them worthy of being invited to the attention of the youth of succeeding generations." The lines identify the sites which the planner reserved for places of worship.

come since the days of Olmsted more popular with suburban developers and the linear or spinal plan in which the main parts of the city are laid out along an artery of transportation. These are the four main forms and the modern city has more or less absorbed them all. We know of their persistence, of the fact that the rectilinear plan has been used since the days of the Egyptians and the radio-concentric plan by their neighbors and rivals, the Hittites, and we know of their interrelationships with the art of every period; that the pattern of the hunting forests

was similar to the pattern of the streets of Paris and similar to the designs to be found on certain fabrics; that today the shapes used by the painter Arp are used to fashion pavements and the surroundings of hotels in pleasure resorts. These forms may be called significant for the art historians but they are not necessarily productive of stimulation in city planning since they conform merely to arteries of communication and are not usually readable to the eye, the scale of the city being so large. Furthermore, since they are well recognized art forms, planners have had a tendency to use them unrelated to the land or the demands of the site. A plan is nothing in itself but a convenience—it has no beauty of its own—but it is worse than useless if it ignores the site, as the grid does on the hills of San Francisco.

These two-dimensional plans very rarely have a social basis and this is understandable because a pattern which was devised for easy land sale or transfer or for promenading in the cool of the evening *en carosse* is not related to the social needs of our own time. A better relationship could be developed perhaps by taking the social, historical or economic unit and planning our city around that. These units we will call related areas.

It is, of course, in our sought-for relationships and in detail that the power of art becomes enormous and this power is today unrealized (as is even the power of science. What we are doing to cities in the name of science is not scientific at all. We could use scientific knowledge to a much greater extent than we have, even in the visual approach, where the size of the angle in the field of vision becomes important and the difference between real and apparent size of buildings can be measured by scientific formulae.) [9] Nothing, however, is purely visual. Questions of memory, hope and purpose enter into our vision of cities and that is where art and knowledge of art are so important. In training ourselves to see the city and its rela-

tionships, we must also take into account social and philosophic problems of symbolism, for instance, and what the city means to people in its visible form. In America we place tall buildings at the center; perhaps that was a good beginning when we did not crowd the centers too much by doing so. But we complicated our problem by dwarfing our important earlier buildings with the skyscraper. Nothing is more ridiculous than the beautiful Independence Hall in Philadelphia, one of our very best architectural inheritances, dwarfed by the Curtis Publishing Company and other tall buildings around.[10] Perhaps these taller buildings instead of crowding the civic area should have been a little further out so that a cup-shaped center in elevation could have been established.[11] In any case, the indiscriminate mingling of business and civic buildings, granted that it is hard to separate the functioning of business from administration, should be discouraged, particularly because our newer civic buildings, like libraries, schools, museums and hospitals are tending to lower and lower heights.

How can we give these complexes any scale? The Greek Temple had an absolute progression of scale and had very little relationship to man which was, of course, the intention. When a bigger Greek Temple was built it had a bigger door, not a man-sized door; unlike the Gothic Cathedral in which however large the portal, the door itself was usually cut to man's measure. We have completely lost any feeling for scale in our modern work. In fact, we are in danger of creating buildings which are as inhuman as machines and of a scale which is unrecognizable because it cannot be related to anything we know. The attempt of designers to use trees to give scale to tall buildings is meaningless since the trees are lost against a skyscraper as they are, for instance, beside Rockefeller Center. Trees are effective, however, where architecture is man-scale and seen beyond roofs as a background, or below them as

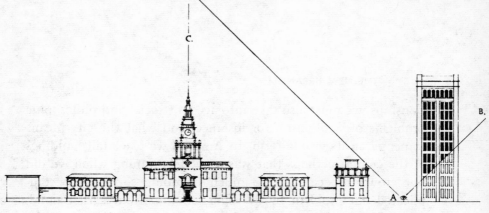

6. Independence Hall. A drawing of the famous landmark showing how the right principle of scale and rule of height of the eighteenth century was observed when the Hall was first built. The angle of vision of 45° within the points CAB should have been preserved; instead the principle was destroyed by surrounding this precious inheritance with buildings entirely out of scale.

a foil for their virtues. Even cobblestones and bricks have to be carefully watched but they can give scale too and the pattern of your paving to the observant eye is as important as your structure. We should watch all detail carefully and avoid huge scaleless walls or avenues which stretch beyond a mile in length and which the eye quickly tires of. The arch gives scale and our best known example is in Paris where the Cour Carrée of the Louvre, spanning three centuries in its building, yet retains a single module for the facades. What, may be asked at this point, is the module for today? We can span a thousand feet without intervening supports in our modern construction but the space between will not be vacant and it will not, let us hope, be continuous glass than which under certain conditions nothing is visually more unpleasant. We were not meant to make walls into windows beyond a certain point and we must scale down the interstices between our structural elements so as to avoid the unfortunate error of approaching a building and finding nothing there.

We must also avoid the dichotomy between the two scales that our American building has lately produced. Coming

378

7. The Temple of Apollo Didymi near Miletus.

into New York over the Pulaski Skyway, an example of this appears—the small rows of houses on the New Jersey side which look like Walt Disney cottages for gnomes against the towers of Manhattan behind and against the bridge itself. This, of course, is accidental but as planners we are faced with the same relative problem since the economic and social requirements of our building industry demand buildings of one or two stories and buildings above eleven stories with nothing in-between; so even in the less dramatic areas of our cities we are faced with this problem of two scales and it is hard to achieve a happy relationship.

A happy effect in small towns has often been realized but in the large city with its triumphs of engineering and its increasing separation of functions we are faced with the task of relating planes and dimensions in which we need the advice and the eye of the painter.

These problems can be studied in schools of art, town planning and architecture; in fact they must be studied there since obviously traffic engineers and efficiency experts are not going to bother with them. By using models we shall be able to make a study of scale relationships and also of color and ornament, as Louis Sullivan did—and let us remind ourselves that

379

if Sullivan is our god it is wise to accept him whole—ornament and all.[12] One does not have to be an architect to solve the problems of civic design—although architecture, if properly taught, is a firm foundation for civic design. All that is needed as a beginning is an ability to grasp a large problem and to comprehend certain fundamentals of massing and lay-out. But we shall need all the artistic skills for the question of detail, and if we look at the great urban complexes of history, the ones that we can all admire, we find that they are rich in detail, in sublety and in light and shade. It is often the case that we can judge the complex from its smallest parts. Even the waste paper blowing through the streets gives us a clue to the regard for art which a community holds. The importance of detail cannot be over-estimated. It *must* be reintroduced and the craftsmen again remembered. Clean lines, balanced masses, and open space are not enough. Like the Capitol in Washington which has the work of many artists in its fabric, the city square and the residential court must show the evidence of many hands.

The creative designer must start, then, with proper relationships as his aim. Suppose that a new town is under consideration. Having been assured that the premises are correct [13] or having quarreled with them until a satisfactory analytic base is arrived at, knowing the number of square feet to be given to this and that, understanding that certain space must be reserved for industry and others for civic use, the designer can begin, *not* to make a plan—this is our objection to the term "planner"—but to visualize in groups certain parts of the coming city as they will appear in three dimensions. The civic designer is not necessarily assuming the role of architect here, although he may be one by training, but he certainly is adopting the vision of a painter or sculptor trained in perspective and dimension. Growing from the site on strategic points of ground are seen the one or more centers of industry, of commerce, of

government, of pleasure, of health, of religion—each with its embryonic form and character. The actual form is variable and of patterns on the ground there are a thousand possibilities; but the forms will already have a quality stamped by variety in height, in vertical and horizontal emphasis, in looseness or compactness of structure.

Now the strategic sites will be connected one to another, perhaps outward from a main center, perhaps in linear fashion, perhaps in a loose series of sub-centers without strong formality. This does not mean that a traffic pattern is being established. The connections may be merely vistas, or linked shopping streets, or pedestrian bridges or tree-lined malls, all planned with the eye, in three dimensions. The traffic pattern will probably be separated from all of these sites, its shape dictated by convenience and its connection with the centers peripheral; darting in to make contact where it is needed but never interfering with the main functions of the city.

A parallel with the siting of a house might be given here. The house is sited on the land for views, exposures, and relation to its neighbors; the driveway and other approaches are then planned to serve it. The house is never sited to fit nicely at the end of an already planned driveway; if it were, the other amenities would be sacrificed. Traffic dominates the city now; the strangulation point has almost been reached; and it cannot be too strongly emphasized that it is folly to base the new city on the demands of traffic. Traffic ways should only be an accommodation, a convenience for the citizen. Such an attitude is necessary now that the mechanization of transport is in an advanced stage.

It will be argued that in all existing cities this approach would be impossible, the street pattern being already fixed. But is it? What city in the United States is without a new highway or cut-off which has been designed to feed yet avoid the im-

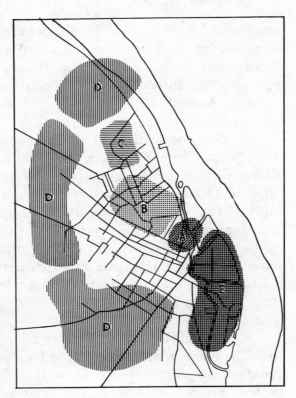

8. An approach to creative urbanism through the revitalization of related areas, described in a report by the author to the mayor of a city in South America.

A. An area containing two connecting squares, both in need of rehabilitation, around which the financial district will be expanded and the old market rebuilt.

B. An area of culture and entertainment, to contain the new cathedral, municipal theater and civic buildings.

C. An area of hotels, tourism and tropical gardens.

D. Areas of new residences for a population which is due to double in size in fifty years.

E. An area of industry. All these areas are chosen for study because of a dominant character or use. All can be defined and related through creative design. An architectural character, scale, heights and density are being suggested for each area.

portant centers of town? Highway engineers will explain that this is their policy—to separate through traffic from local traffic—an admirable plan, which unfortunately cannot change the cities by itself. Perhaps the theory of related areas will prove useful in giving a positive direction to this trend. Applied to existing centers (which should be re-examined in the process in order to develop a three-dimensional quality) the theory will prove that the approach should be the same for replanning an old town—to determine the strategic points and relate them to each other. Here, through historical accident or economic trend, strategic areas are sometimes poorly situated, and that makes the task harder, but it will often be found that over the years the city has created its own landscape and that certain areas have acquired through man's activities an interest which they did not at first possess. It will be found that these can be related by the formation of approaches, opening up of views or the creation of parks; at least no one should despair if at first sight the city seems to have no strategic points. They are always there, even though hidden, and a proper study of traditions, economic, social and artistic, will reveal their identity.

This theory does not depend for its application on sites of great beauty or variety. The dull, flat bottom-lands are a greater challenge than Tivoli or Santa Fe. Granted that many American cities have been founded along rivers subject to flooding, on land better suited to agricultural pursuits—these were mistakes of the past and at great expense through regional or local control they are being made safe for the future. So there they are and will remain. A comparatively flat site can afford the magnificence of taller buildings at strategic points and the pleasures of open space . . . Wordsworth's "haunts of ease" . . . a city on a flat site is not limited as to its extent or hemmed in by rough topography and in it can be created, as many of the Latin countries like Mexico have done, the minor pleasures of

building around courts and connecting court with court by links of open space—one of the positive advantages of a flat site over a hilly one.

It may be pointed out that these strategic points are but islands in our cities of congestion and ugliness. This is quite evident; they are also jewels in the crown in which the velvet becomes a modest background to set off the glitter of the more important gems. If the velvet is worn and frayed it too must be rewoven. The pattern is quiet—residential areas cover by far the greatest amount of land—but minor jewels are shining here—the neighborhood center, the libraries, the local markets. If you give people something to be proud of, or better still, help them to create something they can admire, the influence will spread to homes and grounds in the manner that Jefferson hoped for when he suggested a way in which cities should grow. A deep-seated desire can be realized through creative urbanism. A new generation is tired of our endless streets with their wretched sameness, with their gas station on every corner, with the chain store repeating its endless pattern from coast to coast. No wonder they crowd Stratford-on-Avon or Williamsburg, where picturesqueness, detail, glimpses of history, architecture, or anything else they can find there offer a welcome change from their deadeningly remorseless surroundings.[14]

Planning in three dimensions instead of two demands a new technique. The result, if translated onto paper, does not resemble anything we now make in the form of a city plan. Palladio's Teatro Olimpico does not read in plan at all. Questions of memory, hope and visual pleasure can only be rendered by the artist and to him we must turn for the new technique. We train too many "practical" men—what errors are committed in the name of practicality!—and too few artists. Divorce sculpture, painting and—unthinkable but true, even architecture

384

from city planning—reduce it to a practical working-out of traffic flow and correct land use, and what is left? Not a city surely. The city is supposed to rise upon this base, but it will be an unimaginative thing, a perpetuation of past errors in modern form. The method proposed will *start* with the third dimension, the ultimate form—the creative designer working with the scientist and analyst to produce the common aim—a city, which may, for once, be called "beautiful" in all dimensions.

Our creative designer, then—we must start to train him now since even Michelangelo would be frustrated in the modern city and there is everything to learn—our new man will be relieved of the responsibility for making policy decisions. His client, the people, will receive his recommendations,—solutions exhaustively worked out with the collaboration of natural and social scientists. He will be a visual expert, an artist in the form of cities, and aware of the contribution which others must make if we are to live in communities which achieve an integration of art and life. He must know what tradition means—otherwise there is no point of departure. He must develop the quality of imagination which can seize on insignificant-seeming things and make them into magical touchstones of urbanism; but he must not be arrogant or cocksure—Emerson taught us that the observer should be included in every creative act. With this democratic ideal before him, the creative designer will achieve a lasting triumph in that market place beyond economics, the city born of art.

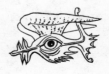

NOTES AND REFERENCES

● CHAPTER 1 THIS IS THE CITY

NOTE 1 ○ Constantin François Chasseboeuf, Comte de Volney, *Tableau du climat et du sol des Etats-Unis d'Amérique* (Paris, 1825), pp. 363-364.

NOTE 2 ○ Thomas C. Cochran and William Miller, *The Age of Enterprise* (New York, 1943), p. 31.

NOTE 3 ○ 69.9% of the population of the United States was classified by the Bureau of the Census as urban in 1960.

NOTE 4 ○ Exceptions are the early New England milltowns which split up farm families to recruit their large female working population, and present-day communities for extractive industries where men often outnumber the women, who do not arrive until the places have become stabilized.

NOTE 5 ○ Carl Brinkmann, "Family" in *Encyclopedia of the Social Sciences* (New York, 1931), VI, p. 68.

NOTE 6 ○ Leon Battista Alberti, "Deiciarchia" in *Opere volgari*, edited by Anicio Bonucci (Florence, 1845), Vol. III, pp. 122-123.

NOTE 7 ○ Innes H. Pearse and Lucy H. Crocker, *The Peckham Experiment—A Study in the Living Structure of Society* (New Haven, 1945), pp. 9, 28 and 42-48.

NOTE 8 ○ In 1960, the total farm mortgage debt in the U.S. was $12,073,580,000; the non-farm mortgage debt in the same year was $108,092,000,000. Source: Statistical Abstract of the United States, 1968.

NOTE 9 ○ Warren S. Thompson, *Plenty of People* (New York, 1948), p. 134. "Here (i.e. in the U.S.) the farm population in 1940 was only 23 per cent of the total population, and the persons engaged in agriculture amounted to only 18.5 per cent of all persons gainfully employed. The proportion is even smaller today—perhaps 14 or 15 per cent."

NOTE 10 ○ See commuting charts in *Where is Ridgefield Heading?* Ridgefield League of Women Voters and Yale-Ridgefield Case-Study Group, Ridgefield, Conn., 1950.

NOTE 11 ○ Aristotle, *Politics*, trans. by H. Rackham in the Loeb Classical Library (London and New York, 1932), pp. 7 and 9.

NOTE 12 ○ *Ibid.* p. 75.

NOTE 13 ○ For a discussion of this point see Chapter 2.

NOTE 14 ○ Brunetto Latini (c. 1220–c. 1294), *Li Livres dou Tresor*, edited by J. F. Chabaille (Paris, 1863), p. 467.

NOTE 15 ○ Sir Paul Vinogradoff, *Outlines of Historical Jurisprudence* (London and New York, 1922). Vol. II, *The Jurisprudence of the Greek City*, p. 2.

NOTE 16 ○ James Fenimore Cooper, *Notions of the Americans* (Philadelphia, 1835), Vol. I, p. 132.

NOTE 17 ○ F. L. Ganshof, *Etude sur le développement des villes entre Loire et Rhin au Moyen Age* (Paris, 1943), p. 33.

NOTE 18 ○ René Maunier, *L'Origine et la fonction économique des villes* (Paris, 1910), p. 155, note 2.

NOTE 19 ○ The author is indebted to Professor Robert Lopez of Yale University for this observation made in one of his lectures on the Medieval City.

NOTE 20 ○ Roderick Duncan McKenzie, *The Metropolitan Community* (New York and London, 1933), p. 64.

NOTE 21 ○ R. D. McKenzie noted the increased importance of the service occupations. *Ibid.* pp. 62 and 63.

NOTE 22 ○ Colin Clark, "The Economic Functions of a City in Relation to its Size." In *Econometrica*, Vol. XIII, pp. 97–113.

NOTE 23 ○ *Ibid.*, p. 98.

NOTE 24(A) ○ Trucks carry one-fifth to four-fifths of the fresh fruits and vegetables to the various markets. Trucks carry more than one-half of the cattle, calves and hogs from farm to market. 75 Metropolitan areas receive all their milk by truck while twenty-seven cities, including Boston, Philadelphia, Chicago and New York receive from 38 to 39 per cent of their supply by truck.

From U.S. Department of Commerce, Office of Domestic Commerce, *Industry Report, Domestic Transportation. An Evaluation of Motor Truck Transportation.* (Washington, 1948), pp. 33–38.

NOTE 24(B) ○ "On October 25–26, 1950, U.S. Highway No. 1, the main north-south Atlantic coastal highway, was carrying, at a traffic-counting station

about two miles north of Richmond, Virginia, in long-distance tractor trailer trucks *only*, seventy per cent as much freight as the Richmond, Fredericksburg and Potomac Railroad."

Oscar Sutermeister, *Journal of the American Institute of Planners*. Vol. XVII, No. 2.

NOTE 25 ○ This outlook on the part of the contemporary artist is best expressed by Holger Cahill in his description of the Eight (Sloan, Luks, Glackens, Shinn, Davies, Lawson, Prendergast, Henri).

"What interested them was experience and the communication of the look and emotion of that experience to a spectator. They were not interested in beauty as such, unless it were beauty as the expression of character. They would seek beauty even in ugliness. This ugliness might inhere in subject matter or in form. For they held a truth which has been brilliantly expressed by Gertrude Stein, that every true work of art comes 'into the world with a measure of ugliness in it. That ugliness is the sign of the creator's struggle to say a new thing in a new way.' "

Holger Cahill, "Forty Years After: An Anniversary for the AFA." In *Magazine of Art*, Vol. XLII, p. 175.

NOTE 26 ○ Thomas Adams, *Outline of Town and City Planning*. Foreword by Franklin D. Roosevelt. (New York, 1935), p. 21.

• CHAPTER 2 THE HYDRA

NOTE I ○ Sir James Frazer, *The Golden Bough* (New York, 1935), Vol. III, p. 391.

NOTE 2 ○ Honoré de Balzac, "Ferragus, chef des dévorants." In *Oeuvres complètes, La Comédie humaine* (Paris, 1879), Vol. VIII, pp. 6–8.

NOTE 3 ○ Thomas Jefferson, *Writings*, edited by Paul L. Ford (New York, 1896), Vol. VII, pp. 458 and 459.

NOTE 4 ○ Ernest Lavisse, *Histoire de France illustrée depuis les origines jusqu'à la Révolution* (Paris, 1911), Vol. III, première partie, p. 405.

NOTE 5 ○ Wayne Andrews, *Battle for Chicago* (New York, 1946), p. 176.

NOTE 6 ○ William Morris, "The Earthly Paradise: A Poem." In *Collected Works* (London, 1910), Vol. III, p. 3.

NOTE 7 ○ William Morris, "News from Nowhere or An Epoch of Rest." In *Collected Works* (London, 1912), Vol. XVI, pp. 41 and 42.

NOTE 8 ○ Thorstein Veblen, *The Theory of the Leisure Class* (Modern Library, New York, 1934), p. 153. The influence of Adolf Loos (1870–1933) on the modern architect's attitude toward ornament should also not be overlooked. In "Ornament und Verbrechen" [Ornament and Crime], translated and

published in several languages in 1908 before being published in the original much later, he explains that our civilization has reached a stage in which ornament is no longer needed. See his *Ins Leere Gesprochen* (Innsbruck, 1932), Vol. II, pp. 79–92. It was Loos' house on the Geneva waterfront (1904) which inspired Le Corbusier to become a modern architect. Richard Neutra studied under Loos in Vienna from 1912 to 1914.

NOTE 9 ○ W. A. Eden, "Studies in Urban Theory II. Ebenezer Howard and the Garden City Movement." In *Town Planning Review*, Vol. XIX, pp. 141 and 142.

NOTE 10 ○ Lewis Mumford, *The Culture of Cities* (New York, 1938), p. 6. On page 283 the author discusses his "Cycle of Growth and Decay," in the outlining of which he acknowledges his debt to Patrick Geddes. Frank Lloyd Wright, *When Democracy Builds* (Chicago, 1945), p. 9. Le Corbusier, *Concerning Town Planning*, trans. by Clive Entwistle (London, 1946), p. 46. Sigfried Giedion, *Space, Time and Architecture* (Cambridge, Mass., 1941), p. 544. Walter Gropius, *Rebuilding our Communities* (Chicago, 1945), p. 53.

NOTE 11 ○ Lewis Mumford. As quoted by Malcolm Cowley and Bernard Smith, editors, *Books That Changed Our Minds* (New York, 1939). Introduction, p. 7.

NOTE 12 ○ Oswald Spengler's message according to Lucien Febure, "De Spengler à Toynbee. Quelques philosophes opportunistes de l'histoire." In *La Revue de Métaphysique et de Morale*, Vol. XVIII (1936), p. 578.

NOTE 13 ○ Geoffrey Scott, *The Architecture of Humanism, A Study in the History of Taste* (2nd edition, New York, 1924), p. 176.

NOTE 14 ○ Lewis Mumford, "Spengler's *The Decline of the West*." In Malcolm Cowley and Bernard Smith, editors. *Opus cited*, p. 225.

NOTE 15 ○ "In our universities, a student is so absorbed by studying music composed by others, poetry written by others, and architecture, painting and sculpture created by famous men of the past, that he rarely finds a chance to try his hand at *making* poetry, music or art of his own invention." Walter Gropius, *Journal of the American Institute of Architects*, Vol. XIV, p. 184.

• CHAPTER 3 VISION AND REALITY

NOTE 1 ○ Louis-Antoine-Léon de Saint-Just, *Oeuvres. Discours-Rapports. Institutions républicaines*. Intr. by Jean Gratien (Paris, 1946), p. 28 and p. 304.

NOTE 2 ○ Jean Signorel, "La 'Cité du Soleil' de Thomas Campanella." In *Mémoires de l'Académie des Sciences, Inscriptions et Belles-Lettres de Toulouse* (Toulouse, 1923), 12th series, Vol. I, pp. 28–30.

NOTES AND REFERENCES

NOTE 3 ∘ Johann Valentin Andreae, *Christianopolis*, trans. and ed. with intr. by Felix Emil Held (New York, 1916), p. 156.

NOTE 4 ∘ A. Huonder, "Reductions of Paraguay." In *The Catholic Encyclopedia* (New York, 1913), Vol. XII, pp. 688–699.

NOTE 5 ∘ Felix de Verneihl, "Architecture civile au Moyen Age." In *Annales archéologiques*, Vol. VI (1847), p. 85.

NOTE 6 ∘ George Kubler, *Mexican Architecture of the Sixteenth Century* (New Haven, 1948), Vol. I, p. 94.

NOTE 7 ∘ Dan Stanislawski, "The Origins and Spread of the Grid-Pattern Town." In *Geographical Review*, Vol. XXXVI, pp. 105–120.

NOTE 8 ∘ Aristotle, *Opus cited*, p. 589.

NOTE 9 ∘ Miriam Beard, *A History of the Businessman* (New York, 1938), p. 18.

NOTE 10 ∘ It was also the favorite order of the Romans and of architects of the Renaissance who considered it best adapted to the monumental. Julien Guadet, *Éléments et théorie de l'architecture* (3rd edition, Paris, 1909), Vol. I, pp. 372 and 381.

NOTE 11 ∘ "Arturo Soria y Mata." In *Enciclopedia Universal Ilustrada* (Madrid, 1927), Vol. LVII, pp. 546 and 547.

NOTE 12 ∘ *The Lineal City*. To the members of the National Housing and Town Planning Council on their visit to Madrid, September 1924 (Madrid, 1924), pp. 10–12.

NOTE 13 ∘ Arturo Soria y Mata, "Le problème social et la cité linéaire." Articles written in 1883 and 1892 reprinted in H. G. Castillo, *Projet de cité linéaire belge*, trans. into French by Albert Simi (Madrid, 1919), p. 40.

NOTE 14 ∘ See forms developed by:
Ludwig Hilberseimer, *The New City: Principles of Planning*. Introduction by Mies van der Rohe (Chicago, 1944).
Ricardo C. Humbert, *La Ciudad hexagonal* (Buenos Aires, 1944).
Alexander Klein, "Man and Town." In *Technion Yearbook*, published by the American Technion Society, New York, Vol. VI (1947), pp. 72–90.

NOTE 15 ∘ Richard Graves, *Euphrosyne: or Amusements on the Road of Life* (London, 1776), p. 21.

NOTE 16 ∘ Pierre Lavedan, *Histoire de l'urbanisme* (Paris, 1926), Vol. I, *Antiquité-Moyen Age*, p. 292.

NOTE 17 ∘ Justus Bier, *Old Nuremberg. A Work of Art in Town Architecture*. Translated by Rosie Guiterman (Nürnberg, 1928), p. 16.

• CHAPTER 4 THE GRAND DESIGN

NOTE 1 ○ Pierre Lavedan. *Opus cited*, Vol. I, pp. 57–58.

NOTE 2 ○ *Ibid.*, p. 250.

NOTE 3 ○ Louis Hautecoeur, *Histoire de l'architecture classique en France* (Paris, 1948). Vol. II, *Le Règne de Louis XIV*, p. 102.

NOTE 4 ○ *Ibid.*, p. 562.

NOTE 5 ○ As cited by I. A. R. Wylie, *My German Year* (London, 1910), pp. 12–13.

NOTE 6 ○ Pierre Lavedan. *Opus cited*, Vol. II, pp. 332–333.

NOTE 7 ○ Fiske Kimball, *The Creation of the Rococo* (Philadelphia, 1943), p. 90.

NOTE 8 ○ Louis Hautecoeur. *Opus cited*, Vol. II, p. 612.

NOTE 9 ○ Mowbray A. Green, *The Eighteenth Century Architecture of Bath* (Bath, 1904), p. 35.

NOTE 10 ○ *Ibid.*, p. 143.

NOTE 11 ○ Elizabeth S. Kite, *L'Enfant and Washington, 1791–1792, Published and Unpublished Documents Now Brought Together for the First Time* (Baltimore, 1929), pp. 47, 48.

NOTE 12 ○ James Fenimore Cooper. *Opus cited*, Vol. II, p. 9.

NOTE 13 ○ Elbert Peets has kindly pointed out to the author his observation that the nearby trees cause a greater visual obstruction than the building itself.

NOTE 14 ○ Harvey O'Connor, *The Astors* (New York, 1941), pp. 112–113.

• CHAPTER 5 FIRE ON THE PRAIRIE

NOTE 1 ○ Gustavus Myers, *History of the Great American Fortunes* (Modern Library, New York, 1931), p. 31.

NOTE 2 ○ Harriet Martineau, *Society in America* (4th Edition, New York, 1837), Vol. I, p. 332.

NOTE 3 ○ The Hudson River School of which the chief figure was Thomas Cole. See Christopher Tunnard, "Reflections on the Course of Empire and other Architectural Fantasies of Thomas Cole, N.A." In *The Architectural Review*, Vol. 104, pp. 291–294.

NOTE 4 ○ Aaron Moses Sakolski, *The Great American Land Bubble* (New York-London, 1932), pp. 86–95.

NOTE 5 ○ Cotton Mather, *Magnalia Christi Americana: The Ecclesiastical History of New England*. Intr. by the Rev. Thomas Robbins (Hartford, 1855), Vol. I, p. 243.

NOTE 6 ○ Amelia Clewely Ford, "Colonial Precedents of Our National Land System as it Existed in 1800." In *Bulletin of the University of Wisconsin* (Madison, 1910), History Series, Vol. II, No. 2, p. 445.

NOTE 7 ○ Everett Dick, *The Sod-House Frontier 1854–1890* (New York, 1937), p. 108.

NOTE 8 ○ Carl Bridenbaugh, *Cities in the Wilderness* (New York, 1938), p. 12. See also Chap. 9, "The Urban Setting," for information on slums and tenements in Charleston and Boston.

NOTE 9 ○ Charles M. Andrews, *Colonial Folkways, A Chronicle of American Life in the Reign of the Georges* (New Haven, 1919), p. 36.

NOTE 10 ○ Dixon Wecter, *The Saga of American Society* (New York, 1937), p. 27.

NOTE 11 ○ Isaac Newton Phelps Stokes, *The Iconography of Manhattan Island* (New York, 1928), Vol. V, pp. 1406 and 1924. Frances Trollope, *Domestic Manners of Americans*, edited by Donald Smalley (New York, 1949), p. 338.

NOTE 12 ○ Everett Dick. *Opus cited*, p. 41.

NOTE 13 ○ William Smith, *An Historical Account of the Expedition against the Ohio Indians, in the year MDCCLXIV. Under the Command of Henry Bouquet* . . . (London, 1766), p. 51.

NOTE 14 ○ Jefferson's geographical mile was 6,080.2 feet long, which explains the unusual number of acres to the square mile. Amelia Clewely Ford. *Opus cited*, p. 377.

NOTE 15 ○ The surveyor's chain had considerable influence on the urban land pattern of the United States. Streets often have a 66-foot width—the length of the surveyor's chain (an eightieth of a mile). *The Real Estate Handbook*, edited by Lawrence G. Holmes and Carrie M. Jones (New York, 1948), p. 452.

NOTE 16 ○ One of the first buildings with apartments in the modern sense, then called "French Flats," was designed and built by Richard Morris Hunt in New York City in 1869. Alan Burnham, "The New York Architecture of Richard Morris Hunt" in *Journal of the Society of Architectural Historians*, Vol. XI, No. 2, p. 11.

NOTE 17 ∘

	1940	%	1950	%	% INCREASE
Owner-occupied non-farm units	11,413,000	41.1	19,528,000	53.3	71.1
Tenant-occupied non-farm units	16,335,000	58.9	17,098,000	46.7	4.7
Total	27,748,000	100.0	36,626,000	100.0	32.0

The Real Estate Trends, published by Roy Wenzlick & Co., Saint Louis, Mo., Vol. XX, No. 14 (March 23, 1951), p. 154.

• CHAPTER 6 A FEW RAGGED HUTS

NOTE 1 ∘ William Alfred Hinds, *American Communities and Cooperative Colonies* (New York, 1908), p. 69.

NOTE 2 ∘ Richard William Leopold, *Robert Dale Owen: A Biography* (Cambridge, Mass., 1940), pp. 15–21.

NOTE 3 ∘ *Ibid.*, p. 25.

NOTE 4 ∘ Bernhard, Duke of Saxe-Weimar-Eisenach, *Travels Through North America, During the Years 1825 and 1826* (Philadelphia, 1828), Vol. II, pp. 108–109, 115, 116 and 118.

NOTE 5 ∘ Oliver Carlson, *Brisbane, A Candid Biography* (New York, 1937), p. 26 ff.

NOTE 6 ∘ U. S. Works Progress Administration. American Guide Series. *Pennsylvania* (New York, 1940), p. 356.

NOTE 7 ∘ Mortimer Smith, *The Life of Ole Bull* (Princeton-New York, 1943), pp. 91–124.

NOTE 8 ∘ Milton R. Hunter, *Brigham Young, the Colonizer* (2nd edition, Salt Lake City, Utah, 1941), pp. 12–17, 148–163, 195.

NOTE 9 ∘ For an extended treatment of this subject see: Eugene C. Barker, *The Life of Stephen F. Austin, Founder of Texas* (Nashville-Dallas, 1925).

• CHAPTER 7 INDUSTRIAL BLUEPRINTS

NOTE 1 ∘ Thomas C. Cochran and William Miller. *Opus cited*, p. 6.

NOTE 2 ∘ Vera Shlakman, "Economic History of a Factory Town. A Study of Chicopee in Massachusetts." *Smith College Studies in History*, Vol. XX, Nos. 1–4, p. 14.

NOTE 3 ∘ *Ibid.*, p. 14.

NOTE 4 ∘ For a detailed account see Leifur Magnusson, "Housing by Employers in the United States." In U. S. Department of Labor, Bureau of Labor Statistics. *Bulletin* No. 263 (Washington, 1920).

NOTES AND REFERENCES

NOTE 5 ∘ Budgett Meakin, *Model Factories and Villages: Ideal Conditions of Labour and Housing* (London, 1905), p. 25.

NOTE 6 ∘ William R. Lawrence, *Extracts from the Diary and Correspondence of the Late Amos Lawrence* (Boston, 1855), p. 104.

NOTE 7 ∘ Samuel Eliot Morison, *The Life and Letters of Harrison Gray Otis, Federalist, 1765–1848* (Boston, 1913), Vol. II, p. 294. Quotation in extenso:
"The rumour of your profits will make people delirious. I hope however you will make hay while the sun shines. . . . I should have voted with you for 15 per cent, though I want the 20 per enough—But it seems too good."

NOTE 8 ∘ Vera Shlakman. *Opus cited*, pp. 51–53.

NOTE 9 ∘ Alan R. Sweezy, "The Amoskeag Manufacturing Company." In *Quarterly Journal of Economics*, Vol. LII, p. 475 ff.

NOTE 10 ∘ Grace Holbrook Blood, *Manchester on the Merrimack. The Story of a City* (Manchester, N. H., 1948), pp. 109–110.

NOTE 11 ∘ John Badger Clarke, *Manchester, A Brief Record of Its Past and a Picture of Its Present* . . . (Manchester, N. H., 1875), p. 271.

NOTE 12 ∘ *Ibid.*, pp. 276–277.

NOTE 13 ∘ Edwin Muller, "Revival on the Merrimack." In *Nation's Business*, Vol. XXXVIII (December, 1950), pp. 43–56, 61.

NOTE 14 ∘ Leifur Magnusson. *Opus cited*, p. 10.

NOTE 15 ∘ Almont Lindsay, *The Pullman Strike* (Chicago, 1942), p. 102.

NOTE 16 ∘ William H. Carwardine, *The Pullman Strike* (Chicago, 1894), pp. 21–25.

NOTE 17 ∘ Wayne Andrews, *Battle for Chicago* (New York, 1946), p. 173.

NOTE 18 ∘ U. S. Works Progress Administration. American Guide Series. *Indiana* (New York, 1941), pp. 168–169.

NOTE 19 ∘ Harold MacLean Lewis, *Planning the Modern City* (New York-London, 1949), Vol. II, p. 99.

NOTE 20 ∘ Tom M. Girdler, *Boot Straps. The Autobiography of Tom M. Girdler in Collaboration with Boyden Sparks* (New York, 1943), pp. 177–178.

NOTE 20a ∘ "Mr. Charlie's Town", p. 1, *Wall Street Journal*, April 29, 1969.

NOTE 21 ∘ Arthur C. Comey and Max S. Wehrly, "Part 1. Planned Communities." In U. S. National Resources Committee. Research Committee on Urbanism. *Supplementary Report of the Urbanism Committee.* (Washington, 1939–1940), Vol. II, *Urban Planning and Land Policies*, p. 6.

NOTE 22 ∘ Richardson Wood, *Yalesburg*. Mimeographed problem in community design. Yale University, 1951–1952 (New Haven, Conn.).

• CHAPTER 8 THE ROMANTIC MOOD

NOTE 1 ○ Stanley L. McMichael, *How to Make Money in Real Estate* (Cleveland, O., 1924), pp. 239 and 242.

NOTE 2 ○ Frank J. Taylor, "It Costs $1000 to Have Lunch With Harry Chandler." In *Saturday Evening Post*, December 16, 1939, pp. 8, 9, 60–65.

NOTE 3 ○ Samuel Swift, "Llewellyn Park, Orange, New Jersey." In *House and Garden*, Vol. III, No. 6, pp. 327–335.

NOTE 4 ○ The author is indebted to Wayne Andrews, Professor at Wayne State University, Detroit, for his introduction to this house and to an early example of romantic planning in Llewellyn Park.

NOTE 5 ○ *Frederick Law Olmsted, Landscape Architect, 1822–1903.* Edited by Frederick Law Olmsted, Jr. and Theodora Kimball (New York, 1928), Vol. II, *Central Park*, p. 178.

NOTE 6 ○ *Ibid.*, p. 170.

NOTE 7 ○ Frederick Law Olmsted, *Public Parks and the Enlargement of Towns* (Cambridge, Mass., 1870), pp. 18, 19.

NOTE 8 ○ Frederick Law Olmsted, *Walks and Talks of an American Farmer in England* (Revised edition, Columbus, O., 1859), pp. 61–66.

NOTE 9 ○ *Riverside in 1871, With a Description of its Improvements.* Office of the Riverside Improvement Company (Chicago, 1871), pp. 6–12.

NOTE 10 ○ Maude Howe Elliott, *This Was My Newport* (Cambridge, Mass., 1944), pp. 170–172.

NOTE 11 ○ Wayne Andrews, *The Vanderbilt Legend* (New York, 1941), pp. 267, 295, 347, 348.

NOTE 12 ○ For an account of the social patterns created by high-income groups in suburban areas see paper by Charles Ascher in *The Library in the Community*, edited by Leon Carnovsky and Lowell Martin (Chicago, 1944).

NOTE 13 ○ Paul Windels, "The Metropolitan Region at the Crossroads." In *Regional Plan Bulletin* (June, 1948), No. 70, pp. 6–7.

NOTE 14 ○ For an account of social and economic pressures in a Connecticut community see Christopher Tunnard, "Westport Improved," in *Magazine of Art*, Vol. XLII, No. 1 (January, 1949), p. 9.

NOTE 15 ○ Leo Grebler, *Production of New Housing* (New York, 1950), p. 135.

• CHAPTER 9 THE COMING REVOLUTION IN ARCHITECTURE

NOTE 1 ○ Osbert Lancaster, "The End of the Modern Movement in Architecture." In *The Architects' Journal*, London, Vol. CXIV, No. 2955 (Oct. 18, 1951), p. 467.

NOTE 2 ○ Niall Montgomery, "Suitability of Premises and Personal Fitness." In *Architecture in Ireland*, Dublin, 1946, p. 22.

NOTE 3 ○ Fiske Kimball, "Three Centuries of American Architecture." In *The Architectural Record*, Vol. LVII, pp. 562–563.

NOTE 4 ○ Le Corbusier (Charles Jeanneret-Gris), *Towards a New Architecture*. Translated from the 13th French edition with an introduction by Frederick Etchells (New York, 1927), pp. 25–26.

NOTE 5 ○ Gaston Bardet, *Pierre sur pierre. Construction du nouvel urbanisme* (Paris, 1946), pp. 179–181. The term "city of shadows" is used by this planner in his analysis of Le Corbusier's scheme for rebuilding Paris.

NOTE 6 ○ John Ruskin, "Influence of Imagination in Architecture." In *Sesame and Lilies, The Two Paths, The King of the Golden River* (Everyman's Library, London-New York, 1944), p. 163.

NOTE 7 ○ Montgomery Schuyler, "Modern Architecture." In *The Architectural Record*, Vol. IV, p. 13.

• CHAPTER 10 THE LEAF AND THE STONE

NOTE 1 ○ Ebenezer Howard, *Garden Cities of Tomorrow* (*Being the Second Edition of "Tomorrow: A Peaceful Path to Real Reform"*) (London, 1902), p. 15.

NOTE 2 ○ Johannes Albertus Franciscus Orbaan, *Sixtine Rome* (London, 1910), pp. 72–73.

NOTE 3 ○ Marcel Poëte, *La Promenade à Paris au XVII siècle* (Paris, 1913), pp. 28–69.

NOTE 4 ○ Thomas Dick Lauder, *Sir Uvedale Price on the Picturesque* (Edinburgh, London, 1842), p. 348.

NOTE 5 ○ W. A. Eden, "Studies in Urban Theory II: Ebenezer Howard and the Garden City Movement." In *Town Planning Review*, Vol. XIX (1947), p. 140.

NOTE 6 ○ Le Corbusier (Charles Edouard Jeanneret-Gris) and François de Pierrefeu, *The Home of Man*. Translated by Clive Entwistle and Gordon Holt (London, 1948), pp. 62, 87 and 91.

• CHAPTER 11 COMMON PLEASURES

NOTE 1 ○ Halsey Ricardo, "Of Colour in the Architecture of Cities." In *Art and Life, and the Building and Decoration of Cities: A Series of Lectures by Members of the Arts and Crafts Exhibition Society, Delivered at the Fifth Exhibition of the Society in 1896* (London, 1897), p. 235.

NOTE 2 ○ Talbot Hamlin, *Architecture, an Art for All Men* (New York, 1947), pp. 171–172.

NOTE 3 ○ Extract from *The Standard* (London, August 3, 1869) referring to

Regent's Park Fountain of 1869 presented by Cowajee-Jehangheer Ready-money, C.S.I.

NOTE 4 ○ William Matthews, *Hydraulia; an Historical and Descriptive Account of the Waterworks of London* (London, 1835), pp. 49–51.

NOTE 5 ○ Charles Mauricheau-Beaupré, *Versailles. L'Histoire et l'art. Guide Officiel* (Paris, 1949), p. 145.

NOTE 6 ○ Bernard Palissy, "Recepte véritable par laquelle tous les hommes de la France pourront apprendre à multiplier et à augmenter leurs Thresors." In *Oeuvres complètes*. With introduction and notes by Paul-Antoine Cap (Paris, 1844), pp. 57–65.

NOTE 7 ○ A. St. H. Brock, *Pyrotechnics: The History and Art of Firework Making* (London, 1922), p. 101.

NOTE 8 ○ Violet R. Markham, *Paxton and the Bachelor Duke* (London, 1935), p. 242.

NOTE 9 ○ Andrew Jackson Downing. From an unsigned article. In *The Horti-culturist*, Vol. I, p. 298.

NOTE 10 ○ William Matthews. *Opus cited*, p. 54.

● CHAPTER 12 AN ARTIST IN THE STREETS

NOTE 1 ○ Corrado Ricci, "The Art of Scenography." In the *Art Bulletin*, Vol. X, p. 243.

NOTE 2 ○ Paul-Henri Michel, *Un Idéal humain au XV siècle. La Pensée de L. B. Alberti (1404–1472)* (Paris, 1930), p. 78.

NOTE 3 ○ Sir Kenneth Clark, "Architectural Background in Italian Painting." In *Arts* (London, 1946), Vol. I, p. 15.

NOTE 4 ○ Fiske Kimball, "Luciano Laurana and the 'High Renaissance.'" In the *Art Bulletin*, Vol. X, p. 140.

NOTE 5 ○ Giulio Lorenzetti, *Itinerario sansoviniano a Venezia* (Venice, 1929), pp. 17–29.

NOTE 6 ○ *Ibid.*, p. 53.

NOTE 7 ○ John Dewey, *Art as Experience* (New York, 1934), p. 222.

NOTE 8 ○ C. J. Gignoux, *Monsieur Colbert* (Paris, 1941), p. 298.

NOTE 9 ○ Eleanor Davidson Berman, *Thomas Jefferson and the Arts; an Essay in Early American Esthetics* (New York, 1947), p. 259.
Jefferson's *Bill for a System of Public Education* called for the establish-ment of a national art gallery and a Department of Fine Arts in the national government.

NOTE 10 ○ Grace Overmyer, *Government and the Arts* (New York, 1939), p. 139.

NOTE 11 ° Edward Bruce and Forbes Watson, *Art in Federal Buildings* (Washington, 1936), Vol. I, *Mural Design*, p. xi.

NOTE 12 ° Louis Hautecoeur, *Les Beaux-Arts en France* (Paris, 1948), p. 87.

• CHAPTER 13 A CITY CALLED BEAUTIFUL

NOTE 1 ° Thomas Hastings, *Collected Writings*. Together with a memoir by David Grey (Boston, 1933), pp. 186–188.

NOTE 2 ° Charles Moore, *Daniel Burnham: Architect: Planner of Cities* (New York, 1921), Vol. II, p. 4. According to Burnham's biographer, his work on the San Francisco and Chicago plans was gratuitous.

NOTE 3 ° Quoted in Hugh Morrison, *Louis Sullivan: Prophet of Architecture* (New York, 1935), p. 184.

NOTE 4 ° Henry Adams, *The Education of Henry Adams* (New York, 1931), pp. 340–343.

NOTE 5 ° Maurice F. Neufeld, *The Contribution of the World's Columbian Exposition of 1893 to the Idea of a Planned Society in the United States*. A study of Administrative, Financial, Esthetic, Social and Intellectual Planning. Unpublished thesis. Department of History, University of Wisconsin, Madison, Wis., 1935.

NOTE 6 ° Montgomery Schuyler, "United States." In Russell Sturgis, *A Dictionary of Architecture and Building* (New York, 1902), Vol. III, columns 925–926.

NOTE 7 ° John M. Gaus, *The Education of Planners* (Cambridge, Mass., 1943), p. 7.

NOTE 8 ° Robert Averill Walker, *The Planning Function in Urban Government* (Chicago, 1941), p. 12.

NOTE 9 ° A. D. F. Hamlin, "Twenty-Five Years of American Architecture." In *The Architectural Record*, Vol. XL, p. 3.

NOTE 10 ° Charles Moore. *Opus cited*. Vol. I, p. 87.

NOTE 11 ° Oliver W. Larkin, *Art and Life in America* (New York, 1949). See Chapter on "The Renaissance Complex."

NOTE 12 ° Charles Moore. *Opus cited*. Vol. I, p. 206.

NOTE 13 ° The study of urban geography also helped to advance this concept.

NOTE 14 ° "La faute impardonable, ce n'est pas d'avoir sacrifié tant de décors precieux, tant de pierres endolories, mais de l'avoir fait sans coeur." Marcel Raval, *Histoire de Paris* (Paris, 1948), p. 104.

NOTE 15 ° John M. Gaus. *Opus cited*, p. 8.

NOTE 16 ° *Report of the New Haven Civic Improvement Commission to the New Haven Civic Improvement Committee* (New Haven, 1910).

NOTE 17 ○ Fiske Kimball, *Thomas Jefferson, Architect*. Original Designs in the Collection of Thomas Jefferson Coolidge, Junior, with an Essay and Notes by Fiske Kimball (Boston, 1916), p. 22.

NOTE 18 ○ *Ibid.*, p. 14.

NOTE 19 ○ An exception is to be found in David Marshall, *Grand Central* (New York-London, 1946), from whose excellent account the author has drawn part of his description of the Grand Central complex.

NOTE 20 ○ Thomas Wolfe, *A Stone, A Leaf, A Door*. Selected and arranged in verse by John S. Barnes (New York, 1945), p. 139.

NOTE 21 ○ Gerald Heard, *Narcissus: A Philosophy of Clothes* (New York, 1924), p. 143.

• CHAPTER 14　IN ALL DIMENSIONS

NOTE 1 ○ Joseph Hudnut, *Architecture and the Spirit of Man* (Cambridge, Mass., 1949), p. 116.

NOTE 2 ○ See Note 8, Chapter 2.

NOTE 3 ○ Louis Sullivan, "What is Architecture?" Reprinted from *The American Contractor*, January 6, 1906. Brochure published by F. W. Dodge Company (New York, 1906), p. 7.

• CHAPTER 15　THE SOCIAL BASIS OF
URBAN ESTHETICS

NOTE 1 ○ J. B. Condliffe, *Planning Pamphlets No. 18*. National Planning Association, Washington, January 1943.

NOTE 2 ○ Sylvie Buisson, "Le Plan des Artistes 1794–1797." In *La Vie Urbaine*, No. 55, pp. 8–21, No. 57, pp. 161–171.

NOTE 3 ○ J. Frederick Dewhurst & Associates, *America's Needs and Resources* (Twentieth Century Fund, New York, 1947), p. 389.

NOTE 4 ○ George Santayana, "Reason in Society." In *Works* (Triton edition, New York, 1936), Vol. III, pp. 341–344.

• CHAPTER 16　THE NEW URBANISM

NOTE 1 ○ The economy of Venice was revived by regional planning in 1917 when, through the initiative of Count Giuseppe Volpi di Misurata, the Italian government created the industrial port of Marghera. Volpi had organized the *Società Adriatica di Elettricità* which impounded the Alpine waters to the north of Venice to produce power for all of northeastern Italy. The port was begun in 1919 and inaugurated in 1922 and has since expanded rapidly with oil refining, aluminum production (Jugoslav bauxite), finished steel products, machine works and shipbuilding, all taking advantage of the cheap

and plentiful power. Today several of the largest dams in western Europe are about to be completed in the Eastern Alps, which will vastly increase the power potential.

NOTE 2 ○ "The Queen would be sorry that Mr. Peabody should leave England without being assured by herself how deeply she appreciates the noble act of more than princely munificence by which he has sought to relieve the wants of her poorer subjects residing in London." Letter from Queen Victoria, March 28, 1866, to George Peabody, quoted in *The Life of the Late George Peabody*, J. S. Bryant, London, 1914. The building of the Peabody housing estates helped to relieve a critical shortage caused by the demolition of London slum dwellings to make way for the railways then entering the city.

NOTE 3 ○ Representative definitions: (The Official City Planner), Harold Maclean Lewis, *Planning the Modern City*, New York, 1949, Vol. 1, p. 7. (The Sociologist), Lewis Mumford, *The Culture of Cities*, New York, 1938, Chaps. V and VI. (The Political Scientist), John Gaus, *Education for the Emerging Field of Regional Planning and Development*, in *Social Forces*, Vol. 29, No. 3, p. 230. (The Economist), G. D. H. Cole, *Building and Planning*, London, 1945, Chap. 2. *Two Kinds of Planning*. The last attempts to clear up current misconceptions in the areas of economic and physical planning.

NOTE 4 ○ Sitte's anti-Haussmann crusade denies us a proper analysis of the *plan rayonnant* of which the Baron was a crude imitator. Camillo Sitte, *Der Städtebau nach seinen künstlerischen Grundsätzen* (3rd edition, Vienna, 1901).

NOTE 5 ○ "The great amount of building under existing laws is still sited on antiquated principles of urban esthetics, as well as on dangerous principles of street design." Ralph Walker, *Introduction* to the English translation of Sitte, *The Art of Building Cities* (New York, 1945), p. viii.

NOTE 6 ○ In a lecture, *The Genealogy of the Plan of Washington*, given before the Society of Architectural Historians in Washington, January, 1951. The lecture has since been published in abbreviated form in which the term does not appear.

NOTE 7 ○ William R. Lethaby, "Of Beautiful Cities." In *Art and Life, and The Building and Decoration of Cities. Opus cited*, pp. 104–107.

NOTE 8 ○ Leon Battista Alberti, *The Architecture of Leon Battista Alberti in Ten Books*. Translated from the Italian by L. Leoni (London, 1726), Book VI, Chapter II.

NOTE 9 ○ Heinrich Maertens, *Der Optische-Maassstab; oder, Die Theorie und Praxis des ästhetischen Sehens in den bildenden Kunsten* (2nd edition, Berlin, 1884).

NOTE 10 ○ Professor George Howe, formerly Chairman, Department of Architecture, Yale, after reading a rough draft of this chapter, pointed out that while the example cited is certainly incongruous, the combination of gigantic and small buildings is sometimes accidentally successful, as in the view of Trinity Church, along the canyon of Wall Street in New York. He

offers as his personal opinion the suggestion that our cities have fewer planning controls and more "accident control," i.e. a guarantee that the incongruities of American city building can be made a point of departure by imaginative "architect-planners."

NOTE 11 ○ The author is indebted to Hans Blumenfeld of the Philadelphia City Planning Commission for this suggestion, made in a lecture on *Scale in City Planning* at Yale University in January, 1951.

NOTE 12 ○ Louis Henry Sullivan, *A System of Architectural Ornament According With a Philosophy of Man's Powers* (New York, 1924).

NOTE 13 ○ That the civic designer may still be required to make his own assumptions, especially with regard to ultimate size, is suggested by G. D. H. Cole. *Opus cited*, pp. 28–29.

NOTE 14 ○ Professor Robert Weinberg of New York University has suggested in a discussion of this point with the author that the orderliness of civic groupings of former times has an underlying appeal which is of greater importance in estimating public response than questions of style or period.

BIBLIOGRAPHY

A CIVIC DESIGNER'S BOOKSHELF.

**A Short List of Recommended Books on Civic Art and Design.
(Additional works will be found among the notes and references.)**

The following books under their different headings are suggested as a reference guide for beginners. Some few are rare and hard to obtain, but the majority are standard works, and editions other than the one given frequently exist. Most of the items will be found in the Avery Library at Columbia University, where the collection of great books on this subject is unequalled in the United States; or in the library of the Print Department of the Metropolitan Museum of Art in New York, where the volumes on architecture and the decorative arts are well selected. The Library of Landscape Architecture and Regional Planning at Harvard University is invaluable for general city planning subjects. A small number of maps is included in the list; supplementary map collections are readily available and for current material the reader's attention is drawn to the constantly revised Sanborn Maps for American cities, which give the heights of buildings. The city has also, from earliest days, attracted the artist and print-maker; a collection of views of cities in the form of prints is not difficult or expensive to assemble even today, and will be found interesting to compare with the more recent technique of the aerial photograph.

Among magazines and journals, *Capitolium*, *La Vie Urbaine*, *Urbanisme*, *The Architectural Review*, *The Town Planning Review*, and *The Journal of the Society of Architectural Historians* consistently give a place to civic design, and occasional articles will be found in, among others, *Annales: Economies-Sociétés-Civilisation*, *Arts et Métiers Graphiques*, *Country Life*, *The Journal of the Town Planning Institute*, *The Journal of the American Institute of Planners*, *Landscape* and *Landscape Architecture*.

1 THEORY

Leon Battista Alberti, *The Architecture of Leon Battista Alberti translated from the Italian by James Leoni.* London, 1726.

The great humanist's other works await adequate translation.

Vitruvius Pollio, *The Ten Books on Architecture*, translated by M. H. Morgan. Cambridge, Mass., 1914.

The architect of the Age of Augustus who established a springboard for the Renaissance.

Sebastiano Serlio, *Regoli Generali*, Books 1–5. Venice, 1551.

Architecture, civic art, decoration and scene design combined in one of the most delightfully illustrated books of the Renaissance, and one which had a great influence in Northern Europe.

Giacomo Barozzio, called **Vignola**, *Regola dei Cinqui Ordini d'Architettura*. Rome, 1563. *Le due Regole della prospettiva*. Rome, 1583.

The disciplines of Vignola are still essential to the training of the civic designer. See Gustavo Giovannoni, *Saggi sulla architettura del*

Rinascimento (2nd edition, Milan, 1935).

Andrea Palladio, *I Quattro Libri dell'-Architettura*. Edition in English by James Leoni. London, 1715.

Important not only for its influence in Great Britain, but for establishing the principles of the Grand Design.

François Blondel, *Cours d'Architecture*. Paris, 1675–1683.

Jacques François Blondel, *Cours d'Architecture*. Paris, 1771–1777.

The Grand Design established and continued in France. Civic designers should not overlook the projects of the Du Cerceaus, nor the 17th century works of Perrault and Le Pautre.

Abbé Marc Antoine Laugier, *An Essay on the Study and Practice of Architecture*. London, 1756.

This author was interested in the path of the foot and the eye.

Julien Guadet, *Eléments et Théorie de l'Architecture*. Paris, 1909.

Deals with the problems of grouping, scale and the place of the monumental.

Heinrich Maertens, *Der Optische-Maasstab: oder, Die Theorie und Praxis des asthetischen Sehens in den bildenden Kunsten*. 2nd edition, Berlin, 1884.

An attempt to define and measure scale in city building.

Camillo Sitte, *L'Art de Bâtir les Villes*. Translated and amplified by Camille Martin. Paris, 1902.

This French edition is chosen because of its illustrations. A recent English translation has been criticised for its inaccuracies by the art historian Rudolf Wittkower and others.

William Richard Lethaby, "Of Beautiful Cities," *In Art and Life, and the Building and Decoration of Cities*. London, 1897.

A message of inspiration for civic designers. The same author's *Form in Civilization* (London, 1922) should also be consulted.

Louis Henry Sullivan, *The Autobiography of an Idea*. New York, 1926.

The American architect who invented a system of civic ornament.

Charles Mulford Robinson, *Modern Civic Art or the City Made Beautiful*. 2nd edition, London and New York, 1904.

An important American popularizer of the City Beautiful. The writings of the American planner John Nolen also belong in this category. See "The Place of the Beautiful in the City Plan," in *Proceedings of the 14th National Conference on City Planning*, 1922.

Sir Raymond Unwin, *Town Planning in Practice*. London, 1909.

Harry Inigo Triggs, *Town Planning: Past, Present and Possible*. London, 1909.

These two influential books, coming at the height of the Garden City movement, nevertheless belong to the tradition of the Grand Design.

Geoffrey Scott, *The Architecture of Humanism*. New York, 1969.

An exquisitely written plea for the continuing tradition of classic design, with an analysis of the Romantic movement. New Introduction by Henry Hope Reed.

Georges Gromort, *Essai sur la Théorie de l'Architecture*. Paris, 1946.

A useful introduction to the principles of architecture and the planning of squares and public places.

Léon Homo, *Rome Imperiale et l'Urbanisme dans l'Antiquité*. Paris, 1951.

An important new work shedding light on the classical age.

Gustavo Giovannoni, *Saggi sulla Architettura del Rinascimento*. 2nd edition, Milan, 1935.

By the late professor of city planning at the University of Rome. Contains a useful explanation and definition of medieval planning.

404

BIBLIOGRAPHY

Pierre Lavedan, *Histoire de l'Urbanisme*. Paris, 1926, 1940, and 1952.
The authoritative history of civic design.

Among philosophers and amateurs of esthetics, the following are especially sensitive to the problems of building and design:

Edmund Burke, *A Philosophical Enquiry into the Origin of Our Ideas of the Sublime and the Beautiful*. London, 1757.

Charles Baudelaire, *Oeuvres*. Texte établi et annoté par G. Le Dautec. Paris, 1938, Vol. II.
See the essay "Des écoles et des ouvriers."

Hippolyte Adolphe Taine, *The Philosophy of Art*, translated by John Durand. 2nd edition, New York, 1873.

John Ruskin, *Lectures on Architecture and Painting*. London, 1854. *The Two Paths*. London, 1859.

Heinrich Wölfflin, *Classic Art: An Introduction to the Italian Renaissance*, translated by Peter and Linda Murray. New York, 1952.

George Santayana, *The Life of Reason, The Sense of Beauty*. Triton Edition, New York, 1936–1940.

Vernon Lee (Violet Paget), *The Beautiful*. An introduction to Psychological Aesthetics. Cambridge, 1913.

The Earl of Listowel, *A Critical History of Modern Aesthetics*. London, 1933.

Miloutine Borissavliévitch, *Les Théories de l'architecture*. 2nd edition, Paris, 1951.

John Dewey, *Art as Experience*. New York, 1934.

2 EXAMPLES AND DESIGNS

Jean Nicolas Louis Durand, *Recueil et parallèle des Édifices de tout genre Anciens et Modernes*. Paris, 1798.
The "Grand Durand" now reissued by Vincent Fréal et Cie., containing the world's great monuments drawn to the same scale.

Robert Auzelle, *Documents d'Urbanisme, présentés à la même échelle, réunis et commentés*. Paris, 1948, Nos. 1–10; (other numbers in preparation).
Plans of squares and plazas, with descriptions, photographs and airviews.

Giovanni Battista Piranesi, *Antichità Romane*. Rome, 1756.

Israel Silvestre, *Recueil d'un grand nombre de vues . . . de France, d'Italie*, etc. 4 vols., Paris, 1750.
Although it is now difficult to obtain complete sets of these artists' works, the prints will often be found singly and in incomplete volumes.

Paul Marie Letarouilly, *Édifices de Rome Moderne*. Paris, 1840–68.
Contains drawings which are models of the draftsman's art.

Werner Hegemann and Elbert Peets, *The American Vitruvius: an Architect's Handbook of Civic Art*, Vol. I. New York, 1922.
If it were only for the illustrations, this book would be the most useful single volume in existence, but the text should not be overlooked. For a graphic review of civic art from 1922 to 1937 see: Werner Hegemann, *City Planning: Housing*. Edited by W. W. Foster and Robert C. Weinberg. New York, 1938.

Alfred Louis Auguste Franklin, *Anciens Plans de Paris*. Paris, 1878–1880.
Maps of Paris from Roman times to 1791.

Pierre Patte, *Monuments Erigés en France à la Gloire de Louis XV*. Paris, 1767.
Suggested "Improvements" to Paris and other French cities of a lavishness without parallel in the history of civic design.

Georges Huisman, *Pour Comprendre les Monuments de Paris*. 2nd edition, Paris, 1949.
A useful handbook on the architecture of Paris.

Paul Léon, *Histoire de la Rue*. Paris, 1949.

Insights on the streets of Paris, engagingly presented.

Colen Campbell, *Vitruvius Britannicus*. London, 1715–1725.

Much that was great in England before the final flowering.

John Speed, *The Theatre of the Empire of Great Britaine*. London, 1676.

Plans from which the builders of colonial America drew their inspiration.

Sir William Chambers. *A Treatise on the Decorative Part of Civil Architecture*. London, 1759.

By an architect who showed a trading nation the virtues of civic art.

I. Grabar, Istoriya Russtovo Iskusstva: Vol. III, *Istoriya Arkhitektury*. Moscow, 1909–1916.

The standard historical survey of Russian architecture. Profusely illustrated.

Andrei Vladimirovich Bunin, *Arkhitekturnaia Kompozitsiia Gorodov*. Moscow, 1940.

Russian architects on esthetic factors in city planning.

Talbot Faulkner Hamlin, *The American Spirit in Architecture*. New Haven, 1926. *Forms and Functions of Twentieth Century Architecture*. New York, 1952.

Fiske Kimball, *American Architecture*. Indianapolis and New York, 1928.

The leading historians of American architecture. Fiske Kimball was the first to point out the considerable influence on Europe of the second important American classical revival.

Isaac Newton Phelps Stokes, *The Iconography of Manhattan Island*. New York, 1915–1928. *American Historical Prints*. New York, 1933.

The latter is a catalogue, albeit an informative one, with illustrations, of the collection of views of American cities now in the New York Public Library.

George Kubler, *Mexican Architecture of the Sixteenth Century*. New Haven and London, 1948.

Anthony N. B. Garvan, *Architecture and Town Planning in Colonial Connecticut*. New Haven and London, 1951.

These two books are recommended for the importance their authors give to theories and examples of civic design.

Examples and criticism of American civic design are to be found in the articles of Montgomery Schuyler, The *Architectural Record*, Vols. I-XXXVI. (See Vol. XXXVI, pp. 267–268, for detailed bibliography). The files of this magazine from 1890 to 1925 should also be consulted for the articles by Ernest Flagg, A. D. F. Hamlin and Fiske Kimball.

3 MASTERS OF CIVIC DESIGN

The following are works by or about twenty painters, sculptors, architects or landscape gardeners who designed all or parts of a city and contributed to its beauty in three dimensions.

Armando Schiavo, *Michelangelo architetto*. Rome, 1949.

A short work on one who attained "the noblest point of art," best supplemented by further reading.

Stanislao Fraschetti, *Il Bernini, la sua Vita, la sua Opera, il suo Tempo*. Milan, 1900.

The creator of the approach to Saint Peter's and the fountains of Rome.

Giulio Lorenzetti, *Itinerario Sansoviniano a Venezia*. Venice, 1929.

Francesco Sapori, *Jacopo Tatti detto il Sansovino*. Rome, 1928.

On the maker of the modern square in Venice.

Domenico Fontana, *Della Transporta-*

tatione dell' Obelisco Vaticano. Rome, 1590.

J. A. F. Orbaan, *Sixtine Rome.* London, 1910.

The second book is a popular account of Domenico Fontana's work for Sixtus V and his creation of the modern radio-concentric plan in Rome.

Lucien Corpechot, *Les Jardins de l'Intelligence.* Paris, 1912.

Jules Guiffrey, *Andre Le Nostre Étude Critique.* Paris, 1912.

Louis XIV's landscape gardener, who took part in the designing of the town of Versailles and parts of Paris.

Jacques Francois Blondel, *Architecture Françoise.* . . . Paris, 1752–1756.

For an appraisal of Jules Hardouin Mansart, creator of the Place Vendôme.

Georges Gromort, *Jacques-Ange Gabriel.* Paris, 1933.

The designer of the Place de la Concorde.

Claude Nicolas Ledoux, *Architecture de C. N. Ledoux.* Paris, 1807.

The architect who designed the town of Chaux and beautified Paris.

William Kent, *The Designs of Inigo Jones.* London, 1770.

The scene-designer and architect, whose Covent Garden began the great tradition of London squares. The author of this work also deserves mention for one of the best groupings in London, the Horse Guards.

Sir Christopher Wren, *Parentalia.* Reprinted, London, 1903.

Wren triumphantly implanted the Grand Design outside London at Greenwich.

John Summerson, *John Nash,* Architect to King George IV. London, 1935. The designer of Regency London.

Fiske Kimball, *Thomas Jefferson, Architect.* Original designs in the collection of Thomas Jefferson Coolidge, Jr. Boston, 1916.

Jefferson introduced the monumental to America in his design for the State Capitol in Richmond, and in his plans for the University of Virginia made use of the Grand Design.

Charles A. Place, *Charles Bulfinch; Architect and Citizen.* Boston, 1925.

America's "second great architect" and Boston selectman, who established the Bulfinch scale in the capital of New England.

Karl Friedrich Schinkel, *Sammlung Architektonischer Entwurfe . . .* Berlin, 1829–35.

The architect and painter responsible for much that is important in the environs of Berlin.

Frederick Law Olmsted, Jr., and Theodora Kimball, *Forty Years of Landscape Architecture.* New York and London, 1922–1928.

The senior Olmsted will be remembered not only for Central Park, but for his improvements to suburban planning.

McKim, Mead and White, *A Monograph of the Work of McKim, Mead and White.* New York, circa 1914–15.

The firm responsible for the second neo-classic revival in America, evidenced first in Copley Square, Boston and later across the nation.

Daniel Hudson Burnham and Edward H. Bennett, *Plan of Chicago.* Chicago, 1909.

Charles Moore, *Daniel H. Burnham, Architect, Planner of Cities.* Boston and New York, 1921.

Burnham envisaged the first great three-dimensional plan for an American city.

A. S. G. Butler, *The Architecture of Sir Edwin Lutyens.* London, 1950.

Includes Lutyens' plans for New Delhi, in which all his skill as a civic designer is evidenced.

Fairmount Park Art Association, *Fairmount Parkway.* Philadelphia, 1919.

Jacques Gréber, *Plan for the National Capital, Canada*. Ottawa, 1951.

The planner of Canada's national capital also designed Fairmount Parkway in Philadelphia.

Sir Patrick Abercrombie and Derek Plumstead, *A Civic Survey and Plan for the Royal Burgh of Edinburgh*. Edinburgh, 1949.

One of the great British civic designer's many plans in which the third dimension is well considered.

4 CIVIC ART

Among the thousands of books on art, the civic designer will be forced to select those periods and artists which are closest to his favorite subject. The following is a mere sampling of the range.

César Daly, *Motifs Historiques d'Architecture et de Sculpture d'Ornement*. . . . Paris, 1869.

Salomon Reinach, *Répertoire de la Statuaire Grecque et Romaine*. . . . Paris, 1897–1924. *Répertoire de Reliefs Grecs et Romains*. . . . Paris, 1909–1912.

Adolphe Napoleon Didron, *Christian Iconography*. London, 1896.

Raimond van Marle, *Iconographie de L'Art Profane*. The Hague, 1931.

D. Guilmard, *Les Maîtres Ornemanistes*. Paris, 1880–81.

Ugo Donati, *Artisti Ticinesi a Roma*. Bellinzona, 1942.

Vincenzo Golzio, *Il Seicento e il Settecento*. Turin, 1950.

F. Fichera, *G. B. Vaccarini*. Rome, 1934.

Werner Hager, *Die Bauten des Deutschen Barocks, 1690–1770*. Leipzig, 1942.

Bruno Brunelli and Adolfo Callegari, *Ville del Brenta*. . . . Milan, 1931.

Ernest de Ganay, *Chateaux et Manoirs de France: Ile-de-France*. Paris, 1938–39.

Charles Mauricheau-Beaupré, *Versailles. L'Histoire et l'Art*. Paris, 1949.

Henri Delaborde, *Ingres. Sa Vie, ses Travaux, sa Doctrine*. Paris, 1870.

Arts, Styles et Techniques. Edited Norbert Dufourcq. Librairie Larousse, Paris.

Useful handbooks. See especially the volumes on French architecture by Pierre Lavedan, on gardens by Ernest de Ganay, on the period of Louis XV by Pierre Verlet.

Prince de Ligne, *Coup d'Oeil sur Beloeil et sur une grande Partie des Jardins de l'Europe*. Introduction and notes by Ernest de Ganay. Paris, 1922.

Sir George Sitwell, *On the Making of Gardens*. With an introduction by Sir Osbert Sitwell. New York, 1951.

Marie Luise Gothein, *A History of Garden Art*. London and New York, 1928.

Geoffrey Jellicoe, *Baroque Gardens of Austria*. London, 1932.

Alice Gardner Lockwood, *Gardens of Colony and State*. New York, 1931.

William Morris Hunt, *Talks on Art*. Boston, 1896.

Royal Cortissoz, *John La Farge, a Memoir and a Study*. Boston and New York, 1911.

Augustus Saint Gaudens, *The Reminiscence of Augustus Saint-Gaudens*. New York, 1913.

Grace Overmyer, *Government and the Arts*. New York, 1939.

Edward Bruce and Forbes Watson, *Art in Federal Buildings*. Vol. 1. Mural Design. Washington, 1936.

Myrtle M. Murdock, *Constantino Brumidi: Michelangelo of the United States Capitol*. Washington, 1950.

Charles E. Fairman, *Art and Artists of the Capitol of the United States of America*. Washington, 1927.

5 THE IMAGE OF THE CITY

All great cities have their historians, and thousands of obscure villages their

faithful chroniclers; dozens of excellent sociological studies exist like Charles Booth's *Life and Labor in London* and Caroline Ware's *Greenwich Village*. Without neglecting these, or the countless works of novelists and poets, the civic designer is especially grateful to those who treat of the city as an artifact and theater of life. Among those who, with Ruskin, have looked at the city in this way belong:

William W. Story, *Roba di Roma*. London, 1876.

All Romans agree that this American understood the meaning of their city.

Augustus J. C. Hare, *Walks in Rome*. Revised edition, London, 1913. *Florence*. London and New York, 1884.

Works which combine the virtues of guide, teacher and friend. May be supplemented by the excellent new guide books edited by L. V. Bertarelli and published by the Touring Club of Italy.

Pompeo Gherhardo Molmenti, *Venice, Its Individual Growth from the Earliest Beginnings to the Fall of the Republic*. Chicago, 1906–08.

The late Italian editions of this work, *La Storia di Venezia nella Vita Privata*, are magnificently illustrated.

Giulio Lorenzetti, *Venezia ed il suo Estuario*. Venice, 1926.

Heinrich Kretschmayr, *Geschichte von Venedig*. Gotha, 1905–34.

All three are indispensable for unravelling the complications of Venetian history and growth.

Marquis de Rochegude et Maurice Dumolin, *Guide Pratique à travers le Vieux Paris*. Paris, 1923.

André Morizet, *Du Vieux Paris au Paris Moderne. Haussmann et ses prédecesseurs*. Paris, 1932.

Marcel Raval, *Histoire de Paris*. Paris, 1948.

Jacques Wilhelm, *La Vie à Paris*. Paris, 1947.

Marcel Poëte, *Une Vie de Cité*. Paris, 1924–31.

State patronage of the arts in France ensures them of a place in every history book. These are among the best on Paris. The first stops at each house or building along the way which has been touched by history or a personality; the last is a pictorial chronicle of quality and discrimination.

Justus Bier, *Old Nuremberg: A work of Art in Town Architecture*. Nürnberg, 1928.

A translation of the German edition which adequately conveys the author's feeling for and understanding of the medieval town.

Steen Eiler Rasmussen, *London: The Unique City*. London, 1948.

John Summerson, *Georgian London*. London, 1946.

The best general interpretation is by a Dane, and the authoritative work on London since Marlborough is by the director of the Sir John Soane Museum.

James Fenimore Cooper, *Notions of the Americans*. London, 1828.

Edgar Allan Poe, *Doings of Gotham*. Pottsville, Pa., 1929.

Henry James, *The American Scene*. New York, 1946.

Three great American writers who turned aside to examine the cities. Their comments are invaluable and their knowledge of architecture will be, to some, surprising.

For the United States, the civic designer must be equipped with the Federal Works Agency's *American Guide* series. Each volume deals with a state or an important city. Uneven in quality, a select few are models of their kind, notably *New York, Missouri, Pennsylvania, Ohio, Indiana*.

INDEX

413